P9-CLC-372

J ◆ E ◆ A ◆ N
RENOIR
Projections of Paradise

J·E·A·N RENOIR

Projections of Paradise

RONALD BERGAN

The Overlook Press
Woodstock • New York

To Catherine Grégoire, who gave me the idea.

First paperback edition published
in the United States in 1995 by
The Overlook Press
Lewis Hollow Road
Woodstock, New York 12498

Copyright © 1992 Ronald Bergan

All Rights Reserved. No part of this publication may be reproduced or transmitted
in any form or by any means, electronic or mechanical, including photocopy,
recording, or any information storage and retrieval system now known or to be
invented without permission in writing from the publisher, except by a reviewer
who wishes to quote brief passages in connection with a review written for
inclusion in a magazine, newspaper, or broadcast.

Library of Congress Cataloging-in-Publication Data

Bergan, Ronald
Jean Renoir : projections of paradise / Ronald Bergan.
p. cm.
Filmography : p.
Includes bibliographical references and index.
1. Renoir, Jean, 1894–1979
2. Motion picture producers and directors-France-Biography.
I.Title
PN1998.3.R46B45 1994
791.43'0233'092-dc20
94-3131
CIP
ISBN:0-87951-608-9
135798642

Contents

PART I

FIRST IMPRESSIONS
(1894–1916)

1

A Château in Montmartre

'As a result of my many talks with Gabrielle about the Château des Brouillards, where I lived until the age of three, I hardly know which are my recollections and which are hers.'

Shortly after midnight on 15 September 1894, a midwife held a baby up for the mother to see. 'Heavens, how ugly! Take it away!' she exclaimed; the father, with a certain amount of prescience, said: 'What a mouth; it's a regular oven! He'll be a glutton.'[1] The cartoonist Abel Faivre, who was staying the night at the Château des Brouillards, thought the infant would provide him with a perfect model for his caricatures.

Doctor Bouffe de Saint Blaise said the mother had come through the ordeal splendidly, and he predicted that the child would have an iron constitution. He swallowed a glass of brandy from Essoyes, the home town of the mother, and left. Other witnesses to the birth were Eugène, the first cousin of the newly-born, a sergeant in the Colonial Army, and 15-year-old Gabrielle Renard, the mother's cousin, who had arrived from Essoyes a month earlier to help with the preparations for the birth. She had her own opinions of the baby. 'Well, I think he's beautiful,' she averred.[2] Everyone laughed, including the father.

The mother sat up in bed and asked Madame Mathieu, the family's cook and laundress, to prepare some baked tomatoes

according to a recipe she had been given by their friend Paul
Cézanne. 'Just be a little less stingy with the olive oil,' she sug-
gested.[3] Faivre had never tasted the dish before and ate almost all of
it, so that Madame Mathieu had to prepare another serving. The
father was not hungry. He had been very worried about his wife,
who had suffered a miscarriage between her first child and this
hippo-mouthed yelling creature. He sat around the table, pale and
gaunt. 'To think of putting Aline in that condition just for a few
minutes', he said self-accusingly. 'Don't you worry, *maître*, you'll
do it again,' the cartoonist said, accurately as it happens, while he
put away more tomatoes *à la* Cézanne. Eugène, who was actually
born in Russia and might have been a model for one of those idle
young men in Chekhov, finished his food, rinsed his mouth out
with some wine mixed with water, stretched his legs, leaned back
in his chair, and closed his eyes.

A few days later, the father wrote to fellow-painter Berthe
Morisot. 'I have a quite absurd piece of news for you . . . namely,
the arrival of a second son. He is called Jean. Mother and baby are
both in splendid health.'[4]

The Château des Brouillards, where the birth took place, was not a
Gothic castle swathed in fog on the Normandy coast as its name
might suggest, but was perched on the slope of the Butte in
Montmartre, number six in a row of dwellings at 13 rue Girardon.
Jean Renoir later described the houses thus: 'A hedge surrounded the
property, which was composed of several buildings and a fine
garden. Once you entered the wrought-iron gate you found yourself
in a lane too narrow for a carriage to pass . . . the inhabitants,
enclosed within the high hedge and enjoying a certain privacy
behind the fences of their own small gardens, dwelt in a world apart,
concealing endless fantasy under a provincial exterior . . . For most
Parisians this little paradise of lilacs and roses seemed like the end of
the world. Cab drivers refused to drive up the hill, stopping their
cabs either at the place de la Fontaine du But [now called place
Constantin Pecqueur], where you had to climb the slope to reach
the house, or else at the rue des Abbesses, on the other side of the
Butte where it crosses the rue Lepic . . . The difficulty of getting to
the place was largely compensated for by the low rents, the fresh
air, the cows, the lilacs and the roses.'[5]

The Château des Brouillards had two upper floors, plus an attic
which had been transformed into an artist's studio. From the attic

window on the west side one could see Mont Valérien, the hills of Meudon, Argenteuil and Saint-Cloud, and the plain of Gennevilliers. The plain of Saint-Denis was visible from the north window, as were the woods at Montmorency. On clear days you could even make out the basilica of Saint-Denis in the distance. 'You felt you were right up in the sky,' wrote Jean. The walls of the rooms had been painted white and the doors Trianon grey, as they had been wherever the artist had lived. Madame Renoir slept upstairs over the dining-room; her husband on the second floor next to the guest room; their elder son Pierre, when he came home from school on weekends, over the drawing room; and Gabrielle above the kitchen.

It is ironic that the artist, who suffered terribly from rheumatism, should have chosen a cold house called the Château des Brouillards. What he needed and desired was the warming sun of the Midi. At the beginning of 1895, during a freezing winter, the baby Jean was taken ill with pneumonia. For an entire week his mother and Gabrielle were on constant vigil, carrying the child about in their arms, because if he were laid flat on the bed he began to suffocate. In desperation, they finally telegraphed Auguste, who was painting down at La Couronne, near Marseilles. Dropping his brushes, he immediately hurried to the station, without even a suitcase, and caught the first train to Paris. 'Thanks to the love of those three devoted people, I was pulled through a crisis which might otherwise have been fatal. Yet once the danger was past, no one made further mention of it. If it had not been for Gabrielle, I should never have known anything about it.'[6] Always in search of warmth, Auguste was off again to the Midi as soon as the baby had recovered.

Auguste had moved into 13 rue Girardon in October 1889 with Aline, whom he was yet to marry, and their five-year-old son Pierre, nearly five years before Jean was born. But the artist had been living on and off in Montmartre since 1873, when he frequented the Nouvelle–Athènes café in the rue Pigalle together with Edouard Manet, Marcellin Desboutin, the painter and writer of verse trage-dies; Charles Cros, poet, musician, inventor and wit; the poets Villiers de l'Isle Adam and Jean Richepin; Paul Cézanne, and Auguste's lifelong comrade Georges Rivière, author of *Renoir and His Friends*, and future father-in-law to Cézanne's son. The district possessed everything Renoir *père* adored, and which his second son was to love, from dance halls to circuses, from music halls to the café concert, and its bustling streets were filled with the kind of

people he liked and respected, the workers of Paris. There were also parades of pretty girls, *midinettes*, dancers, acrobats and equestrians.

In the 1870s Montmartre was still a village, an atmosphere it has managed to retain over the years. Auguste settled at 74 rue St Georges, where he rented a studio midway between the Grands Boulevards and the place Pigalle. Then as now it was packed with cafés and places of entertainment, nightclubs and exclusive restaurants frequented by nobs who drove up the hill for a night out and were ready to pay enormous prices for the privilege. 'I will provide low life for millionaires,' says Moulin Rouge impresario Jean Gabin in *French Cancan*, the motion picture Jean chose to celebrate his return to film-making in his native country after 15 years' absence in California; an exuberant, colourful homage to the theatre of *La Belle Époque*. One is constantly made aware in Jean's films of his need to get back to the adult world of his father, and his own romantic memories of childhood, filtered through the not always rose-coloured lens placed there by Gabrielle, his all-enveloping and loving nurse.

Montmartre was where Jean chose to live whenever he returned from America, an area that could not but help form a distinctive part of his character, a certain cynical Montmartroise humour and an attraction towards *la vie de Bohéme*. Although the true name of Montmartre is the Mont de Mercure, a very old tradition dating from the eighth century makes it the 'Mont des Martyrs' because, in the year 272, Saint Denis, first Bishop of Paris, and his two prelates were said to have been martyred there. When Saint Denis was beheaded, the legend has it, he picked up his head and walked on towards the hilltop, washing his bloodstained face in the fountain on the way. The hill of Montmartre is also linked with the uprisings of the first Paris Commune in 1871 which resulted from a feeling of betrayal when France capitulated before the Prussian armies.

Artists and writers began to settle in Montmartre in the early nineteenth century because life there was cheap and the hill picturesque. In the cemetery, which Jean visited as a child, are the tombs of Théophile Gautier, Alfred de Vigny, Stendhal, the Goncourt brothers, Greuze and Berlioz, as well as Madame Récamier and Alphonsine Plessis (the model for *La Dame aux camélias*). More importantly, the young Jean was exposed to a stream of living artists visiting his father's household. Among the regular visitors to the Château des Brouillards were Paul Cézanne, whose son was to become a great friend of Jean's, Claude Monet, Camille Pissarro,

Edgar Degas, Berthe Morisot and her daughter Julie Manet, the poet Stéphane Mallarmé, Paul Durand-Ruel, the art dealer who was among the first to champion the Impressionists, and Ambroise Vollard. A creole from the isle of Réunion, Vollard was a thin-bearded bright-eyed man who had opened a small gallery in the rue Lafitte at the beginning of 1884, and was introduced to the Renoir circle by Pissarro, who was also born in the Antilles. He wrote two of the best-known books on the painter, *La Vie et l'oeuvre de Pierre-Auguste Renoir* (1919) and *Renoir* (1920). Vollard's name became so confused in Jean's mind, that he believed that the American silver dollar had been named after him. For years he called it a vollard, expecting to find the art dealer's face on the coins. Later in life, he was still apt to say from time to time, 'The development of space missiles costs billions of vollards.'

When Gabrielle took Jean shopping with her in the neighbourhood, Toulouse Lautrec was often to be seen sitting in the window of a café on the corner of the rue Tholozé and the rue Lepic. The dwarfish artist would call to them to sit down with him and his girfriends of the moment, sometimes belly dancers at the Moulin Rouge, Montmartre women with exotic names dressed in Algerian costume.

In order to get to the Château des Brouillards today, one can take the métro to place Pigalle and walk up the rather scruffy rue Houdon, in number 18 of which Pierre Renoir was born. Walking further up rue Ravignon, away from the crowds that gather in the cafés down below, a few pleasant houses start to appear on the side of the Butte.

Separated from the cafés and restaurants in a more residential district, there is a street recognisable from one of Max Douy's set designs for *French Cancan*. This is where Nini (Françoise Arnoul), the young laundress with dreams of becoming a dancer at a *caf' conc'*, meets the infatuated Prince Alexandre (Gianni Esposito). On the corner of the rue Girardon is the Bar L'Assommoir, close to where Zola set his novel of the same name, part of the Rougon-Macquart series, two of which, *Nana* and *La Bête humaine*, Jean filmed. There are associations everywhere.

The large numberless house on the corner is the Château des Brouillards. There is no plaque. There are few flowers growing on the hedges, and the garden is unkempt. 'All along our fence there were rose bushes which had reverted to their wild state,'[7] was Jean's description of it. The house with its off-white peeling walls and

shutters occupies the whole block. It has seen better days. In the near distance the white dome of Sacre Coeur is visible.

Up here on the Butte, over a century ago, a small boy played in a garden while his father painted. The house is still there . . . and the memories.

Jean was baptised in 1896 at the Church of Saint Pierre de Montmartre, the third oldest church in Paris after St Germain-des-Prés and St Martin-des-Champs. His godfather was George Durand-Ruel, one of the sons of Paul Durand-Ruel, and his godmother was Jeanne Baudot. She was the 16-year-old daughter of the chief doctor of the Western Railway Company. Two years before, Jeanne had seen Renoir canvases in the house of her parents' friends, the Gallimards, and begged to be introduced to the painter so that he could instruct her. 'What do you want me to teach you?' Auguste asked 'I'm learning every day.'[8] But the young girl and the middle-aged artist got on very well, and she became a good Impressionist painter. Her colourful pictures adorn the walls of the mansion of her nephew, Jean Griot, former editor of Le Figaro, at Louveciennes, the town outside Paris where Jean's paternal grandparents lived out their last days.

The sun shone on the day of the baptism. The bright dresses and lace parasols of the women contrasted sharply with the black of the men's jackets and top hats. Faivre was there, so was cousin Eugène, in his Colonial Infantry uniform decorated with medals. He was the son of Auguste's elder brother Victor, a tailor, whom a Russian grand duke had admired so much that he took him back to St Petersburg.

In the garden, Jean's godparents distributed the traditional sugared almonds to the children of the family and the neighbourhood, while the adults drank from a cask of Frontignon wine Auguste had had sent up from the south, and ate vol-au-vents and brioches chosen at local shops by the host himself.

The baby's elder brother, 11-year-old Pierre, who was of a taciturn nature, unwound after drinking a little of the Essoyes wine and recited some verses from the battle scene in Le Cid to the young girls from next door. When Faivre started to tell an off-colour story, Auguste gave him a kick under the table to remind him that young women were present. Although his own language could be spicy (as Jean's later was) and he was free from prudery, Auguste disliked smutty jokes being told in front of the daughters of his friends. After

luncheon everyone strolled under the trees at the Château des Brouillards. The final word on the day came from Joséphine, the fishmonger, who declared it the finest christening she had ever seen in Montmartre.

2

La Belle Époque

'I have spent my life trying to determine the extent of the influence of my father upon me.'

Over a century earlier, another significant baptism had taken place. On 8 January 1773, a foundling was baptised François, but had no surname as his parents were unknown. The newly-born male child had been found the same day abandoned in Limoges, and taken to the General Hospital. It was 23 years later that the surname Renoir first seems to have appeared in the records. On 24 November 1796, François Renoir, shoemaker, of rue du Colombier, Limoges, married Anne, daughter of the local carpenter Joseph Régnier. Curiously, nobody named Renoir lived in Limoges during that time. There was, however, a Renouard, also a shoemaker, in the town. It has been assumed that this man adopted the foundling – a common occurrence when a craftsman wanted an apprentice who would cost only the food he ate.

By a strange coincidence, although there was no Renoir in the town, there was more than one Lenoir, two of whom were well known to the bridegroom and the registrar. One of these was the abbé Lenoir, the priest who baptised François in 1773; the other the magistrate who married him in 1769. It has also been assumed that when François was asked his name at the marriage ceremony he

said, 'Renouard', and that the registrar wrote down the phonetic
Renoir – a mistake which François, being illiterate, could not correct.
Or could it have been that the 'L' of Lenoir was written in such a
way as to suggest an 'R', not impossible with extremely florid
handwriting? A clerical error thus gave Jean Renoir's great-grand-
father a name that would become famous.

François gladly accepted the name, but he did not accept the
mystery of his birth. Like many a foundling he visualised his parents
in the most romantic light, and dreamed that he was of noble blood,
perhaps the result of a below-stairs liaison between an aristocrat and
a maidservant of the household, a frequent occurrence during the
days of the *ancien régime*. At the restoration of the monarchy in 1815,
François Renoir, believing himself entitled to estates and fortunes
and encouraged by his wife and eldest son, travelled to Paris to
persuade the commission which dealt with the claims of the dispos-
sessed aristocrats that his father had been guillotined during the
Terror. The fact that he was born in 1773, and the Terror was 20
years later, must have conveniently escaped him. François returned
to Limoges unheard, but he continued to believe he was of noble
birth for the rest of his life. However, none of his descendants,
especially his famous artist grandson, cared to be thought of as a
blueblood. Auguste Renoir preferred to be considered an artisan and
a man of the people, as did Jean, despite some of the latter's
aristocratic tastes and a certain (atavistic?) empathy with the philos-
ophy of nobility. One sees this positive attitude to the character of
Louis XVI in *La Marseillaise*, deepened by his sympathetic approach
to the role as played by his brother Pierre; to the Baron (Louis
Jouvet) in *Les Bas-Fonds* (*The Lower Depths*); the aristocrats Captain
de Boeldieu (Pierre Fresnay) and Captain von Rauffenstein (Erich
von Stroheim) in *La Grande Illusion*, and the Polish Princess Eléna
Sorokovska (Ingrid Bergman) in *Eléna et les hommes*. Some members
of the Renoir family used to refer to Auguste as 'Monsieur le
marquis' as a joke, a title given affectionately to Robert de la
Chesnaye (Marcel Dalio) in *La Règle du jeu*.

Of course, one of the great strengths of Jean as a film director was
his recognition of the nobility of spirit in a character, irrespective of
the character's origins or class – Jean Gabin is called a 'prince' by an
old beggarwoman in *French Cancan* – the proletariat were not
automatically extolled, the bourgeoisie not automatically con-
demned. Even within the context of the Popular Front from which
emerged *La Marseillaise*, produced by the CGT (*Confédération Gén-*

érale du Travail), the trade union organisation attached to the Communist Party, Jean unashamedly presented aristocrats capable of virtue and humanity.

Léonard, the eldest son of François Renoir, was born on 7 July 1799. In due course he was apprenticed to a journeyman tailor, a man who moved from town to town, staying at each one as long as there was work. This nomadic existence lasted until 1828 when the 29-year-old Léonard, a tailor in his own right by that time, visited Saintes, 100 miles west of his birthplace. There he met and married a 21-year-old seamstress, Marguerite Merlet. Jean's grandmother (who modelled for her son Auguste) was a delightfully no-nonsense person who preferred soap and water to cosmetics, wore plain dresses and rejected the highly decorative fashion. She was also plain-speaking, saying what she thought rather than what others wanted to hear.

Soon after the marriage Marguerite and Léonard went back to Limoges, made a home for François and his wife, and helped carry on the family business at 35 boulevard Sainte-Catherine (now 71 boulevard Gambetta) where six children were born, two of them dying young. The four who survived were Henri, born in 1830, Lisa born two years later, Victor who came along four years after Lisa and, finally, on 25 February 1841, nearly five years later than Victor, Pierre-Auguste Renoir.

On 29 May 1845, François died, aged 72, and Léonard and his family decided to move to Paris. 'It's no use asking me about Limoges,' Auguste told his second son in later years. 'I was not more than four when I left it and I've never seen it again.'[1] But Limoges had its effect on him just the same. It was then, as now, famous for hand-decorated porcelain, and Auguste's first job was as an apprentice in the earthernware works in rue Vieille du Temple.

Auguste also sang in the choir at the church of St Eustache in Les Halles, where the composer Charles Gounod was organist and choirmaster. The boy had a very good singing voice, and legend has it that Gounod offered to train him as an opera singer after the 13-year-old got into the chorus at the opera. The world might have lost a great painter to the ephemeral art of the singer, had Auguste, who loved working with his hands, not chosen to continue his career in pottery and art.

He began to paint, and studied at the studio of Gleyre and at the École des Beaux-Arts. In October 1863, a 'Renouard' was placed

twenty-eighth out of 80 students in the winter semester examination. However, he soon rebelled against his teachers, who dismissed the realistic art of Courbet and Manet, meanwhile making friends with Alfred Sisley who worshipped Corot. Other friends who used to meet at the Closerie des Lilas in Montparnasse were Fréderic Bazille and Claude Monet. At the instigation of Monet, they would take their sketching-pads into the country. This *plein air* group, which later included Camille Pissarro and Paul Cézanne, often went to the forest of Fontainebleau. The small town of Barbizon in the forest had earlier attracted painters (Théodore Rousseau, Virgilio Diaz, Jean-François Millet, Jules Dupré), who became known as the Barbizon group, though their landscapes were not painted wholly or even mainly on the spot; they usually made a sketch out of doors then finished the canvas at their leisure in the studio or inn where they lodged. Monet condemned this, asserting that a painter must paint what he saw when he saw it, that the key to landscape painting was the depiction of life. It was Auguste's deep belief in the importance of painting in the open air from life that affected his film-director son who, as soon as he was able, moved out of the 'studio', taking his camera and microphones with him.

Auguste often stayed at the inn of Mère Anthony at Marlotte, a little way from Barbizon, because it was cheaper. There he painted *Le Cabaret de la Mère Anthony* in 1866, in which can be seen the painters Sisley and Jules Lecoeur, the innkeeper herself, the bearded Renoir rolling a cigarette, Nana the waitress, and Toto, a white poodle. Or, at least, that is how they are generally identified. A newspaper, prominently displayed on the table, is *L'Evènement*, the paper in which Zola had staunchly defended Manet from attack. Again retracing his father's footsteps, it was at Marlotte that Jean later made his home, and where he shot his first film, *La Fille de l'eau*, in which there are scenes in a café that recall *Le Cabaret de la Mère Anthony*.

Jean's mother began to make her first appearances in Auguste's paintings around 1880. The artist had met Aline Victorine Charigot when he was lunching at the *crémerie* opposite his 35 rue St Georges studio in Paris. She lived with her widowed mother and was 18 years his junior. Like her mother and Auguste's, she was a seamstress. She was born in Essoyes on 23 May 1859 and was the essence of the Renoir girl. She had the 'cat-like face' he loved, round with a small nose, large and slightly almond-shaped eyes, a creamy com-

plexion and a domesticated air. 'He liked women who had a tendency to grow fat, whereas men, he thought, should be lean,' wrote Jean. 'He liked small noses rather than large ones, and he made no secret of his preference for wide mouths, with full, but not thick lips; small teeth, fair complexions, and blonde hair.'[2]

Auguste put Aline into *Le Déjeuner des canotiers* (Luncheon Of The Boating Party) which showed friends on the balcony of the restaurant Fournaise, on an island in the Seine at Chatou, a little further upstream from La Grenouillère, which Renoir had painted in 1869. *Le Déjeuner* portrays a group of friends who have just finished lunch; on the tables are bottles of wine and dishes of fruit. The sun shines brightly on this carefree holiday scene. Jean's mother is the girl in the foreground in a yellow straw hat, arms on the table, hands propping up a little dog to which she is pouting a kiss. We can certainly see a resemblance to her celebrated film-director son. The delightful painting has all the atmosphere that Jean was to recapture in *Une Partie de campagne (A Day In the Country)*, and on other excursions to *guingettes* such as in *Boudu sauvé des eaux (Boudu Saved From Drowning)* and *Les Bas-Fonds*.

It was not long before Auguste was painting Aline in the nude, mainly for a series of Bathers paintings, the first of these being executed in Italy. Aline remembered how, on their trip to Italy when she was 22 and still relatively slim, Auguste added folds of flesh onto her painted image, revealing the tendency he had to enlarge his female figures. This reflected his desire to move beyond his immediate experience of the model towards an ideal of female beauty as a vision of physical amplitude.

When Aline fell pregnant in 1884, the couple started to live together. She was an excellent hostess and cook, and invitations to the Renoirs were sought by painters and writers. It must be remembered that Essoyes is in Burgundy, always considered the gastronomical centre of France. At least, it is historically and geographically in Burgundy, but the vineyards are counted as belonging to Champagne. In later life when Jean visited the family home in Essoyes (officially in the French *département* of Aube), he would argue for hours over a glass of *marc* with his friend Félix Suriot, a small-time vintner, as to whether Essoyes ought to be in Champagne or Burgundy, with the epicurean Jean naturally favouring the latter. Such disputes may not mean much to Anglo-Saxons but they are a matter of – if not life and death – a certain import in a country where the people of a region are considered to be as

distinctive as its wines. The two districts had two different cultures, each boasting exceptional cuisine.

Jean and his younger brother Claude (always referred to as Coco) retained all their lives the barrel-like vocal timbre of the region, as rich and rolling as the soil of Essoyes. This was due not only to the influence of their mother, but to the fact that both were brought up by Gabrielle, who always spoke in the tones of a Burgundian peasant woman, even when she was married to the painter Conrad Slade and living in deepest California. The oldest son, Pierre, who spent less time in the area and more time in Paris than either of his brothers, had a deep, resonant voice, with all traces of regional accent ironed out by the Conservatoire and the stage.

As a Burgundian on his mother's side, Jean loved good food all his life and took pleasure in eating well. He always knew the best restaurants to visit wherever he was in the world. Stories of his appetite and epicureanism are bound to crop up in every conversation in which his friends reminisce about him. Leslie Caron remembered that 'he ate ravenously when he was younger'. During the play (*Orvet* which he wrote for her), he was gargantuan. He ate enormous quantities of food and would drink a litre of wine at dinner.'[3] Once, after a casting session for *The River*, while dining with author Rumer Godden at the Café Royal in London, Jean 'let out a bellow that raised the roof' when the wine waiter brought a bottle of chilled Burgundy to the table.[4] Later, in India with Jean and his wife, Godden noted that 'as we drove out to Barrackpore, they spent the time in nostalgic talking about the food they especially loved and missed – particularly *tête de veau* – in all its ghoulish detail.'[5] The only dish Jean could cook himself in his house in Beverly Hills was a *gigot*. In fact, there exists a home movie of him cooking over his electric spit, filmed in the late 60s with a video camera given to him by some Japanese admirers.

Many of the dishes he liked were from simple peasant recipes; he had the idea that the working classes in France knew how best to cook. This belief derived from his memories of the furnace in the kitchen at Essoyes where the food was cooked very, very slowly. Jean lived in a house where his mother was mistress of the kitchen and where the quality of the food was high. Aline had a book full of recipes which she had written down, containing many culinary secrets. The cuisine *chez les Renoirs* was always extraordinary, even on Good Friday when Aline would prepare a *brandade de morue* – cod with a garlic, oil and cream sauce, a dish planned a week in advance.[6]

However, the rather ascetic Auguste was far less interested than his sons in the wonders that came from his wife's kitchen.

It was at their rented four-room apartment at 18 rue Houdon, just off the place Pigalle, that the Renoirs' first child was born on 21 March 1885. A few months later Auguste began work on the theme of Aline feeding the baby and, during the next year, produced two drawings and three oil paintings, all depicting the same pose, with the approximately six-month-old baby Pierre grasping his own foot. They were executed in part at Essoyes, which Renoir first visited that autumn. Octave Mirbeau, author of *The Diary Of A Chambermaid*, commented on *L'Enfant au sein* (The Child at the Breast): 'Admire his Woman with Child, which, in its originality, evokes the charm of the Primitives, the precision of the Japanese and the mastery of Ingres.'[7] Allowing for the extra flesh Auguste gave his models, Aline was no longer the young girl with the good figure in the early paintings. She was 26 but becoming increasingly matronly. Pierre would grow to look more like his father, while Jean was the image of Aline.

After a trip to Algeria, Auguste and Aline were married on 14 April 1890 at the Mairie of the ninth *arrondissement*, and were able to recognise five-year-old Pierre as their legitimate child. (The fact that his mother and father were married some time after Pierre's birth is completely and uncharacteristically ignored by Jean in both his book on his father and in his own memoirs, as well as in most biographies of the painter). After a honeymoon in Sicily, the couple settled at the St Georges studio. Auguste travelled a lot, often to the Midi, and also continually visited Berthe Morisot at Mézy, some miles downriver from what was known as the Renoir part of the Seine, as well as attending her soirées in Paris. She and her circle knew nothing of Aline until Auguste brought her and six-year-old Pierre to visit in the summer of 1891, a year after their marriage. After a subsequent visit from Auguste, Morisot wrote to Mallarmé: 'Renoir has just been with us for a few days, this time without his wife. I could never manage to convey to you my astonishment when I first saw that ungainly woman. I had imagined, I can't say why, that she would be like her husband's paintings. I shall introduce you to her this winter.'[8] Although Morisot instinctively reacted against the wives of the men who attracted her, she and her husband, Eugène Manet, Edouard Manet's brother, would dine with the Renoirs at the Château des

Brouillards later that year, where they would discover the merits of Aline as a hostess.

Gradually, Auguste began to stay *en famille* for longer periods, and with the birth of Jean, and the proximity of Gabrielle, he found two ideal models easily to hand.

3

The Little Theatre of
Little Jean Renoir

'The costumes and props, like the scenery, were parts of a whole, belonging, with the actors, to a world that was clearly make-believe but which possessed the quality essential to any work of art, namely unity.'

Jean Renoir lived in a house full of women. His mother and Gabrielle, and all the young girls, servants and models who moved around the house, gave it a distinctly anti–masculine atmosphere. Auguste once told Jean, 'I can tolerate only women in my home.' But Georges Rivière wrote in 1935: 'Though he gave women a beguiling appearance in his paintings, and gave charm to those who had none, he generally took no pleasure in their conversation. With a few exceptions, he only liked women if they were susceptible to becoming his models.'[1] The phrase in *The River* spoken by the English mother (Nora Swinburne), about a woman being only a woman if she has children, was a quote from Auguste and not in the novel by Rumer Godden on which the film was based. In *La Bête humaine*, the Julien Carette character says something similar: 'I don't trust a woman who doesn't have children.' Jean, on the other hand, was truly a man who loved women, and he treated them as intellectual equals. His three longest romantic relationships were with strong-minded women, who tended to dominate him slightly. His career in cinema was also deeply influenced by his relationships with women; indeed, he started working in film at the instigation of

his first wife. Ten of Jean's films have women's names in their titles, and so do his two plays.

From his earliest days, Jean was used to seeing women (including his mother) in the nude, in the flesh as well as in pictures around the house. It was at the pretty Villa Reynaud at Magagnosc, on the side of the mountain near Grasse, rented by the Renoirs, that Gabrielle posed in the nude for the first time. 'She had just turned 20 and she was in the flower of youth. She was so accustomed to seeing her friends pose in the nude that she took the suggestion as a matter of course. She had already appeared in countless pictures, but always fully clothed and always with me. I was the "star" and she had the secondary role,' wrote Jean.[2]

Gabrielle was a large, dark, healthy farm girl, with a strong profile and gypsy looks. When she arrived in Paris during Madame Renoir's pregnancy, she had hardly ever been out of her native village of Verpillières-sur-Ource, a few kilometres from Essoyes. The nuns had taught her how to read and write, sew and iron, but she always went barefoot except when she went to school. On Sundays, Gabrielle was ill at ease in her starched dress that she wore to Mass. She preferred to catch a trout with her hands and escaping detection by the game warden, could tell the year of any local wine, would help to bleed a pig and to shovel up manure dropped by the horses as they came in from the fields, proudly adding to the family's manure-heap in the courtyard. When she first saw the Château des Brouillards she exclaimed, 'A fine garden you have! There's no manure heap!'[3] On her first morning in Paris, she did not appear for breakfast. Aline found her already out in the street, playing with the other children. 'My mother decided it was a good omen, for all she intended asking her young cousin to do was to play with me after I came into the world,' commented Jean.[4]

Jean could not get on without 'Bibon', his nickname for Gabrielle, which emerged from his vain efforts to pronounce her name. 'I was never able to get beyond the first syllable. After the "Ga", I got muddled and the name became Gabibon, and finally I dropped the Ga. My younger brother, Claude [Coco], seven years later completed the process of simplication by calling her "Ga" and nothing else.'[5] Friends and acquaintances of the Renoirs over three generations became accustomed to hearing the words 'Bibon' and/or 'Ga' peppering their conversations.

For Jean 'the world in those days was divided for me into two parts. My mother was the tiresome part, the person who ordered

me to eat up my dinner, to go to the lavatory, to have a bath in the sort of zinc tub which served for our morning ablutions. And Bibon was for fun, walks in the park, games in the sand-heap, above all piggy-back rides, something my mother absolutely refused to do, whereas Gabrielle was never happier than when bowed down under the weight of my small body . . . Intolerable infant that I was, I had reached the point of allowing no one to touch me when I was in Gabrielle's arms, as though some contagious germ had attempted to invade my private domain.'[6]

Throughout all his writings, autobiographical and fictional, the maternal figure of Gabrielle is never absent for long. In *The Notebooks of Captain Georges*, Jean's 1966 novel, Gabrielle is transmuted into an English nurse called Nancy. 'I hit Nancy on several occasions. She made no attempt to resist, simply covering her face with her hands and saying reproachfully, "Georges, you're unkind . . . you're hurting me." She was a sturdy woman and I a brat. She could very easily have put me over her knee and spanked me soundly, but the idea never occurred to her. "Why do you hit me?" she once asked. "Because I love you," I said. "If I didn't I wouldn't hit you." I would never have thought of hitting my mother . . .

'Today, more than 40 years later, Nancy still lives on for me . . . I evoke her, not in human shape, not in any definite shape, but rather as a very soft cushion, soft but firm, wholly enclosing me. It is not silk or sand or hay or cloud, but a cushion of living matter, and whatever the posture of my sluggish limbs she envelops and deliciously sustains them . . . It is relatively unknown these days for anyone to start life in the state of 'sentimental exaltation.' That is a happiness known to children rocked in their mother's arms and fed at her breast, but these are growing fewer. I knew it through Nancy when I was a little boy old enough to register impressions.'[7] It is clear that Gabrielle meant far more to Jean than his mother, who is a rather vague and distant figure in his memoirs. The final words of *My Life and My Films*, written when Jean was approaching his eightieth birthday, 15 years after his old nurse had died in Los Angeles, are: 'Wait for me, Gabrielle.'[8]

'At the moment I'm painting Jean pouting. It's no easy thing, but it's such a lovely subject, and I assure you that I'm working for myself and myself alone,' Auguste wrote to a friend early in 1896, when Jean was about 18 months old.[9] The picture was of Gabrielle, Jean and a little girl, and shows the pouting Jean reaching out for an

apple held by the girl. Gabrielle, in a red blouse which stands out against the green wall behind her, has her protective hands around the child's waist. You can see the love for Jean on Gabrielle's face. Another painting of the period, *The Artist's Family*, once again has the kneeling Gabrielle's protective hands around the standing Jean, wearing a girl's smock and bonnet. On the left is Pierre in a matelot suit holding the hands of his large, imposing mother. These are two in a group of paintings of Jean at an early age, usually with Gabrielle, described by the contemporary critic Gustave Geffroy as 'Masterpieces which tell of the patience and solicitude of the woman without any sentimental *mise-en-scéne*, simply by the posture and gesture of the arms which surround the child.'[10]

When painting, Auguste 'directed' his models as gently as Jean was to direct his actors and actresses. 'I was never punished when I behaved badly while posing. And Lord knows I misbehaved often enough. "It would make him hate the studio. Don't say a word to him!". . . Renoir did not insist on absolute immobility. Indeed, I still have a feeling that he feared it . . . as a rule, he would simply ask me, as he did all his models, to stay more or less in the place he had chosen, in front of different pieces of coloured cotton cloth fastened to the wall with drawing pins. He was not particular about the position of the head or limbs. Occasionally, in order to make sure of some detail, he would say, 'Would you mind holding still for a minute?' And in fact it would be only for a minute.'[11]

Speaking of Jean as a stage director, Leslie Caron remembered how 'he would say, "Would you mind trying it this way, see if it's more comfortable?" or "Yes, yes. If you say so." Then if you'd say "I don't want to do that", he'd say alright don't, then amazingly you'd somehow find yourself doing what he wanted.'[12] Marcel Dalio, who featured in two of Jean's most acclaimed films, *La Grande Illusion* and *La Règle du jeu*, stated: 'There was no way of knowing what he wanted. All we knew was that we were well placed spatially, which kept us from falling over one another. We all took turns crowing about how great we were. With him, we were creative, the words came easily. We were always correctly positioned. It all added up to truth.'[13]

Auguste, instead of deciding on the pose that Jean was to take, would wait until the child had found something with which to occupy himself, thus keeping him quiet. The results of this approach were *Jean Eating Soup*, *Jean Playing with Toy Soldiers*, *Jean with Building Blocks* and *Jean Looking at a Picture-Book*.

One morning at the villa they had rented near Grasse in 1900, Auguste announced that he was going to paint Jean's portrait. The boy protested, preferring by far to play in the tropical garden (that 'might have been conceived by Douanier Rousseau'[14]) with his pet rabbit Jeannot Lapin. Gabrielle saved the day by suggesting that Jean make a coat for a little painted tin camel which he adored. 'The weather's getting cold and it will soon be winter. Your camel simply must have a coat.'[15] The thought pleased the boy so much that he immediately sat down in front of his father's easel and began sewing. Auguste, always afraid his children would hurt themselves playing with sharp-edged or pointed implements, muttered as he took up his brush: 'Your hand slips and the needle goes into your eye and you're blind for life.'[16] But his absorption in capturing the sheen of Jean's hair made him forget the potential danger of the needle manipulated by the chubby hands. 'Pure gold,' he kept murmuring.[17]

Auguste's description of Jean's shoulder-length reddish hair as 'pure gold' was a matter of great embarrassment to the child. Auguste refused to allow the ringlets to be cut, not only because he enjoyed painting them, but he thought that a thick head of hair afforded considerable protection from the sun's rays and in the case of a fall. 'If we do not let children have the protection provided by Nature, we then have to tell them to be careful, which is just as bad for their young minds as premature education.'[18]

In 1899, when Jean was five, Auguste painted him standing with a hoop in his hand, wearing a blue velvet suit with a lace collar, and a ribbon in his long hair. Over 40 years later, Jean saw the picture at the Durand-Ruel gallery in New York, and was tempted to buy it, despite his memories of loathing the 'Little Lord Fauntleroy', and his 'rather surly expression'[19]. (A sweet half-smile to the objective eye.) When Jean consulted Gabrielle about the painting of the portrait, she told him, 'It's not how you usually looked. We had to put the suit on you by force, and you kept kicking me all the time.'[20] This account decided Jean against buying the picture.

Even at the age of seven, to Jean's despair, he was often mistaken for a girl, despite his trousers. Street urchins would run after him shouting, 'Mademoiselle! Where's you're skirt?'[21] They also called him '*tête de loup*' (wolf's head), the familiar name for a mop used to clean spider-webs out of the corners of ceilings. This insult particularly angered the boy because of his father's distaste for the household implement due to Auguste's having a soft spot for spiders.

One year after their annual holiday at Essoyes, Jean was given a

cheese to carry home to Paris. 'In the train, the other people in the compartment began to sniff the air and fan themselves with a newspaper; finally not being able to restrain themselves any longer, they said to Madame Renoir, "Don't you think your little girl has done something in her drawers?" I was indignant at the double insult and I immediately took down my drawers to prove my innocence as well as my sex.'[22]

Strangely enough, Jean's own son Alain had his long 'girlish' locks retained as late as his fifth birthday, mainly at the insistence of the child's mother.

In 1897, the Renoir family moved to 64 rue La Rochefoucauld, a corner apartment where rue La Bruyère crosses rue La Rochefoucauld, in order to shorten the walk Auguste would have to take to his studio in the same street. The apartment was on the fourth floor, with a large balcony overlooking the two streets. Fearing that Jean, who had a mania for climbing, might fall over the edge, Auguste had a protective fencing of chicken wire attached to the top. He also forbade the waxing of the floors for fear that the children might slip, insisting they be washed down with Eau de Javel instead. As it happened, Auguste's father-in-law, Monsieur Charigot, suddenly upped and left his wife and went to settle in America because she kept complaining that he soiled her beautifully waxed floors. This passionate hatred for the waxing of floors reappears in the episode *La Cireuse électrique* from Jean's last film, *Le Petit Théâtre de Jean Renoir*, in which a housewife is manically obsessed with her waxed floors, the cause of a fatal accident. A highly polished floor also precipitates a comic pratfall in *Eléna et les hommes*.

Auguste and Aline had always been the most solicitous of parents. When Pierre was a baby, they used to enjoy going to the theatre, so they would ask a young girl who lived near by to look after the child. She was a reliable girl and they had complete confidence in her. Nevertheless, they would leave the theatre during the intervals, jump into a cab and drive back home for a few minutes to see if the baby was still asleep. It was not sentimentality on their part, it was simply that they were apprehensive. 'There might be a fire,' Auguste explained, 'or I might have forgotten to turn off the gas.'[23] Later, when Jean was born, they did the same, even though Gabrielle was there to look after him.

At a new apartment in boulevard Rochechouart, Auguste's pictures were hung so close together that they touched. 'A visitor

would get the impression of entering a brightly-coloured garden filled with plants, faces and figures. To me it was the natural order of things, and it was only when I went to other people's houses that I had the feeling of being in an unreal world.'[24]

It was there that many of Jean's tastes, aside from pictorial ones, were formed. One day, Georges Durand-Ruel, Jean's godfather, brought him a Polichinelle – a puppet as big as he was. It was clad in shiny satin, a material he associated with a girl and the detested hair ribbons. 'As soon as I saw it I yelled in horror. I don't know why I hated this character in his English form as Mr Punch. I only liked the Neapolitan one, dressed in white clothes too big for him.'[25]

It was at the age of three that Jean visited a puppet show for the first time. His father advised Gabrielle against taking him to the show in the Champs-Elysées because the puppets wore cheap, over-shiny silk costumes. Instead, he recommended they go to the Tuileries Guignol, which had remained faithful to its origins. Guignol was the name of a French marionette, generous, bibulous and witty, originating in Lyons, with the local characteristics of the peasant and provincial man of the Dauphiné. He was invented by the puppet-master Laurent Mourquet (1744–1844), who grafted native humour on to the Italian Polichinelle which became Punchinello in England then Punch.

Guignol, dressed like the artisans of his day, in a grey jacket and bicorne, with his hair tied back with a black ribbon, presided over the action. As plain as Mademoiselle Henriette was, she aroused the passions of the 'doctor', the 'proprietor' and the 'gendarme', among characters continually whacked by Guignol's cudgel. There is only a small leap from Guignol to the spirit of the *commedia dell'arte* troupe of *Le Carrosse d'or (The Golden Coach)*, shot in Italy in 1952, which has the 44-year-old Anna Magnani courted by three handsome men, a viceroy, a bullfighter and a soldier.

'I shall never forget the first performance I saw. To start with I was positively hypnotised by the drop curtain, painted as an imitation of red and gold draperies. What dreadful mysteries lay behind it? The "orchestra" consisted of a single accordion, and its harsh sounds made me impatient for the show to begin.'[26] When the curtain rose after the traditional three knocks of French theatre, Jean confessed that he grew so excited he wet himself, 'a reaction useful even now in enabling me to gauge the merit of any new play. I do not mean that I go quite that far, but a certain desire, fortunately controllable, is like an inner voice warning me, "Watch out, this is

going to be an important First Night." I once confessed my weakness to my father, and to my surprise he replied, "Me too!" '[27]

Auguste admitted that he had felt the same during the overture to *Don Giovanni*, and father and son experienced 'this delightful sensation' simultaneously when they attended a performance of *Petrouchka*, appropriately the tale of a puppet, the Russian Punch. This was in 1911, when Jean, with his parents and Gabrielle, went to the Ballets-Russes, where they sat in a box.

The influence of Guignol is evident in Jean's first five films, in which he emphasised brutal contrasts, while the movements of Catherine Hessling, Jean first wife and star of all of them, resembled those of a marionette or a mechanical toy. Although he considered it 'not a cinema that suited me', Jean felt that 'Guignol also endowed me with a fondness for simple tales and a profound mistrust for what is generally called psychology.'[28] The puppet prologue to *La Chienne* was a stylised gate that led him into a new realism.

When Jean was six, at the turn of the century, he, Pierre, Gabrielle and La Boulangère (Marie Dupuis, one of Auguste's favourite models) visited the World's Fair and, of course, went to the top of the Eiffel Tower. More significantly, at that time, Jean discovered Alexandre Dumas whose Musketeers 'restored the dignity of long hair . . . But the Musketeers were not merely a matter of hair; first and foremost they were an affair of honour. Without putting it into words, I went through life saying to myself, "I am a man of honour." I walked the streets in search of orphans to be saved and travellers in danger, attacked by bandits whom I drove off with magnificent flourishes of my sword . . . But all that was outward show, a display of heroism and lordly gesture. Inwardly, and not far below the surface, I remained a complete coward. Explosions terrified me. On 14 July I ran away from the street boys' firecrackers and hid behind the closed door of my bedroom.'[29]

Dumas *père* was also a great favourite with Renoir *père*, who hated Dumas *fils*. 'I detest everything he's done, *La Dame aux camélias* more than all the rest,' he told Jean. 'I have always had an absolute horror of the sentimentalised prostitute.'[30] He was also deeply suspicious of tales about the misfortunes of poor, little orphan girls, though this did not deter his son from making his debut as a film director with a melodrama about a little orphan girl, the influence of Jean's twin gods, Chaplin and D. W. Griffith, winning out over that of his father.

It was Gabrielle who taught Jean to adore melodrama. They visited the Théâtre Montmartre at place Charles Dullin (now the Théâtre de l'Atelier), considered part of the *Boulevard du Crime* celebrated in Marcel Carné's *Les Enfants du paradis*. The most popular pieces were bloodthirsty melodramas such as *Le Bossu, La Tour de Nesle, Les Deux orphelines* (filmed by D. W. Griffith as *Orphans Of The Storm* in 1922), and Gabrielle and Jean's favourite, *Jack Sheppard, ou Les Chevaliers du Brouillard*. 'We must have seen that last work over half-a-dozen times. The settings of *Jack Sheppard* impressed me by their romantic unreality, notably the Thames Embankment where the effect of fog was achieved by veils let down from the flies . . . Superior minds regard this kind of theatre as "false". They have replaced it with the so-called realistic theatre, which to my mind is as false as the theatre of romanticism.'[31]

With his Uncle Henri and Aunt Blanche, Jean went to café-concerts every Thursday matinée. It was to these visits that Jean owed his acquaintance with the delightfully bawdy repertory of the singers at the beginning of the century, those songs evoked so affectionately in *French Cancan* by Patachou and Edith Piaf, playing Yvette Guilbert and Eugènie Buffet respectively. Just as Griffith brought his love of Victorian melodrama into his films and, later, Fellini's intoxication with vaudeville and the circus as a child translated itself into his oeuvre, among the most powerful influences on Jean Renoir was the theatre. This first manifested itself in mature form in *La Règle du jeu*; then, in the three colour films of the 1950s, *Le Carrosse d'or, French Cancan* and *Eléna et les hommes*, and in his last work, modestly entitled *Le Petit Théâtre de Jean Renoir*, at the end of which the actors, breaking the bounds of realism, come forward to take a curtain call. It was also Jean's final bow to his audiences.

4

A Champagne Childhood

'My father felt well whenever he was at Essoyes, and as he covered his canvases with colour would enjoy having us around as well as the villagers.'

After having visited his wife's family for some years, Auguste finally decided to buy a house in Essoyes in December 1895. For the first time in his life, at the age of 56, he owned property. In June 1902, he extended it by purchasing the house next door and building a studio. Auguste spent 15 summers at Essoyes, always taking the vacation from the beginning of July.

Essoyes was where Jean spent the happiest years of his childhood. 'There is no other place like it in the whole wide world. My enchantment used to begin as soon as I got within ten miles of the village, when the train from Paris had passed the flat plain of Champagne and entered the hilly region covered with vineyards near the hamlet of Bourguignons. And the countryside has the same aspect as all regions that produce good wine: a river at the bottom of the valley. In this case it is the Seine. Down below there are meadows with cows, while along the slopes are woods or vineyards . . . The Seine tributary which flows through the village is known as the Ource. Its banks are shaded by fine trees. Long, waving weeds cover its bed. The Ource follows an irregular course. That is doubtless one of the reasons Renoir liked to paint it.'[1]

One of Jean's companions of the river was Godefer. He was the young son of a poor farm labourer, and shared a wooden shack with a dozen brothers and sisters. 'Godefer's great ambition was to wear a pair of shoes. Not to own a pair, but simply for a few hours of a single day to know the glorious sensation of being "rich". . . It was I who profited by our exchanges. Godefer gave me numerous presents and I gave him nothing. For instance, he taught me how to make a sling and how to use it to break window-panes . . . He taught me how to climb a fence without being seen and steal chickens from farmyards . . . on one occasion to square the debt between us, I gave him a pair of new shoes which my mother had just bought me. I had not yet worn them.'[2]

Godefer also taught Jean to poach river-pike in competition with P'tit Duc, the freshwater poacher. They would sneak out before dawn, unpick the lock on a moored boat, and drift out with the stream. 'It was wonderful, as wonderful as the rise of the Guignol curtain.'[3] With Gabrielle's tales of having caught trout and eluding the gamekeeper when she was a child, the poacher took on a special significance for Jean, and crops up in several of his works, including the play *Orvet* and unrealised screenplays. Poachers represented the free spirit, the nature god, so present in his films. Witness Marceau the poacher (Julien Carette) in *La Règle du jeu*, symbol of impracticality and anarchy, being pursued by Schumacher the gamekeeper (Gaston Modot), the incarnation of authority and order. Jean liked to picture himself as a bit of a poacher (with certain film producers and moneymen as the gamekeepers?), against those that tamper with the natural order.

Aside from the Huck Finn-like Godefer, Jean would accompany Paul Cézanne, the son of the painter, on long river expeditions in a flat-bottomed boat, pushed along with poles. 'There is nothing so mysterious as a river,' Jean wrote. 'Away from other human beings, lost in the overhanging foliage, fearful of breaking in on the sound of the water gliding over the weeds, we felt as if we were characters in a tale by Fenimore Cooper, whose writings Paul had introduced me to. We lay on our stomachs in the skiff, silent and motionless, our faces near the surface of the water, watching the movements of a large fish, which in turn was watching its prey.'[4]

Jean has written lyrically of his days at Essoyes. His memories include 'the sound of the heavy wooden clogs on the stony roads; the quiet pleasure of being with Renoir as he painted in the meadow on the side of the river near the old paper mill; my mother's red

dressing-gown as she sat in the tall grass; the children's voices as they ran after one another around the willow trees; the games the young men and the models played as they splashed about in the waterfall of the old mill-race.'[3]

It is difficult not to sense the same exhilaration when watching the characters on the river in *Une Partie de campagne*, a recreation of a lived experience, or in the river scenes in *Le Déjeuner sur l'herbe*, and the way the tramp Boudu is drawn towards the freedom of the banks of the Marne away from a comfortable bourgeois life.

'You have to be a cork, a cork in the current. You have to follow the current,' was an expression of his father's that always stuck in his mind. A river runs through many of Renoir's films, as well as giving its name to one of them. It also plays a more than important role in *Une Partie de campagne* and *Le Déjeuner sur l'herbe*, while the word 'water' appears in the titles of *La Fille de l'eau, Boudu sauvé des eaux* and *Swamp Water*, as well as being an essential element in *The Southerner* and, for rather different reasons, in *On purge bébé*. 'I cannot conceive of cinema without water. There is an inescapable quality in the movement of a film which relates it to the ripple of streams and the flow of rivers.'[6] In *The River*, the Ganges is not only seen as sacred to the Indians, but it becomes a symbol of ever-flowing, eternally renewed life.

These days the only way to get to Essoyes, now indisputably in the district of L'Aube, is by car, or by bus from Troyes, 49 kilometers away. It is a pretty little village with a tendency towards somnolence in the heat of a summer's day; in winter, too, it has a sleepy atmosphere, but comes to life on market day. The few tourists are probably drawn off the beaten track by the Renoir museum or by the fairytale forests surrounding it. Down its streets walked Mallarmé, Maillol, Cézanne, Matisse, George Rivière and Ambroise Vollard, as well as the Renoir family.

The town of Essoyes has a football team, a tennis club, a library, and *pétanque* is played in the square. There is the Maison de la Vigne to visit, dedicated to explaining the history of Champagne and how it is made. In the first room is the Salle d'Ethnographie, which displays a variety of vats and other instruments of pleasure. Beside it is the Salle de Dégustation where the visitor can taste and buy wine, and watch a video on 'the night they invented champagne', as well as one on the life of Auguste Renoir. Champagne is often evoked when alluding to Auguste's paintings and Jean's films, and

perhaps only a connoisseur of wine could have made *Une Partie de campagne* – 'Very fruity and attractive, with surprisingly dry finish'; *Le Carrosse d'or* – 'Deep colour, full-bodied and nice length'; *Le Déjeuner sur l'herbe* – 'Mellow with spicy overtones.'

The family house, where Coco was born, is still, on the evidence of photographs, very much as it was in Jean's childhood. On Auguste's death, the house was bequeathed to Pierre, who left it to his son, Claude, who continues to live there. Claude, the great cinematographer with the wonderful eye, now almost totally blind, is tended by his wife Evangèle, who complains that all he wants to do is eat, drink and listen to the radio. Their daughter Sophie Renoir, an actress who appeared in Eric Rohmer's *My Girlfriend's Boyfriend* (1987), visits him from time to time. His son, Jacques, from his first marriage, never does. In the eye of his mind Claude can still watch, like in Kafka's Cinema Of The Blind, the films he made with Jean, especially those in colour – *The River*, *Le Carrosse d'or*, and *Eléna et les hommes*.

In the small graveyard are the tombs of the Renoirs. Here are buried Auguste, Aline, Pierre, Jean, Coco, and Dido, Jean's second wife. Dédée, his first wife, known to the world as Catherine Hessling, is buried near Fontainebleau. Gabrielle lies beside her husband Conrad Slade in the Mount Auburn Cemetery in Cambridge, Massachussets, a universe away from this French country cemetery. The river Ource chuckles away nearby, as if to say, '*I'm still here. I am immortal.*'

The joys of holidays in Essoyes apart, Jean still suffered from his girlish locks and from his being prevented from attending school. The two were linked in his mind, knowing that his hair would have to be cut before he could become a pupil. What he desired most was to go to the Collège de Sainte-Croix at Neuilly, which his elder brother attended, and to have a chance to wear the magnificent cap for which he envied Pierre.

Pierre had been happy there, and the teachers encouraged him in amateur dramatics. On Sundays, when Pierre came home from school, he would put on plays with other children from the neighbourhood. They would wrap themselves in old curtains and give imitations of the actors the grown-ups had seen at the Montmartre Theatre. At Louveciennes, where Jean's grandmother lived, 'Pierre would saunter ahead of us, reciting lines from Racine to the daughter of one of the neighbours, whom my mother might have

asked to come with us. Although only 12, my brother had begun to make an impression on young girls by the gravity of his manner, which was perhaps to be the basis of his talent as an actor in later years.'[7] Aline used to boast proudly that her first-born would be an actor some day, but Auguste attempted to dissuade his son from a career 'where you only create wind; where nothing remains, and all is temporary.'[8] He had wanted Pierre to become a lawyer, but gradually grew proud of his eldest son's acting talent.

In 1907, Pierre won a prize at the Conservatoire de Paris and began a career as an actor. He appeared in his debut film role in 1911 in *La Digue*, the first feature directed by Abel Gance, but he had small regard for French cinema. Pierre got more satisfaction from playing Ibsen, Strindberg and Hauptmann under André Antoine, the actor, producer and manager, and director of the Odéon Theatre from 1906 to 1914.

It was the birth of Coco (christened Claude), Aline's third child, at Essoyes on 4 August 1901, which changed Jean's situation. Knowing that Gabrielle would have her hands full with the new baby, Auguste finally allowed Jean to go off to school. The artist did not actually believe in 'education' and expressed his sympathy with the boys who played truant. He thought Sainte-Croix better then most because of its extensive grounds, considering the quality of the air more important than the quality of the teaching. In addition he expressed his preference by saying, 'In Protestant schools you become a pederast, but with the Catholics it's more likely to be masturbation. I prefer the latter.'[9]

Everyone gathered around for the ritualistic cutting of Jean's immortalised hair. Auguste regretted losing a model, but he was soon to put the new arrival through the same process. While Aline instructed the barber as to how much and where to snip the locks, the other models, Gabrielle and La Boulangère, wept. Jean was overjoyed. Unlike Samson, he gained strength from the haircut which represented a first step towards manhood.

However, despite all the great expectations, Jean was not happy at Sainte-Croix. The glamour associated with the famous school cap soon wore off, and the restrictive and grey atmosphere of the Jesuit school had a depressing effect on a boy brought up in a colourful bohemian world. Most of all, he hated the disgusting state of the lavatories so much that he preferred to relieve himself in the bushes. Terrified of being caught out, he literally became ill with worry.

Jean was also puzzled by the attitude of his schoolmates towards

sex. From his earliest childhood, he had seen his father paint nude
women, and nudity was seen as a pure and natural state, with no
mystery surrounding it. 'The very sight of photographs of naked
women threw them into a state of excitement incomprehensible to
me. They would pass them on to one another on the sly, and lock
themselves in the lavatories so as to be able to contemplate them at
their leisure. Some of them would masturbate furiously while gazing
at these pictures, which represented a paradise that was earthly but
unattainable. The good Brothers added to the interest of the photo-
graphs by hunting them down, confiscating them and punishing the
owners.'[10] In his novel, *The Notebooks of Captain Georges*, Renoir
writes of a schoolmate of the narrator: 'He was literally obsessed
with sex. He would undo his fly-buttons in class, and get it out and
stroke it under cover of a dictionary. His pockets were stuffed with
photographs of naked ladies and gentlemen in extraordinary pos-
tures. They meant nothing to me.'[11]

On Sundays, the parents would visit their children in the large,
dreary-looking parlour. Auguste seemed out of place in his working
jacket, buttoned-up collar, and shoulder-length hair under a soft felt
hat beside the other fathers with their respectable starched collars,
dark silk cravats and waxed moustaches. Jean felt pangs of guilt at
being rather embarrassed in front of his peers, who cast strange
glances in Auguste's direction. One Monday, during a break
between classes, a boy whose father owned a huge grocery store
near the Opéra, came up to Jean and offered him two sous. 'Here,'
he said. 'Give this to your father, and tell him to get his hair cut.'
Jean saw red and rushed at the boy, hurling him to the ground while
furiously punching him and trying to throttle him at the same time
before two or three of the Brothers appeared on the scene. Later the
boy apologised to Jean, explaining, 'You should have told me your
father was an artist.'[12]

Had he known about the incident, Auguste might have swelled
with pride, but he almost spanked Jean when he boasted of having
sold a pencil to one of the other pupils. Auguste made him return
the money plus the toy pistol Jean had recently been given. Auguste
had a fear of seeing his children become 'mercenary traders', and
tried to instil in them the concept that values based on money are
only relative. Jean has explained that 'to do anyone a favour in the
hope of receiving pay for it seemed to him ignoble . . . He was
anxious to inculcate into us the idea that such things as helping one's
fellows, friendship and love were not for sale.'[13] This goes some

way towards explaining Jean's rather carefree attitude to money, and
he was fortunate in having the protection of certain more hard-
nosed good friends, secretaries, financial advisors and his second
wife, Dido.

Jean's younger brother was not as fortuitously protected from his
spendthrift nature in his adult life. Intelligent and likable, but
ineffectual and talentless, Coco, in family friend Alice Fighiera's
words, 'devoured his fortune' and was forced to sell the family
home at Cagnes-sur-Mer. In the 1940s, Coco borrowed money to
construct a huge cinema in Antibes. When Alice's husband told him
he should have bought an apartment building instead, he replied in
his thick Burgundian accent, 'Can you see a Renoir collecting
rents?'[14]

Auguste would consent to spanking as long as they were on the
backside, although he would never administer them himself. He
forbade slapping a child's face and was angered by schoolmasters
who hit children on their hands with sticks or rulers. He disapproved
of it only because of the damage it might cause to the fingers and
nails. Jean liked to cut his nails short, because he was less likely to
hurt himself when climbing trees, but his father told him, 'You
must protect the ends of your fingers; if you expose them you may
ruin your sense of touch, and deprive yourself of a great deal of
pleasure in life.'[15]

Above all, the precept that Auguste communicated to his three
sons most emphatically was that there was nothing worse than being
a cad or, in slightly stronger terms, a scoundrel. It took various
forms, but the main one was lack of respect for others. 'He would
tolerate almost anything my brothers and I did, whether it was
getting poor marks in the classroom, playing truant, making a noise
while he was working . . . singing improper songs or tearing our
clothes. I know that he begged my mother to shut her eyes to certain
pranks. On the other hand, he scolded me one day when I helped
myself to some Brie by cutting off the soft point at the end of the
piece, thereby depriving the rest of the family of the centre, which
is the most delicate part being farthest from the rind . . . Even as
children we knew enough to give up our seats to an older person in
a public conveyance. We also knew, fundamentally, all men are
equal.'[16] It is this philosophy, absorbed at his father's knee, that
most manifests itself in Jean's life and films.

Auguste, in short, was an extremely loving father, but never
indulgent. He was too concerned with what sort of adults his sons

would become to turn a blind eye to behaviour he thought unworthy. Jean, too, was a similar sort of father, surprisingly strict with his own son. Like Auguste, Jean was the most tolerant and generous of men, but anyone whom he felt was purposefully malicious received no grace with him. He condemned them totally and violently. He had a natural indignation when confronted with spitefulness. If faced with a man who was unkind, but had had little education, he excused it. But with someone who was well-educated and privileged, Jean's rage was frightening to see. 'He carried on like Jupiter throwing incredible tantrums,' commented the actor Pierre Olaf.[17]

In *Renoir: The Man, The Painter and His World*, Lawrence Hanson writes, 'One of the most refreshing aspects of Renoir [Auguste] is his changelessness; from boy to old man his likes and dislikes remained firm, and throughout his long life the dislikes were expressed in the same manner, with a quiet but devastating irony. His speech was always pithy and pungent; he called a spade a spade, like his father and mother, like his workshop companions, and laughed at refinements which he saw as evasions.'[18] The same could be said of his famous film-director son.

5

Painting Paradise

'Cagnes seemed to be waiting for Renoir [Auguste], and he adopted it, as one gives oneself to a girl of whom one has dreamt all one's life and then discovered on the doorstep after having roamed the world over.'

In February 1898, in search of warmth, Auguste stayed in Cagnes, a few miles along the coast road from Nice. It was his first visit, and he returned enthusiastic about the town. Exactly a year later, still seeking a place in the sun, he returned to Cagnes, where he underwent treatment for his rheumatism. In January 1900, Aline joined him in the south where they rented the Villa Reynaud near Magagnosc, stayed until mid–May, and returned for a sojourn of five months from November 1901. Before deciding to settle in Cagnes, they tried several other places in the Midi. In 1902, they were at the Villa Printemps at Le Cannet, not far from Cannes.

Auguste was determined to settle on the Côte d'Azur, and he hesitated for some time between Magagnosc in the mountains and Cagnes on the sea. Finally, Cagnes was chosen because the doctors told him the air would be healthier for him there. His pattern became fixed for many years: winter in Cagnes, summer at Essoyes, a week or two in Paris. As he was never part of the fashionable Parisian world, he was happy to distance himself from it for most of the year.

It was on 28 June 1907 that Auguste bought the small farm of Les

Collettes in Cagnes from an Italian peasant who lived on it in a little farmhouse with his mother. With its ancient olive grove on a hillside overlooking the medieval town, he had in his grasp a world where he could imagine that the ancient pagan gods might come back to earth. Provence was an area rich in associations of timeless classicism – a tradition which was currently being propagated by the spokesmen of the Provençale literary revival which the writer Frédéric Mistral had pioneered. 'What admirable people the Greeks were!' Auguste once mused. 'Their existence was so happy that they imagined that the gods came down to earth to find their paradise and to make love. Yes, earth was a paradise of the gods. That is what I want to paint.'[1]

Jean, too, became intoxicated by Les Collettes, and drank deeply of his father's pantheism. This vein is evident in many of his films, culminating in *Le Déjeuner sur l'herbe*, much of it filmed at Les Collettes. In the film, among the olive trees, repressed sexual passion is released by the great god Pan, and it was at Cagnes that Jean, home from the war, met the woman who was to arouse him more than any other in his life.

At Aline's urging, a massive stone house was built on the property, into which the Renoirs moved in autumn 1908. Auguste hated the house, which he never painted, finding it too large and oppressive. For an Impressionist such as he, the colour of the bricks was too dull. Indeed, it has little charm, but the gardens and the vistas are another story. It was under the trees that he painted the foliage, the little farmhouse, and the broad panoramas of the landscape. Les Collettes was the perfect setting for Renoir's final period.

The garden was planted with scores of tangerine trees, and two vineyards. Aline, who remained a peasant woman at heart, made a vegetable garden, built a henhouse and raised poultry. There was also a row of orange trees that Auguste wished to paint. However, when Jean and Coco were young boys they used to pick the oranges from the trees before their father was able to paint them. The artist complained about this to a gardener friend who replaced the trees with *bigaradiers*, trees which bore the bitter Seville oranges which the lads did not like the taste of at all, thus allowing Auguste to paint the fruit unhindered. But the pride of the property were the olive trees which Jean considered among the most beautiful in the world.

'They have stood for five centuries; and storms, droughts, frosts,

pruning and neglect have all combined to give them the weirdest shapes. The trunks of some of them resemble strange divinities. The branches are twisted and intertwined in patterns which not even the most daring designer could create. Unlike olive trees in the Aix region, which are small and trimmed on top to facilitate gathering the olives, these trees have been left to grow freely, and they lift their crown of foliage proudly towards the sky. They are large trees, cloaked in majesty combined with feathery lightness. Their silvery leaves cast a subtle shadow. There is no violent contrast between light and shade.'[2]

If any readers doubt this description, they could compare it with the sequence in *Le Déjeuner sur l'herbe* which captures the trees in exactly the above terms even though, in 1959, the year of the film, many of the ancient olive trees Jean remembered were not as tall and the branches of some of them had been amputated in order to save them.

Years later, Jean had an olive tree taken from Les Collettes and planted in the garden just outside the living-room window of his home in Beverly Hills. Looking at it one day, he compared himself with the tree. 'You cut it down and it grows again with new vigour.' This analogy was immediately punctured by his plain-spoken wife Dido, who interrupted saying, 'Oh, stop hamming!' Jean smiled sweetly, but the olive tree meant more to him than he could explain.[3] Above all, it was a link with his blissful youth, his beloved parents, and a part of the world where he felt at his happiest.

During the olive season in the south of France, Auguste would employ young girls from the area to come with long poles and knock the olives down onto a large tarpaulin spread on the ground. They would then be collected and either bottled or turned into oil. Jean remained an expert on olives all his life and heaven forfend any restaurant that served inferior quality oil. He was once heard to tell a waiter at a Paris restaurant that the olive oil on the dressing of his asparagus was '*Du Castrol*'.[4]

When living in California, Jean envied the olive trees on his friend Charles Laughton's 15-acre estate in Pacific Palisades. Since the olives were dropping from the trees and rotting, Jean asked Laughton if he could take them, because he knew what to do with them. Laughton and his wife, Elsa Lanchester, were quite happy for Jean and Dido to load their car full of boxes and sacks of olives and transport them back to their home in Beverly Hills. There they were put to soak in a great barrel of brine in the kitchen. After six weeks

or so, when the brine was supposed to be poured off and replaced with a fresh lot, the Renoirs invited the Laughtons to dinner, and to help change the brine. With Charles Laughton on one side and Jean Renoir on the other, like Hardy and Hardy, the barrel cracked and burst, and the entire kitchen was flooded with brine and olives. After spending a good hour cleaning up the mess, Jean gave up the project and threw all the olives away. Nothing like that had ever happened at Les Collettes in his father's day.

Today, Les Collettes overlooks the ugly, dusty, noisy, sprawling seaside town of Cagnes-Sur-Mer. There is no pavement or path up the very steep road, and pedestrians must cling to the walls of the houses on the left-hand side, hoping that cars coming down will spot them in time. The road grows steeper and steeper as it climbs higher and higher, past villas called the *Tour d'Ivoire* and *La Maison Blanche*, well-kept, Provençal-tiled houses perched on the side of the hill.

The old abandoned gardener's shack which Jean used in *Le Déjeuner sur l'herbe* for the house of the peasant family with whom Professor Etienne Alexis (Paul Meurisse) stays and where the biologist discovers the simple joys of life, is still there.

At the time of the shooting of *Le Déjeuner sur l'herbe* here in 1959, the property still belonged to Coco, although he had already sold part of it. A year later, Les Collettes was bought by the town of Cagnes. Coco could have obtained four to five times as much if he had sold it to a private individual, but he wanted it to remain open to the public.

The house, the furnishings and the garden have been kept almost exactly as they were when Auguste lived here. The only dramatic change is the view across the built-up town towards the polluted yet still blue Mediterranean. Auguste never saw the concrete spreading like a cancer on the landscape beneath him. Neither did Jean, even as late as his final sojourn here. He would not have been pleased, given his views on 'progress' of this sort.

In the dining room there is a bust of Coco Renoir, a young boy with a little mischievous face. Opposite is the Renoir painting of *La Ferme de Collettes*. Its colours are not exaggerated; they are there for all to see, just outside the window. A photograph of Auguste on the wall reveals his gnarled hands, his intense, drawn face under a cap. Not the face of a hedonist.

In the centre of another room is an unconvincing bronze of

Auguste by Richard Guino, a Catalan and pupil of Aristide Maillol, who made sculptures under the direction of Renoir when he was unable to execute them himself. The artist, with an astonished expression on his face, is holding his paint brush like a dagger as if preparing to stab someone with it. There is also a not very characterful bust of Jean by Guino. The subject, around 19 years old, has a little moustache and has been given a gaping mouth. Coco's Puckish face is seen again on yet another Guino bust, and a solemn one of Pierre is passed on the stairs.

Auguste's studio contains his bed, his easel, his rickety chair with wheels attached to enable the crippled artist to move around. Hanging on the wall and on the back of an armchair are a number of broad-brimmed straw hats familiar from the summer paintings. One wants to believe they are the very hats that Aline and other Renoir models wore when posing for him.

In Coco's small bedroom is a bust of Auguste's youngest son. The seven-year-old Coco is revealed as a sweet little boy with long hair, but with little of the elfin about him. It is claimed to be the only bust executed by Auguste's own hands, and it has far more character than those by Guino. But there are identical busts for which the identical claim has been made. Coco's son Paul made a nice profit from trading in Renoir busts. He had got hold of the original moulds and manufactured busts on an assembly line. Paul's son Manuel, according to Jean's cousin Maurice Renoir, 'although not a crook like his father, exploited the name of Renoir in a vulgar way' by manufacturing sparkling mineral water. An advertisement for it reads: 'Renoir is marvellous. No, not the artist or the *cinéaste* who directed *The River or Boudu sauvé des eaux*. It is a delicious water, without sugar, salt or calories.'[5]

In a sense, Coco was to the Renoir brothers what Zeppo was to the Marx Brothers. He grew up with an immensely famous artist for a father, and was brother to a celebrated actor and a world-renowned film director. He himself went into film production, co-directed a film (*Opéra Musette with René Lefèvre*, who played the title role in Jean Renoir's *Le Crime de Monsieur Lange*), was an assistant director on *La Bête humaine*, and owned a number of cinemas. But he remained the unknown Renoir. The actor Pierre Olaf called Coco 'a phony', who seemed willing to authenticate Renoirs without being absolutely sure or having the expertise to know whether the paintings were genuine or not.[6] Alice Fighiera summed him up thus: 'Coco had no talent whatsoever. Coco thought his name would be

sufficient to get him on in the world. Coco always wanted to do what Jean did. When Jean did ceramics, he did. When Jean went into the cinema, Coco did the same. He tried everything and failed everything.'[7] However, Auguste Renoir's son did join the French Resistance during World War II.

In Auguste's bedroom, the largest upstairs, is a painting of the dark-haired Gabrielle and a photo of Jean, a rather porcine young man, extremely serious, with his hair brushed back. His painful experiences as a soldier in World War I are reflected in his eyes.

Aline's bedroom is next to her husband's with a connecting door and a splendid balcony. Jean's bedroom, much nicer than Coco's, looks over a road, once a dirt track that separated the property in two. The land across the road, sold by Coco to a private owner, contained the ceramic workshop built by Auguste for his sons. Just off Jean's room is the studio Auguste used during the winter months, because of its three windows facing south, north and west, and its small fireplace.

Behind the house is a large female nude statue by Guino after Maillol, set against a row of orange trees recognisable from a painting in the big house by Albert André, minor Impressionist and friend of Auguste.

Les Collettes gave the adolescent Jean, coming home from school, the liberty of movement he required. It was the memory of this house that he carried with him to California, where he tried to recreate the atmosphere of Provence at the home he designed in Beverly Hills.

6

The Rules of War

'The fighting troops in the First World War were complete anarchists. They didn't give a damn for anything, least of all for noble sentiments.'

In July 1911, the 16-year-old Jean Renoir gained the first part of his *baccalauréat*. He then studied philosophy by correspondence, and pursued a course in mathematics, neither with any conviction or success. Although his schooling had been seriously disrupted by continual moves – from Sainte-Croix and Sainte-Marie de Monceau in Paris to various other schools, including the École Masséna at Nice – he had too restless a nature and a dislike of discipline, self or otherwise, to ever apply himself to formal study.

Jean would often run away from school, arriving home hungry and dirty. His parents seldom scolded him for such behaviour. They shook their heads and came to the conclusion that he was destined for manual rather than intellectual work. Auguste used to speculate on what talents his son might have, and to what ends they could be put. Certain professions were mooted – blacksmith, carpenter, nurseryman, game-warden (an ironic choice given Jean's life-long sympathy for poachers). One choice Auguste did not favour was a caree·in commerce.

When Jean was a small child, his ambition was to become a Napoleonic grenadier. This interest was awakened by Gabrielle's

readings to him from *Images d'Epinal*, a book with coloured pictures printed from wood-blocks, depicting scenes of French colonial military victories in North Africa. Jean was also so taken by the police uniforms at the *gendarmerie* he and Gabrielle used to pass in the rue la Rochefoucauld, that he determined to become a *gendarme* when he grew up.

At Magagnosc, the village near Grasse, Jean had been dazzled by the housemaid's lover, a sergeant in the *Chasseurs Alpins*. 'Sometimes the great man took me to have a meal with his platoon. He put his beret on my head and let me touch his rifle. To me this was glory . . . I was truly a sergeant in the *Chasseurs Alpins*, decorated with a colonial medal and with an authentic lustre emanating from my small person. I forgot about my long hair, although I hated it to the point of weeping.'[1] Perhaps it was this memory that led Jean, many years later, to join the *Chasseurs Alpins* during the Great War.

This passion for uniforms, one he shared with his idol Erich von Stroheim, seems paradoxical in the light of Jean's hatred of war. But it derived from his love of theatrical spectacle and tales of derring-do, and from a genuine respect for the courage and honour of the soldier. Thus Jean's comment about having directed *La Grande Illusion* because he had wanted to make a pacifist film that is full of admiration for uniforms and the army. The future director of this masterpiece among films with an anti-war theme also had an affection for toy soldiers, as did his father. When one of Auguste's friends suggested that the child's enjoyment of such toys would make him grow up a militarist, Auguste retorted, 'In that case, we would have to keep building-blocks away from him because they might make him want to become an architect.'[2] (Auguste had almost as poor an impression of architects as he had of militarists.)

On 17 February 1913, Jean enlisted in the First Regiment of Dragoons for a period of three years. He adored horses and had wanted to join a cavalry regiment like his father had in 1870 during the Franco-Prussian war. Writing in *The Notebooks of Captain Georges*, he described its appeal. 'I still feel a stirring of the blood at the memory of my finest moment as a cavalryman, the charge by the whole division which was the highpoint of the manœuvres . . . You must picture four regiments, sixteen hundred horsemen in two ranks, extending over a front of well over half a mile. The horses knew that something tremendous was going to happen, and we had great difficulty in keeping them in line.'[3]

In the army, Jean found himself in a new milieu in the garrison,

where he enjoyed mixing with other classes. Up until then he had led a very spoiled and protected life in a cultured atmosphere, and was only occasionally brought in contact with working class children. The schools he attended were for the sons of the wealthy. This breaking down of class barriers and the comradeship he experienced powerfully permeates his two films on prisoners of war: *La Grande Illusion* (World War I) and *Le Caporal épinglé* (World War II). 'In the army a pal's a pal,' says the working-class Claude Brasseur in the latter film. 'It doesn't matter what he is in civilian life.'

Jean's own views are again shared by the fictional Captain Georges. 'High society, indeed, is nothing but a commercial market where everyone has something to sell or buy. Here, round the dormitory stove, no man asked anything of his neighbour except his presence . . . I felt that I was part of a whole, no longer a dog astray in an empty street, a rich, well-fed dog but desperately in need of other dogs to sniff at.'[4]

In August 1914, not long after Jean passed his officer's degree at the military school of Saumur, war broke out. Pierre, who was living with the stage actress Véra Sergine, and with whom he was performing at the Odéon under the management of André Antoine, decided to enlist. He thus gave up a blossoming career and a comfortable house not far from the Champs-Élysées, which Véra had transformed by having it completely painted in white, including the walnut woodwork and panelling.

Aline came up to Paris from Cagnes hoping to see Pierre once more before he left for the front, but arrived too late. However, she discovered that Véra was six-months pregnant. In December 1914, Véra gave birth to Claude, and Aline immediately arranged for the mother and child to stay at Les Collettes while Pierre was on active service.

Auguste managed to get to the little town of Lagny in the eastern part of France, where Jean's regiment of dragoons was stationed, waiting to leave for the front. Auguste made his views on the war known to his son. 'What stupidity! Instead of killing young men in holes they ought to use the old and infirm; we are the ones to be there . . . Everything is in La Fontaine; why don't the idiotic politicians read him.'[5]

In mid-September, Jean wrote to his mother that he had been hospitalized because of a kick received by a horse; at least, that was how she understood what had happened to him. Actually, Jean,

who had often gone on excursions to brothels with other soldiers, had explained that he had received a 'coup de pied de Vénus' (a kick from Venus), an expression used in the cavalry to indicate venereal disease. When Aline arrived to see him at the hospital in Amiens, she was none the wiser, and writers on Renoir *fils* have continued in the belief that Vénus was the name of Jean's unthinking horse.[6]

Merging his personal experience with that of Captain Georges, Jean vividly described the effects of V.D. on his hero. 'He suffered a pain between the legs. He was warned against alcohol, spiced foods, riding and all forms of strenuous exertion. Treatment was potassium permanganate, salts-of-silver injections, as many copaiba pills as my stomach would stand, two hot baths a day in water softened with sodium bicarbonate and a "bland" diet . . . The doctor told him that he must control his thoughts because "Every time you get an erection it delays the cure." '[7]

When Jean had recovered, he announced that he was bored in the cavalry and would join the *Chasseurs Alpins* operating in the Vosges. As sub-lieutenant in the sixth battalion, he was sent to the front. There an incident occurred during the retreat near Arras that appealed to his sense of the ridiculous and which reflected his attitude to the nature of war. 'I had been sent out on patrol with half-a-dozen other dragoons. From the top of the hill we caught sight of half-a-dozen or so Uhlans, also patrolling. We deployed in battle formation, while the Uhlans on the opposite hill did the same. We started off at a walk, well in line, then broke into a trot, and then into a gallop; and when we were within a 100 yards of the enemy we charged, each one of us determined to spear the horseman in front of him . . . The space between us narrowed. We could make out the expression on the drawn faces of our adversaries under their shapskas, just as they could ours under our helmets. In a few seconds the affair was over. The two patrols rushed past each other at a furious pace, treating a few grazing sheep to a brilliant if harmless display of horsemanship. Somewhat crestfallen we returned to our lines, and the Germans went back to theirs.'[8] This rather cinematic anecdote delighted his father, when Jean related it to him.

Notwithstanding that the War fulfilled Jean's childhood ambition to strut around in a military uniform, stimulated his notion of comradeship, inspired courage in him and also sharpened his ironic humour, it was a dirty, bloody, chaotic affair that made cripples of both him and his brother, and hastened his mother's death.

*

In April 1915, after months in the trenches, Jean was wounded in the leg by a bullet from a Bavarian sniper. It happened one morning during a patrol between the lines, but Jean had to lie in agony until sundown when he was slung across a mule and evacuated to the hospital at Gérardmer, near Colmar. Although Aline had been recently diagnosed as diabetic, considered an incurable illness at the time, she insisted on making the journey to Alsace to see her wounded son.

According to Jean, the doctors were about to amputate his left leg because gangrene had set in and turned it 'an odd shade of cobalt blue,' but Aline opposed it 'so vehemently that the military doctor at the hospital abandoned the idea. He was replaced by Professor Laroyenne, a specialist, who cured the gangrene by using a curious system of circulating distilled water through my leg. He did not conceal from my mother that I would not have survived the amputation.'⁹

In May, Aline wrote to Georges Rivière from the Hotel de la Gérardmer: 'Last night Jean underwent a huge operation which lasted more than seven hours before they took him back to his bed. He was very ill when I left him. My concern made me hasten back to the hospital early the next day where I found him much better than I had dared hope. He had had a fever for eight hours. The doctor whom I saw yesterday evening did not hide from me the fact that Jean's condition was still very critical as he still has an infection which might take over ten days to cure. Thankfully, he was in good health when the bullet hit him.'

A few days later she wrote again to Rivière: 'Jean is getting better, but I don't know yet whether to cry victory but this evening his temperature was down. I got my appetite back for the first time since the injury and today is the 19th day. It is truly a miracle that I will tell you about one day.' On 26 May another letter began: '*Mon cher* Rivière, I'm leaving Gérardmer on Monday evening. I'll stay a few days at Essoyes and will be in Paris on Saturday . . . Jean is getting on well. All the same, the poor thing must remain at least another month. I promised him that I would return to see him soon after I've been back to Cagnes and hasten the preparations to get back to Paris. It will be impossible for me to be at Gérardmer while Renoir is in Cagnes, which is much too far . . . Jean has suffered a great deal.'¹⁰

It was one of the last letters Aline ever wrote. She returned to Les Collettes where she took to her bed. On 28 June 1915, Auguste

wrote to Durand-Ruel: 'My wife, ill already, came back from Gérardmer even worse and did not recover. She died yesterday, happily without knowing it.'[11]

Aline died of diabetes according to the doctors, but Jean felt that she had died of the nervous strain of a journey to the front to visit him. This incident could not help but create a feeling of profound guilt within the young man, an emotion that lingered for the rest of his life, and surfaced from time to time.

Jean writes of how he was told of his mother's death by Véra Sergine, who had since become his sister-in-law. As one of the most famous stage actresses of the day, her arrival at the hospital at Besançon, where Jean had been transferred, caused quite a stir. 'Véra made her entrance. Her hair was cut short and she wore a dress that stopped at the knees. Her attire seemed all the more strange as she was in mourning. She had come to break the news to me of my mother's death. I was so shocked by this new creature that it took me several seconds to grasp her terrible message. The girls my fellow-soldiers and I had left behind had had long hair. Our idea of feminine charm was associated with hair worn like that; and here we were suddenly confronted with the new Eve.'[12]

Despite the intense grief Jean must have felt at the death of his mother, he remembered the remarks of his fellow patients after Véra had gone. 'That kind of outfit suits her because she's an actress . . . you have to get used to it . . . That's all right for Paris, but I'm sure that at home in Castelnauddary neither my mother nor my sister . . . If I find my wife rigged out like that when I get home, I'll give her a kick in the arse.'[13] This perception of comedy inherent in the midst of tragedy and vice versa was to become a characteristic of much of Jean's work, and he was later to adapt this dialogue for the scene in *La Grande Illusion*, when the POWs are unpacking the women's dresses for the drag show.

Because of the bullet wound, Jean was destined to limp for the rest of his life, a limp that is evident in his few appearances on screen. Writing as an old man, he reflected that 'a person who limps does not see life in the same way as someone who does not limp. But I directed films as much with my legs as with my head, and the result of that wound, which never healed, was that four years ago, at the age of 75, I had to abandon a career which, to my mind, was only just beginning.'[14]

The pain in his leg, from which he frequently suffered, became

part of his existence. At times, the wounds would ooze blood and pus, necessitating an immediate dressing. As late as 1956, when he made *Eléna et les hommes*, the 62-year-old director had to have fresh bandages applied to his old war wounds every night, and he was forced to direct some of the film from a bed brought onto the set. Like his father, Jean was to end his days in a wheelchair.

Pierre had also been badly wounded at the same time, his arm shattered by a bullet. Véra had hurried to his bedside in the hospital in Carcassone, only to be told that he would never fully recover the use of his right arm. There was anxiety that Pierre would be unable to resume his career as an actor, but Professor Gosset, 'a surgeon of genius',[15] restored the partial use of the right hand by bonegrafts taken from other parts of his body. Later, a special apparatus was devised to support his arm. Pierre returned to the stage after the war, having learned to avoid certain movements of the arm which would betray his infirmity. Like Jean, Pierre would also suffer great pain from time to time, a continual reminder of the war.

In order to be near his invalid sons – Jean had been transferred to a hospital in Paris – Auguste decided to stay for a while at the first floor apartment at 38 bis boulevard Rochechouart which he had been renting since October 1911. As it was on the corner of rue Viollet-le-Duc, the architect Auguste hated most, he had even considered moving, so strongly did he feel about it. By now, however, he could no longer walk, and two people had to carry him up the stairs while he sat on a wide leather band. His studio was on the same floor as the apartment, and he only used the stairs the day he arrived and the day he left.

'The death of my mother had completely crushed him and his physical condition was worse than ever. The journey from Nice to Paris had tired him so much that he was unable to visit me in the hospital. But as soon as I was well enough to dispense with having my leg dressed, I easily got permission to spend most of my time at home,'[16] Jean recalled. Auguste was ill and lonely, and was glad of a companion.

Pierre would often pay visits with Véra and two-year-old Claude, the future cameraman. Coco was at school in Cannes and Gabrielle had married the American painter Conrad Slade, a fervent admirer of Auguste. This extraordinary marriage between the extrovert Burgundian peasant girl, who had only the barest amount of education and never learned to speak English, and an introverted upper-crust New England intellectual and artist took place in 1914.

Slade was the son of a Harvard professor, and he himself studied philosophy there under George Santayana. Will Durant described Santayana as 'a refined mixture of Mediterranean aristocracy with New England individualism; and, above all, a thoroughly emancipated soul.'[17] The description could as well have applied to Slade who, though in many ways a typical product of Boston high society, rebelled against his family and set off for France in order to become a painter. Under the influence of the Impressionists, he painted mostly landscape and still-life.

After the wedding, the Slades set up home in Montparnasse at the opposite end of Paris from the Renoirs. Rumour had it that Gabrielle quit the Renoir household shortly before her marriage because Aline had asked her to leave. It is likely that, with her own increasing infirmity, she had become jealous of her husband's dependence on his maid and model.

At the boulevard Rochechouart apartment, Jean on crutches and Auguste in a wheelchair were being cared for by the cook Grand' Louise. They played draughts because Auguste hated cards and Jean was not good enough at chess. But most of all they talked. It was then that Auguste spoke to his son about his past life, reminiscences which formed the basis of Jean's illuminating book, Renoir, My Father, which he wrote in 1957–58 during a three-year lull in filmmaking.

Despite his near fatal wound and the recurring pain, Jean felt fit enough in a few months to return to the war, and Auguste went back to Cagnes, anxious about his son. Jean could have remained peacefully at home after he was wounded but, determined to help win the war to end all wars, he signed up again, this time for the air force, the only service that did not require a medical examination to enter.

He soon found himself in an airplane as an observer taking pictures of the enemy positions. The planes were twin-engined wooden Caudrons, which were no match for the Germans' faster and better equipped Focke-Wulfs. On one mission, while the plane Jean was in was being chased and shot at by a Focke, a pilot from a French fighter squadron in the latest Hispano-Suiza Spad, swooped to its rescue and shot down the German plane. Jean soon learned that the man who saved his life was Major Pinsard, later General Pinsard. He was to become the main inspiration behind La Grande Illusion when he entered Jean's life again some years later in a scene reminiscent of a picaresque novel.

After some months as an observer, during which time he learned something about photography, Jean had a hankering to become a pilot and was transferred to the flying school at Ambérieu for training. 'Hitherto I had been only an observer, which I had not enjoyed at all. I was in love with machinery, and to be ferried about in the air by another man gave me the feeling of being shown a toy which I was not allowed to play with. Toys are only interesting if one can take them to pieces. At the end of my course I underwent my pilot's test and was turned down; I weighed five kilos too much. I subjected myself to a week's diet which was the more painful because I was naturally greedy; I enjoyed wine even more than good food. I shall never forget that wretched week; but I was rewarded by passing my test with honours. On the same evening I gorged myself with sauerkraut washed down with Alsatian wine.'[18]

At the beginning of 1916, Jean was a pilot in a reconnaissance squadron billeted in Champagne, a part of France he knew only too well. There he received a letter from Cagnes in an envelope addressed by Grand' Louise. Inside was a violet, which had been picked at Les Collettes under the olive trees, and three words written in a shaky hand: 'To you, Renoir.'[19]

Jean remained with the reconnaissance squadron until a bad landing aggravated his leg wounds, thus putting an end to his flying career. Now a full lieutenant, he spent the last months of the war stationed in Paris at the apartment in the boulevard Rochechouart, which allowed him plenty of spare time to indulge his new passion – the cinema.

PART II

COMPANIONS IN SILENCE (1917–1930)

7

A Fearsome Beam of Light

'The earliest films were the direct expression of the dreams of the film-maker and bore his unmistakable signature, together with all the influences that had combined to shape him, English pantomime or popular melodrama, or, above all, the delightful American burlesque show.'

While serving in the bomber squadron, Jean became friendly with the son of the celebrated Professor Richet, Nobel Prizewinner and discoverer of anaphylaxis, defined in immunology as an 'often fatal bodily reaction to contact with a foreign substance.' Evidently, the good professor did not suffer from the complaint: Richet Jr, just back from leave, told Jean that his father had taken him to see a film featuring an extraordinary 'American' performer called Charlot. He went on to say that, according to his father, Charlot had restored simplicity to the art of the cinema, concentrating on the basic emotions of fear, hunger, envy, joy and sadness. This determined Jean to see this Charlot on his next furlough in Paris.

He first called on his brother Pierre, who immediately asked him, 'Have you seen Charlot?' Jean told him of Professor Richet's enthusiasm. 'That doesn't surprise me,' said Pierre. 'Greatness attracts greatness.'[1] So the brothers set off to see a couple of Charlie Chaplin shorts in a little cinema near the place des Ternes. In 1916, when Jean first discovered him, Chaplin had moved from Essanay to Mutual, commencing an extremely creative and inventive period during which he completed 12 films, each with a different theme.

These included *The Vagabond, The Pawnshop, The Rink, Easy Street, The Cure* and *The Immigrant*.

'To say that I was enthusiastic would be inadequate,' Jean wrote. 'I was carried away. The genius of Charlot had been revealed to me . . . It was years before I learned my idol's real name . . . I saw every film of his that was shown in Paris again and again, and my love of him did not grow less.'[2]

The influence of Charlie Chaplin on Renoir is discernible from the French director's earliest films, especially in the stylised performance of Catherine Hessling, his leading lady and wife (who herself revered The Little Tramp) – certainly there are hints of *The Gold Rush* in *La Petite Marchande d'allumettes (The Little Match Girl)* through to the silent slapstick of *Tire au flanc*. The anarchic Boudu, perhaps only second to Charlie as the world's most famous screen tramp, is kindred to Chaplin's creation, and an audaciously direct homage is paid to *Modern Times* at the end of *Les Bas-Fonds*. Components of Charlot are to be found in Jean-Louis Barrault's extraordinary, liberated, cane-wielding performance as the evil alter ego of the eponymous doctor in *Le Testament du docteur Cordelier*, and there are certainly echoes of *Shoulder Arms* in *Le Caporal épinglé*. Renoir's films stressed much of the 'fear, hunger, envy, joy and sadness' that Professor Richet had noted in Chaplin's work, but it was only in the first episode of *Le Petit Théâtre de Jean Renoir*, his very last film, that Renoir gave way to the sentimentality that sometimes marred Chaplin's vision.

Jean claimed that it was Charlie Chaplin who converted him to cinema. His very first experience of the medium, way back in 1897 when he was only two years old, had not been a happy one. Aline had decided to buy a whitewood wardrobe for Gabrielle's bedroom, and sent the nurse and her charge to the Grands Magasins Dufayel, a leading department store, to pick one out. The store, which considered itself in the forefront of progress, offered a free film performance. It was just over a year since the Lumière brothers had given the first public cinema show, a 20-minute programme of 10 films. Seeing them today is the cinematic equivalent of viewing the Lascaux cave paintings. When the cinema was in its infancy, so was Jean; as it matured, so did he. His first exposure to the art of film, as related to him by Gabrielle, is described thus: 'Scarcely had we taken our seats than the room was plunged in darkness. A terrifying machine shot out a fearsome beam of light piercing the obscurity,

and a series of incomprehensible pictures appeared on the screen, accompanied by the sound of a piano at one end and at the other end a sort of hammering that came from the machine. I yelled in my usual fashion and had to be taken out. I never thought that the staccato rhythm of the Maltese cross was later to become for me the sweetest of music. At the time I did not grasp the importance of that basic part of both camera and projector without which the cinema would not exist. So my first encounter with the idol was a complete failure. Gabrielle was sorry we had not stayed. The film was about a big river and she thought that in the corner of the screen she had glimped a crocodile.'[3] One wonders whether this vague memory surfaced again when he was making his first Hollywood film, *Swamp Water*, which certainly contains a river and a crocodile.

It was around seven years later, when he was a boarder at the school of Sainte-Marie de Monceau, that Jean had his second encounter with moving pictures. Every Sunday a film was projected onto a white sheet while the music master played the piano. The boys' favourite was always a burlesque comedian known as Auto-maboul, who wore a goatskin, huge spectacles and a cap. The films were mainly crude affairs, based on mechanical jokes such as a car exploding, but they implanted in Jean a weakness for slapstick comedy, something which explains his avid viewing of *The Three Stooges* on American TV when in his seventies. Jean never felt he had the opportunity to exploit knockabout comedy in his own work. 'Life is a tissue of disappointments. Certain colleagues whom I admire and envy realised that dream, among them René Clair and Mack Sennett.'[4] An odd comment from someone whose oeuvre, which does include a measure of slapstick, is of a far wider range than either Clair's or Sennett's, and is vastly superior.

After discovering Chaplin, Jean became interested in other films and reached the point of seeing three features a day, two in the afternoon and one in the evening. Among those he particularly liked were the American landmark serials, directed by French *emigré* Louis Gasnier, starring Pearl White. So keen was he on Miss White, that his fellow-soldiers nicknamed him 'Elaine Dodge' after the heroine of *The Exploits Of Elaine*.

Although the idea of working in film never occurred to him, he 'soon began to realise that in addition to the talent and physical appearance of the actors there had to be someone who put the whole thing together, devised the settings and probably instructed the players. My brother Pierre told me that this was the director. I

began to note differences of style in the films made by different directors. It was a new stage in my development.'[5]

The release of D. W. Griffith's *The Birth Of A Nation* in 1915, a momentous event for the American cinema, and the same director's *Intolerance* the following year, awakened Jean's intense interest. Many of the American film-maker's spectacles and melodramas conjured up the plays of the *Boulevard du Crime* of his youth, but far more important to him was Griffith's use of the close-up, which Jean came to call 'the Marvel of Marvels'. 'I am ready to bear the most tedious film if it gives me a close-up of an actress I like. And in my passion for the close-up I have sometimes inserted perfectly irrelevant sequences in my films simply because they allowed me scope for a really good one,' he later commented.'[6]

D. W. Griffith had made his screen debut as an actor in Edwin S. Porter's *Rescued From The Eagle's Nest* (1907), a film which amply demonstrates the early use of close-ups and cross-cutting. When Griffith started directing in 1908, he articulated what Porter had done. 'Why not move a camera up close and show an actor's full face? That would reveal his emotions, give him a chance to show what he is thinking . . . '[7] Griffith believed that the close-up would be a means of eliminating unrealistic pantomime to indicate emotion. By 1911, Griffith had used close-ups, dissolves, cross-cutting, deep focus and split screen.

Jean would not have seen the Porter films, nor the early Griffith work in which the director was learning his craft and inventing a technical grammar for the silent screen, so that *The Birth Of A Nation* came as a revelation. Despite the film's blatant racism – the hero forms the Ku Klux Klan – and its grotesque distortion of history – after the defeat of the South the negroes gain equality – *Birth Of A Nation* remains a remarkable work in which all the innovations of the early films reach maturity. For better or worse, Griffith and Chaplin were the most potent influences on Renoir when he began his film-making career.

During Jean's ravenous film-going excursions, he preferred to avoid French films, finding them too 'intellectual' for his taste. This prejudice was confirmed when Pierre expounded his views on the matter. 'The cinema doesn't suit us,' he told Jean. 'Our burden of literature and drama is too heavy for us to follow that particular line. We must leave cinema to the Americans. French dramatic art is bourgeois, whereas the American cinema is essentially working class. Between ourselves, I envy my colleagues over there who have

that kind of public to work for – Irish or Italian immigrants who scarcely know how to read.'[8]

When Jean started going to the cinema, the French film industry was in a parlous state. The war had dealt it a severe blow because exports to other areas of Europe were suddenly disrupted. In addition, many actors and film technicians had been called up for military service. Max Linder, an influence on Chaplin, who was at the height of his fame in 1914 when he was recruited, became a victim of gas poisoning early in the war and suffered a serious breakdown. The dapper little comedian was continuously dogged by ill health until his suicide in 1925. At the same time, growing competition from American studios with the increased imports of their pictures was gradually eroding the the French film industry.

The situation would not have improved much by the time Jean first contemplated directing a film some years later. 'It seemed impossible to me that anything worthwhile could be made in France. These American films that I loved so much, these admirable actors whose play enraptured me, weren't they despised or even unknown to most of our critics? (I dreamed of Pearl White, Mary Pickford, Lillian Gish, Douglas Fairbanks and William Hart). And I, who dreamed timidly of walking in their footsteps without hope of equalling them, how could I imagine having the least chance in this country of mine where everything is done by routine? As for going to America, I could never have had the self-assurance to consider that utopian project.'[9]

Jean could never have imagined either that he would meet many of his idols one day on an equal footing, and make films in Hollywood; and, more importantly and in spite of his early views, that he would play an essential role in the golden age of the French cinema and beyond.

8

The Golden Muse

'Along with the roses, which grew almost wild at Les Collettes, and the great olive trees with their silvery reflections, Andrée was one of the vital elements which helped Renoir to interpret on his canvas the tremendous cry of love he uttered at the end of his life.'

Auguste Renoir, though crippled by arthritis and in constant pain, still travelled to Paris and Essoyes for short periods of the year, but remained most of the time at Les Collettes, where Grand' Louise looked after him. It was way back in the summer of 1897, before he had enlarged the house at Essoyes to contain a proper studio, that he had the accident which, Jean believed, led to the final years of pain and deformity. Like so many people in those days, Auguste was a keen cyclist. One rainy day he skidded, fell, and broke his right arm. The arm was put into plaster, but he continued to paint. 'He was', said Vollard, 'the only painter who had ever painted as well with the left hand as the right . . . He was in fact ambidextrous but this cannot take away from the feat. A broken arm is not painless, nor can it be forgotten when in plaster, but he refused to be intimidated and painted on as if nothing had happened. He was not one to complain of physical pain, and did not do so now.'[1]

But the more intolerable his suffering became, the more Renoir painted. At that period, a journalist asked him, 'With such hands, how do you paint?' 'With my prick,' replied Renoir, with uncharacteristic crudeness.[2]

When Auguste heard that a German bomb had demolished his old studio in the rue Saint-Georges, it seemed a symbolic destruction of his past. Many of his good friends from the Montmartre days had died. In September 1917, he was told of the death of Edgar Degas. The tragic figure, friendless, practically blind, forced to leave his old home, had at last ceased to wander wretchedly round the darkened streets of wartime Paris. Renoir was a great admirer, not so much of the rather cantankerous man, but of the paintings and, especially, the sculptures. He had said 'Le premier sculpteur, c'est Degas!' and 'Since Chartres there has been only one sculptor, in my view, and that is Degas.'[3] He had been particularly struck by La Petite Danseuse de quartorze ans (1881), now in the Louvre, so different from his own voluptuous women.

Tragically, Auguste, who had loved using his hands ever since he had been a craftsman in his youth, and was to encourage both Jean and Coco to take up ceramics after the war, was only able to sculpt through an intermediary. Richard Guino first came to Essoyes in the summer of 1913 to execute Venus Victorious, the only substantial sculpture supervised by Renoir, and one which most closely reflected his intentions. In 1916, Guino returned to Essoyes to model a bust of Aline from a seated study 'par praticien interposé'. (Jean inherited this study of his mother, and gave it pride of place in his home in California).

The name of Richard Guino loomed large again for Jean in 1973, when the sculptor's heirs took out a law-suit against Auguste Renoir's heirs, claiming that they themselves should benefit from the value of the works. The court judged that the sculptures which Guino had executed to Renoir's designs should be attributed jointly to the two men.

When Guino came to work in Cagnes, Renoir was already disenchanted with the collaboration. He replaced Guino with Marcel Antoine Gimond, another pupil of Maillol, then in his mid-twenties, to whom Renoir said, 'Vous avez – c'est énorme – le sentiment de la grâce.'[4] It was Gimond who made a bust of Renoir on the day of his death.

There was no doubt that Auguste was miserable and lonely, missing Aline terribly. Of one visit to Cagnes, when on leave, Jean wrote: 'I found the house sinister. The orange trees and the vineyards were almost wild. It was as if people, trees, everything mourned my mother. The car was garaged and covered with a thick layer of dust . . . '[5]

But there were some compensations. Paul Cézanne (the painter's son) and his wife, Renée, settled next to Les Collettes; Jean and Pierre, too, visited their father when they could, and so did Henri Matisse, who lived his winters in Nice. However, when Auguste Renoir was 75, crippled, lonely and morose, he had an astonishing rebirth. One day, a lively, red-headed 16-year-old girl arrived at Les Collettes, and transformed the lives of both Auguste and Jean Renoir.

Andrée Madeleine Heuchling was born in the small town of Moronvilliers in the Haute-Marne in Alsace in 1900. In 1915, Andrée, her mother and sister had to flee their home town which was being pounded by French bombs. After having crossed Switzerland, they ended up in Nice. The young girl got a job retouching pictures for a photographer in the place Massena where she met and made friends with 17-year-old Alice Burpin (later Alice Fighiera), who was also working there while waiting to get into college. Andrée, known to everyone as Dédée, also modelled at the Académie de Peinture at Nice.

One day, Dédée told Alice that a painter called Matisse had asked the Académie to send him a young, female model. 'But I don't want to pose at his home. I'll refuse to take off my clothes,' she said. 'But I'll go and see what he wants.' When she arrived at Matisse's house, the artist took one look at her and said, 'You're a Renoir.' He told her to visit Auguste Renoir at Les Collettes on his behalf.[6]

Matisse was right. Auguste immediately saw a similarity to Aline and to his feminine ideal. Physically, Dédée was a living Renoir, with her feline face, red hair, 'almost white eyes like a pig's',[7] beautiful hands and plumpish figure, with 'a big behind and short legs,'[8] the sort that Auguste liked. She wore no make up.

Confusing his dates somewhat and believing that his mother was still alive when Dédée came to Renoir (Aline had died in April 1915, two years ealier), Jean wrote in his memoirs: 'She was the last present given to my father by my mother before her death. My father was looking for a blonde model for his big painting, *Baigneuses*. My mother applied to the Nice Académie de Peinture and discovered Dédée. Dédée came from Nice every morning except Sunday, and her arrival was like the touch of a magic wand. My mother's death had plunged the house and its inmates into a state of utter gloom. Despite her corpulence, my mother was the soul of gaiety. Everything grew bright around her and while she was alive Les Collettes could be seen as a symbol of quiet happiness. With her

departure the gaiety had fled, and with the arrival of Dédée it was restored. Dédée adored my father, who returned her love.'[9]

Her closest friend Alice is adamant that Dédée never posed for any paintings by Auguste, especially not *Les Grandes Baigneuses* (now in the Louvre), which many critics have indicated as featuring her. It is certain that Dédée allowed Auguste to make sketches of her, but in his latter years the artist so generalised the features of his models, sometimes combining elements from different sitters in a single figure, that it is often impossible to identify them. One, for example, Madeleine Bruno, found it hard to recognise her own slight figure in the massive forms that he painted using her as a model. What Auguste might have done was use Dédée's head on the nude body of another, less slender, woman. But he did speak of 'the simple and noble' way in which Dédée posed. 'Rubens would have been satisfied with it!'[10] Titian and Rubens remained the most important influences on Renoir's last paintings. 'That old Titian,' Renoir joked, 'he even looks like me, and he is forever stealing my tricks.'[11]

In his article *Renoir à Cagnes* in 1933, Georges Besson wrote: 'When his young model arrived from Nice all his troubles were forgotten even though he still suffered as much as ever. Before ten in the morning he would be in his garden studio examining his work of the previous day and exclaiming at the quality of the light on the olive trees glowing in the morning sunshine. He would crack jokes: "It's a great pity that someone can't recount later on that I used to paint surrounded by nymphs and crowned with roses, or even better with a beautiful girl on my knees like the Raphael of Ingres – though she must have been a little cumbersome." '[12]

Dédée was devoted to the crippled painter. She bandaged his hands in which she placed his brush, carried him to and from his bed to the armchair where he was obliged to paint. 'Somewhat like Abigail beside David, I rewarmed the heart of the old artist,' Dédée said many years later when she was known as the actress Catherine Hessling.[13]

During the last two years of his life, this pain-ridden and disabled man made more than 100 sketches and paintings – portraits, nudes, and heads – most of them dominated by his favourite colour red, used in an extraordinary variety of nuances. The best of these have been described as hymns to light and colour, youth and life, among them *Le Repos après le bain*, *Danseuse nue au tambourin*, *Femme à la guitare*, *La Femme à la robe de mousseline* and *La Liseuse rose*.

Of that period, the art critic John House wrote: 'His last works painted at Les Collettes, notably *Les Grandes Baigneuses* were the most radiant of his career. But by the time he painted them his dream of a serene old age was broken . . . Nevertheless he managed to distil his dream of serenity into his painting . . . fulfilling his dreams of painting an earthly paradise.'

All this creative activity was, in the main, inspired by the proximity of Dédée's youth, gaiety and beauty. 'It's to you that we owe our fortune,' Pierre once told Dédée.[14] She was in continual high spirits, and loved singing Niçois ditties around the house. 'This delighted Renoir, who maintained that a house without song was a sepulchre,' wrote Jean,[15] who put much of her into his portrait of Agnes, the young prostitute, in *The Notebooks Of Captain Georges*: 'Every movement she made was expressive of living. She could not go upstairs without running or singing, wash without making a party of it, eat without revelling, or wake without a gurgle of happiness. Her gaiety was infectious. I, too, when I was with her, found myself running and singing, laughing and gurgling.'[16] In fact, the fictional narrator reflected the feeling that Jean himself had in Dédée's presence when he first met her at Les Collettes, during one of his furloughs in 1917.

At the Armistice, Jean returned to Cagnes, to live with his father and younger brother at Les Collettes, without any idea of what he was going to do for a living. Although the cinema and motor cars (he was soon to own a Napier) were twin passions, he did not, at this stage of his life, envisage either becoming a practitioner of the art of film or a racing driver, although he contemplated the latter.

Auguste encouraged Jean, Dédée and 17-year-old Coco to work at pottery by having a studio and an oven installed in an old building not far from the large house. They were soon joined by the painter Albert André and his wife Maleck. The five of them worked every day, gathering clay from the fields and mixing it with sand from the bed of a stream nearby. After fashioning their plates and vases on the old-fashioned potter's wheel, they placed them in a wood oven to bake for about 10 hours. In the evenings, while waiting and checking the temperature of the oven by means of a small hole bored in the door, they would listen to phonograph records, eat Provençal dishes such as *pissaladière* – an onion and tomato tart garnished with anchovies and olives – and homemade black country bread and wine. 'Later I was often to think nostalgically of our tranquil life at

Les Collettes under the big olive trees, and the good smell of wood smoke that accompanied our work. Dédée, pressed against me, would look up at the stars, and we would rejoice together in the contemplation of limpid skies. In Paris one seldom looks at the stars.'[17] In the episode, *Le Dernier Réveillon*, from Jean's final film, he has the tramp couple, on the banks of the Seine in Paris, staring up at the firmament, distinguishing them from the other city dwellers.

Jacques Renoir, Pierre's grandson, who worked as a cameraman with Jacques Cousteau and makes publicity films, has written a screenplay about the last days of Auguste Renoir and the growing romance between Jean and Dédée, seen through the jealous eyes of the teenage Coco. He dreams of directing the picture at Les Collettes with Kirk Douglas in the role of the great painter.

Jean was plainly smitten by Dédée. The only women he had come across while in the male environment of the services were prostitutes. He had never met anyone quite like this young girl who was so devoted to his father. It was clear that Jean was falling in love with Dédée, and they were drawn together by their work and their great affection for the ailing Auguste.

'The *patron* told me that his son wants to marry me,' Dédée wrote to Alice, a few months before Auguste's death,[18] confessing that she was not at all in love with Jean, but was much more attracted to Pierre. However, the actor, who was seldom at Les Collettes, was romantically involved elsewhere. 'Renoir had dreamed of adopting me when Jean asked me to marry him,' Dédée claimed in later life. '"*Alors*," said Renoir, "I can't adopt Dédée any longer. I can't divide my small heritage into four parts."'[19]

Meanwhile Auguste's health was deteriorating rapidly. His nights were frightful, because any rubbing of the sheets caused sores. 'In the evening he would put off as long as possible the moment when he would have to undergo the "torture of the bed". His sores would have to be dressed, and talcum powder applied to places easily irritated . . . We would lift him up, pull down his trousers, and spinkle him with talcum . . . But it was no use. "It's like fire,' he would grumble. "I'm sitting on blazing coals!"'[20]

Jean was with him constantly, helped by Dédée, Grand' Louise, the young model Madeleine Bruno, and a nurse. One morning, Jean went to Nice and, on his return, Auguste was in bed breathing with difficulty. The doctor explained to Jean that his father had a serious lung infection and had burst a blood vessel. A few hours earlier, the

artist had asked for his paint-box and brushes, and painted some anemones which Nénette, the maid, had gathered for him. When he had finished, he lay down, closed his eyes and said, 'I think I'm beginning to understand something about it.' According to Grand' Louise, these were his last words. However, the nurse reported that he said, 'Today I learned something.' Another eye-witness said he had exclaimed, '*Je suis foutu!*' ('I'm done for'), but he had been saying that every time he fell ill during those last few years.

Auguste Renoir died during the night of 3 December 1919 of congestion of the lungs. He was buried at Essoyes on 6 December. One famous Renoir was gone, but the name would continue to resound in another medium.

9

The Opening Sequence

'The bug of film-directing had now taken root in me and there was no resisting it. I felt the need to express myself through the ingenuity of my own products, whether they were china vases or films.'

On 24 January 1920, a few weeks after Auguste Renoir died, Jean and Dédée were married at Cagnes town hall. The bride confided to her friend Alice that she married Jean not out of love but admiration; also because he was Auguste's son, and because she saw a means of becoming a Renoir, the prestige of which would change her life. On their wedding night, though Jean was very sexually excited, he never touched her. Dédée had explained to him that she was a virgin and had no wish to rush into anything.

The three Renoir sons shared the paintings and other possessions left by their father, which assured them financial independence for a considerable time. But Pierre continued his acting career, and Jean and Coco stayed on at Les Collettes working at ceramics, which they began to sell.

Some examples of Jean's ceramics can be seen at Les Collettes. These include a pair of tiles on which two harlequinade figures are rather crudely drawn; another is a little bowl around which are daubed apples and a pear. Much better are two vases in Jean Griot's collection, executed later and with a certain skill. One is decorated with a pattern influenced by Georges Braque, whom Jean knew and

greatly admired (he possessed a magnificent Braque still life which hung in his Beverly Hills home), the other depicts a landscape at Les Collettes, done in the manner of his father. But it is clear that if Jean had stuck to ceramics, he would have been famous for only one thing – as the child model in his father's paintings – a mere footnote in the Auguste Renoir story. He was to come much closer to his father's vision by painting with the camera.

After the birth of their son Alain at Cagnes on 31 October 1921, Jean and Dédée decided to move nearer Paris. Twenty-year-old Coco had been called up for military service, Gabrielle and her husband were living there, and so were many of their friends. Jean bought a villa at Marlotte, the village near the forest of Fontainebleau where Auguste had painted. The house had a superb hall in black and white, and large rooms filled with gorgeous furniture in the style Auguste had loved. The splendid fitted carpets were red, and there was a magnificent dining room, with much of the gold and silver cutlery that had graced Aline's table at Les Collettes.

At Marlotte, in order to keep faith with the memory of his father rather than out of any natural vocation, Jean built a kiln and resumed his ceramic work, a craft he practised until 1924. The Renoirs were soon joined at Marlotte by their friends, Paul and Renée Cézanne with their two children, Aline and Jean-Pierre, who moved to the nearby property of La Nicotière. The old house with a fine court-yard, much smaller than Marlotte, would later serve as the setting for the first film Jean directed, *La Fille de l'eau*.

The proximity of Fontainebleau to Paris meant that Jean and Dédée were able to satisfy their infatuation with the cinema. 'We went to the cinema nearly every day, to the point that we had come to live in the unreal world of the American film. It may be added that Dédée belonged to the same class of woman as the stars whose appearance we followed on the screen. She copied their behaviour and dressed like them. People stopped her in the street to ask if they had not seen her in a particular American film. We thought nothing of the French cinema. So it was very easy for us to believe that Dédée had only to show herself to be accepted as another Gloria Swanson or Mae Murray or Mary Pickford.'[1]

Dédée's friend Alice from Nice often visited the Renoirs at Marlotte with her husband Pierre Fighiera, and in summer they would go bathing and boating on the River Loing. One glorious Impressionist day, the two couples were messing about on the river,

laughing and playing in a boat, with Dédée doing her Lillian Gish impersonation at the stern, when Jean said, 'Oh, that's too funny. We must make a film.'[2] Sometimes, when Jean began to tire of the work, he would take photographs of his wife to pass the time, but this was the first occasion that he had ever thought of making a moving picture. He bought an 8mm camera and started shooting a few home movies, mainly concentrating on Dédée, developing them at night in the cellars of the huge house. Thus began his new career.

In 1923, Jean and Dédée went to the Colisée on the Champs-Elysées to see *Le Brasier ardent* by Ivan Mosjoukine. The Russian-born Ivan Mozhukhin (Mosjoukine in France, Mosjukine in the USA, Moskine in Germany) made most of his films in France, but suffered from the coming of sound, and died poor and forgotten in a Neuilly clinic in 1939. *Le Brasier ardent*, co-directed by Alexander Volkov, was about a detective who falls in love with the wife whose fidelity he has been hired to investigate. Jean was delighted by the use of various devices such as slow motion, superimposition, rapid montage and surrealist decor, and the mixture of burlesque, bizarre humour and drama.

'The audience howled and hooted, shocked by this spectacle so different from their usual pablum,' wrote Jean. 'I was ravished. At last, I had before my eyes a good film produced in France. Of course, it was made by Russians, but at Montreuil, in a French environment, under our climate . . . I decided to abandon my *métier* of ceramics and try to make films.'[3]

Elsewhere Jean explained, 'I set foot in the world of the cinema only in order to make my wife a star, intending, once this was done, to return to my pottery studio. I did not foresee that once I had been caught in the machinery I should never be able to escape. If anyone had told me that I was to devote all my money and all my energies to the making of films I should have been amazed.'[4]

However, Dédée later commented, 'His friends, without doubt anxious to get him to spend his money, advised him to go into cinema.'[5] She failed to add that she was thrilled to be chosen as his chief interpreter, and changed her name to Catherine Hessling, which, for some reason or another, she thought sounded American.

At the beginning, through his childhood friend, Pierre Lestringuez, a writer with cinema contacts, Jean decided merely to participate on the financial side, using part of his father's inheritance to help produce a film with a starring role for Dédée. The scripts

Lestringuez suggested did not appeal to them, so Jean sat down and wrote a screenplay that reflected his admiration for American films, and particularly D. W. Griffith's melodramas. Entitled *Catherine*, it also anticipated later Renoir films in which low-life characters are contrasted with the hypocrisy of the bourgeoisie, films such as *Nana, La Chienne* and *The Diary Of A Chambermaid*.

Jean had purposely set the story in the south of France – an important sequence takes place on the Grasse-Nice tram line – so that location work would take them to Cagnes where he and Dédée could stay at Les Collettes. The director selected for *Catherine* was the actor Albert Dieudonné, who had once partnered Jean's sister-in-law, Véra Sergine, on stage in a play called *Un Lâche*. Dieudonné would become most famous for playing the wild-eyed, possessed, hawk-profiled title role in Abel Gance's *Napoléon* in 1927.

'While we were making the film . . . I could not restrain myself from constantly interfering with the director,' Jean wrote. 'Dieudonné needed the patience of a saint to put up with the two of us.'[6] Mostly, in fact, Dédée, who had never acted before, was painstakingly directed by her husband.

The story relates how Catherine (Hessling), a young servant girl, accompanies the tubercular Maurice (Dieudonné) and his family from their village to Nice for the sake of Maurice's health. Maurice falls in love with Catherine, but dies during the Nice carnival. She is then forced to fend for herself, and is helped by a sympathetic pimp (Lestringuez under the name of Pierre Philippe). She returns to the village and her former employer, Monsieur Mallet the mayor (Louis Gauthier), but when he is vilified for employing a fallen woman, she runs away. Caught in a storm, Catherine is forced to shelter in a deserted tramcar which breaks loose, but she is rescued by the mayor's son (Pierre Champagne) at the last moment. Jean played an important secondary role, providing comic relief as a hypocritical monocled sub-prefect.

Although rather clumsily directed – stuffed with a ragbag of unoriginal techniques, including inept rapid cutting – it had some outstanding location photography by 29-year-old Jean Bachelet, who had worked as a newsreel cameraman prior to *Catherine*. (He was to become director of photography on 11 of Renoir's films.)

Many years later, both Jean and Dédée made extremely unfavourable comments about *Catherine*. 'I trust that no trace still lingers of that masterpiece of banality,' Jean wrote. 'It was a total failure . . . it was never shown in any cinema.'[7] As for Dédée: 'It ought to be

hidden from sight . . . But what an idea to make that, above all with that Dieudonné, who was not a very reliable sort.'8 Although Dédée's remarks in later years were almost invariably bitter, her views on her first director might have been apt. When *Catherine*, which was not given a public showing for three years, was re-edited and less-than-enticingly retitled *Une Vie sans joie (A Joyless Life)*, Dieudonné, scotching rumours that Renoir had co-directed the film, pompously told the press, 'I am the sole director of a screenplay which I composed following an outline imagined by M. Jean Renoir . . . with my collaboration. In addition M. Jean Renoir has financed the film and has been my student. I shall see by his future productions if I have reason to be satisfied.'9

La Vie sans joie ran only a few days after it opened at the Max Linder cinema in November 1927. Not the most auspicious beginning to a career in films for Jean, but it gave him a taste for direction, and a desire to get more out of Dédée whose performance had been far too mechanical. Ignoring the fact that her screen debut passed virtually unnoticed, it still set Dédée dreaming that Hollywood would soon be clamouring for her. 'You believe that acting is just putting on make-up and going in front of the camera,' Alice Fighiera remarked to her. 'Don't you realise that you have to do more than make contortions? You have to learn to act.' Dédée replied, 'You know Alice, if the Americans call me, then I know I have talent. If they don't then it's not worth it.'10 They never did.

10

Forest Murmurs

'La Fille de l'eau *was born in 1924 of the strange juxta-position of Catherine Hessling and the Forest of Fontainebleau.'*

Dédée's life had changed considerably since her marriage to the great painter's son. Barely 20 years old, she enjoyed a glamorous exist-ence, dressing like her favourite film stars and driving a fast Napier car. She and Jean frequently went out to nightclubs and theatres, and spent a lot of money. In fact, she encouraged her husband to spend and spend. Dédée wore furs, made scenes in restaurants, and ogled other men, gaining her the reputation of an *allumeuse* (sexpot) who slept around. But she seldom went further than flirting and teasing. She was living in a film fantasy.

Jean once said to Alice, 'You know my wife spends a lot of money. It's stupid. She actually has the taste of a concierge's daughter.' As proof Jean showed Alice a little mirror encrusted with gold that Dédée had bought that day. 'What's that?' asked Alice. 'It's completely useless.' 'But it's art,' Jean replied. 'After all, it's beautiful because it pleases her.'[1]

In truth, Dédée had a fine dress sense and knew how to make herself look good; she had revealing clothes designed to her specifi-cations by Paul Poiret, the most fashionable couturier of the day. She appreciated painting, something developed by her years with

Auguste, and the couple acquired a number of fine Impressionist and Post-Impressionist works to add to the Renoirs already adorning the walls at Marlotte.

It was Dédée who forced Jean to put her into another film. Not much more than a month had passed since the completion of the shooting of *Catherine*, when Jean asked Pierre Lestringuez to come up with a script that would showcase his wife. The result was *La Fille de l'eau*, which Jean decided to adapt and direct himself.

Auguste once told Jean: 'The bourgeois . . . love to weep over the misfortunes of the poor little orphan girl. They go home sobbing their hearts out, and then discharge the maid because she's pregnant.'[2] However, this did not deter his son, following on *Catherine*, from making his debut as a film director with another melodrama about a little orphan girl. But he was still under the influence of Griffith, and he saw Dédée as his Lillian Gish. She was quite happy to take on the mantle.

Jean put his money into *La Fille de l'eau*, which he not only produced, directed and co-wrote, but designed as well. As he was to do throughout his career, he attempted to surround himself with as many friends as possible, always insisting that one should have a good time while making a film.

His debut picture was shot during the summer of 1924 at La Nicotière, the Cézannes' house, in the Forest of Fontainebleau, and at the café Au Bon Coin in Marlotte, where Jean had a village constructed around the existing buildings. The painter André Derain, whose works were sold by Vollard and whom Jean had met in the Midi, played the proprietor of the bistro. Harold Livingston, a young American who was spending the summer at Marlotte, took the role of the *jeune premier*, and the large Pierre Lestringuez and the lean Pierre Champagne were the villains. Jean got his brother Pierre to play a brutish peasant with a pitchfork coming to wreak revenge, and two-year-old Alain Renoir appeared twice, first throwing a stone at a window, and again looking at a box of baby rabbits held by his mother, whom he resembles. The German shepherd dog was also one of the family.

The plot, which 'was a secondary consideration, simply a pretext for purely visual imagery',[3] concerned Virginia (Hessling), a lonely and very innocent young girl, who lives with her father and her uncle Jeff (Lestringuez, again under the name of Pierre Philippe) on a barge. After her father accidentally drowns, Virginia flees, with

her dog, from her uncle's advances, and is befriended by a young poacher, Ferret (Maurice Touzé), who introduces her to a life of petty crime. The growing enmity between Ferret and a farmer, Justin Crépoix (Pierre Champagne), culminates in Ferret's setting fire to Justin's haystack. Drunk and angry, Justin and his friends burn Ferret's caravan. Virginia runs away and meets a young man, Georges Raynal (Livingston), who tries to help her. The next night, Virginia dreams of being rescued from her tormentors by Georges, who sweeps her off on a white horse across the tree tops. Georges finds her asleep and carries her to the nearby miller's house, where kindness and care open up a new life for her. But her wicked uncle reappears to spoil things until Georges knocks Jeff into a canal. The lovers embrace and set out into the sunset on a visit to Algeria.

Conventional and melodramatic as the plot is – Griffith filtered through French sensibility – *La Fille de l'eau* already contains many of the elements that later became hallmarks of Renoir's work – the poetic expression of landscape, an acute sense of visual realism, an eclectic style, the triumph of love over class barriers and the shifts between the comic and the tragic. In his earlier films, however, there was an element of technique for technique's sake – Jean was enjoying experimenting with a new toy – though the style well served the intermingling of dream and reality.

In retrospect, the opening shot of sun-dappled water – a barge is being pulled along a canal by Hessling on horseback on the bank – is seen as an archetypal Renoir moment. The bar in the village is a conscious reference to *Le Cabaret de la Mère Anthony*, painted by his father at Marlotte; the sympathetic poacher Ferret recalls Godefer, his childhood friend from Essoyes – Virginia and Ferret are seen paddling in a stream and laying out baskets to catch lobsters. The forest of Fontainebleau is used as more than just a background. 'The straight trunks of the great beech trees and the blue light filtering through the foliage forming a vault over them. You could almost believe you were at the bottom of the sea among the masts of a sunken ship,' was how Auguste described the place, the very lines used by Jean in his 1955 play *Orvet*.[4] This 'disturbing unreality' of the forest is well caught by Jean Bachelet's monochrome camera.

During the shooting, Jean got Bachelet to experiment with enlarging details, such as a close-up of a lizard's head that filled the screen 'so that it looked like a ferocious crocodile,'[5] an animal for which Jean, unaccountably, had a soft spot. (He had to wait until he

got to Hollywood and made *Swamp Water* before he could actually introduce crocodiles into one of his films.)

At the centre is Catherine Hessling, a touching Griffith-type put-upon heroine with some Chaplinesque moments. Although she did not have the benefit of Hollywood lighting and make-up, which made Lillian Gish and Mary Pickford unreal in their perfection, she has an attractive and expressive face – despite the rather crudely-drawn and unlikely bow lips on the French peasant girl. The other characters are one-dimensional in a two-dimensional setting – the villainous uncle, the handsome young hero who comes to her rescue, the carefree poacher and evil peasants.

But what is astonishing about Renoir's first film as director is his command of the medium – it has a fluency and expressiveness that requires few intertitles. In a moment reminiscent of the opening scenes of Sergei Eisenstein's *Strike* (1925) and Jean Vigo's *L'Apropos de Nice* (1930), in which people are compared with animals by means of superimposed images, the sinister peasant Pierre Champagne's craning neck and hooked nose fades into the head of a goose.

La Fille de l'eau also seems part of the Surrealist movement, especially the eerie dream sequence with its use of slow and reverse motion (predating Jean Cocteau's *Le Sang d'un poet*, 1930). Yet it was shot just in the summer of 1924, which coincided exactly with André Breton's *Manifeste de Surréalisme*. Jean had seen neither René Clair's *Entr'acte*, featuring various members of the *avant-garde* in the cast: Francis Picabia (who conceived it), Man Ray, Marcel Duchamp and Erik Satie; nor Marcel L'Herbier's *L'Inhumaine*, both of which appeared in the same year as *La Fille*. Luis Buñuel's startling film debut, *Un Chien Andalou*, was still four years away, and Eisenstein was yet to make his first feature. What Renoir *had* seen was Abel Gance's *La Roue* (1923), which might have later been in his mind when he made *La Bête humaine*, with its railway milieu, but whose rapid montage techniques were immediately influential.

On the whole, Renoir's use of dynamic montage is effective. As the wicked Jeff attempts to rape Virginia, there is a close-up of his lustful eyes, and cuts between her dog, a clock and Virginia trying to avoid his caresses. According to Alexander Sesonske, who had the patience to count such things, in its hour and 40 minutes, the film contains about 775 shots and 75 titles, and in the delirium sequence, 'Renoir combines 31 shots in just over 12 seconds . . . the most rapid sequence of images Renoir was ever to compose.'[6]

Virginia, lying in a tree, hallucinates after suffering a fall down a

canyon (brilliantly convincing), her diaphanous form leaving her body. As this was not yet a cinematic convention, Renoir keeps returning to the sleeping girl to remind audiences that it is a dream they are watching. Some of the methods misfire, such as over-exposure to create light which only looks like a trick that went wrong, and a scene with the two villains on a branch of a tree sitting on either side of the heroine is amateurish. The ride across the sky on the horse is also rather basic when compared with Douglas Fairbanks' similar exploit in *The Thief Of Bagdad* of the same year. Nevertheless, the sequence was a substantial achievement for a tyro film director. Jean explained how it was done. 'On a large stage in the Gaumont studio at Buttes-Chaumont I had had a canvas cylinder some 20 metres in diameter constructed. The interior of the cylinder was painted jet black, as was the floor. Catherine was dressed in white and mounted on a white horse. She had to gallop against this black background, far enough away from it to avoid casting a shadow. The camera, installed in the centre of the cylinder on a rotating platform, followed the gallop in a perfect pan shot. The whole thing was done in two stages on the same film. First Catherine was photographed on her horse, and then, without the film having been developed, a background of clouds was photographed . . . '[7] Jean fails to mention that Dédée is on the horse ridden by the hero.

La Fille de l'eau, then, is an apprentice work, though one that revealed where Jean's vocation lay. Unfortunately, a distributor could not be found for the film, and Jean Renoir and Catherine Hessling remained completely unknown outside their circle.

On day Pierre Lestringuez invited Jean and Dédée to lunch with a friend of his, Pierre Braunberger, who had just come back from Hollywood where he had been an assistant to MGM boss Irving Thalberg, and had worked on *Monsieur Beaucaire*, starring Valentino. The Renoirs were spellbound by Braunberger's tales from, what they considered, the promised land. Braunberger liked *La Fille de l'eau* and was determined to release it. He managed to get a showing in April 1925 at the Ciné-Opera, but it failed to make any impression whatsoever.

It seemed as though Jean's dreams of making Dédée into a star had failed and his creative participation in the cinema had been a passing phase. There was only one thing to do – return to making and selling ceramics. To this end, he opened an art shop near the Madeleine, and he and Dédée rented an apartment at 30 rue de

Miromesnil, a building where the Cézannes and Pierre Renoir, now divorced from Véra, lived.

In the shop were displayed Jean's own ceramics and those of Maleck André. Luckily, Maleck's husband Albert was selling his paintings, and she had done the backdrops for shows at the Casino de Paris, because Jean's shop was not a going concern. He had the uncomfortable feeling that what works of his he sold were only because of the Renoir name and not because of any intrinsic value they might have. 'The sad but inescapable fact is that I was not born to be a shopkeeper . . . I could see only one way out of the situation and that was to become a layabout . . . '8

He pretended to have put a career in films out of his mind by repeating to himself every morning, 'There's no such thing as the cinema.'9 At the same time he wrote a number of synopses for screenplays, always with Dédée in mind. *Alice* was about another orphan girl who, after her father's funeral, finds he is financially ruined and has to deal alone with his creditors. *Don Juan* or *Don Juan s'appelle Des Essarts et Sganarelle Michelet*, was an updating of the legend, which replaced the stone guest with a figure in a painting, and ended with the libertine hero crashing through a window of a tall building to the street below. *La Rouquine* was about a prostitute who is helped to remake her life by another in the same profession. But all these stories lay gathering dust.

Wandering aimlessly along a Montmartre street on day, Jean ran into Jean Tedesco, a friend who had recently turned the famous Théâtre du Vieux Colombier in Saint-Germain-des-Prés into an *avant-garde* cinema, where he found it possible to show good films and make a little money. Until 1924, Jacques Copeau's famous theatre company had occupied the 'Vieux-Co', where Louis Jouvet and Valentine Tessier, future participants in Renoir films, had performed. Tedesco informed Jean that he had included the dream sequence from *La Fille de l'eau* in a programme of film excerpts, and invited him to come to the performance. At first, Jean was indignant, asking Tedesco what right he had to arbitrarily extract a part of a film from the whole without his consent. Tedesco insisted that Jean come along and make up his own mind. The same evening Jean and Dédée, despite their misgivings, went to the Vieux Colombier. Jean recalled: 'The programme started with a rather tedious documentary about a power station, and the lights went up again on a scene of general boredom. The audience seemed to us even hostile, and determined not to be interested in anything. We were dreadfully put

out by this. The dimming of the lights scarcely reduced the babble of conversation. The title "Extracts from *La Fille de l'eau*" appeared on the screen. The pianist played a few introductory chords and accompanied the opening scenes with very soft music, followed by an improvisation in the heroic style for the riding sequence . . . when the lights went up again and the screen was bare [there was] a continuous ovation, and for the first time in my life I knew the sweet smell of success. Jean Tedesco had placed us in the middle of the auditorium, in a position where the whole audience could see us. Catherine was recognised and the applause broke out again. The whole audience rose spontaneously to its feet. No, decidedly, we weren't going to give up film-making!'[10]

11

Femme Fatale

'From the commercial point of view Nana could hardly fail: with that title we were, we thought, bound to break through the barrier separating us from the commercial cinema.'

The applause that greeted Jean and Dédée at the showing of the extract from *La Fille de l'eau* at the Vieux-Colombier had a revitalising effect and prompted them to postulate a number of theories about the kind of cinema they would like to be involved with.

'For Catherine and me the cinema was a medium of expression that deserved a life of its own,' Jean recollected. 'We felt in those days that it was worthy of better than the business of reproducing literary and stage works, which was all that most audiences expected of it. Catherine and I dreamed of developing a French cinema free from all theatrical or literary encumbrances.'[1]

No sooner had Jean formulated this ideal than it crumbled to dust. He chose *Nana*, based on Emile Zola's 1880 novel, for 'my first film worth the trouble of discussing',[2] and was later to adapt, among others, Hans Christian Andersen, Georges Feydeau, Georges Simenon, Gustave Flaubert, Guy de Maupassant, Maxim Gorky, Octave Mirbeau, Prosper Mérimée, and Zola again.

There is a strong belief that the finest films derive from original screenplays – and it is noticeable that in most best-film lists made up by reputable critics playing the competition game over the years,

films not derived from another source tend to dominate. The survey which appears every ten years in the British film magazine *Sight and Sound* can be taken as some sort of barometer of taste. Only two films have appeared in every 'ten best' list in each decade since 1952 – Eisenstein's *Battleship Potemkin* (1925) and Renoir's *La Règle du jeu* (1939), both of which had original screenplays. Erich von Stroheim's *Greed* (1924), Orson Welles' *The Magnificent Ambersons* (1942) and Kenji Mizoguchi's *Ugetsu Monogatari* (1953) are among the few drawn from literature that appear with any consistency. At the Brussels World Fair of 1958, twelve films were screened that were reckoned to be the Best Films of All Time, selected by a jury of 117 film historians from 26 countries, and a mere two (*Greed* and Pudovkin's *Mother*, 1926) were taken from novels. The Jean Renoir film chosen (there is invariably one on these occasions) was *La Grande Illusion* (1937).

In so far as this relates to Renoir's oeuvre, the consensus is that *La Grande Illusion* and *La Règle du jeu* are his finest works, but among his films whose origins were plays or novels, *Boudu sauvé des eaux, Une Partie de campagne, La Bête humaine* and *Le Carrosse d'or*, also make substantial claims to greatness.

Auguste Renoir had known Zola personally and admired his works enormously, although he once commented, 'What a queer idea, to believe that working people are always saying "*merde*"!'.[3] Jean remembered Zola visiting his father. 'He was a very kindly man, there was a smell of grease and leather about him . . . he was really nice, and he brought me candy.'[4] Nevertheless, Auguste did not go along with Zola's powerful defence of Dreyfus during the celebrated Affair. There was a tendency in Auguste, as in his son, to take the easier 'curse on both your houses' line. 'People are either pro- or anti-Dreyfus. I would like to try to be simply a Frenchman,' Auguste claimed rather sententiously.[5] According to Jean, 'Renoir liked human beings too much not to approve of all parties whatever their colour. He liked the Commune because of Courbet's association with it; and the Catholic Church because of Pope Julius II and Raphael.'[6]

When Jean was making films for the French Communist Party – *La Vie est à nous* and *La Marseillaise* – he was still tempted to see all sides of a political question. In discussions throughout his life, he was able to express his views vigorously on any subject, while being able, on another or even the same occasion, to defend an antithetical

position equally powerfully. Thus enters the most quoted of all the lines in Renoir's films: 'The terrible thing about this world is that everybody has his reason' from La Règle du jeu, often used to explain Jean's balanced attitude to his characters and his apparent ability to sympathise with all of them. Yet the word 'terrible' takes away any complacency from his humanism.

Jean liked to illustrate his philosophy with the following anecdote. 'I have always hated the idea that on one side there are people who are completely black and, on the other, people who are completely white. There is no white. There is no black . . . When I entered the cavalry, the first time I said the words "white horse", I became an object of ridicule. It was then explained to me that there are no white horses, any more than there are black horses. There are dark grey horses, light grey horses, dark chestnut horses, and light bay horses; in short, there isn't a single horse that doesn't have a few hairs of another colour.'[7]

Nana, for which both Jean and Pierre Lestringuez had a profound admiration, was a naturalistic novel that exposed the evils of upper class society during the Second Empire. (There had been three earlier screen versions of the novel in 1912, 1913 and 1923.) However, Jean was not attracted to the work as a basis for his next film out of any desire to draw any social or political analogies between Zola's time and post-war France; his prime motivation yet again was the need to find a role that would satisfy his wife, because he was finding it more and more difficult to satisfy her in other ways.

One day at Marlotte, Dédée's mother asked her daughter, 'Why are you so unhappy Dédée? You have a charming husband, you have a magnificent child, why are you so unhappy?' 'Well, I like to sit next to him, but not to be in his bed,' Dédée replied. 'But when you get married you must share your husband's bed,' the mother replied.[8] According to her friend Alice Fighiera, Dédée was unable to find gratification from her husband in bed.

It seemed as though, for all her erotic exterior, Dédée found difficulty in being sexually aroused. Searching for some kind of revelation, she experimented with orientals and blacks, in the belief that white men might be lacking the spark that would ignite her.

Neither could Dédée bear being a mother. When she went out for a walk with Alain and the nanny pushing his pram, she would remain several paces in front or behind so that nobody would think she was the child's mother. Alain grew up without ever feeling his

mother's love. A photograph taken at Marlotte shows Dédée holding the four-month-old Alain on her lap, a distressed look on her face as if she were merely waiting for someone to take the brat out of her sight. How different from those paintings by Auguste of Aline and Gabrielle enveloping the children in loving arms. Only performing, on screen and off, brought Dédée any pleasure.

If Jean Renoir had modelled *Catherine* and *La Fille de l'eau* on the rustic melodramas of D. W. Griffith such as *Way Down East* (1920), a very different film by a very different director was to be the inspiration behind *Nana*. Jean maintained that he saw Erich von Stroheim's *Foolish Wives* (1922) over ten times. (He consciously pays tribute to the hunting scene in *Foolish Wives* with the rabbit-hunting episode in *La Règle du jeu*.)

Stroheim, who had been Griffith's assistant and had earned the title of 'the man you love to hate' by playing a succession of brutal Prussian officers, established his reputation as both a creative genius and a profligate with studio money with *Foolish Wives*. In it, Stroheim plays a cynically amoral count who attempts to seduce the wife of the American ambassador to Monaco while carrying on a long-term affair with his chambermaid and planning to rape a half-witted young girl.

Stroheim seldom moved the camera; a long shot generally dissolves into a medium shot and then a close-up of a character, while irises and fades are preferred to conventional editing. He was the master of *plan-séquence*, used to describe a protracted shot in which development takes place through movement within the frame rather than by cutting together different shots. The term would often be applied to the works of Renoir, and later to the films of such directors as Luchino Visconti and Michelangelo Antonioni.

During his multiple viewings of the film, Jean must have absorbed the technique by osmosis, but what he relished most in *Foolish Wives* was the wealth of social and psychological detail, and the theme in which love crosses class barriers and lust remains unsatisfied. Ironically, this witty, titillating Ruritanian melodrama, lavishly filmed in a multiple reconstruction of Monte Carlo on the Universal backlot, altered his perspective on the cinema and realism.

'Stroheim pointed out something to me that I hadn't known at all,' he wrote. 'Something simple I hadn't known, only that a Frenchman who drinks red wine, and eats Brie, with Paris roofs in front of him, can't do anything worthwhile unless he draws on the

tradition of people who have lived like him. After *Foolish Wives* I began to look. It astounded me. Burning with admiration, I understood how I had gone astray until then . . . I glimpsed the possibility of making contact with the public by the projection of authentic subjects in the tradition of French realism. I started to look around me and, amazed, I discovered many things purely French quite capable of transposition to the screen. I began to ascertain that the gesture of a laundress, of a woman combing her hair before a mirror, of a street-merchant in front of his cart, often had an incomparable plastic value. I made again a sort of study of French gesture across the paintings of my father and the artists of his generation.'[9] Armed with this new-found enlightenment, Jean felt ready to tackle a French literary classic of the naturalistic school. However, he failed to take into account his wife's acting, which was firmly rooted in the unnaturalistic school.

As Jean was about to embark on his second film as director in October 1925, the *New York Times* was judging the best American films of the year, among which were Chaplin's *The Gold Rush*, Stroheim's *The Merry Widow*, and King Vidor's *The Big Parade*, one of the first anti-romantic views of the Great War.

Owing to the cost of making *Nana*, Pierre Braunberger, who would release the film and had contacts in Germany, suggested the film ought to be a Franco-German co-production, shot both in Paris and Berlin. This would alleviate some of the financial burden, which was falling principally on Jean. It would also allow the additional casting of German performers, in the hope of appealing to a wider audience; in silent films there was never, of course, any problem of language or accents. In the event the German company bore only a fraction of the costs.

Jean, who spoke and read German, was attracted 'by the spirit of Germany.'[10] He first visited the country at the age of 16 with his parents who had rented a house on a lake in Bavaria. His great friends in Berlin were the philosopher and art-historian Karl (or Carl) Koch and his wife Lotte Reiniger, the creator of silhouette animation. In 1916, Koch was an artillery captain in the German army, and had commanded an anti-aircraft battery in the region of Reims. Jean, then a pilot in reconnaissance, remembered that his squadron 'was the target of a German battery that caused it much grief. Koch and I came to the conclusion that it was his battery and my squadron. So we had fought together.'[11]

For the role of Count Muffat, Jean chose Werner Krauss, whom he had admired in the title role of Robert Wiene's *The Cabinet Of Dr Caligari* (1919), considered to be the first true example of Expressionism in the cinema. The heady presence of this strange and imposing actor was to edge Jean's style towards German Expressionism. Krauss would become an Actor of the State in Nazi Germany, appearing in *Jew Süss* (1940), which turned Lion Feuchtwanger's pro-Jewish novel into one of the most notorious of anti-Semitic films. Valeska Gert, from the German theatre, played Zoé, Nana's chambermaid. Future film director Claude Autant-Lara, then a 23-year-old scene decorator, designed the backdrops which were built at the Grünewald Studios in Berlin. Many years later, an embittered old man and a member of the French National Front, he wrote scathingly about Renoir.

The screenplay of *Nana*, ably adapted by Renoir and Pierre Lestringuez, with captions written by Denise Leblond-Zola, the author's daughter, married to the writer Maurice Leblond, eliminates many of the characters and situations – much of the first half of the novel – and concentrates on Nana's affairs with three men. What was lacking (as in *La Bête humaine*, Jean's other Zola adaptation) was the novelist's view that heredity caused the protagonists' abnormal behaviour. In the wider context of Zola's Rougon-Macquart cycle, Nana, the daughter of Gervaise, the central character of *L'Assommoir* (1877), is morally brutalised by her childhood, an element of her later need to destroy men.

The film begins with Nana triumphant as Venus on the stage of Bordenave's theatre, in which she has displayed more sex appeal than talent. Count Muffat (Werner Krauss), chamberlain to the emperor, visits her dressing room. Nana, half-dressed, postures from behind a screen, while Muffat remains stiff and formal, 'embarrassed to be seen for the first time in his life in the dressing room of an actress.'

Nana persuades Muffat to buy her the leading role in Bordenave's new production, but the opening night is a flop. When Muffat brings Count Vandeuvres (Jean Angelo) and his young nephew Georges Hugon (Raymond Guérin) backstage, Georges immediately falls in love with her.

Having abandoned the stage, Nana is installed as Muffat's mistress in a luxurious townhouse. She ruins Vandeuvres, who has also become her lover, humiliates Muffat, and Georges, who has been refused by Nana, stabs himself with a pair of scissors. Finally, Nana

dies of smallpox in Muffat's arms, seeing visions of Georges and Vandeuvres.

Nana provides a hint of Renoir pleasures to come. It touches on the director's love of artifice and theatrical spectacle, seen from both backstage and the gods, and his fascination with class relations. The exploration of character within a wide social setting is there, as is the mixture of comedy with tragedy, both lyrical and grotesque, and the parallel world of servants and masters.

For the critic Noël Burch, *Nana* was important because it marked the first structural use of off-screen space. 'More than half the shots . . . begin with someone entering the frame or end with someone exiting from it, or both, leaving several empty frames before or after each shot.'[12] André Bazin, however, found the film unsatisfying because the shots succeeded each other with neither dramatic nor logical rigour. It is rather leisurely in pace and often stilted, almost as if Renoir was weighed down by the lavish sets, after his two previous al fresco films.

But all stylistic, structural and thematic analyses of the film cannot avoid being submerged by the performance of the leading lady. Dédée is both touching and abominable, her Nana a caricature femme fatale – white-faced, kohl-eyed, grotesquely grimacing, gesticulating and twisting her body in what are intended as erotic movements. Zola describes his character as a spider trapping its prey. 'She was not a woman at all but a marionette. The word, as I use it, is a compliment. But this was a transfiguration, which, alas for us, the public could not accept,'[13] admitted Jean. He had thought 'that since the moving picture depended on the jerks of a Maltese cross it must be played jerkily.'[14]

Yet Dédée's dancing is exciting, especially at the Bar Mabille, when she drunkenly joins the chorus girls in a frantic Cancan, high-kicking men's top hats out of their hands, a scene foreshadowing *French Cancan*, and there are affecting moments when her vulnerability is evident behind the brazen facade. Her stylised performance contrasts with those of Krauss and Jean Angelo, who both give soulful, noble performances. Krauss is particularly good in an episode which smacks of Stroheim perversity (and Emil Jannings' cock-crowing over Marlene Dietrich in *The Blue Angel*, 1930), when he is made by Nana to behave like a little dog, to bark, sit up and beg.

Many years later, Dédée claimed that Carl Dreyer asked her to take the title role in *The Passion Of Joan of Arc* (1928). But she refused

because Dreyer wanted to make Joan too sentimental. She said to him, 'Mr Dreyer do you see me, me, as Joan of Arc, a virgin, a saint.' He replied, 'But Nana was a saint, Madame!'[15]

In June 1926, *Nana* was previewed at the Moulin Rouge, with the orchestra accompanying the film with some airs by Offenbach. At the end of the screening Madame Perret, the wife of the director Léonce Perret, a man who had turned out a number of highly chauvinistic propaganda films, rose and said, 'This is a Kraut film.' When Pierre Braunberger protested, she laid into the little man with her umbrella, cutting him on the head. Some of the audience, presumably because of the names of Catherine Hessling, Werner Krauss and Braunberger (a French Jew) on the screen, also took up the chant. 'They're all Boches! It's a Boches film! Down with the Boches!'[16] Verdun lay only a decade ago.

'That first night was the epitome of my whole career,' recalled Jean. 'It has been my destiny always to be caught between the extremes of rebellion and orthodoxy, with never a safe middle way: but at least the audience of that kind have the merit that they are not indifferent.'[17] However, despite showing for several weeks at the Aubert Palace, and doing reasonable business in Germany, *Nana*, which cost over a million francs to make, put its director considerably in the red.

12

Black and White Follies

'Jazz was a religion which attracted devotees. I am happy to have lived through that period when the great exponents of hot jazz were discovering themselves.'

In order to pay the huge debts accrued by *Nana*, Jean was forced, not for the last time, to sell some of his father's paintings. Pierre Renoir, too, had put some of his inherited works of art on the market in order to help the distinguished Louis Jouvet's theatre company, of which he was then the lynchpin. His most fruitful period was with Jouvet during the time that Jean Giraudoux was writing his best plays for the company. Pierre played the title role in *Siegfried* (1928), and was Jupiter in *Amphitryon 38* (1929) with Jouvet as Mercury and Valentine Tessier (soon to be Jean's Emma Bovary) as Alcmena.

Selling the paintings was so painful a process that Jean and Dédée disguised their feelings by acting as frivolously as they could. The first time that potential buyers from Germany came to visit them at Marlotte, a picnic cloth covered with cheese, *saucisson*, bread and wine was spread out on the red carpet of the living room, and the foreign guests were invited to join Jean and Dédée cross-legged on the floor. The visitors were told that it was usual for French people in country houses to eat lunch in this fashion; a case of '*déjeuner sur le tapis*'. The Germans had to be polite because they wanted to buy

the paintings, and sat down without a murmur. On another occasion, Dédée, dressed in a pair of Jean's trousers, served jam on boiled potatoes as a '*spécialité de région*' to another group of Germans.

There was a rumour, put about by an acquaintance of Dédée, and completely refuted by her close friend Alice Fighiera, that Auguste had given *Les Grandes Baigneuses* to Dédée as a gift, and that Jean sold it against her wishes. In fact, the painting for which Dédée was supposed to have posed was among the works left to Jean in Auguste's will, and it was one for which Dédée had no special affection.

'Every sale seemed to me a betrayal,' Jean explained. 'At night I wandered about my house at Marlotte, of which the walls were being slowly but inexorably stripped bare. I had kept the frames. They were like gaping outlets to a hostile world. Never had I felt myself so closely linked to my father's memory. The time came when only a few pictures were left, and one night I asked Catherine to come and talk to me in the drawing room. I don't remember exactly what happened. All I can say is that, surrounded by those empty frames, we felt like homeless orphans. We resolved to give up the cinema and at all costs to hang on to a few of my father's pictures that still remained. But it was too late. I had to pay the last bills for *Nana*.'[1]

The situation, however, failed to have any sobering effect on Dédée, who continued to be seen in all the fashionable Parisian haunts spending money as she had in the first flush days of her marriage. Six-year-old Alain, meanwhile, saw more of his grandmother, Madame Heuschling, and his nanny, than he ever did of his mother. At least he had the benefit of having the Cézanne children, Aline and Jean-Pierre, who lived nearby at La Nicotière, to play with. Luckily, Alain would soon gain a loving surrogate mother.

For both Jean and Alain, Sundays at La Nicotière were among their happiest memories. Jean described how, after allowing enough time to digest the huge lunch, the guests would drink apéritifs under the chestnut tree, while others, sipping white wine, played *boules*. 'The keynote of a day spent with the Cézannes at Marlotte was absolute liberty, and to me, as I recall them, they represented the *fêtes galantes* of the cultivated middle-class.'[2] It was at the Cézannes' that Jean met Jacques Becker for the first time.

Becker was 20 years old at the time, and was trying to avoid

entering his father's business of manufacturing batteries. He was much more interested in sports cars, art, American movies and jazz. Two years previously he had worked as a porter on a trans-Atlantic liner and had visited New York where he listened to some of the best jazz musicians. Jean and Dédée, who was becoming a regular flapper, also succumbed to the jazz age. They went to hear Louis Armstrong on his first visit to Paris and visited *La Révue Nègre*, starring Josephine Baker, at the Théâtre des Champs-Elysées. It was at *La Révue Nègre* that Jean saw Johnny Huggins, a black dancer from New York.

He decided 'in a gesture of farewell to the cinema'[3] to borrow some money from Pierre Braunberger and others, use some of the film stock left over from *Nana*, and make a short avant-garde film utilising the dance talents of Huggins and Dédée. It was a natural progression for Dédée, whose performances hitherto had been conceived in a manner closer to dancing than acting. Jean, thinking of the Guignol shows of his childhood, and memories of *Petrouchka*, limited her make-up to a thick white base, with black eyes and mouth. 'Since the cinema is black and white,' he thought, 'why photograph other colours?'[4]

Charleston was shot in three days (Huggins was unable to spare more time) in the courtyard of the studios at Epinay-sur-Seine in October 1926. The futuristic tale was developed from an idea by André Cerf, who had appeared as Nana's stable boy. A black explorer (Johnny Huggins) from Africa, arrives in Terre Inconnue in a spherical flying machine which lands on top of a Morris column in a ruined city. Inside the column dwells the last surviving human being (Catherine Hessling) in Europe, whose only companion is a large monkey (André Cerf). When the explorer lowers a rope ladder and descends to the street, she peeks out from her column, emerges and attempts to make friends. Finding this alien rather wary, she tries to seduce him by performing the Charleston, 'the original dance of the white people', as he informs his people at home on a telephone which she draws on a wall. He watches, imitates her by taking a few tentative steps, but soon they both dance until exhausted. He then climbs back in his flying machine, and she follows him up the rope ladder, passing en route a tattered poster advertising the film *Nana*. Another in-joke is a chorus of six angels, represented by the heads of Renoir, Pierre Braunberger, Pierre Lestringuez, André Cerf and a couple of other friends, attached to tiny beating wings.

Dressed in a skimpy costume and long black kid gloves Dédée dances in a very athletic and sinuous manner. Huggins, clad in a formal suit, white gloves, battered hat and shoes, performs an eccentric soft-shoe and tap rather in the style of Bill 'Bojangles' Robinson. They are both funny and charming and the dancing, seen from a variety of views and angles, using both slow and accelerated motion, even when watched without a musical soundtrack, is exhilaratingly rhythmic.

Charleston was seen only by a select group of people and was lost sight of for many years. Jean had now been involved as producer, director and bit-part player in four films, none of which made any money, nor did they make his name. His next offer to direct a film came from an unexpected source.

Madame Regina, the owner of a number of brothels on the *Côte d'Azur*, had been shown, by her friend Pierre Lestringuez, the dream sequence from *La Fille de l'eau* and was impressed by its eroticism. She thought that Jean, at present unemployed, might be persuaded to direct a number of pornographic films to be projected in her 'houses'. Jean was not uninterested in the proposition, especially after visiting the Madame, with Lestringuez, in her most lavish establishment in Nice, where he was shown a couple of blue movies she had had shot by a local amateur film-maker. One of them was entitled *The Baron*, in which the hero, without ever removing his tail-coat, bow-tie or top hat, managed to satisfy two ladies at the same time. Jean felt he could make much sexier and better films, and was tempted by the challenge. He and Lestringuez discussed certain possible scenarios, including adaptations from the Marquis de Sade. However, just as he was about to commit himself to Madame Regina, an offer came to shoot a mainstream film that would earn him more money.

The offer to make *Marquitta* came from Pierre Renoir's second wife, Marie-Louise Iribe, the niece of the set designer Paul Iribe who was a friend of Coco Chanel. She had started a production company called Artistes Réunis with her new husband, and to keep it in the family, Marie-Louise asked Jean to direct a screenplay by Pierre Lestringuez, who also happened to be her brother-in-law. *Marquitta* was to be a vehicle for her, so there was no place for Dédée in the scheme. Although she initially objected to Jean taking on the task, Dédée realised that he would at least be earning some money, for once without bearing the onus of producer; money that could be

used for pleasure and to finance another film with her in the lead. *Marquitta* was Jean's first taste of being a jobbing director, something he was able to avoid with most of his European films.

'To direct *Marquitta* would be to cross the frontier into the world of the commercial cinema, that is to say, the world in which producers and distributors tinkered with scripts, chose the cast and generally took it upon themselves to represent the so-called "public taste", which in fact is simply their own taste,' Jean explained. 'To direct *Marquitta* would be to give up all idea of "making" a film in the way that one writes a poem or composes a sonata. True; but on the other hand one had to go on living and the fee would help me out of a difficult situation. So I accepted, and deserted the ranks of the avant-garde cinema for those of the industry.'[5]

Marquitta, named after a popular song of the day, was shot at the Gaumont Studios and on location in Nice. Opposite Marie-Louise Iribe was Jean Angelo, who had acted with her in Jacques Feyder's *L'Atlantide* in 1921, and had played Count de Vandeuvres in *Nana*. Born Jean Barthélémy, Angelo had been an actor in Sarah Bernhardt's stage company at the age of 15 and, like Jean, was wounded in the war. Here, he portrayed a Slavic prince who discards his mistress and picks up a street singer, Marquitta (Iribe), only to discard her, too, when he grows to dislike her manners and suspects her of stealing the crown jewels. But a revolution dethrones him and, starving, he in turn is picked up in the street by Marquitta, now a star. The film ends with an automobile chase along *la moyenne Corniche*, the high coastal road from Nice to Monte Carlo, Marquitta pursuing the prince to keep him from suicide. She succeeds in time for the happy ending.

Despite the banality of the plot and the commercialism of the venture, Jean claimed that 'with *Marquitta* I reached the climax of my passion for technical innovation',[6] forgetting the work he was to do in his next film, *La Petite Marchande d'allumettes (The Little Match Girl)*, and later innovations, though achieved with simpler means. He had devised a wooden laminated track for a moving camera which reduced the jolting so prevalent on a system of rails before zooming was used. The gaps between the sections were carefully smoothed with sandpaper, and the camera was then mounted on a chassis of which the wheels had been replaced by cushions. 'This contrivance which delighted Jean Bachelet, was despised by most film technicians, perhaps because it was so out of keeping with the aesthetics of film apparatus. There was also the fact that the studios

insisted on using their own equipment. Moreover, the machinists were accustomed to the railway system, and this kind of cushioned carpentry seemed to them ridiculous.'[7]

A short time after the filming, Pierre Champagne, who had played a cab driver in the film, took Jean for a ride in his new Bugatti Brescia, a car he had dreamed of owning for some time. Travelling at great speed, the car skidded on an oil slick on a hillside in the forest of Fontainebleau. Champagne was killed instantly when he fell heavily on a heap of stones, while Jean, miraculously, had landed on a grassy bank. There he was found unconscious by poachers who were en route to sell their game at Les Halles. They went out of their way to take him to hospital, though they could have been arrested. He never forgot the incident, and it formed the basis for *Orvet*.

Champagne had been a good friend of Jean's since the days at Les Collettes, and his acting had been confined to Renoir films – he had been a young hero in *Catherine*, the rough peasant, Crepoix, in *La Fille de l'eau*, and La Faloise, the snobbish dandy in *Nana*.

Marquitta was the first of Jean's films to make money at the box office, though he himself received little benefit from it, either in profits or prestige. No copy of *Marquitta* seemed to remain extant, which according to Jean was 'no great loss.'[8]

Not long after *Marquitta*, Marie-Louise Iribe divorced Pierre, taking with her most of his father's paintings which she threw into a truck before driving off with them. He never saw them again. Previously, Pierre had taken back a fur coat he had given her, 'a mean act Jean would not have been capable of,' according to Alice Fighiera.[9]

13

Dédée In Toyland

'Oh, it was marvellous, it was exciting, and it was all the more exciting because the results were beautiful! The photography was new; we had grey tones that didn't exist in orthochromatic film, and we were very happy with it.'

In 1927 the Brazilian-born director Alberto Cavalcanti made three films, produced by Pierre Braunberger and starring Catherine Hessling. Cavalcanti had studied law and architecture in Geneva, and had entered films in Paris as an *avant-garde* set designer on such films as Marcel L'Herbier's *L'Inhumaine* (1923). His own first films as director dealt more with everyday life, suggesting the 'poetic realism' of the French cinema of the 1930s. The films with Dédée were *En Rade (Sea Fever)*, a feature, and two short films, *Yvette*, based on Guy de Maupassant, and *La P'tite Lili*, a ten-minute film based on a popular song. The latter was set during *La Belle Époque*, and was the story of a poor girl of the streets, exploited by men. Jean played a sarcastic pimp and six-year-old Alain appeared, too, as a boy fisherman. What a strange conjunction it was in Jean's life that at that moment his son and the three women who came to mean most to him in his life, were in the same spot at the same instant.

At the time of these three films, Cavalcanti had an 18-year-old Brazilian girl called Dido Freire in his charge. Her father had been a consul in various places around the world before taking an important

post in Liverpool, then one of the principal European ports for the Latin American trade. He insisted that the family spoke Portuguese during meals, French in the afternoons and English at all other times. He also sent his three daughters, Dirce, Dulce and Dido, to the local schools rather than those reserved for the diplomatic corps. As a result, Dido was fluent in English, French and Portuguese, as well as Spanish and Italian. After she had finished her schooling, she decided she wanted to go to Paris and work for Cavalcanti, a close friend of the family.

La P'tite Lili offered a brief glimpse of Dido, who would become Madame Jean Renoir 14 years later. Working on the same film, as the editor, was 20-year-old Marguerite Houllé, who would soon share Jean's life. Ironically, given the fact that Jean met both Dido and Marguerite for the first time on the film, Dédée later claimed that *La P'tite Lili* was the only picture she made that she really liked, commenting that she thought those she made with her husband had been too romantic.

The fiasco of *Nana* and the crippling debts that followed had cured Jean of putting his own money into films. But his desire to direct another picture was unassuaged and, urged on by Dédée, he approached his friend Jean Tedesco, the director of the Vieux Colombier theatre, to discuss possible subjects and how a film could be made without too much financial risk.

Tedesco, a passionate supporter of the *avant-garde* cinema, thought that perhaps a film could be shot in a little studio atop the theatre. They were to be assisted by film technician and cameraman Charles Raleigh, an Englishman who had worked in Hollywood on Mary Pickford and Douglas Fairbanks movies, but preferred to live in France where 'the point of view on the questions of women was better, more logical.'[1] Raleigh had already worked for Jean as one of the cameramen on *Nana*. All they had to do was find a subject, dictated, as always, by its suitability as a vehicle for Dédée. At that stage of his career, Jean would not have dared consider any screen-play that did not have her in mind. As far as he was concerned, he was a film director merely at the service of her talent.

Jean recalled that, while posing for his father, Gabrielle would read to him from Hans Christian Andersen's *Fairy Tales*, which she and Auguste enjoyed as much as the child did. One evening a friend of Auguste's arrived during a sitting and heard Gabrielle reading *The Ugly Duckling*. 'What!' he said to Auguste. 'You allow your son

to listen to fairy tales, to downright lies? First thing you know he'll be getting the idea that animals talk!' 'But they do!' replied the artist.[2]

Thus Jean thought that one of Andersen's tales might be an appropriate basis for a film. He finally alighted on *The Little Match Girl*, of which both he and Dédée were extremely fond, and elements from two other Andersen stories, *The Tinder Box* and *The Steadfast Tin Soldier* in which toys come to life.

Jean Tedesco described Jean the businessman thus: 'Chewing a toothpick with a dreamy air, Renoir in conversation with some possible buyers or exhibitors would let his gaze wander like a tyro and his imagination run on about the film that would follow. In venturing into this dangerous underbrush that Louis Delluc called the "jungle of the cinema" he quickly encountered the sharks and scavengers that flourished then as well as now. He soon understood that there was only one reasonable solution for an artist, that of joyously taking the risks of an independent film-maker. It was then that our friendship became the basis for our collaboration as craftsmen within the frame of the Vieux Colombier.'[3]

The 'smallest studio in the world' above the Vieux Colombier theatre-turned-cinema, where a motor and generator from a wrecked car provided the electricity, was a place where Jean could work with complete freedom on *La Petite Marchande d'allumettes*. (It was the only film to be made there.) Renoir, Tedesco, Raleigh, Jean Bachelet, the cinematographer, and Danish designer Erik Aaes invented reflectors, painted the sets themselves, and even devised lights with a colour temperature suitable to the new panchromatic film, a black and white film sensitive to all colours in the visible spectrum. Early silent films were shot on orthochromatic stock which was totally insensitive to red. But in 1926, Robert Flaherty's *Moana*, the first feature on panchromatic stock, revolutionised cinematography with its soft gradations and realistic flesh tones. However, panchromatic film was slower – less sensitive to light. So Jean used it only for exterior shots, keeping orthochromatic for the studio to provide stark blacks and whites. The film was developed in a tiny laboratory built in the kitchen at Raleigh's house at Neuilly.

Paris stage matinée idol Charles Boyer agreed to play the young man whom the match girl dreams of seeing as a toy soldier. He had made only a few films, his last being *Capitaine Fracasse* directed by Cavalcanti. But the 30-year-old Boyer had to excuse himself when

he was offered the opportunity to make an extended international tour in several of Henry Bernstein's plays. He said he regretted it because he thought Catherine Hessling was the most beautiful woman he had ever seen.

La Petite Marchande d'allumettes takes place on a snowy New Year's night when Karen (Catherine Hessling) wanders the streets of the town trying to sell her matches. (Dédée's mother, Madame Heuschling, appears as a passer-by.) Nobody takes any notice of her except one young man (Jean Storm), before he is distracted by his friends who lead him into a restaurant. She rubs the icy window of the restaurant and stares at the revellers inside. After being pelted with snowballs by some schoolboys, she is rescued by a policeman (Manuel Raaby, dressed like an English bobby) with whom she gazes at the dolls, soldiers and animals in a toy shop. Seeking shelter and warmth under a broken fence, and lighting her matches for warmth, she falls asleep and dreams of the toys in the window becoming life-sized and animate. When Death (Raaby) pops out of a jack-in-the-box, she is protected by an officer (Storm) in charge of wooden soldiers. They ride through the clouds on a horse, pursued by Death. But Death catches her, placing her body under a cross which changes into a rose tree whose petals turn into snowflakes. Karen is found dead in the snow.

The short film (29 minutes) is enchanting. The models, stylised sets, double exposure and other cinematic tricks provide appropriate visual means by which to transfer Andersen's prose to the screen. The horse-ride across the sky in the dream sequence, far more assured than the one in *La Fille de l'eau* was filmed on a sandy plain at Marly. First Renoir tried to photograph the ride from a motor car, but it got stuck in the sand. He then mounted a horse himself, carrying a camera, and riding alongside the horses during the chase.

But whatever the success of the style and structure of the film, which Jean later called 'a purely technical experiment'[5], it still depends very much on the actress at its centre. In relaxed contrast to *Nana*, Dédée seemed far more in her element in *La Petite Marchande d'allumettes*, and is noticeably more moving and attractive, her long blonde hair let loose in the dream sequence, than in any of her other films. The role also enabled her to get closest to her beloved Chaplin. There is a moment when she shakes herself in the cold in the exact manner of Charlot in *The Gold Rush*. In a sense, the film is her apotheosis.

It was the last picture Jean directed that starred Catherine Hessling, although she made a brief appearance in *Tire au flanc*, a short while after. The film, therefore, effectively marked the end of a five-film partnership, a creative rupture that was soon to lead to an emotional one.

14

Slapstick, Swords and Sand

'Although I had chosen none of the stories, I can claim that after a few weeks' work on the scripts I made them my own and came to take pleasure in them. Once again I was made to realise that in art the subject is less important than the execution.'

La Petite Marchande d'allumettes was first shown in Geneva in June 1928, its Paris première delayed by an unfounded charge of plagiarism. Once again bad luck dogged a Renoir film, eliminating any possibility of success. Maurice Rostand, Edmond Rostand's son, had written a comic opera based on the Andersen tale which included a barrel organ, as did the film. What seems a most trivial case, brought by Edmond Rostand's widow and son, lasted two years, until it was thrown out of court. By then, talking pictures had come in, and the film was finally released with a musical soundtrack (a rehash of themes from Schubert) and intertitles, neither of which pleased Jean. An original music score was to have been played with a small orchestra at the Vieux Colombier, and the film was intended to be projected without titles.

Immediately after shooting *La Petite Marchande d'allumettes*, Pierre Braunberger gave Jean the chance to direct a film that had the makings of a sure-fire hit. It was to be *Tire au flanc* (army slang for a shirker), based on the military comedy by André Mouezy-Eon and A. Sylvane, which had played at the same theatre for 20 years, and

had already been filmed twice before. (François Truffaut produced another version of it in 1961.)

'It gave us the possibility of doing something amusing and besides, since the title was very well known, it would be easy to sell,' Jean commented.[1] It would also be the first of four collaborations with the extraordinary simian-faced actor Michel Simon. He was to become Jean's surrogate figure in a battle against traditional values.

The Swiss-born Simon, six months Jean's junior, seemed to embody the proletarian earthiness so much admired by Renoir *père* and *fils*. As a 16-year-old, this son of a sausage maker left Geneva for Paris, where he worked as a boxer (thus the flattened nose), and as an acrobatic clown in the music halls, before performing in the theatre from 1918.

Jean first met the actor through Alberto Cavalcanti, who had been the set designer on Marcel L'Herbier's *Feu Mathias Pascal* (1925), Simon's first film. His second was Carl Dreyer's *The Passion Of Joan of Arc* (1927), but neither picture allowed him much scope for his archaic humour. The part of Joseph (not in the original play), the faithful valet of the reluctant soldier in *Tire au flanc*, gave him that chance. The sexual candour of Simon, who happily admitted to frequenting brothels to satisfy his unorthodox tastes, fascinated Jean. 'There's only one thing on earth that has a little life in it, and that's a woman's clitoris,' he once said.[2]

Tire au flanc was the first Renoir film where the central character was not a woman, and there was no suitable part for Dédée. However, she makes a brief appearance as a teacher, playing in the woods with a group of children who are surprised by soldiers in gas masks, leading into a Mack Sennett-like chase. For the title role, Jean chose Georges Pomiès, a dancer and mime with no previous acting experience.

Departing a fair distance from the play, the scenario by Renoir, Cavalcanti and Claude Heymann drew on a number of humorous anecdotes that Heymann had related to Jean about his experiences of basic training during World War I. Jean also added a few of his own memories of army life, a theme that he would elaborate on in *La Grande Illusion* and *Le Caporal épinglé*. The film was shot on location at the 'Cent Gardes' barracks in Saint-Cloud, and in the surrounding *bois*.

It tells of Jean Dubois d'Ombelles (Pomiès), an aristocratic, absent-minded and bungling poet, who lives a sheltered life with his

wealthy aunt and her nieces, Solange (Jeanne Helbling) and Lily (Kinny Dorlay). When he and his valet Joseph (Simon) are called up for military service, Jean, ill-prepared for life in the barracks, constantly finds himself in trouble and finally lands in an army prison. ('A complete idiot, that boy.' 'He has an excuse, he is a poet.') When he is freed, he and Joseph entertain the troops, and Jean becomes a hero by putting out a fire and overcoming Muflot (Zellas), the barracks bully. The film ends with a triple wedding – Jean to Lily, Solange to Lieutenant Daumel (Jean Storm), and Joseph to Georgette (Fridette Faton), the maid – and the message: 'Fundamentally, all army comrades are good chaps, even Muflot.'

Filmed with refreshing spontaneity and fluency, *Tire au flanc* avoids any suggestion of theatricality and is packed with well-executed gags, some original and some not. Clever use is made of 'silent sound' such as different reactions people have to a military march-past, and tracking shots are timed for comic effect, as is an overhead shot of the hero chasing a mouse around his mattress in prison.

Michel Simon has some splendid slapstick moments including spilling sauce on the General, accidentally taking a sip of benzine then throwing it on the fire, and appearing in drag as an angel at the concert, which prefigures the troop show in *La Grande Illusion*; and his little dance outside the cell is very like those memorable few joyful steps that Jean Gabin attempts in *French Cancan*. There is also a stout soprano boring the audience, similar to the one in *Eléna et les hommes*, who empties a drawing room almost before she opens her mouth. The burlesque is a trifle protracted, ending with a pure Keystone Kops routine in which a hose is turned upon the theatre audience, the fat soprano also receiving the full force of it.

But *Tire au flanc* also contains elements of Jean's growing familiarity with, and love of, the more classical eighteenth-century French comedy, something which would find full expression in *La Règle du jeu*. The film opens with an eighteenth-century tapestry, in front of which are flirting servants. Following a fade, the camera returns to the tapestry, with the servants replaced by their masters and mistresses. Towards the end, there is a mistaken identity rendezvous in a park that suggests the last act of *Le Mariage de Figaro*. In the concert scenes, Pomiès plays Pan, the first of many appearances in a Renoir film of the director's favourite Greek deity.

The film forms a link between the silent comedy of Chaplin (*Shoulder Arms*) and Keaton (*Battling Butler*) and his own early sound

film, *Boudu sauvé des eaux*, satirising bourgeois life and institutions. It is difficult to disagree with Jean's statement that, 'When I made *Tire au flanc*, I was a bit more in control of my medium. I was beginning to know where I was going. I was beginning to see that I could indulge certain aspects of my character without shocking the public too much.'[3] The greater freedom seems to have come from not having to build a film around Dédée, although it did not stop him continuing to search for vehicles for her.

'I cannot refrain from dividing my career into two purely material halves, during the first of which I paid to make films, whereas in the second I was paid to do so,' wrote Jean.[4] His next two films were plainly in the second, less rewarding, category. Before taking on *Tire au flanc*, he had agreed to direct *Le Tournoi*, an historical film commemorating the two thousandth anniversary of Carcassonne in South West France. The shooting was delayed in order to coincide with the city's *Fête du Bimillénaire*, a revival of a fifteenth-century pageant to take place among the finest remains of medieval fortifications in Europe.

It was Henry Dupuy-Mazuel, the historical novelist, screenwriter, film producer and head of the *Société des Romans Historique Filmés*, who commissioned two commercial films from Renoir. Most notably, Dupuy-Mazuel had produced and adapted (from his own novels) *The Miracle Of The Wolves* (1924) and *The Chess Player* (1927), both of them lavishly and superbly directed by Raymond Bernard, who was hailed 'The French D. W. Griffith', a title Jean would have dearly loved to earn for himself when he started in films. Now he felt he was finding himself as an original artist and would not have wanted any such label pinned on him. But in 1928, Jean was still the third Renoir, after Auguste and Pierre.

Le Tournoi is set in 1562, when Catherine de Medici (Blanche Bernis) ruled in the name of her 12-year-old son Charles IX (Gérald Mock), and tried to maintain power in an uneasy peace between Catholic and Protestant factions. A cruel and decadent Protestant nobleman (Aldo Nadi) falls in love with an innocent young woman (Jackie Monnier) at the court, who has been secretly promised to a virtuous Catholic (Enrique Rivero). A jousting match decides their fates during a tournament of knights.

During shooting, Jean controlled the largest forces he had ever had at his disposal, including hundreds of mounted cadets from the Cavalry School at Saumûr which he had attended in 1914. Despite

the fact that *Le Tournoi* turned out to be one of Jean's most impersonal films, and that he could not really get involved in the pompous pageantry, fustian court intrigues and conventional amours, he gained experience by having to face certain cinematic challenges and enjoyed surmounting them.

One challenge that especially appealed to him was getting a shot of guests at a large banquet without using a series of close-ups, or a camera travelling along one side, which would have displayed a row of backs. 'I had a narrow banqueting table made, about 20 metres long and one metre wide. I then had a kind of bridge constructed, mounted on four bicycle wheels. The camera was suspended from the middle of this bridge and was pushed to the centre of the table. The lens was just above the heads of the actors, and while shooting was in progress the technicians removed any props which would have got in the way of this gantry. The device was successful.'[3]

In 1959, a fire at the Paris Cinémathèque destroyed the last print of *Le Tournoi*, but a much shortened version was later reconstructed from surviving film, not the best way to judge its quality. However, few people would have blamed Jean if he himself had been the arsonist.

The second occasional film Renoir made for Dupuy-Mazuel's *Société des Films Historique* was *Le Bled* (an expression meaning the interior of a North African country), made to celebrate the centenary of the first French colonists who settled in Algeria in 1830. At the time of Jean's visit, the national movement was rather moderate and collaborationist, although there were elements agitating for representation in the French parliament. But until the 1954 insurrection, the *colons* thought themselves able to govern Algeria as they wished. Anti-colonialist sentiments were rarely expressed among the French in the late 1920s, and such views never crossed Jean's mind when he was making what amounted to a propaganda film.

Unlike many exotic melodramas shot on studio sets, *Le Bled* was filmed on location in Algeria, at Biskra, Boufarik and Staouéli. It was Jean's first visit to the colony, although his father had toured Algeria in search of light and warmth in February 1881, and then in the following year when he stayed about six weeks. Jean remembered how Auguste told him how he had discovered the value of white in Algeria. 'Everything is white: the burnous they wear, the walls, the minarets, the road . . . And against it, the green of the orange trees and the grey of the fig trees.'[6] This was something that Jean was to appreciate for himself as soon as he arrived.

The location photography of *Le Bled* manages to capture most of the exciting whiteness of the country, and takes in different picturesque aspects of Algeria, from town to country, from North to South (special train tracks were laid in order to shoot in the desert). But the screenplay, the first with which Jean had little involvement, was a run-of-the-mill romantic adventure. It tells of how Pierre (Enrique Rivero), a young Frenchman sailing to Algeria to join his prosperous farmer uncle (Alexandre Arquilliére) and cousin (Diana Hart), meets a young woman (Jackie Monnier) on the boat. Once in his new country, he becomes romantically involved with her and, when she is abducted, he manages to rescue her, paving the way for 'happily-ever-after'. Highlights include a gazelle hunt and the use of a trained falcon to catch the villain (Manuel Raaby) during the dramatically staged climactic chase. This blatantly commercial film marked the end of Renoir's silent output.

Dédée did not accompany Jean to Algeria, where he worked closely with his editor Marguerite Houllé, with whom he was developing an intimate relationship. Jacques Becker had also come along for the trip, and played a farm worker in the film. On his return, Jean and Pierre Braunberger paid a visit to Berlin, a city Jean had been very fond of since filming *Nana* there in 1926.

In April 1929, the liberal newspaper *Die Weltbühne*, exposed the secret rearmament of Germany, which had been proceeding illegally since 1921. In the same year, a few months before Jean's arrival, the Socialist government had prohibited May Day demonstrations, Berlin workers were 'ordered to disperse', and the police opened fire, killing 25 people and severely injuring 36 more, an event witnessed from a window by Bertolt Brecht.

In the theatre, Brecht and Kurt Weill's *The Threepenny Opera* – 'a chorale of the poorest of the poor' – which had opened in August 1928, was still packing in audiences, and people in the streets were repeating Mack the Knife's phrase, '*Erst kommt das Fressen, dann kommt die Moral*' (First comes the belly, then morality). G. W. Pabst's *Pandora's Box* had appeared at the same time. Adapted from two of Franz Wedekind's plays about Lulu, the woman who destroys men and meets her death at the hands of Jack the Ripper (a character very much in the tradition of Nana), it starred Louise Brooks, whose black bobbed hair framing a pale kittenish face, and intense eroticism of each expression and gesture, was to make her one of the icons of the cinema and inspire Pabst to his greatest film. Both Brecht's

singspiel and Pabst's film came out of a Germany suffering rapid inflation and the rise of Nazism.

Jean was introduced to Pabst while the German director was filming *Diary Of A Lost Girl*, with Louise Brooks in the title role. Both Jean and Braunberger spent a day on the set as extras in a nightclub scene. On the same visit, confused by Jean in his memoirs with a later one in 1933, he met the Swiss-born painter, Paul Klee, while visiting Alfred Flechtheim the art dealer, artist and satiric writer. With Flechtheim and Klee, Jean toured the fleshpots of Berlin in the last throes of the Weimar Republic. Through Karl Koch, he also made the acquaintance of Brecht, whom he would later see in France and in Hollywood.

Dédée joined Jean for a short while in Berlin to appear in *Die Jagd Nach Dem Gluck/La Chasse à la fortune*, co-directed by Rochus Gliese and Karl Koch, who wrote the screenplay with his wife Lotte Reiniger. Three years previously, Reiniger had made *The Adventures Of Prince Achmed*, the world's first feature-length animation film, using silhouette cartoons adapted from Chinese shadow theatre. Jean Tedesco and Aimée, his dancer wife, also had parts in the Gliese-Koch film, while Dédée again played a seductress, and Jean appeared as a seducer. Only Reiniger's shadow theatre scenes survive from it.

During this interim period in both Jean and Dédée's lives and careers, they co-starred in *Little Red Riding Hood*, a short film directed by Alberto Cavalcanti, only fragments of which are extant. Dédée played the title role for laughs, and Jean portrayed the wolf as a variation on his shady pimp in *La P'tite Lili*. The film ended with Little Red Riding Hood being carried off in a balloon by the seat of her pantaloons.

Most of it was filmed among friends at Marlotte; Marguerite was the editor, 24-year-old Pierre Prévert was one of the assistant directors and also played a little girl, while André Cerf was a notary. The same team also made a parody of a trailer *Vous verrez la semaine prochaine* (Next Week's Coming Attraction) in which Jean, Dédée and 10-year-old Alain appeared.

Jean, in contrast to Dédée who exhibited no maternal feelings, adored his son, spoiled him and refused to send him to school. He had hated his chic schools, had often run away from them, and did not want Alain to suffer the same fate. Consequently, Alain was given two tutors, one the *curé* at Marlotte, and the other a member of the Communist Party; neither seemed conscious of the other's existence. It was certainly a method of getting a balanced education.

The exciting visit to Berlin, the days of shooting films in a spirit of gaiety and friendship at Marlotte, hid a certain malaise. Jean had not directed a film for two years, far more money was being spent than earned, the French cinema (and, by extension, Jean) was attempting to come to terms with the arrival of sound and the death of the silent film, and Jean's marriage to Dédée was disintegrating.

PART III

SOUND BEGINNINGS
(1930–1933)

15

The Bitch

'More and more, I believe that films are talking. I think that we have lived through the silent-film period – luckily it gave us some beautiful films – but we're leaving that stage, we've just got out of it.'

Dédée, who was more often at the apartment in the rue de Miromesnil, just off the rue du Faubourg Saint-Honoré, than at Marlotte, was still enjoying the high life in Paris, mainly in the company of Madame Anspac, a woman of scandalous reputation. Alain was largely at Marlotte with his nurse and grandmother, Madame Heuschling. His one adult friend was young Dido Freire, still working for Cavalcanti, who took him to the zoo, to fairs and to the cinema. One summer, Dido got written permission from Jean to take Alain to England, to her mother's house on Merseyside for a visit. On another occasion, Mrs Freire invited Dédée and 12-year-old Alain to stay. Dido's younger sister, Dirce, remembers Dédée as amusing and very decorative. 'I was 16 or 17. She was an actress in Paris, married to Jean Renoir, and the daughter-in-law of Auguste Renoir. She seemed so glamorous. She wasn't at all maternal. Dido was the one to take Alain out, not his mother. She stayed at home.'[1]

On one occasion in Paris, Alain came across his mother walking in the street accompanied by a man. When Alain greeted her, he was ignored. Dédée's companion asked, 'Who is that boy?'. 'I've no idea,' Dédée replied.[2] When the occasion arose, Dédée would often

introduce Alain to her male friends as her young nephew. Rather like the woman in Pinero's *The Magistrate*, who keeps her grown-up son in short trousers, Dédée seemed desperately afraid to reveal her age, even while still in her twenties.

There was no doubt that Dédée made Jean suffer, and rows between them became more frequent. She once threw a bottle of cognac at him, she threatened him with a revolver, and would theatrically threaten to fling herself out of the window of their apartment. Eventually, an exasperated Jean said, 'After you, madame,' an offer she refused.[3]

Despite the tensions between them, Jean wrote another screenplay for Dédée. Entitled *Madame Bovary à rebours* (Madame Bovary In Reverse), it was a tale, set on the Riviera, about a cabaret singer surrounded by rich men who ultimately bring about her downfall. Jean called it an 'adventure story without any psychological pretension . . . expressed more in gestures than words.'[4] It was clear that Jean had not yet adjusted his ideas to the talkies, nor had he broken free from the feminine image of Dédée he wished to portray on screen. He was also still under the influence of Stroheim and the German cinema.

'Every technical and photographic means will be used to create a *louche* ambience surrounding the characters.' He described Gaby, the heroine, thus: 'She has reached a stage of elegance whereby one attains perfection by simple means. She wears tailored suits, which in the eye of philistines seem to cost 200 francs, but for the connoisseur represent the height of refinement. She is neurasthenic and deeply disillusioned. She is a Madame Bovary in reverse. Her aspirations for a simple life are in no way phony. She often frowns and frequently gives the impression of being on the defensive. Her conversation is studded with slang but that doesn't prevent her from being distinguished. She knew suffering, and in another sphere she had experienced hard times.'[5] There were more than enough clues pointing to aspects of Dédée in this portrait.

However, Jean had just read a book that he passionately wanted to adapt to the screen, and in which he visualised Dédée and Michel Simon. It was *La Chienne*, a novel written by Georges de la Fouchardière, published in 1930.

On taking up the co-directorship of the Billancourt studios in Paris in 1931, Pierre Braunberger fought to get his partner Roger Richebé to allow Jean to make *La Chienne* and brought in a wealthy shoe manufacturer, Marcel Monteux, to put up the money. As it

was to be a talkie, a technique with which Jean was as yet unfamiliar, Richebé suggested that Jean make a film on a small budget and a short shooting schedule as a sort of test before being allowed to make *La Chienne*. The film, based on the 1910 one-act farce by Georges Feydeau, *On purge bébé*, took Jean only three weeks in March 1931 to complete; one week to write the script (with the help of Pierre Prévert and Claude Heymann), one to shoot, and a third to edit.

The 62-minute film is extremely faithful to its source, more so than any other Renoir screen adaptation, and departs only briefly from the single artificial-looking set. Most of the action is captured in long takes in front of a stationary camera, and is composed almost entirely of full and medium shots – there are barely half-a-dozen close-ups – adding to the impression of filmed theatre. 'Where I would have used the camera with a little more abundance, I was obliged to limit myself in order to complete my 30 to 40 shots a day,' Jean explained.[6]

For those who think that toilet humour is the preserve of the British, it comes as a surprise to find that *On purge bébé* is toilet humour taken to the nth degree. The plot involves the attempts of Monsieur Follavoine (Jacques Louvigny), a porcelain manufacturer, to clinch a deal with Monsieur Chouilloux (Michel Simon) to supply the French army with 300,000 unbreakable chamber pots. Meanwhile, Follavoine's wife (Marguerite Pierry), obsessed with their child Toto's constipation, is trying to get him to drink a laxative. Toto (Sacha Taride) refuses to take it unless Chouilloux swallows some first. Chouilloux refuses, but when accused of being cuckolded by his wife's cousin, he drinks the laxative down thinking it is water. When the hapless man's wife (Olga Valéry) and cousin (Fernandel) arrive, an argument ensues, while Toto pretends to have drunk his laxative and is embraced by his mother.

Jean's first talkie was indeed just that – the voices seldom cease for a moment. However, the ensemble playing is a delight, and the action moves swiftly within the static frame. The only sound effect which was commented on was that of a toilet flushing several times in the course of the film. 'In my concern for realism I used a real flush in one of the studio's toilets. The result was a cataract of sound that delighted the producers and caused me to be regarded as a great man,' Jean wrote.

A year before, in *L'Âge d'or*, Luis Buñuel utilised the noise of a toilet flushing, not contextually as in *On purge bébé*, but as one of the

many aural (as well as surreally visual) images that set out to shock. In Chaplin's last film, *The Countess from Hong Kong* (1967), an anachronistic farce, the same lavatorial sound is used as an unfunny piece of business.

On purge bébé was the only opportunity Jean ever had to work with the great horse-faced screen comic Fernandel. The 27-year-old, who had made a reputation in music hall, was finding it difficult to find work in films when Jean asked for him. From then on, every time they met, Fernandel would shake Jean's hand and say, 'You gave me my first break.' In a sense, Michel Simon could have said the same thing to Jean, who was about to give him two of his finest roles.

On purge bébé was shown at the Roxy in June 1931, and was one of the few early Renoir films to show a profit, mainly because it was so cheap to make. Jean had passed his test, and Richebé was now prepared to allow him to direct *La Chienne*, the start of his mature period. At last Jean had found a perfect role for Dédée that would put her back on screen in a leading part in a major film for the first time in three years. Perhaps it would even help patch up their marriage.

She was thrilled to be working under Jean's direction again, knowing how indulgent he was to her whims, and also felt that she was now experienced enough as an actress (though she had never spoken on screen before) to do justice to the title role of the prostitute. But it was not to be.

Billancourt Studios had a young actress under contract called Janie Marèze, fresh from *Mam'zelle Nitouche*, in which Jean had had a small role. Richebé, overriding both Braunberger and Jean's pleas to cast Dédée, insisted on the younger up-and-coming Marèze. Jean was therefore faced with a Cornélian choice. Dédée, who was devastated by the snub, indicated that Jean should refuse to direct the film if she was not given the part. When it seemed there was no hope that Richebé would yield on the matter, Jean decided to choose the film over his wife's wishes. 'This betrayal marked the end of our life together,' Jean recalled. 'This was the end of an adventure which should have been pursued in happiness. The cinema was for both of us a jealous god.'[8] In an interview she gave in the 1960s, Dédée said she separated from Jean because he refused to put her into comic films. Her dream was to play a parody Carmen opposite Michel Simon as Don José.[9] Of course, Charlie Chaplin had got there first

in his 1916 version, in which the comedian played Darn Hosiery to Edna Purviance's Carmen.

Dédée, who was now just over 30, had never really evolved from the style of the silent screen stars such as Mary Pickford, Mae Marsh and Lillian Gish, who had first inspired her ambitions of film stardom. Thanks to Jean, she had made some impact with her singular performances, at her best in *La Petite Marchande d'allumettes*, successfully combining stylisation with naturalism as her idols had done. But the caravan had moved on. Ironically, she might indeed have shifted into another dimension as an actress if she had been allowed to star in *La Chienne*. For Jean, however, the break with Dédée was probably the making of him as a true artist.

La Chienne, a Zolaesque tale about the Pimp, the Tart and the Client, opens with a puppet prologue, an expression of Jean's childhood love of Guignol. A puppet announces: 'Ladies and Gentlemen we will have the honour of presenting to you a great social drama. The spectacle will prove that vice is always punished.' A second puppet, a gendarme, reinforces the first. 'We have the honour to present you a comedy with moral implications.' Here Guignol appears, armed with his club, argues with the others and then beats them from the scene. He addresses the audience in what can be seen as Renoir's manifesto: 'Ladies and gentlemen, don't listen to them. The work we will show you is neither a drama nor a comedy. It has no moral intentions and it will prove to you nothing at all. The characters are neither heroes nor villains. They are just poor humans like you and me.' He then introduces the major characters, who appear superimposed on the puppet stage. 'There are three principals, He, She and the Other One, as usual. He is a decent fellow, timid, not too young and extraordinarily naive. In intellect and feeling he is above the milieu in which he lives, so that in this milieu he is taken for an imbecile. She is a little woman who has her charm and her own vulgarity. She is always sincere; she lies all the time. The Other One is 'my Dédé' and nothing more.'

The Dédé in this case, a name which must have resounded uncomfortably for Jean throughout the shooting, was the diminutive given to André-Etienne Joguin, the pimp, played by Georges Flamant. Michel Simon was Maurice Legrand, the unhappily married clerk and Sunday painter who falls for Marèze as Lulu (echoing Wedekind's heroine), having rescued her from a beating by her pimp, Dédé. Legrand sets Lulu up in an apartment where he hangs his paintings, away from his wife's scorn. Lulu claims them as her

own, and becomes a celebrity in the art world, while Legrand has to steal from his employer to satisfy her demands. The morning after having found her in bed with Dédé, Legrand kills Lulu out of anger and jealousy.

After the prostitute is murdered, the camera remains on a street singer and the crowd gathering outside her house. When Dédé goes upstairs, the camera rises vertically to the window of Lulu's room, and then slowly descends. The movement is repeated when the concierge leaves the crowd to go up and deliver the post. A few minutes later, she pokes her head out of the window to shout, 'Murder!' The audience is in no doubt that the pimp will be falsely accused of the crime. Dédé is arrested, convicted and guillotined. The clerk becomes a tramp. (The ending later got Simon thinking of doing *Boudu sauvé des eaux*.)

By filming in the noisy streets of Montmartre – in the place Emile-Goudeau and the surrounding area, not far from Jean's birthplace – without using any dubbed sound at all, a real, habitable world was created. When René Clair made *Sous les toits de Paris* in a studio in 1929, he added street noises and boulevard songs to drown some of the dialogue. *La Chienne* was among the first French sound films to be shot and recorded in actual locations. Jean explained how it was done. 'When shooting out of doors we sought to damp down background noise with hangings and mattresses . . . I did not want to shoot street scenes in the studio. I wanted the realism of genuine buildings, streets and traffic. I remember a gutter whose waters rippled in front of a house which was to serve as background for an important scene. The microphone made it sound like a torrent. It must be borne in mind that in those days we did not possess directional microphones. I solved the problem by taking a close-up of the gutter and thereby justifying the noise it made.'[10] The song sung by the street singers was *La Sérénade du pavé*, made popular by Eugènie Buffet in the cabarets of Paris in the 1880s, and later sung by Edith Piaf as Buffet in *French Cancan*.

Renoir had transformed an amoral little melodrama into a work of unsentimental naturalism, creating characters rather than types. Such were the performances of the leading actors – the handsome, nattily dressed Flamant, the seductive blonde Maréze and the remarkably expressive Simon – that audiences were able to empathise with all three protagonists. The director had moved a long way from the stereotyped, one-dimensional characters of his silent films, who were only there to serve bourgeois morality. Now he would

turn away from Griffith, Stroheim and Chaplin (although the influence still surfaced from time to time), and the rapid montage of Abel Gance and the Russians. There would be no room in his brave new realistic world for performers like Catherine Hessling. It was ordinary people who would begin to interest him, mainly the inhabitants of Paris. As Jean revealed, 'Only when the actors began to talk did I gradually realise the possibility of getting to the truth of the character. It was when I began to make talking pictures that I had the revelation that what I was most deeply concerned about was character.'[11]

'I made it exactly the way I wanted to, paying no attention to anything the producers wanted,' Jean wrote.[12] These seemingly perfect working conditions led to the situation that most independent directors fear more than anything else; a film taken out of their hands and edited without their participation. Somehow, according to Jean, since Georges de la Fourchardière, the author of the novel from which the film was adapted, was known to be a humorist, Richebé expected a comedy. It is doubtful that the co-producer would have read neither the screenplay nor the book, so it is more likely that Richebé was shocked by the film's uncompromising realism. He therefore decided to ask the director Paul Fejos to re-edit it. The Hungarian-born Fejos had just returned to Europe from Hollywood where his best film was *Lonesome* (1928). He started cutting *La Chienne* with Denise Tual, but when Fejos heard that Jean had been barred from the cutting-room and was vigorously against the new editing, he desisted. Nevertheless, the editing continued in Jean's absence.

After three days and nights, drifting from bar to bar in Montmartre trying to blot the situation from his mind, Jean met the 23-year-old Yves Allégret, one of his assistants on *La Chienne*, who took him to Braunberger. The producer, who liked the first cut more than his partner, had advised Jean to visit Monsieur Monteux, the shoe manufacturer who had put up most of the money for the film. Jean was received by Monteux and his mistress Berthe de Longpré, 'famous throughout Paris for her flawless bosom'.[13] Jean's story touched her so much that she insisted Monteux promptly order Richebé to release the film in its original form as edited by Jean and Marguerite Houllé.

The premiére of *La Chienne* before an invited audience at the Palais Rochechouart was a great success. The actress Valentine

Tessier sobbed unrestrainedly; Pierre Renoir, not often given to praise, told his brother he thought the film 'very good', and Jacques Becker, on leave from the army, was overwhelmed. 'I shall have finished my military service in two months,' he told Jean. 'From that day on you'll find me on your doorstep, and I shall go on pestering you until you've taken me on as your assistant.'[14] (Becker was subsequently to work on almost every Renoir film before the war.)

Richebé was still not confident that the film would be well received by a non-partisan audience, and decided to open it in Nancy. There, extreme right wing groups, who believed the film to be disrespectful to law and order, created their own disorder by howling the film down. Nor were the critics much kinder, and it was withdrawn after two days. Another Renoir commercial disaster seemed imminent. But a friend, Sam Siritzky, a large Russian Jew who had served in the Turkish navy, put *La Chienne* on at his theatre in Biarritz, proclaiming on his posters, 'Above All Avoid Seeing this Film. It Is Horrible.' It worked and the public flocked to see it, enabling a run of over three weeks. The film then opened at the Colisée in Paris in November 1931 with some success. When shown in the USA and Great Britain, it was always advertised as *La Chienne*, because an English translation of the title (The Bitch) was deemed unfit.

In 1945, Jean's friend and fellow exile in Hollywood, Fritz Lang, remade *La Chienne* as *Scarlet Street*, with Edward G. Robinson, Joan Bennett and Dan Duryea, a key *film noir* of the period. The only available comment on it from Jean came years later when he remarked to American director Tay Garnett, 'It's a pity they had to remake *La Chienne* in Hollywood, and so badly,' one of the very few negative remarks he ever made about a colleague, let alone Lang who was a friend.[15] The critic Robin Wood has pointed out some of the differences between the two directors' approach to the same subject. Renoir 'continually invites us to enjoy the human oddities and particularities of his people in a way in which Lang in *Scarlet Street* does not: Lang is interested in the tragic process, and refuses to allow himself to be distracted from it . . . a Renoir shot has about it an air of improvisation, of inventing bits of business, of drawing spontaneously on the particular gifts and attributes of the players; a Lang shot functions strictly in relation to the one that preceded it and the one that follows it . . . Renoir's camera is habitually at the service of the actors, Lang's at the service of the precise and rigorous

expression of an idea.'[16] There was a further interweaving of the careers of Renoir and Lang, when the latter remade *La Bête humaine* as *Human Desire* (1954), and the influence of Lang on Renoir can be seen in Jean's last Hollywood film, *The Woman On The Beach* in 1946.

In the late 1960s, when Peter Bogdanovich was complaining to Jean about how unco-operative the German director had been on his book *Fritz Lang in America*, Jean said very quietly, 'Peter, you must remember that this is the man who created the German film industry.'[17]

If *La Chienne* was an attempt to imitate life, so life imitated the film in an extraordinary way. During the shooting, Michel Simon, who had been married briefly, became almost as infatuated with Janie Marèze as his character had been in the picture. She, however, had fallen for Georges Flamant. Jean had chosen the 26-year-old Flamant, an amateur actor, because he had frequented the underworld and was at ease with the argot of the milieu. Flamant, who had rescued the convent-educated Marèze from her demanding sugar daddy, had a tremendous hold on her. He would often make her undress and lie naked on a couch while he sat at her feet watching her. 'You see, mate,' he told Jean, 'all I do is look at her. I look at her with devotion, but I don't touch her. After an hour I can do anything I like with her. Without touching her – that's important.'[18] Marèze's accent was initially over-refined for the role of Lulu, so Jean made her imitate Maurice Chevalier and it worked perfectly.

The film completed, Flamant bought himself a huge Cadillac (*une belle Américaine*) although he barely knew how to drive. He then invited Marèze for a spin along the Côte D'Azur, but he lost control of the car and it crashed, killing his passenger. Simon was so distraught during the funeral that he fainted, and later had to be restrained from attacking Flamant. It was a tragic ending to Jean's glorious beginning in talking pictures.

16

Through a Lens Darkly

'I tried to do what Simenon does in his books: He surrounds the spectator with a particular atmosphere. To arrive at this goal I may have exaggerated the obscurity.'

Jean and Dédée had known Georges Simenon and his painter wife Tigy since 1923. Jean admired the Belgian writer's grimly realistic thrillers and saw in Inspector Maigret the perfect role for his brother Pierre, with whom he had wanted to work for a long time. (Pierre is only glimpsed briefly in *La Fille de l'eau*) The novel he especially wanted to film was *La Nuit du carrefour*, one of the earliest Maigret stories. No work by Simenon had yet been adapted to the screen.

Intent on persuading the author to grant him the film rights, Jean sped his racing Bugatti to Ouistreham on the Normandy coast, where the peripatetic Simenon was staying at the time. The 29-year-old Simenon, who was always seduced by the older Jean's almost 'childish' naturalness and spontaneity, agreed to the film being made, despite knowing that there would not be much money in it for him.

Although *La Chienne* had made a small profit, Braunberger and Richebé at Billancourt were unwilling to finance the new venture. The money, therefore, came from various private sources and what Jean's friends could afford. The 26-year-old Jacques Becker, just released from military service, was appointed producer and co-

assistant director; 17-year-old Claude Renoir (Pierre's son) got his first chance to work on a film as assistant cameraman to Paul Fabian; Mimi Champagne (Pierre Champagne's widow) was in charge of continuity, and Marguerite Houllé was again editor. Most of the cast were not professional actors; Jean Gehret, the Swiss musicologist who had taken a small role in *La Chienne*, played the greasy, roly-poly, xenophobic insurance agent who discovers the body of a diamond merchant in his car; the dramatist Michel Duran was Jojo, the garage hand; the painter Edouard Dignimont was the accordion-playing garage owner, and critic and experimental film-maker Jean Mitry also had a part. In order to achieve the accents that identify Karl and Elsa Andersen as the foreigners whom most of the other characters despise, Jean chose two Danes, actor Georges Koudria and dancer Winna Winfried, whom he described as 'a funny creature, a strange little 17-year-old kid with a very pale face.'[1] Most of the cast and crew worked for virtually no pay, as well as helping out with scene-painting and other odd jobs.

Renoir and Simenon rented a villa at Cap d'Antibes as a suitable place to work on the script. Not far from Les Collettes, it was a sunny world far removed from the grey setting of the film. When the screenplay was completed, Jean went looking for a location that would coincide with the Carrefour des Trois Veuves, a dreary cluster of houses and a garage situated around a crossroads described in the novel. He found what he was looking for at Bouffémont, about 50 kilometres north of Paris, where the film crew and cast remained in a rented house during the shooting in the first months of 1932. And the weather was perfect! It was cold, rainy and miserable, just right to evoke the essential atmosphere of the piece. Pierre Renoir, who had, in Maigret, his biggest and best film role to date, was only available during the day because he was appearing on stage in Marcel Achard's *Domino* in the evenings. The whole method of making *La Nuit du carrefour* remained for Jean 'a completely absurd experiment that I cannot think of without nostalgia. In these days, when everything is so well organised, one cannot work in that kind of way.'[2]

La Nuit du carrefour is, like Howard Hawks' *The Big Sleep*, notorious for its unfathomable and complicated plot. But the Renoir film has further obstacles to comprehension than the later Bogart-Bacall movie made in 1946. Because Jean was running out of money, a number of elucidating scenes had to be abandoned, a situation that made the already murky plot murkier, so that the last sequence had

to be shot very quickly in order to complete the film. Neither are matters eased by the quality of the direct sound – dialogue has to compete against the drumming of the rain on the roof and the noises of the busy motorway – and the untrained, high-pitched foreign voice of Winna Winfried.

Briefly, *La Nuit du carrefour* tells of the murder of an Amsterdam diamond dealer in mysterious circumstances. Inspector Maigret is sent to investigate. At the small crossroads community, he holds each inhabitant suspect in turn. What a weird bunch they are, slinking in and out of the shadows! The murdered man's wife is gunned down when she arrives to identify the body; Else, the Danish woman, is almost poisoned and strangled; someone takes a pot-shot at Maigret, and there is a car chase with police in a Bugatti (Jean's) after a gang. Finally, the inspector discovers a link with cocaine smuggling and the Parisian underworld before finally solving the case. The murderer turns out to be one of the garage mechanics, actually Else's first husband.

Impenetrable as the plot is, the film compellingly captures the eerie ambience of the crossroads with its dank fields, speeding cars, and strange inhabitants – the sleazy garage owner, the sinister Dane with a black monocle, the latter's young sister (or is she?) who is attracted to Maigret; a remarkably erotic performance from Winfried (sometimes bordering on the style of a silent screen vamp), draping herself across the furniture. When she is placed in handcuffs, she and Maigret look as though they are about to dance cheek-to-cheek. Pierre Renoir, literally the still centre around which the action rages (he is often caught in the middle of the frame) is a powerful presence, sombre but with an eye to the comic, poised and calm, but ready to pounce on his prey when necessary.

The director lends the film a dark, decadent and hallucinatory aspect, creating an absurdist world obviously heightened by the inexplicable events and motives. Aural motifs such as cars backfiring, a dripping tap, and a sinuous tango continually played on a gramophone, deepen the experience, and shots of newspapers being bought and then swept along the gutter – an image Jean might have taken from *Five Star Final*, a 1931 Warner Bros. press drama starring Edward G. Robinson – indicate the swift passing of events. The car chase along the streets was also influenced by the American gangster movies that were gaining popularity, films such as Edward G. Robinson in *Little Caesar* (1930) and James Cagney in *The Public Enemy* (1931). But *La Nuit du carrefour* also looks forward to the

fatalistic, melancholy poetic realism of the Marcel Carné-Jacques Prévert films such as *Quai des Brumes* (1938) and *Le Jour se lève* (1939), Renoir's own *La Bête humaine* (1938), and further to the American *film noir* of the 1940s. Jean-Luc Godard, with typical audacity, was to call *La Nuit du carrefour*, 'the only great French thriller, the greatest French adventure film.' Unfortunately, as with many a Renoir film, few people appreciated its quality when it was first shown in April 1932 at the Théâtre Pigalle, and it remains a sadly neglected masterpiece of the early sound cinema.

The bleakness of *La Nuit du carrefour*, derived as it was from Simenon, could also be seen as a reflection of Jean's state of mind at the time of his separation from Dédée. He had been obsessed by her and she had hurt him. Now he sought consolation in Marguerite Houllé, his film editor with whom he had worked closely, almost head to head, since *La Chienne*.

Marguerite was born in 1907 in Montreuil, a working-class suburb of Paris. She had entered the film industry at the age of 15 as a colour tinter. In those days, many important films had one or two reels tinted in several colours by stencils, painstakingly cut by hand and run past dye rollers in contact with the print. She gradually moved into continuity and then editing. It was as editor on Calvalcanti's *La P'tite Lili* in 1927 that she was first introduced to Jean.

Both Marguerite's father and brother-in-law were engaged in the struggle for trade union rights, and she herself was a militant fighter for women's suffrage (women did not have the right to vote in France until 1944) and a member of the Communist Party. Marguerite and her friends were influential in persuading Jean to take a more openly left-wing stand on certain issues, ideas which would find direct expression in his films at the onset of the Popular Front, beginning with *Le Crime de Monsieur Lange* in 1935, the year Jean and Marguerite started living together.

Marguerite, who was nicknamed 'the little lion' because of her curly hair, offered Jean the companionship he needed at that time. According to Alice Fighiera, 'The part Marguerite played in Jean's private life didn't count for much. They lived together on and off, really more because she worked with him a lot. It was a convenient relationship. She was kind to him. He worked with her, then slept with her after filming. It was banal. A man and his mistress. She was very ordinary. Jean seldom spoke of her to me, and he always told me what was in his heart.'[3]

Jean made only a passing reference to Marguerite in his memoirs, calling her 'my friend and editor', and hardly ever mentioned her in any of his other writings and interviews. This was the woman he was closest to for almost 10 years, who changed her name to Marguerite Renoir (the credit she was always given on screen even after breaking with Jean) and who worked intimately with him as his editor on 13 of his films, among them the greatest he made.

Alice and Dédée still corresponded and saw each other whenever they could – Alice lived on the Riviera and Dédée had taken over the flat in rue de Miromesnil, Paris – but after Alice had received Jean and Marguerite at her home in Nice, Dédée stopped writing. Although they had been close friends since their teens, Dédée continued to hold a grudge against Alice for over two years for what she saw as a betrayal. Although she knew that the break-up of the marriage had nothing to do with Marguerite, Dédée remained bitter that Jean had found another woman so soon.

Then one day Alice received a message at the office where she worked in her husband's flower exporting business. It said, 'Madame Renoir telephoned and wishes to meet you at a restaurant for lunch tomorrow.' Alice thought it was Marguerite, who had taken the name of Renoir, but it turned out to be Dédée who was visiting Nice. Alice knew after a few minutes of conversation that their long friendship was over. During the meal, Dédée offered to buy, with gold, the Auguste Renoir painting that Jean had given Alice, and which she treasured. Alice refused. After Dédée had reviled Jean, the two women parted company in a cool manner.[4]

The name of Catherine Hessling appeared only twice more on the credits of a picture after Dédée and Jean parted: Pabst's *Du haut en bas* (1933), in which she finally got to act with Michel Simon, and *Crime And Punishment* (1935), her only sound films. Yet it was not her voice that prevented her from making a career in the talkies: she did radio tests for the poet Robert Desnos, who found she spoke beautifully.

'I gave up the cinema because it ceased to be artisanal,' she commented later in life. 'When I made films I had a say in everything. I sewed my own dresses. I never wanted to be a movie star. It was M. Renoir who said, I will exercise my marital rights to make you act in films. It was for me a shameful activity.' (She destroyed many of the documents and articles in which she featured.) 'I didn't want to be an interpreter but a creator, and my best memory was to have sufficiently subjugated Cavalcanti during *La*

P'tite Lili to allow me to give a kick up the backside to the extras who took their places in front of the mirror. But my Chaplinesque playing got me treated by certain critics as a horrible Japanese doll.

'I never appreciated Renoir's direction. I'll just pardon him *Nana*. Poor Auguste, ah! He was so afraid that Jean would be a failure. As long as I can remember, it was Jean's fear of failure that struck me, and his instability. He wasn't interested in ceramics, it needed patience. Then it was necessary to invest money in the cinema, hence the fear. Did you know that this big man of six foot trembled in panic? It wasn't pretty to see, I assure you. But he always had money. He never lacked anything. He used to say the most incredible things such as he knew misery, that's funny.'[5]

Although Jean, years after his first marriage, would sometimes refer to Dédée as *une merdeuse*, he would never speak slightingly of her to their son Alain. He never wanted him to have memories of a bad mother. When Alain had been decorated in World War II, Jean wrote to his son to tell him that Dédée must be very proud of him. In addition, while Jean was living in Hollywood, he saw to it, through an agent in France, that Dédée's mother, Madame Heuschling, was well cared for, and later that her grave was tended.

17

Nostalgie de la Boue

'When I see Boudu, *I forget that I made the film, I forget what happened, I only see one thing: a great actor on the screen.'*

After *La Chienne*, Jean Renoir and Michel Simon started looking for another film to make together. Several possibilities were considered. There was *Emile*, about a 'shopkeeper of bicycle accessories in Provence',[1] written by the comic writer Jacques Deval (best known for *Tovarich*), and an adaptation of Jules Laforgue's *Hamlet*. In the early 1930s, the artist André Derain announced that Jean was going to film a scenario of his called *Tavuke N'Bongo*, written especially for Michel Simon, set in the milieu of rag and bone men. According to Derain, it was 'a social study, a tragi-comic film made with simplicity so that the public will not lose for an instant the thread . . . to make good films, one has to have a sensible scenario, very lively, original, and conceived by an author of rich imagination, beautiful natural decor which abounds in France, and interpreters with expressive masks that have a soul.'[2] Simon explained that it was 'neither a comedy nor a drama. It is a human story, very simple. As bare as a parable from the gospels.'[3] Although *Tavuke N'Bongo* was never filmed, it might have set him thinking along certain lines.

Simon, remembering the end of *La Chienne*, suggested the subject of *Boudu sauvé des eaux* to Jean. He had taken over the title role of

the tramp in 1925 on the Paris stage from Marcel Vallée in the play by René Fauchois, who himself played M. Lestingois. So keen was Simon to play it again on screen, that he and his friend Jean Gehret, put up the money. Jean, who had had a soft spot for hoboes ever since his introduction to Charlot's Little Tramp, was also excited by the chance to work with Simon on a film that would again question conventional bourgeois values, something the original play had little interest in doing.

Boudu, a scruffy tramp, means to put an end to his life after losing his black mongrel dog in the Bois de Boulogne. But M. Lestingois (Charles Granvil), a bookseller, rescues him from drowning in the Seine and takes him into his home. There Boudu sets about seducing his rescuer's wife (Marcelle Hania) and Anne-Marie, the maid (Séverine Lerczinska), Lestingois' mistress. 'One should only help those of one's own class,' concludes the bookseller. ('Happily she's fallen for one of our set,' the marquis comments in La Règle du jeu of his wife's adultery.) However, the disruptive vagabond gradually begins to display certain tame middle-class tendencies, and when he wins 100,000 francs in a lottery, he decides to marry and settle down with Anne-Marie. As the wedding party rows down the Marne, Boudu overturns the boat and disappears beneath the water, presumed drowned. 'It's his destiny to drift with the current (fil de l'eau) again,' remarks Lestingois. Once on shore, Boudu abandons his wedding suit and dresses himself in the clothes of a scarecrow, before romping joyously on the banks of the river in celebration of his narrow escape.

The film opens with a scene on a stage where M. Lestingois, disguised as a satyr, is seducing the maid (as a nymph) to the pipes of Pan, a theme which continues with Lestingois' quotations from Greek mythology. Boudu is later referred to as Priapus, and the melody on the flute, played by the neighbour (Jean Gehret) from his window, acts as a seductive call to Boudu's natural soul to return to his life in the open air. However, Renoir's pantheistic symbolism is never underlined, but runs gently like a rivulet through the screenplay.

We are not in ancient Greece but in Paris at a specific time and place: the hot summer of 1932, on the banks of the Marne and on the quais of the Seine at the Pont des Arts. By taking his camera and sound equipment out on location, still a rare occurrence in those days, Renoir gave the film an almost documentary reality; the people

in the streets, a marching brass band with children dancing around them, weekend trippers picnicking at the riverside, are all caught for an instant.

One can verify the street realism of the film even today by walking along the Quai Conti on the Left Bank, which has not changed much in six decades; the building where M. Lestingois had his bookshop is still there, and so is the Pont des Arts, from which Boudu jumped, repaired since it collapsed in the early 1970s.

By means of deep-focus photography, Renoir was able to give the Lestingois apartment the feel of a real lived-in space in which man, wife, maid and unwelcome guest interrelate. The director's budding genius is revealed in the way, in order to demonstrate that the family does not live in isolation as the one-set play implies, he gets the maid to shout down to a neighbour in the courtyard for a box of matches to light the stove. (He would soon celebrate community life around a courtyard in *Le Crime de Monsieur Lange*.) There are moments when the camera cuts away from the apartment to 'dead' shots of roofs or Notre Dame, almost comparable to those in the films of the Japanese humanist director Yasujiro Ozu, who was also developing his personal style that year, though neither knew each other's work at the time.

Although these shots offer tantalising glimpses of a world outside the apartment and bookshop, Renoir does not denigrate Lestingois or the life he leads. As played by Charles Granvil, he is rather lovable – witness his slipping a student (Jean Dasté) a free copy of Voltaire's *Lettres d'Hamabed*, because the young man cannot afford it. Boudu, who has no respect for books, spits in Balzac's *The Psychology of Marriage*. Despite his periodic irritation at Boudu's antics, Lestingois never really regrets his initial kindness, and continues to treat his rescuee rather like a large pet.

A component in the creation of the character of Boudu was derived from Jean's memory of a mongrel of his called Jerry, named after the dog in the Jack London story, *Jerry on the Island*, who kept running away. As Boudu, Michel Simon, giving one of the greatest of screen performances, often behaves and looks like an orang-utan in a cage, swinging on the doorframe, rolling on a table and turning somersaults. His twitching, jaunty walk indicates constant inebriation (a walk unequalled until Jean-Louis Barrault's Monsieur Opale in Renoir's *Le Testament du docteur Cordelier* in 1959), and his inability to handle objects – his comic puzzlement at what to do with a table napkin, or how to fill a kettle – present a man ill at ease with the

restrictions of home life. After he smears boot polish on his shoes, he wipes it off with a satin bedspread, a scene which provoked gasps of horror from the first audiences, especially women.

The exhilarating last few minutes of *Boudu* are a perfect marriage of style and content. The camera drifts away from the band playing the 'Blue Danube' at the wedding feast on the banks of the river to the boating party. While his bride rests her head on his shoulder, Boudu sees a water lily floating nearby. He attempts to grab it and overturns the boat. After drifting along like a male Ophelia, he gets to the shore, divests himself of his bourgeois suit, dresses as a tramp again, bums a sandwich from a young couple and shares it with a goat.

His liberty is then expressed with the use of a rapturous and lingering 360-degree pan (Pan?) starting with Boudu, taking in the hat he has thrown away into the water, and river scenes – people rowing, walking along the bank, and shimmering water under a bridge. The film ends with a view of the sky and a steeple above a chorus of singing *clochards* on the march.

It is not too fanciful to see the film as a reflection of Jean's own new-found freedom from marriage and his own anti-conformist attitudes for which Boudu was his surrogate. The Renoir film, which changed the slant of the stage original, was as far from the world of boulevard comedy as it could get, particularly the ending. In the play, the anarchic tramp is reintegrated into society by marrying the maid; in the film, Boudu, on the wedding day, escapes at the last moment, regaining his untrammelled existence. When Fauchois first saw the film, he accused Jean of betraying him and threatened to have his name removed from the credits. But some 30 years later, a short while before his death in 1962, when *Boudu* had gained a certain reputation, the playwright changed his mind. 'A very free adaptation of my play, *Boudu* properly belongs to Renoir,' he said. 'Its merits are an achievement before whose mastery it is only honest to bow.' (*Down And Out In Beverly Hills*, directed by Paul Mazursky in 1986, was loosely based on *Boudu*. It began as a familiar satire on the bourgeois Californian life-style led by Richard Dreyfuss and family, a life disrupted by tramp Nick Nolte, who teaches them better values, but Mazursky ditched Renoir's ending for a comfortable, toothless one.)

Boudu sauvé des eaux was greeted coolly when first shown. Another Renoir flop, it only reached the general British public in 1965, and Americans in 1967. In fact, so much of *Boudu* exemplifies

what made Jean Renoir a great director; the improvisatory air, the fluent camerawork always at the service of the screenplay, the small human details that provide an added dimension to the characters who never become stereotyped, and who always have his understanding, and often his love; the constant relationship between the characters and their environment; a sense of place and community, and a genuine, unsentimental *joie de vivre*. There are no heroes and villains. Each is stupid and wise, noble and petty. Renoir's cinema is egalitarian. Events and people are never taken at face value. Individuals are trapped by the rules of the social game; masters and servants, bosses and workers, officers and men, bourgeois and *clochard*.

18

Filming Flaubert

*'Madame Bovary was a strange undertaking. It's a project
in which I tried to combine a real background with the
most stylised acting possible.'*

As Jean was still supporting Dédée in the style to which she had
become accustomed, and paying for Alain's education, he had to
look around for a film that would help keep the wolf away from
three doors – that of the apartment in the rue de Miromesnil where
Dédée lived, of the mansion at Marlotte, the walls of which were
stripped bare of its paintings, and of the old house he rented on the
rue Alexandre-Guilmant at Meudon in the outer suburbs of Paris.

When he was approached by the playwright Roger Ferdinand to
direct a film version of his play *Chotard et cie*, Jean could not afford
to refuse. Ferdinand, who put up most of his own money, worked
with Jean for two months on the scenario and was present during
many of the 23-day shoot from mid-November to December 1932
in the Joinville Studios. No chance of the director going out into the
streets, or extending his range here, or even 'betraying' Ferdinand as
he had René Fauchois on *Boudu*. Jean was hired to put Ferdinand's
play on the screen for as small a budget and in as short a time as
possible.

At least Jean was able to gather around him a number of friends,
almost a prerequisite for a Renoir film: among them Jacques Becker,

assistant director and bit-part player; Charles Raleigh, technical director, with whom he had last worked four years earlier on *La Petite Marchande d'allumettes*; Suzanne de Troyes, on continuity since *La Chienne*, Marguerite Renoir as editor, and his teenage nephew Claude as assistant cameraman. There were also familiar faces among the cast, including Georges Pomiès, the lead from *Tire au flanc*, and Max Dalban, who had appeared in Jean's last three films. The magnificent Fernand Charpin, fresh from portraying Panisse in Marcel Pagnol's two films, *Marius* and *Fanny*, took the title role, which he had played on stage.

François Chotard is a wealthy provincial grocer whose marriageable daughter, Reine (Jeanne Boitel), is in love with a naive and penniless poet Julien (Pomiès), whom Chotard has no time for. The father, however, agrees to the marriage in the hope of turning the poet into a grocery clerk. But after Julien wins the Prix Goncourt, Chotard encourages him to write more. It is too late. The poet has discovered a taste for the grocery business, while the grocer pursues a literary career.

This rarely-seen piece is an amiable, well-played comedy in the Pagnolesque vein, which the presence of the charming, bald and Midi-accented Charpin helps to emphasise. Renoir did the best he could with the material, from the opening shot in which the camera tracks around the grocery shop to reveal Chotard, until the Mozartian masked ball finale. Yet too much of the film was static – at the service of the dialogue rather than the other way around. 'I believe in dialogue not as a means of explaining the situation but as an integral part of the scene,' wrote Jean. 'Dialogue is a part of the theme and reveals character. For the real theme is the person, whom dialogue, picture, situation, setting, temperature and lighting all combine together to depict. The world is one whole.'[1]

Chotard et cie is seldom mentioned in articles, books and interviews on Jean Renoir, who seemed to have conveniently forgotten it. When he was asked by the Cinémathèque if he had a print, he replied, '*Chotard*? I don't remember it.'[2]

As neither *Boudu sauvé des eaux* nor *Chotard et cie* made any money, Renoir and Pierre Braunberger decided to look once again towards Germany for financial assistance, as they had done for *Nana*. But the idea seemed, to say the least, foolhardy in the spring of 1933, a few months after Hitler had come to power.

Almost immediately after the German election on 30 January,

Joseph Goebbels was appointed Minister of Propaganda and Public Enlightenment, and strict controls were imposed with the aim of achieving political conformity and artistic uniformity. Jews were promptly purged from the industry, and liberals and independently-minded filmmakers were discouraged by censorship. The day after the Reichstag fire, Bertolt Brecht, whom Jean had met on his earlier visit, was among the many writers in danger who fled the country. On 10 May, during Jean's visit, Brecht's books were burned, along with those of many other German and non-German writers. Several of the intellectuals who refused to go into exile were tortured, imprisoned and murdered. Some of those who did escape, like Walter Benjamin, Stefan Zweig, Klaus Mann and Ernst Toller, later committed suicide.

The Nazi Party had gained a foothold in the cinema from about 1927, the year after *Nana*, as well as organising 'spontaneous' demonstrations against films they disliked. *All Quiet On The Western Front* (1930) and *Kühle Wampe* (1932), with a screenplay by Brecht, suffered in this way. Among the first Nazi films made were *Hitlerjunge Quex*, *SA-Mann Brand* and *Hans Westmar*, all released in 1933.

Early in the year, Fritz Lang, whose *The Testament Of Dr Mabuse* was promptly banned, was summoned to the office of Dr Goebbels who, to the film director's astonishment, offered him a chance to direct Nazi productions. Lang took a train to France the same evening, leaving behind his possessions, bank savings, and his wife and co-screenwriter, Thea Von Harbou, who had joined the Nazi Party.

In the midst of all this, the Jewish Braunberger was busily meeting German film producers and distributors, while Jean became re-acquainted with his old friends Karl Koch and Lotte Reiniger. Jean was told stories of brutality, and witnessed a gang of Brown-shirts forcing an eldely Jewish woman to go down on her knees and lick the pavement. He became anxious for Braunberger and suggested they leave for Paris immediately. Braunberger refused and, to make matters worse, the little man stood in front of a tall, uniformed Nazi, gave the Hitler salute with one hand and held his nose with the other. Fortunately, the Nazi did not notice the provocative gesture, but Jean bundled Pierre onto a night train to Paris a few hours later. Jean stayed behind for a few days, during which 'a tragi-comical incident' took place. A taxi he was taking had to go via Kanzleiplatz, where Hitler's official residence stood. When the taxi

driver came to the square and found it cordoned off to keep back the
adoring crowds waiting for their new Chancellor to emerge, he
ignored the guards, put his foot down and drove into the empty
square. 'As it came opposite the entrance to the Chancellery a huge
Mercedes drove out. Standing erect beside the uniformed chauffeur
was a personage whom I could not fail to recognise – Adolf Hitler.
Quite unperturbed, my driver kept level with the Führer's car, and
we continued thus, a few yards apart, amid the clamorous plaudits
of the crowd, which Hitler acknowledged with the Nazi salute.
Women went down on their knees, and men wept with emotion
. . . The generals in the back seat of the Mercedes glared suspiciously
at me, obviously wondering who I was . . . Hitler himself was far
too busy saluting to pay attention to trifles. My chauffeur did not
even bother to look at the great man. Eventually we came to an
intersection and Hitler turned left while I turned right.'[3] It was, in
fact, the Berlin visit that gave Jean impetus to turn left in a rather
more significant sense.

It would have seemed natural for Renoir's next films to reflect his
greater political awareness, sharpened by his experiences in Germany
and discussions with Marguerite and her crowd. Then, too, an
anxious Europe was being threatened by the rise of Fascism. Instead,
a penurious Jean was grateful to be offered the chance to direct
Gustave Flaubert's *Madame Bovary* which had recently come out of
copyright. The offer came from the *Nouvelle Société des Films*, which
belonged to Gaston Gallimard, the publisher of the *Nouvelle Revue
Française* and son of the collector friend of Auguste. Gallimard saw
the title role as ideal for his lover Valentine Tessier, with whom he
was living.

There have been five screen versions of *Madame Bovary* to date. The
first was made in Hollywood in 1932 starring Joyce Compton and H.
B. Warner, renamed *Unholy Love* and relocated to America. Three
years after Renoir's adaptation, came Gerhard Lamprecht's German
attempt with Pola Negri, who was rumoured to have been romanti-
cally linked with Hitler. In Hollywood again, Vincente Minnelli's
Emma Bovary was Jennifer Jones in 1949, the year she married David
Selznick. The most recent was Claude Chabrol's of 1990.

Jean was not the first choice as director. Originally, Gallimard's
novelist friend, Roger Martin du Gard, agreed to write the screen-
play and the dialogue, and Jacques Feyder was to direct. Feyder had
been looking for a suitable project since 1931 when he returned from

Hollywood where he directed Greta Garbo's last silent film, *The Kiss*, and two Ramon Novarro vehicles. Roger Martin du Gard, whose own novels inherited features of nineteenth-century naturalism, seemed a good choice. But after a disastrous lunch with Gallimard and Tessier, Feyder said he could not see Valentine in the role. As a matter of fact, although he was being honest, Feyder was hoping to get the plum part for his actress wife, Françoise Rosay, who was also at the meeting. However, the 42-year-old Rosay would have been even more miscast than the 40-year-old Tessier. When Feyder withdrew, so did Roger Martin du Gard.

Valentine Tessier, who was a member of Louis Jouvet's company at the Comédie des Champs-Élysées with Pierre Renoir, suggested Jean to Gallimard. Pierre was cast as Charles Bovary opposite Tessier, whom Jean considered 'like a sister to me';[4] his young nephew Claude would continue to serve his apprenticeship as assistant cameraman, Marguerite Renoir was in charge of editing, and Karl Koch came from Germany at Jean's request to help him on the screenplay.

Although Flaubert's most famous novel did not figure among Jean's favourites, he was happy to take on the task, perhaps obliterating from his mind his father's summing up of *Madame Bovary* as 'the story of an idiot whose wife wanted to become somebody. When one has read these 300 pages one can't help thinking, "I can't be bothered with these creatures." '[5]

Aside from being able to earn some money, the film-maker's reasons for taking on a masterpiece of French literature seemed little to do with any particular passion for the novel itself. In 1957, Jean explained to two young interviewers from *Cahiers du Cinéma* (29-year-old Jacques Rivette and 25-year-old François Truffaut) why he made the film. 'What attracted me, is that it was an experiment with theatre people. Valentine and my brother were essentially theatre people, and along with them we had a group composed of many other theatre people . . . And I was very happy to do a film, to write a script for theatre people, with dialogues that seemed as if they had to be spoken by theatre people . . . the joy of having certain phrases that you know must be spoken by lips accustomed to speaking words.'[6]

A further attraction, and challenge, was that the crafted and stylised dialogue, almost entirely Flaubert's, would be spoken in real settings – 'real farms with real cows, real geese, real chickens'[7] – but performed by the actors as if they were in the theatre. In order to

achieve this, the director and his team left for the locations in Normandy, at Rouen, Rys and Lyons-la-Forêt in October 1933.

The problems for the critic judging *Madame Bovary* today are virtually the same as those in 1934; mainly the cuts imposed on it, the casting of the title role, and the very notion of transposing a great work of literature to the screen. Only those privileged few who saw it in its original three-hour version, before it lost 73 minutes on release, were able to judge the film as it was conceived. The producers fought to have it released at its original length, but the distributors refused. Therefore, Jean cut a bleeding chunk from it, all of which was destroyed. 'But oddly enough, once it was cut the film seemed much longer . . . in its present (117 minutes) state, I find the film to be a little boring. But when it lasted three hours, it wasn't boring at all,' Jean remarked.[8]

There is no doubt that a further hour would have given the picture more breadth, and perhaps, depth. However, most of the major set-pieces of the novel survived the cuts: Emma's courtship by the stolid Dr Bovary; the ball at which Emma, now the bored wife, can waltz with handsome men to her heart's content; the agricultural fair at which she begins her affair with Rodolphe Boulanger (Fernand Fabre); the visit to a performance of Donizetti's *Lucia di Lammermoor* at the Opera House at Rouen, her romances with Léon Dupuis (Daniel Lecourtois) and Lheureaux (Robert Le Vigan), and her suicide by poison gained from M. Homais, the pharmacist (Max Dearly).

In fact, because 'everybody' is familiar with *Madame Bovary*, Renoir stuck almost too faithfully to the progress of the novel, though this approach did allow audiences to bridge some of the gaps left by the cutting. What disappeared was the gradual build-up of Emma's boredom with her drab husband and routine existence, rendering the contrasts of the ball and opera less dramatic.

Each scene is classically composed – again with a fine use of deep focus – and separated by fades, and the camera style is less flowing than hitherto, allowing the film to move in a stately manner. There are some breathtaking moments, especially in the fine use of the Normandy landscapes in which Charles Bovary seems so much at ease, and a sudden surprising shot of an old woman that comes directly from Cézanne's famous portrait of his mother. There is also a splendid original score by Darius Milhaud, as well as the piano music played by Emma, and the music in a café and at the opera.

The authentic staging of the late nineteenth-century production of *Lucia* was brought about by Jean's hiring of an old opera director whose memory went back to those days. But, on the whole, rare for Renoir, the film edges on the respectful and the academic.

Yet this would not have mattered but for the fatal miscasting of the title role. Tessier, obviously a stage actress of considerable presence and range, is too much the 'grande dame' in the part, too emotional, and certainly too old. Thus, many of the scenes are undermined by her performance. She is never Flaubert's romantic young girl, fresh from the convent, who escapes the monotony of her provincial environment by carrying on illicit affairs which she invests with false glamour. She suggests, rather, a woman who has actually once lived an exciting life before marrying Charles. The dilemma for anyone playing Emma Bovary (and for the director), is to allow audiences to distinguish between the character's self-dramatisation and overplaying and that of the actress. In the moments when the dividing line is clear, as at the ball and on her death bed, Tessier manages to overcome her initial unsuitability for the role. (The 29-year-old Jennifer Jones in the Minnelli version was closer, despite her Hollywood sheen.) Pierre Renoir, on the other hand, gives a beautifully judged and soulful performance, as much as the dull stick Dr Bovary would permit.

'There is one person in it whom I admire enormously,' commented Jean some years later. 'It's my brother Pierre. Ah! Really very handsome. And Valentine Tessier is simply delicious, she's adorable, she has a way of walking, of twirling her skirt, of entering, of leaving, a type of security . . . '[9] (Over two decades later, Jean cast Tessier more felicitously as Françoise Arnoul's mother in *French Cancan*.)

In contrast to her character on screen, Tessier, who was always attracted to Pierre, fell further in love with him during the shooting. Gallimard found out and wrote her desperate letters from Paris, which Tessier returned unopened. There was also a rumour that the jealous Gallimard stole into the lab of the Billancourt Studio one night, found the wedding night scene in which Valentine and Pierre kiss, and burned it out of the film.[10]

The three-hour version was shown five or six times in the small screening room at the Billancourt Studio to selected audiences, who were mostly delighted by it. Among the people who praised the uncut version was Bertolt Brecht, whom Jean called 'that remarkable poet, artist in logic and masterful organiser.' Since Jean admired the

German writer immensely, his opinion of *Madame Bovary* 'was the greatest reward for this film.'[12]

Brecht was paying a short visit to Paris from his exile in Denmark in December 1933, when the film was shown a month prior to its release. The previous summer, he had been temporarily living in Paris where his ballet, *The Seven Deadly Sins Of The Petit Bourgeois*, was performed, with music by Kurt Weill, and Weill's wife, Lotte Lenya, in a vocal part. She, Weill, Brecht and Hanns Eisler, who would write the score for Renoir's *The Woman On The Beach* in Hollywood in 1947, often visited Jean and Marguerite at their house in Meudon. Brecht in Paris was described by his friend Kurt Kläber as looking 'as disreputable as ever . . . his cap was pulled more tightly over his brow; his shoes were a little more scuffed . . . [but] in a very fashionable drawing room, faced by a huge mirror, he became starkly aware of his shabby footwear.'[13] But the writer always felt comfortable in Jean's house. During the gatherings of German exiles at Meudon, Brecht got Jean to sing old French songs, and Brecht would sing his own lyrics to music by Weill and Eisler, accompanied on the concertina. Jean was open-handed and understanding to Brecht and his compatriots, little realising that he would become an exile himself in a few years, arriving in America in 1941, the same year as Brecht.

Karl Koch, a friend of Brecht's, would also visit. In 1927, Koch, Weill and Brecht had hoped to collaborate on a Ruhr epic, a 'scenic oratorio', which was to include film, for the Essen opera house, but it remained unrealised due to costs. Jean worked with Koch again on a couple of films, but he would have dearly loved to have collaborated with Brecht as his friends Fritz Lang and Charles Laughton were to do in America.

Jean, however, had a stronger affinity with Koch that Brecht, as can be gathered from his description of the two men. 'Brecht was a lean German with an ascetic tendency. Koch was a plump German who enjoyed his comforts, a gourmand as well as a gourmet (he taught me how to roast beef over an open fire), cultured to his fingertips, unconcerned with politics but capable of doing battle for a symphony or a fine painting.'[14]

The truncated version of *Madame Bovary* opened at the Ciné-Opéra in January 1934, but was not a success. Nevertheless, the subsequent films that Jean was to direct from 1934 to 1939 – from *Toni* to *La Règle du jeu* – were to form the basis for his perennial

reputation as a genius of the cinema. From now until then he would no longer take on anything in which he did not wholeheartedly believe, and where he would not be fully in command of his material. There would be no more films like *Marquitta*, *Le Tournoi*, *Le Bled*, *Chotard et cie*, or even *Madame Bovary*. His films would be committed to higher ideals than the making of money. Just as well, because Jean Renoir, who was to create, by consensus, at least two of the greatest films ever made, was unable to derive much financial reward from them.

PART IV

CITIZEN RENOIR
(1934–1940)

19

Provençal Passions

Toni was to speed up my separation from the notion of the predominance of the individual. I could no longer be satisfied with a world which was nothing but the dwelling-place of persons having no link between them.

Marcel Pagnol was Jean Renoir's junior by a few months. There are few *cinéastes* as closely identified with one geographic location as Pagnol. His province is Provence, more exactly Marseilles and its environs, the area where he was born. Pagnol's pictures are redolent of its sights, sounds and smells – the vineyard-covered hills, the rich Southern accents, the constant chirping of crickets, the taste of *pastis*, the clunk of *pétanque*. The splendid array of colourful characters, defined by their professions in a tight-knit community, is an essential part of this environment. 'The subjects of my films are simple, for I find there is no art outside ordinary places and people,' Pagnol claimed, a statement that echoed Jean's feelings in the 1930s.

Jean got to know Pagnol well at the time the latter entered cinema in 1931 as producer, advisor and screenwriter on *Marius*, the film of his hit play of the same name. His object was to use the cinema merely as a medium for bringing his plays to wider audiences, and as a record of the stage performances of them. When he started taking a hand in directing himself, he became more interested in the process of film-making.

Pagnol, who preferred to call himself a *cinématurge*, produced,

wrote, directed (or 'supervised') all his films. He chose the actors, technicians and even workmen. Jean compared the studio Pagnol built near Marseilles in 1934 with the *atelier* of a medieval master-carpenter and artist, something the son of the great painter envied. Jean also envied Pagnol's 'gifts both for commerce and for the art of entertainment.'[1]

The first film produced by his own company, Films Marcel Pagnol, was *Angèle*, which he shot in natural surroundings by installing his troupe on a farm and using direct sound. Although *Angèle* was made after *La Chienne* and *Boudu*, it is often cited as the first important French talkie shot on location, and was acknowledged as the first neo-realist film eight years before the term was coined by the critic Antonio Pietrangeli in reference to *Ossessione*, Luchino Visconti's debut feature. In fact, *Toni*, Jean's film of the same year (1934) can be seen now as far closer than *Angèle* to the ideals of the Italian neo-realist movement in its use of non-actors and its social concern. Although *Toni* remained unseen by most of the directors labelled neo-realist, it was a direct influence on *Ossessione*, based on James M. Cain's *The Postman Always Rings Twice*, a subject suggested by Renoir to Visconti, who was a lowly 27-year-old assistant on *Toni*. Jean, who was introduced to Visconti through Coco Chanel, handed him the typescript of a French translation of the novel to read, remarking it would make an interesting subject for a film.

When Marcel Pagnol offered Jean the facilities of his studio at Marseilles and his distribution organisation, Jean and Marguerite left Paris in the summer of 1934 for the South, taking with them only a few technicians, including nephew Claude, making his debut as director of photography, and one actor, Max Dalban, who had been in almost every Renoir film since 1929, to play the only Northerner among southern Europeans.

In stark contrast to *Madame Bovary*, Jean had decided to take a contemporary *fait divers* as the basis for his next film. He completely abandoned the studio, filmed exclusively outdoors and in genuine interiors in the Midi, used authentic sound and drew his actors from the region where the story was set and shot. Among them was a black American who happened to be working there, making him one of the few blacks in the films of the time to be treated on a par with the other characters.

Among the professional actors were Edouard Delmont, Andrex,

and Charles Blavette, all of whom were Pagnol regulars. Blavette explained that when he turned up in the courtyard of the studio in Marseilles, the set designer Léon Bourrely told him that the boss (Pagnol) wanted to see him. Pagnol said, 'Look, Jean Renoir is working on a film, *Toni*. He's looking for a lead, and I told him you had the part.' Blavette replied, 'It can't be. What?' Then, 'the light in the room began to dim. It was simply Jean Renoir who had entered the room and who was standing in front of the window.'[2]

Toni was derived from an account of a murder told to Jean by Jacques Mortier, an old friend of his since they had been classmates at Sainte-Croix and at the lycée in Nice, who was the police chief at Martigues, a small town in the Rhone delta, where the crime was committed. Mortier, also a writer of thrillers under the nom de plume of Jacques Levert, assembled the facts of the case, and Jean then wrote the screenplay with the art critic Karl Einstein.

It told of Toni Canova (Blavette), who comes to Martigues from Italy to work in the quarry. He becomes the lover of Marie (Jenny Hélia), in whose boarding house he lives, but falls in love with Josepha (Célia Montalvan), a young Spanish immigrant, whom he wishes to marry. But Josepha is seduced by Albert (Dalban), the foreman of the quarry and, in a double wedding, Josepha marries Albert, and Toni weds Marie. Two years later, both marriages have broken down. Toni has gone to live in the hills with a group of Corsican charcoal burners, still dreaming of carrying off Josepha, while Josepha and her cousin Gaby (Andrex) plan to run away together after taking Albert's money. Albert wakes up as Josepha is robbing him and beats her up before she kills him with the gun he has left lying around. Toni, who is arrested for the crime, is fatally shot while attempting to escape.

Baldly related, this tale of passion, jealousy and murder resembles a *verismo* drama on the lines of *Cavalleria Rusticana*, but the film is remarkable for its avoidance of the melodramatic. The plot seems to emerge only incidentally from the details of the everyday life of the immigrant workers, whom Renoir presents bluntly, without romanticism or special pleading, creating a sense of community.

The depth and fluidity of the camerawork, the use of natural light and the feeling for figures in a landscape, form an environment essential to the characters and their interaction with it. Within this recognisable world of deprivation and hardship, the characters take their pleasures where they may. Sex, a driving force throughout many of Renoir's films, here differs from his previous bourgeois

settings, where it had functioned as a matter of power or diversion. In *Toni*, Renoir's first film set among the working classes, sex is revealed as something that gives meaning to hopeless lives, an essential part of Renoir's all-encompassing view of nature, so that Albert makes love to Josepha in a ditch, and Toni sensually sucks a bee-sting from Josepha's neck.

Every frame contains a gesture or a movement that demonstrates simple moments of life being lived rather than acted – the combing of hair, the pouring of coffee, the fondling of a kitten. The sound track, too, always so important in Renoir's films, has an immediacy and richness that adds another dimension to the work; 'montage rather than sonorisation,' according to Jean Cauliez.[3] The improvisational dialogue is a *mélange* of accents – Italian, Spanish, Provençal – and, for Jean, 'the Piedmontese and Corsican songs had a lot to do with setting the tone of that film',[4] just as the street ditty, *La Sérénade du pavé*, and the songs *Les Fleurs du jardin* and *Sur Les Bordes de la rivière* had haunted *La Chienne* and *Boudu sauvé des eaux*, and as other melodies would do in future films.

Sadly, the producer, Pierre Gaut, found it necessary to cut several minutes from the film. The lost footage showed Toni and Josepha putting Albert's body in a laundry cart, covering it with dirty linen and pulling it along the path towards the woods. On the way they come across some of Toni's Corsican coal-worker friends, who jokingly decide to follow along and sing behind them as a mock cortège.

'It was a good scene, I think, but we had to cut it and it disappeared. Yes, it's too bad,' Jean commented. 'At the time, corpses weren't accepted in films, or else they had to be rather noble corpses. The death had to have taken place before the revolution, and there had to have been a duel. A gentleman killed in a duel without too much blood was acceptable. But a gory murder like the one in *Toni* was not acceptable to the usual distribution channels. So it was very difficult to release the film.'[5]

Toni received a cool reception when it was shown in February 1935 at the Ciné-Opéra and Bonaparte cinemas in Paris. Rivette and Truffaut expressed the view that the failure of *Toni* was due to the fact that it was released immediately after *Angèle*,[6] which, together with its authentic Provençal background, has a beautifully crafted script (from a Jean Giono short story) and a familiar melodramatic plot of a fallen woman redeemed. Audiences were just not ready for Renoir's grittier, more quotidian approach. 'People hate to have

their expectations upset, and at that time the film was strange, unexpected. And it seemed brutal to people . . . It was as welcome as a hair in a bowl of soup,' Jean judged.[7]

'I attached as much importance to the countrywoman surprised while doing her washing as to the hero of the story,' Jean explained. 'What characterised *Toni* is the absence of any dominating element, whether star performer, setting or situation. My aim was to give the impression that I was carrying a camera and microphone in my pocket and recording whatever came my way, regardless of its comparative importance . . . it signalled the accomplishment of my dream of uncompromising realism . . . it was to speed up my separation from the notion of the predominance of the individual. I could no longer be satisfied with a world which was nothing but the dwelling-place of persons having no link between them . . . in the film I began to feel the importance of unity . . . I made a point of using panning shots which clearly linked the characters with one another and with their environment.'[8]

Camaraderie was an important element in Jean's life at the time. Although most of his films carry the stamp of his own personality – if one loves the work, one loves the man – they were made in a true communal spirit of friendship. It is in the nature of making a film, when a group of people are thrown together for a period of time, that intimacy is created, a process depicted so graphically by François Truffaut in *La Nuit américaine/Day for Night* (1973). At one stage in that film, Jean-Pierre Léaud asks the director, 'Are films more important than life?' Truffaut's film is the affirmative answer. Renoir's response would have been different. It often seems that, for him, the making of a film was a good excuse to be in the company of people he liked and loved.

During the making of *Toni*, Jean recalled the games of *pétanque* his team played against one of Pagnol's. The joys of this favourite pastime of the Midi were recreated in the very last episode of his very last film. *Le Roi d'Yvetot* is not only a homage to the game but to his friend Pagnol.

Constantly in his memoirs, Jean recounts the incidental pleasures of film-making, and titles one chapter 'Friendship', something for which he had a great capacity until the end of his life. Through the pages are warm recollections of Paul Cézanne *fils*, and three Pierres – Champagne, Lestringuez and Braunberger. Of his relationship with Jacques Becker, he wrote: 'The affection between us went far beyond the bounds of normal friendship, so much so indeed that

had it not been for our physical aspect ill-intentioned minds might have suspected a relationship of quite another kind. And why not? I am a firm believer in loving friendships in which there is no sexual element."[9] He was to recapture the same affinity, many years later, with François Truffaut.

With *Toni*, Jean began his explorations into how to reconcile individual liberty with the fraternity of the human race, in both of which he believed passionately, a theme that was to dominate his subsequent pre-war films.

20

'Vive le Front Populaire!'

'I believed that every honest man owed it to himself to resist Nazism. I am a film-maker, and this was the only way in which I could play a part in the battle.'

Despite Renoir's commercial disasters, looking back on the beginning of 1935 when *Toni* was released, it can be seen that he already reigned supreme among French film directors. René Clair had left France to make films in England before going on to America; since *Angèle*, Marcel Pagnol had directed only a couple of his most minor films; Marc Allégret, who directed *Fanny* (1932) for Pagnol, had just made the charming *Lac aux dames*, which made stars of Simone Simon and Jean-Pierre Aumont, but it was a conventional work, and Abel Gance had failed to adapt to sound, his Romantic visual imagination seemingly constrained by it. Jean Vigo, who, in *L'Atalante*, had brilliantly utilised the anarchic and bacchanalian side of Michel Simon, as revealed in *Boudu*, died tragically on 26 October 1934 aged 29, a few weeks after the film's première. Marcel Carné had yet to embark on a feature; he was an assistant director to Jacques Feyder, Renoir's only rival at the time. Feyder had brought out *Le Grand Jeu*, an exotic romance set (not filmed) in Morocco, but *Pension Mimosas* and *La Kermesse héroïque* were yet to be released.

After *Toni*, Jean, thinking of other projects concerning 'simple'

people, expressed a wish to make a film about Lapp fishermen and hunters. He remembered Robert Flaherty's *Nanook Of The North* (1922), and had recently seen the same director's *Man Of Aran*, a documentary about the fishermen of a barren, impoverished island off the coast of Ireland. What appealed to Jean was Flaherty's view of the importance of primitive societies and the natural environment. When Jean failed to get anyone interested in his ethnological venture, he turned his attention to a subject nearer home, which was a more direct result of his being caught up in a wave of radical politics, and reflected the tumultuous political events of the day.

A few months before Jean had started filming *Toni*, the infamous crooked financier Alexander Stavisky committed suicide in his ski-chalet at Chamonix. The swindler was alleged to have had excellent co-operation from official quarters for his nefarious activities. Both left and right made political capital from the scandal, the Fascist *Action Française* bringing up the fact that Stavisky was Jewish, and the Communist Party presenting him as a product of a corrupt system.

On 22 January 1934, there were 750 arrests as both left and right clashed with police. The Prime Minister, Camille Chautemps, who was implicated in the Stavisky affair, resigned, giving way, on 29 January, to a new Radical government led by Edouard Daladier. One of Daladier's first acts was to dismiss the Paris chief of police, Chiappe, who was alleged to have had dealings not only with Stavisky but also with the extreme right. M. Chiappe was the man who had suppressed Luis Buñuel's *L'Âge d'or* in 1930, after giving in to right-wing pressure. (Buñuel later immortalised him by having Fascists shout 'Vivre Chiappe' at the end of his updated 1964 version of *The Diary Of A Chambermaid*.) Chiappe's exit sparked off riots in the place de la Concorde on 6 February, when 100,000 people gathered opposite the Chamber of Deputies, among them such Fascist paramilitary groups as the *Croix de Feu*, leaving 12 dead and 57 injured. On 12 February, there was a one-day general strike called by left-wing groups and trade unions.

When the Daladier government fell in March, Gaston Doumergue returned to form a National Government 'to restore both order and the honour of the Republic.' The unstately quadrille continued nine months later, when Doumergue resigned, and Pierre Flandin succeeded him. In June 1935, Pierre Laval took over as prime minister, the same month that Jean was present at the First Writers Congress

For The Defence Of Culture in Paris. One of the speakers was Brecht, who destroyed the myth that the origins of Fascism were due to some 'miseducation' of the Germans. He spoke of the need of artists to understand the economic basis of Nazism, an exploitative movement dominated by big business. Alarmed by the power of the Fascist leagues, a union of all the parties of the left, mainly Radical Socialists and Communists, was formed, calling itself *Le Front Populaire*. On Bastille Day, 14 July 1935, a crowd of about 250,000 gathered for an 'assize of peace and liberty to fight Fascism' in the velodrome in the bois de Vincennes. Among the assembly were Jean, Marguerite, Jacques Becker and other friends. During the same period, Jean attended Communist Party rallies and wrote and spoke in support of the left.

These heady days of smoke-filled rooms, passionate political discussions, red wine, salami sandwiches and radical songs were a dramatic contrast to Jean's middle-class upbringing and the egotistical frivolities of his former life with Dédée.

Among the people with whom Jean was in close contact was the *Groupe Octobre* (named after the month in 1917 in which the Russian Revolution succeeded), a radical theatre company formed in 1933 by Jean-Paul Dreyfus (later Le Chanois, the code-name he adopted in the Resistance). Its aim was to reveal the vital political issues of the time to a proletarian audience, taking plays to factories, shops and strike meetings, in an attempt to break away from the traditions of the bourgeois theatre. Members of the group included Guy Decombres, Raymond Bussières, Jacques Brunius, Fabien Lorris, Sylvie Bataille, Marcel Duhamel, Henri Cartier-Bresson, Sylvaine Itkine, Jean Dasté, Joseph Kosma, Lou Tchimoukov (actually Lou Bonin), Pierre Unik, Paul Grimaud and Jacques Prévert, many of whom would work with Jean, making a marked impression on his subsequent films.

Jean Castanier (often credited under his real name of Castanyer), Renoir's Catalan painter friend and a member of the *Groupe Octobre*, who had designed sets for *La Nuit du carrefour*, *Boudu* and *Chotard et cie*, had an idea for a film called *Sur la cour*, about a group of print-shop workers and laundresses who hope to set up a co-operative. He had found a producer, André Halley Des Fontaines, and early in 1935 he explained the plot to Jacques Becker, who immediately wanted to direct it. Becker, who had assisted Renoir on three films, and produced a short by Pierre Prévert entitled *Le Commissaire et bon*

enfant (1934), considered himself ready to become a director himself. But Des Fontaines did not feel confident enough in Becker to entrust the film to him and asked Renoir to direct it. Jean agreed, not knowing of Becker's wishes. As a result, Becker was furious with Des Fontaines, who was a friend, and most of all with Jean, whom he felt had betrayed him. Castanier was disappointed that Becker was unable to grasp the fact that the film was to be a collective enterprise and not one to satisfy individual egos. The temporary rift between Jean and his bosom pal was soon healed, however, with Becker back working with Renoir on his next five films.

The first draft of the screenplay of *Sur la cour*, renamed *Le Crime de Monsieur Lange*, was written by Jean and Castanier, but it lacked an essential spirit. Jean suggested they bring in Jacques Prévert to supply it. Prévert, born a month into the century, had been part of the Surrealist movement in the 1920s, and was beginning to establish himself as a poet with a taste for social satire combined with incongruous humour. He had written the script and acted in *L'Affaire est dans le sac*, a delightful, irreverent surreal comedy directed by his younger brother Pierre in 1932.

Le Crime de Monsieur Lange was shot in approximately 28 days during October–November 1935, on location in Paris and at the Billancourt Studios. As related by Jean, 'Prévert came on the set every day. I constantly said to him, "Well, old man, here we have to improvise," and the film was improvised, as were all my films, but with Prévert's constant collaboration. I'm sure that it would be impossible to know the origin of which ideas were mine and which were Jacques'. Actually, we found everything together.'[1]

What they found was a bang up-to-date story of contemporary Parisian life, seen from a left-wing perspective. But, like many great works of art, it has wider and more durable humanistic qualities, allowing it to survive the years and be appreciated by audiences without knowledge of its specific political background. This classic film of working-class solidarity, presented in the language of ironic black comedy, expressed the optimism of the Popular Front rather better than more didactic efforts.

Most of the action takes place around a courtyard where a group of exploited print-workers slave away for their crooked boss Batala (Jules Berry). Amédée Lange (René Lefèvre), Batala's assistant, spends his free time writing Westerns about Arizona Jim. Batala swindles Lange into signing away his author's rights and publishes *Arizona Jim*, but Batala's shady dealings catch up with him and he

absconds, leading everybody to believe he has been killed in a train crash. (Here Renoir alludes to the 1933 Paris-Strasbourg express railway disaster, the second worst in history at that date.) The workers seize control of the publishing house and make a success of it as a co-operative. When Batala returns, disguised as a priest, intending to regain control, the normally timid Lange shoots his former boss dead.

The film begins with a sequence in which the laundress Valentine (Florelle), who has fled to a frontier town with Lange, explains to the patron and some guests at a hotel how her lover came to be wanted for murder. Finally, the film returns to the opening scene, where we see Lange and Valentine crossing the border to freedom. Once again, as in *La Chienne*, a murderer gets off scot-free.

The most striking element about the style of *Monsieur Lange* is the remarkable mobility of the camera, moving from place to place, character to character, linking them all and thus underlining the strong sense of community that binds them. The final 360-degree pan when Lange murders Batala is an even greater *tour de force* than the one that concludes *Boudu*. Suddenly Lange becomes a man of action, taking on the nature of his cowboy hero, and the camera follows him rapidly from window to window, down the stairway to the courtyard, then swings around to catch Batala in the light, like a rabbit caught in headlights.

For all its sense of improvisation and fluidity of movement, the film is a carefully structured piece – intricate plot, crafted dialogue – yet it never seems constrained. Jean thought it would make a very good opera, perhaps on Brecht-Weill lines. 'It's full of opportunities for interesting songs. The song of the printer, the song of the laundress, the air of the concierge, right in the middle of the garbage cans,' he remarked.[2] As it is, Florelle as Valentine, the laundress, sings 'Au Jour le jour, à la nuit la nuit', with music and lyrics by Joseph Kosma and Jacques Prévert, rather awkwardly interpolated into the action, accompanied by a hidden orchestra on the sound track. The song of the concierge (Marcel Levesque), on the other hand, is a drunken rendering of 'C'est la Nuit de Noël', at a celebratory dinner, after which the man stumbles out to find the dying Batala in his priest's clothes asking for a priest. The *concierge*, a comic figure representing authority, begins to cry out for a priest, his shouts echoing around the empty courtyard.

As Renoir focuses so forcefully on character behaviour – not on motivation or psychology, but the way in which he discovers people

at a given moment in their lives – the performances always loom large in any estimation of his films. Jules Berry, the most hypnotically suave and odious villain in French cinema, creates one of the rare leading characters of whom Renoir is negatively judgemental. (Among others, only Kostileff in *Les Bas-Fonds*, and Von Keller, the Nazi major in *This Land Is Mine*, come to mind.) However, Berry's wicked capitalist – 'Ha! Co-operatives! But what's that, a co-operative? It's ridiculous . . . Everybody in charge! . . . Oh, no! What's necessary is authority, someone who gives orders, a man! Me! Ha! And then when I feel like it, I'll throw everyone out the door!' – has enough insidious charm and wit to be convincing. When Lange asks who would miss him if he died, he replies, '*Les femmes, mon vieux!*'

René Lefèvre, with his pale, rather blank face and receding hairline, is the antithesis of Berry, and perfect as an ordinary working man caught up in extraordinary events. The character is hesitant and awkward, a dreamer who only becomes animated and attentive at the mention of his Westerns. 'He is always elsewhere,' says Valentine. The rest of the cast play as an ensemble, moving in and out of the action, among the two opposing protagonists.

Truffaut, who tried to capture an element of it in *Domicile conjugale/ Bed And Board* (1970), called the film 'the most spontaneous of Renoir's films, the one most crowded with acting and technical miracles, the one most full of pure beauty and truth; one might even say it was touched by divine grace.'[3] Critic André Bazin called the film 'one of Renoir's most beautiful works and one of the most representative of his genius and talent';[4] while Georges Sadoul described it as a signpost because 'Prévert and Renoir had, almost without effort, discovered the touchstone of popularity throughout France. They had learnt how to portray the ordinary man in the street – the butcher, the baker, the humble clerk and the successful business-man – with the exactness of Émile Zola and of Auguste Renoir'.[5]

These comments were only delivered some years after *Monsieur Lange* opened to rather indifferent reviews in January 1936. Although couched in the form of a comedy, the dark undertones, the inherent social consciousness, the impassioned plea for collectivism and working-class solidarity against the evils of capitalism, though worn lightly, as well as anti-clerical, anti-military elements, and the condoned murder, made it an uncomfortable form of entertainment for contemporary middle-class French audiences.

*

In December 1935, after completing *Le Crime de Monsieur Lange*, Jean was invited to visit Moscow, where *Toni* was to be shown at a festival. Travelling with Marguerite and nephew Claude, he stayed 10 days. During the screening of *Toni*, reels were shown in the wrong order, but as the Russians did not seem to notice anything amiss, Jean kept silent so as not to embarrass his hosts. Claude remembers them seeing a great many films during the day, and going to parties at night, full of vodka and songs.

By the mid-1930s, the Soviet cinema had lost much of its early genius and exuberance, although there were still some masterpieces produced, despite, or in some cases, because of the heavy hand of Stalinist censorship and the imposition of Socialist Realism. In January 1935, Sergei Eisenstein had been humiliated by the All Union Conference of Cinematographic Workers, and hence found it difficult to start a project. Alexander Dovzhenko, too, was having a problem finding an approved subject, and *Aerograd* (1935) was his first film for three years. Lev Kuleshov, accused by the authorities of 'intellectualism', was unable to make any major films since the extraordinary *Dura Lex* in 1926. Pudovkin had recently been seriously injured in a car accident and was unable to work for a long period. Dziga Vertov, though not rebuked by the Central Committee like Eisenstein or Kuleshov, was allowed to fade away after his *Three Songs For Lenin* (1934). The film that impressed Jean most during his stay in Moscow was Grigori Kozintsev and Leonid Trauberg's *The Youth Of Maxim*, one of the most human of revolutionary works, a study of a flesh-and-blood unromanticised individual caught up in the struggle.

Unlike André Gide, who was in the Soviet Union at almost the same time, Jean's enthusiasm for the Communist experiment was undimmed when he returned to France, ready to make a film on behalf of the French Communist Party before the May 1936 elections. Gide, who had been attracted to Communism like many of his fellow intellectuals and artists in the 1930s, expressed his disappointment with the Soviet Union in *Retour de l'URSS*, where he found social inequalities as grave as in the Western capitalist countries and an insistence on the blind orthodoxy which he had been fighting all his life.

Coincidentally, on his return from Moscow, Jean read an essay by Gide in a collection edited six years before under the title *Ne Jugez Pas*. The particular piece, called *La Séquestrée de Poitiers*, concerned a case in which a young woman was kept prisoner for

years in an upstairs room by her mother and brother after she had
become pregnant by a young soldier while engaged to an officer her
parents had chosen. Early in 1936, Jean wrote three synopses for a
film to be called *La Séquestrée*, for which he wanted the unusual-
looking German singer-actress Marianne Oswald, who had recently
performed Jean Cocteau's '*chanson parlées*', *Anna la Bonne* and *La
Dame de Monte Carlo*, to play the confined girl.

Unlike Gide, who just presented the facts and believed that the
girl had become a voluntary recluse, Jean wanted to use the true
story as an ironic exposé of the hypocrisy of both the citizens of the
town, who knew of the girl's ill-treatment but remained quiet, and
of the respectable provincial bourgeois family who behaved in this
manner. The unmade film would have ended with the mother
serving tea to friends and remarking on the difficulty of bringing up
children. Though not overtly political, it would have continued, in
a slightly more dramatic and realistic vein than *Monsieur Lange*,
Renoir's attack on authoritarianism, be it from the family, the army,
the church or the state.

While looking for someone with cash to take an interest in the
proposition, the novelist Louis Aragon, who had broken with the
Surrealists in 1933 and had fully embraced the Communist Party,
asked Jean to take on the supervision of *La Vie est à nous* for the
Party.

'The red springtime of the Popular Front and its procession of
revolutionary images; factories occupied by workers; the 14 July
Bastille Day parades in which giant portraits of Maurice Thorez and
Léon Blum were carried alongside those of Robespierre, Saint-Just
and Émile Zola; the leftist flags flashing scarlet, the joyous throng
singing La Carmagnole, La Marseillaise and the Internationale
through the heart of working-class Paris.'[6] That was how Count
Don Luchino Visconti di Modrone, alias Luchino Visconti,
described the atmosphere in Paris during the period he was working
as one of Renoir's assistants. It was at this period that Visconti
embraced Communism, an ideology he remained committed to,
more or less, for the rest of his life, as well as being immensely
influenced by Renoir in his eventual decision to become a director.
'It was in fact my stay in France and my meeting with a man like
Renoir that opened my eyes to a lot of things. I realised that films
could be the way to touch on truths we were very far away from,
especially in Italy.'[7]

In the run-up towards the May 1936 elections, Jacques Duclos, one of the leaders of the Communist Party, had the idea to commission a propaganda film to show at public meetings. Like Lenin, who believed that the cinema was a significant tool of the Revolution, Duclos was conscious of the power of film. Because *Le Crime de Monsieur Lange* had labelled Renoir as France's leading left-wing filmmaker, he was the Party's natural choice to 'supervise' the film, whose different episodes were directed by different hands. Jean was, so to speak, *metteur en scène en chef*, surrounded by his younger assistants, including Jacques Becker, back in the fold. It was to be a true collective film, on which nobody would be paid, and would be financed by contributions from Party workers, who gave what they could after public meetings.

'The making of *La Vie est à Nous* put me in touch with people having a genuine love of the working class. I saw in the workers' possession of power a possible antidote to our destructive egotism,' wrote Jean many years later, characteristically unapologetic about his past. 'Left-wing militants at the time were truly disinterested. They were Frenchmen with all the defects and virtues of Frenchmen, wholly without Russian mysticism or Latin grandiloquence. They were warm-hearted realists. Their views might differ, but they were still Frenchmen. I felt at ease in their company, enjoying the same popular songs and the same red wine.'[8]

Jean got to know Maurice Thorez, the secretary-general of the Party since 1930, who once spent a few days with Jean and Marguerite at Les Collettes, where Coco and his family lived. Thorez, a son of the people, who resembled a wrestler, was to go underground when the Party was banned by the return of the Daladier government during the War, but returned from exile in the Soviet Union when granted a pardon by De Gaulle.

Jean had left the house in Meudon and taken an apartment in his favourite district of Montmartre at 9 rue des Saules. In the same building lived his brother Pierre, now married to Elisa Ruis, a much younger actress, who would play the role of Madame de Lamballe in *La Marseillaise*. The apartment was not far from the cultural centre at rue Navarin run by Louis Aragon for the Party, and where Jean met many members of the *Groupe Octobre*, some of whom would become his collaborators on *La Vie est à nous*. The screenplay was written by Renoir, Paul Vaillant-Couturier, a leading member of the Party, André Zwobada and Jean-Paul Dreyfus (Le Chanois).

*

La Vie est à nous opens as a conventional, eulogistic documentary on the wonders of France, 'one of the richest and most beautiful countries in the world'. The narrator goes on to intone statistics on wheat, wine and steel production over idealised images of bountiful fields, vineyards and forests. The film then cuts to a schoolroom in which the narrator is seen to be a teacher (Jean Dasté) facing a class of poor kids who have obviously seen nothing of the wealth described. The first shots then have functioned ironically. Seen today, however, they present as a double irony, because the documentary section is an unintentional parody of Soviet propaganda films made at the same time, while famine was rife.

The scrawny schoolboys in berets and shorts file out into the dreary streets whistling *La Cucaracha*, a hit of the day, and questioning why they are poor if France is so rich. They pass a woman on a soapbox declaiming that 'France doesn't belong to the French people. It belongs to the 200 families', which is followed by newsreel shots of unemployment, depression and strikes, the *Croix de Feu* on the march, and Hitler barking like a dog. When a man in a crowd says nothing can be done to stop them, a worker replies, 'Yes! There's the Communist Party.'

A newspaper vendor is beaten up by Fascist thugs for selling *L'Humanité*, the Communist daily. But hundreds of comrades fill the screen, answering the call to join and defeat the enemy. At the offices of *L'Huma*, as it was (and is) popularly known, the editor Marcel Cachin peruses a number of letters sent in by readers. Three of them form the basis for three illustrative episodes or, in Brecht's term, *Lehrstücke* (didactic pieces).

The first, directed by Jean-Paul Le Chanois, tells of the dismissal of an aging factory worker and the way the Communist cell gets the management to keep him on. Jean appears briefly as a café owner, his voice more recognisable than his face. The second episode, directed by Jacques Becker, perhaps the best fictional sequence, concerns a poor farmer having to sell all his goods at an auction. But his Communist nephew (Gaston Modot) gathers enough of his comrades to dissuade anyone else but them from making bids. As a result, the farmer's furniture, animals and tractor are bought for a measly 112 francs and returned to him and his family.

The third episode, directed by Renoir, tells of how a young unemployed engineer (Julien Bertheau) is reduced to tramping the streets in search of work, queuing at a soup kitchen only to find it closes before his turn. Cold and hungry, he slumps in a doorway

where he is found by two members of the Party, who take him to a warm café where many others are gathered. Here the film resembles a Salvation Army advertisement, the difference being, that instead of a choir singing Onward Christian Soldiers, the Chorale Populaire de Paris sings in praise of workers' unity through Communism. 'Comrade, you are not alone!' the engineer is told.

The final section mixes fact and fiction, with the characters seen in the three episodes attending a rally where the speakers are Jean Renaud, Marcel Cachin, Marcel Guitton, Jacques Duclos and Maurice Thorez. Behind them are pictures of Lenin and Stalin. The film ends with the singing of the Internationale by crowds of people marching with their fists in the air. The last shot is of a little blond child being held up against the sky, suggesting that a glorious future will be his.

La Vie est à nous glows with enthusiasm and optimism (the Popular Front had just won a victory in the Spanish election in February 1936), and contains many striking images among some cruder ones. Despite the mixture of styles, from French naturalism to Russian Socialist Realism, the collaborative effort still has a unity and the stamp of Renoir on it.

Completed several weeks before the May election, it was not distributed as a commercial film but was projected at political meetings. There was no charge for admission, but the viewers had to subscribe to a new periodical, Ciné-Liberté, run by the Front Populaire which also had a cinema club at the rue Navarin. The magazine was started by Germaine Dulac, the director who had given up making fictional films for newsreel production in 1929; Henri Jeanson, the witty critic and scenarist; film theorist Léon Moussinac, and Renoir. The first issue was published on 20 May 1936 and contained an article by Renoir on Chaplin's Modern Times, which had just been released.

La Vie est à nous, under the title of The People Of France, was shown in New York in December 1937, when the white heat that engendered the film had cooled considerably. It was compared unfavourably (and unfairly) by Bosley Crowther in The New York Times with The Spanish Earth, the Joris Ivens documentary supporting the Republican cause in the Spanish Civil War which boasted commentary written and spoken by Ernest Hemingway. (Renoir, a friend of the radical Dutch director, contributed the French narration for release in France.) 'Whereas The Spanish Earth was a masterpiece of beautiful and simple cinematic statement, making its points

conclusively by artful implication, *The People of France* appeals to
the case for the poor against the privileged with blunt and repetitious
insistence . . . It is too bad that the imagination and ingenuity of
some very fine artists should be compelled to carry such an obvious
and burdensome diatribe.'

Variety called it 'a paste-up job using some doc material and some
especially made for the film, all having a decided Communist slant
. . . The distributors claim to have shown it here now because of its
artistic interest. It's more revealing of Communist zeal and fervour
than art, however.'

In France, it had an impact at its first public showing at the small
Studio Git-le-Coeur cinema on the Left Bank in November 1969,
because the *événements* of May 1968 were still fresh in the minds of
the audience.

In June 1936, the Socialist Léon Blum became Prime Minister
after election gains by the Popular Front alliance. Strikes were
ended, pay rises of twelve per cent, a 40-hour working week, and
an annual two-week paid holiday were granted. Union leader Léon
Jouhaux stated that 'For the first time in history an entire class has
won improved conditions.' But the Communist Party refused to
participate in the Blum government because of disagreements with
aspects of the Socialist election manifesto and the government's
lifting of sanctions against Italy which had been in place not long
after Mussolini's invasion of Abyssinia in October 1935. Jean was
among the 400,000 who gathered to demonstrate in the Père Lachaise
cemetery shouting, 'Vive le Front Populaire! Vive Le Commune!'
However, the month that the Spanish Civil War erupted, he and his
companions were able to escape to the banks of the Loing river to
enjoy *Une Partie de campagne*.

21

Two Months in the Country

'If I were the son of a nursery gardener, I would probably know a great deal about trees, and I would have an extraordinary taste for gardens. But I'm the son of a painter, so I'm more or less influenced by the painters who surrounded me, who surrounded the little person I was when I was young.'

Une Partie de campagne seems a tranquil interlude in Renoir's oeuvre, a leisurely holiday between the films with big themes, a breathing space before another confrontation with the world at large, a last sigh of pre-war contentment.

Jean wanted to return to the world of Auguste Renoir and fellow Impressionists after having tackled three contemporary subjects. He had always liked the novella by Guy de Maupassant called *Une Partie de campagne*, principally because it was set beside a river. In order to be faithful to the master of the nineteenth-century naturalist short story, he originally conceived it as a relatively short feature, no longer than 60 minutes.

Auguste used to meet Maupassant at a mutual friend's house in Louveciennes. 'The two men were friendly enough but frankly admitted they had nothing in common,' Jean wrote. 'Renoir said of the writer, "He always looks on the dark side" – while Maupassant said of the painter, "He always looks on the bright side." There was, however, one point on which they did agree: "Maupassant is mad," asserted Renoir. "Renoir is mad," declared Maupassant.'[1] Jean fails to mention, however, that Maupassant was indeed certified insane

at the end of his short life – he died a month short of his forty-third birthday, about a year before Jean was born – his health undermined by VD contracted in his youth and the pressure of work.

Aside from Maupassant's realism, what attracted Jean was the way in which the writer built simple, often absurd, episodes around banal lives, in an objective and ironic manner. But the director, believing in the anti-Fascist cause and an alternative social system, differed philosophically from Maupassant's essentially pessimistic view of his characters' inability to escape from the limitations of their petty lives, their avarice and lechery. Yet Jean, though by nature an optimist and, at that period, committed to the ideals of the Left, was not even a member of the Party when he made *La Vie est à nous*. He always retained a measure of scepticism towards specific ideologies, and was suspicious of 'progress'. 'Progress is dangerous because it is based on perfect technology. It is its success which has distorted the normal values of life and compelled man to live in a world for which he was not intended.'[2] He felt that Fascism and Communism both believed in progress, though his opinion expressed in 1974 was 'if I were forced to do so, with my back to the wall, I would opt for Communism because it seems to me that those who believe in it have a truer conception of human dignity.'[3]

When he attended the Popular Front meeting at the bois de Vincennes, he had found himself between two opposing groups arguing the aims of the revolution. A carpenter said that he would loot the cellars of the rich. 'They can keep their pictures and silver dishes. All I want is good red wine.' A girl from the other group said, 'What right have we got to take the place of the bourgeoisie if we're simply going to imitate their debauched way of living? I want the revolution to improve the human condition, to make a nobler and more generous kind of man than is possible in a reactionary society.'[4] Jean leaves us to judge which of the interlocutors he feels closer to.

The serenity of *Une Partie de campagne* does not reflect the conditions under which it was made. For the location shooting Jean chose the banks of the Loing river at Montigny near his home in Marlotte where, in 1866, Auguste had painted his *Cabaret de la Mère Anthony*, and where he had shot *La Fille de l'eau* and part of *La Vie est à nous*. Montigny-sur-Loing itself is still a picturesque village with a church set up in the hills and private gardens laid out on the islets. Nearby at Moret was Alfred Sisley's house where the painter lived and died,

forever faithful to the forest. Jean had searched in vain for suitable sites on the banks of the Seine where Maupassant had set the story, but the open-air riverside dance halls of *La Grenouillère* and *Le Déjeuner des canotiers*, the painting in which his mother first appeared, had been replaced by factories and other modern buildings.

Jean, therefore, wrote the script with the Loing region in mind, since it could represent the Seine of 80 years earlier. But, most of all, he selected the area because of his deep knowledge of it. 'I knew what time the light would be hitting a specific group of trees in a particularly pleasing way. I knew even the smallest details of the landscape.'[5]

So in the summer of 1936, four Renoirs, Jean, Marguerite, 16-year-old Alain and 21-year-old Claude, director of photography, set off for the forest of Fontainebleu. With them were six assistant directors – Yves Allégret, Jacques Becker, Jacques Brunius, Henri Cartier-Bresson, Claude Heymann and Luchino Visconti – a further crew, and the cast. They all stayed in a house borrowed from Jean's friend, Anne-Marie Verrier, whose husband was a forest ranger. It was situated on the banks of the Loing, near a bridge. A sign marked 'Restaurant Poulain – Repas 2F 50' was nailed to the front, and it became the *auberge* of the film.

Among the cast was 24-year-old Sylvie Bataille, who had played Jules Berry's secretary/mistress in *Le Crime de Monsieur Lange*. She was a member of the *Groupe Octobre* and married to the writer Georges Bataille. Jean commented that *Une Partie* grew out of a desire to find another part for her, and he thought that she would look just right in the costumes of the period. As Henriette Dufour, the dark, fresh-faced, beautiful daughter of the bourgeois Parisian couple on a country outing, Bataille found her most famous role of all her 24 films. During Jean's career, there were a number of pictures whose genesis lay in a wish to work with certain performers. For instance, just as his first films were designed for Dédée, so *Boudu*, *La Carrosse d'or* and *Eléna et les hommes* were created for Michel Simon, Anna Magnani and Ingrid Bergman respectively.

The only thing that Jean had not calculated were the elements. The script had been written for fine weather, to include scenes of brilliant sunshine with one or two cloud effects. But the wind changed and the rains came and stayed. The weather conditions forced Jean to alter the script slightly, the threat of a storm adding a new dimension to the drama. But there was no way the story could have been filmed in the rain, so the team was holed up for days on

end from mid-July to the beginning of September waiting for the clouds to clear. They ate well, played cards, but tensions began to mount, and the film ran over the budget that Pierre Braunberger had allocated.

Claude Renoir, whose memory of the time was somewhat clouded, said, 'We had to wait for weeks to get bad weather in order to shoot the storm scene, but there was a very pleasant and relaxed atmosphere.'[6] However, Sylvie Bataille was furious with Jean when he had to desert the film in August to start work on *Les Bas-Fonds* for which he had been contracted. Jean commented rather naively that, 'Everybody was happy but Sylvie, who was having some problems with her personal affairs.'[7] In any event, Braunberger decided to pull the plug on the picture, around 35 minutes of which had been shot.

Later, however, when Braunberger had a look at the footage edited by Marguerite, he thought it would be worth extending into a full-length feature. While Jean was occupied on *Les Bas-Fonds*, Braunberger asked Jacques Prévert to provide him with additional material. Prévert, who had just co-written *Jenny*, the first of his seven-film collaboration with Marcel Carné, was ready with the script quickly and insisted on reading it aloud to Jean and Braunberger in a café near the Salle Pleyel. Unfortunately, Jean was not happy with it, mainly because it diverged too drastically from Maupassant and from his own conception of the film. Refusing to abandon the project, Braunberger acquired another script from Michèle Lahaye, which Jean found more acceptable. But by then he had already embarked on *La Grande Illusion*, time was passing, and it would be difficult to gather everybody involved together again at the house on the Loing. It seemed inevitable that *Une Partie de campagne* would remain unfinished and unseen.

Nevertheless, Braunberger continued to keep faith with the film throughout the war. He was among the first Jews rounded up in Paris during the Nazi occupation, but escaped from a camp at Drancy. While hiding from German troops on a little island in a river in the Lot, *Une Partie de campagne* flashed before him, and he realised that, with an added music score and a few captions, the film could be released as it stood.

In 1946, on his return to Paris, he searched out the copy that Marguerite had edited, but to no avail. Luckily, an uncut negative was found in the archives of the Cinémathèque Française, which had been founded by Henri Langlois in association with Georges Franju

and Jean Mitry in the year *Une Partie de campagne* had been abandoned. Marguerite edited it over again, and with two intertitles replacing two missing (unshot) scenes, and a haunting score by Joseph Kosma, the 40-minute film was ready for release on 8 May 1946. 'It may be the only film I've done in which nothing was trimmed. Everything is used,' Jean observed.[8]

Une Partie de campagne takes place one Sunday in the summer of 1860, when M. Cyprien Dufour (Gabriello), a Parisian ironmonger, borrows the milkman's cart and takes his wife Juliette (Jane Marken), daughter Henriette (Sylvie Bataille), grandmother (Gabrielle Fontan) and Anatole (Paul Temps), his clerk and future son-in-law, on a rare trip to the country for a picnic. There they meet two young holiday-makers, Henri (Georges Darnoux) and Rodolphe (Jacques Brunius). 'Are they the Prévert brothers?' asks the grandmother, 'I knew them when they were babies.' The two young men, in order to be alone with the mother and daughter, provide M. Dufour and Anatole with fishing poles. The couples pair off, and go rowing. Rodolphe pretends to be courting Mme Dufour, while Henri and Henriette become serious about one another. They stop at an island, where they kiss in huge close-up. The idyll ends on a sad note, because a caption tells us that after they parted Henriette married the idiotic *petit-bourgeois* Anatole. 'Years passed with Sundays as bleak as Mondays. Anatole married Henriette, and one Sunday . . . ' the ex-lovers return to the island where they meet once more. 'Every night I remember,' she confesses to Henri.

The young lovers are parted by class, leaving them with a painful regret for what they have lost. The two young upper-class men first see the women as prey to help while away the time, although Henri is surprised by the girl's bearing, and the two seductions are ironically compared – Rodolphe and Madame Dufour playing at passion; Henri and Henriette acting it out for real.

Both Jean's pantheism and social consciousness come into play, but are never underlined. When Henriette speaks about the life of insects, or Rodolphe imitates a Pan figure chasing his female prey (as in the prologue to *Boudu*), their thoughts and actions emerge from their characters and not from director-screenwriter. 'How amazing the country is. Every blade of grass hides tiny living things. We may kill some with every step,' says Sylvie Bataille expressing this vague sort of yearning, with a catch in the throat.

'If certain landscapes, certain costumes, bring to mind my father's paintings, it's for two reasons: first because it takes place during the

period and in a place where my father worked a great deal in his youth. Second, it's because I'm my father's son, and one is inevitably influenced by one's parents,'[9] Jean remarked.

Renoir had the uncanny ability to make references to certain Impressionist paintings in an unstudied manner as if La Balançoire and Le Déjeuner sur l'herbe were painted after Auguste Renoir and Edouard Manet had seen the film. Although the girl on the swing is framed in a window as in a painting, the scene refuses to be arty, and when she swings so does the camera, making audiences share her exhilaration. Jean asked Claude to think about the painting (but not to copy it) in order to capture its characteristics, the dappled lighting and the contrast. (Satyajit Ray uses the same moment in a homage to Renoir in Days And Nights In The Forest, 1969). Perhaps it was what André Bazin was to call 'Impressionism multiplied by the cinema.'[10]

Again there is no straining after the aesthetic when the family take their déjeuner sur l'herbe under the cherry tree in the most natural and casual manner. There are other allusions – the white-faced Anatole (rather too broadly caricatured to convince that Henriette would ever marry him) and the corpulent M. Dufour resemble Laurel and Hardy as they go fishing.

Claude Renoir's travelling camera moves along the river dwelling on the water and the banks – the rain sweeping the river is magnificently used – balanced by Kosma's music, including a lovely lilting tune hummed by Germaine Montero, creating wistful but unsentimental nostalgia for the days of the director's childhood. Renoir's glowing, witty, bitter-sweet, sensuous tribute to the countryside through which a river runs has seldom been surpassed.

Jean's presence is felt behind every scene of Une Partie de campagne, and his own brief appearance as M. Poulain in braces, silly hat and little moustache, adds an extra personal touch. 'I've made a tarragon omelette', he says, as he limps into view. Almost his entire dialogue consists of talking about food, except for a remark about Madame Dufour. 'What a woman!' he exclaims. Claude Renoir thought his uncle 'not so good as an actor, but he's very charming.'[11] Marguerite Renoir plays the dark-haired attractive servant girl, somewhat resembling Dédée. A shaven-headed Alain Renoir is seen fishing over the bridge, and when asked by the Dufours if there are any fish, he replies, 'Maybe there are, and maybe there aren't,' and later appears with other boys looking over a wall at the Parisians.

Alain had been taken away from his two tutors, the priest and the

Communist, and sent to various schools at Fontainebleau and Versailles, and about to enter the Lycée Condorcet in Montmartre. None of these pleased the boy. Because Jean could not spare his son much of his time, he would give him as many gifts as he could, as well as imparting pearls of wisdom, and recommending that Alain read *Memorable Deeds and Sayings* by Valerius Maximus and *The Good Soldier Schweik* by Jaroslav Hašek – books nicely balanced between the conservative and the anarchic. The anti-democratic Maximus, who fulsomely admired the Caesars, especially his emperor, Tiberius, denounced luxury and effeminacy, writing, 'Necessity makes the most effectual hardening for human weakness.' Against Maximus' eulogies to moderation and abstinence, was set Hašek's naive, fumbling, shrewdly inept and 'unheroic' lumpen hero of the Austrian army.

Jean Renoir, aged 42, had already become a father figure to a number of young men and women in the film business. During the shooting of *Une Partie de campagne*, Luchino Visconti, third assistant director and assistant prop man, became another disciple. 'The whole group that gravitated to Renoir was made up of Communists,' Visconti commented. 'At first, naturally, I was looked on with suspicion. To them I was an Italian, I came from a Fascist country and, to top it all off, I bore . . . the weight of an aristocratic name. That suspicion melted almost at once, however, and we became fast friends . . . In a way, my friendship [with Renoir's group] became my road to Damascus.'[12]

Visconti shared with Jean a similar cultural background in childhood, and had also had a rather chaotic education, having run away from a series of schools. Described by the younger man as 'half rebel, half snob in a tramp's hide', Jean was admired for 'his rich humanity, his affection for people and their work, his extraordinary skill at directing actors, his meticulousness, his technique.'[13]

Yet, almost since he began making films, Renoir's name had been synonymous with scandal and failure, the aborted *Une Partie de campagne* being just a further example. In an article in *Ciné-Liberté*, Jean derided young directors whom he called 'elegant riff-raff' who 'worship the photogenic golden calf'.[14] For him, remaining independent meant having a united, incorruptible crew on which to rely. 'You cannot venture into the cinema world unless you know you are surrounded by accomplices. A film is a lot like a burglary . . . A professional [thief] would never dream of robbing the Bank of France, any more than an explorer would venture alone into the jungle.'[15]

22

Moscow on the Seine

'My problem was in keeping Gorky's spirit pure, keeping it almost uncompromisingly pure, and at the same time transposing it and keeping as they were the exterior setting, the clothing, and the French people who were to bring this spirit to life.'

With Léon Blum's Socialist government now in power, France became more strongly allied to the Soviet Union. When Jean was asked by Alexandre Kamenka to direct a screen version of Maxim Gorky's 1902 play, *The Lower Depths*, he jumped at it, remembering that one of Kamenka's most celebrated productions was *Le Brasier ardent*, the film that had so impressed him in 1923. Since coming to Paris from St Petersburg in 1920, Kamenka had produced a series of fine silent films for his Société des Films Albatros, staffed entirely by fellow Russian *emigrés*. He had the reputation for giving his directors complete artistic freedom and showing little concern for making a profit. But with the coming of sound, Kamenka found it difficult to sustain his previous success. Nevertheless, he managed to borrow enough money for his long-cherished dream to make a film of Gorky's masterpiece of Russian realism.

When he approached Jean, Kamenka already had a screenplay written by Eugène Zamiatin and Jacques Companeez, both Russians newly installed in France. Jean, however, wanted to write his own script, as he had done for all his sound films. Kamenka agreed, and taking the Zamiatin-Companeez text as a basis, Renoir and Charles

Spaak began a collaboration on the work, known in French as *Les Bas-Fonds*.

Since starting in the cinema in 1929, the Belgian-born Spaak had worked mainly as screenwriter for fellow-countryman Jacques Feyder. He took to Jean immediately. 'Men's ideas interest him far less than their instincts, their cravings,' Spaak later commented. 'Imagine Renoir with some champion of the Left; he'd befriend the fellow not for his ideals or his viewpoints, but perhaps because he had a connoisseur's knowledge of tobacco or horses . . . Renoir attached much more importance to people's professionalism, to the precise knowledge they acquire through contact with their work or with nature, than he did to their ideology. The instant he found something authentic in a person, he was charmed. He would like a mechanic in overalls in the same way he liked a marquess who wore the right tie at the right time . . . '

When the screenplay was completed, it differed so much from the original that Jean felt it should be submitted to Gorky for his approval before embarking on the film. Besides departing from the texture of the play, Jean had changed many details. The part of Luka, the man who distributes false hopes, was considerably reduced, and Satine the card sharp (originally played by Stanislavsky), had become a very minor role. Gorky's play ends with the suicide of the actor, Renoir's film with the escape from the doss-house of Pepel and Natasha. Above all, the stage setting of 'a cellar, resembling a cave with only one small window to illuminate the dark recesses', was enlarged into a tenement house. The film also answered a criticism of Chekhov's, expressed in a letter to Gorky: 'How the Baron has got into the night lodgings and why he is a Baron is not made sufficiently clear.' Renoir explains it by showing the Baron losing his money at a casino, and the bailiffs emptying his mansion.

'Gorky read it, and to my great surprise, despite the enormous differences between my script and the work that inspired it, he approved of it wholeheartedly,' reported Jean. 'He even wrote a few lines to announce publicly his approval of it and to say it seemed to him as though it wouldn't be a bad film, that it would be good.'[1] However, Gorky had also written, in a letter to Kamenka, that *The Lower Depths* was a play 'where nothing happens, where the whole thing is atmosphere, nothing but atmosphere', and that the film-makers would 'break their teeth on it'.[2]

Maxim Gorky never lived to see the finished product because he

died on 14 June 1936, a month after he had received the script. During the 1937–1938 purge trials, former police chief Yagoda alleged that Gorky had been poisoned by order of a Trotskyite plot, but the writer had been in poor health all his life. For a man who had suffered under the Tsarist regime, which had imprisoned and banished him, the October Revolution had meant nothing but good, and although he deplored some of its excesses, he was always a wholehearted advocate of its constructive work. Like Jean, Gorky was a realist in his view of the worst in human nature, and a romantic in his faith in brotherhood and the hopefulness of the new generation.

As a believer in improvisation on the set, Renoir often shaped and adapted his films for certain performers. By casting Jean Gabin and Louis Jouvet in the leading roles, the screenplay moved even further from Gorky to Renoir.

These two magnificent actors were poles apart. Whereas Jouvet's background, like that of his colleague Pierre Renoir, was the theatre, Jean Gabin started as a dancer in the Folies-Bergère and other music halls. The 48-year-old Jouvet had made only four films (not counting a solitary silent screen appearance in *Shylock* in 1913), two of them screen versions of two of his stage hits, Marcel Pagnol's *Topaze*, and Jules Romains' *Knock* (both 1933). The 32-year-old Gabin had nine films behind him, and was just emerging as a star when he made *Les Bas-Fonds*, the first of a line of first-rate roles he played in the 1930s. Jouvet was an actor of supreme intelligence who analysed his parts word by word, and for whom Jean Giraudoux rewrote many lines; Gabin worked more from emotion and feeling.

'Gabin was at his most expressive when he did not have to raise his voice,' Jean wrote. 'Magnificent actor that he was, he got his greatest effects with the smallest means. I devised scenes for his benefit which could be spoken in a murmur . . . Gabin could express the most violent emotion with a mere quiver of his impassive face where another man had to shout to get the same effect.'[3] An interesting view of an actor who actually had a clause in his contracts that he had to be given at least one scene in which he could fly into a rage.

It was Jouvet who converted Renoir to conducting rehearsals in the Italian fashion. Jean explained: 'It consists in seating the actors round a table and getting them to read their lines without any expression whatever . . . What happens is that the actor learns his

part in this way, denying himself all reaction until he has explored the possibilities of every phrase, every word, every gesture. Actors who try to interpret their role from the outset are very apt to fall into the commonplace . . . Se we get together, actors and director, and we go through the text two or three or even twenty times. And suddenly, in this lifeless reading of the lines, the director discovers a tiny spark. That's it! Starting from there the actor has a chance to achieve an original interpretation of the role.'[4]

Although he was working for the first time with Gabin and Jouvet, Jean, as usual, had familiar faces around him: Gabriello and Paul Temps (who played M. Dufour and Anatole in *Une Partie de campagne*), and Jacques Becker (assistant director), Jean Bachelet (cinematographer) and, naturally, his companion Marguerite Renoir as editor.

There was a thoroughly professional air about the brisk 25-day shoot, between August and October 1936, on location between Epinay and Saint-Denis on the banks of the Seine, and at the Éclair Studios at Epinay. This was thanks largely to the seasoned performers, among them Suzy Prim, who was Jules Berry's lover and had performed in plays by Ibsen and Strindberg as well as at the Folies-Bergère; and Vladimir Sokoloff, a veteran of the Moscow Art Theatre, the only genuine Russian in the cast, ironically giving the only rather off-key performance. *Les Bas-Fonds* was his last European film before his Hollywood career. Robert Le Vigan, Lheureux in *Madame Bovary*, played the Shakespeare-quoting alcoholic actor who hangs himself (off screen), although we see him preparing the rope. Le Vigan, who had portrayed Christ in Julien Duvivier's *Golgotha* the year before, in which Gabin was Pontius Pilate, actually did kill himself after World War II during which he had been a Nazi collaborator.

'I was not trying to make a Russian film. I wanted to make a human drama based on the play by Gorky,' Jean stated,[5] and it is best to see *Les Bas-Fonds* from this perspective. The characters might have Russian names, and there are references to roubles, but a French spirit pervades the film, with sporadic Russian choral singing among the French popular songs subtly suggesting the stage original. Perhaps it might have rung truer if Jean had set it squarely in France. Yet, though the body of the play has been altered, the soul has been retained.

A Baron (Jouvet), who has gambled all his money away,

befriends Pepel (Gabin), a burglar whom he finds robbing his mansion. The Baron later joins the thief and other assorted dregs of society at a squalid doss-house owned by Kostilev (Sokoloff), who acts as a fence for Pepel. Kostilev's wife Vasilissa (Prim) is having an affair with Pepel, who is really in love with her younger sister Natasha (Junie Astor). Kostilev and Vasilissa, in an attempt to bribe the police inspector (Gabriello), promise him Natasha's hand in marriage. But when Kostilev dies after a struggle with Pepel, the two lovers take to the open road.

The film 'opens out' the play without the strain that the phrase often implies. It may reduce the claustrophobia of the original, but there is little diminution of impact. Renoir's characters have to breathe, they cannot remain confined for long, even in a subject like *Les Bas-Fonds*. The camera pans through the gardens of a restaurant as a brass band plays on a summer's day. It is Renoir *père's Moulin de la Galette* again that comes into frame. Amidst this paradise is the police inspector, attempting to seduce an innocent girl, but he is not perceived as a perverse villain the way a similar character would be seen by Stroheim, but as a fat Chaplinesque oaf.

Renoir knows that tiny moments and gestures add dimension to a scene: Jouvet, who only smokes if he has won at gambling, stands with a cigarette in his hand as he is about to leave the casino and strikes a match, but lets it drop at the last second; Gabin finds time to chat to a baby in the street. When Jouvet arrives at the doss-house with his slightly bow-legged gait and world-weary air, Luka comments, 'Nobility is like the pox, you can never shake it off.'

A favourite scene of the director's was when Gabin and Jouvet sit on the bank of a river ('Have you ever slept on grass?' Gabin asks his aristocratic companion) and talk of their lives. While Jouvet tells of the different symbolic costumes he has worn in life, he notices a snail crawling up a blade of grass. He picks it up and allows it to climb up his finger. 'The audience warms and one senses their passionate interest in the movements of the snail. The Baron becomes familiar to them and they identify themselves with Gabin in listening to his story,' Jean remarked.[6]

The most convincing relationship in the film is the elegantly modulated one between Gabin and Jouvet, from their first encounter when Jouvet offers the thief a meal. They are men from different classes, but 'brothers in arms', like Gabin and Pierre Fresnay in *La Grande Illusion*. For Renoir it is only an accident of birth that separates people, and here they find themselves on the same social

level. There is also a sensuous interplay between Gabin and Prim, no more so than when he reveals that he is abandoning her for her younger sister ('I see you were after someone younger of the same breed'), their profiles framed by a window with a courtyard beyond visible in deep focus.

The final sequence is a direct, and extraordinarily affectionate and bold, homage to *Modern Times* as the two vagabonds, Gabin and Junie Astor, like Chaplin and Paulette Goddard, walk along the road, not away but towards the camera, which then rapidly tracks back from them.

Les Bas-Fonds is a film of chiaroscuro, of gestures, of luminous close-ups, of framing, of a roving camera, of atmosphere, but also of splendid performances, dialogue, and character. It may be less profound in tone than the play, or Akira Kurosawa's 1957 version (as Japanese as Renoir's was French) but it is the work of a director gaining in power and confidence.

The film, which opened at the Max Linder cinema in December 1936, did reasonably well at the box office, mainly on the strength of Gabin and Jouvet's names on the billboards. It also became the first film to win the Prix Louis Delluc, named after one of the first critics to consider film as an art form and evolve a theory, and who coined the word *cinéaste*. Since 1936, the prize has been awarded annually to the best French film.

23

Brothers In Uniform

'People were nice enough to think that La Grande Illusion *had a great influence and told me so. I answered, 'It's not true.* La Grande Illusion *had no influence, because the film is against war, and the war broke out right afterwards!'' '*

While working on *Les Bas-Fonds*, Renoir and Charles Spaak thought of a story of five unemployed workers who win a lottery and buy a country inn on the banks of the Marne, splitting the profits. However, Jean felt, for some reason, that it would be more suitable for Julien Duvivier. There was little in Duvivier's past work to suggest this, but after *Golgotha*, *La Bandera* and *Le Golem*, he was keen to tackle a contemporary French subject. It became *La Belle Équipe*, starring Jean Gabin and Viviane Romance, a successful example of the cinema of the Popular Front with believable working-class characters, their simple pleasures, and sunny open-air camerawork. Perhaps Jean had rejected it for himself because it was rather too close to some of the films he had made in the past. He hated repeating himself.

He was far more interested in some of the tales Spaak had to tell about the time he served at the front in 1915, where he had been captured and held prisoner by the Germans for some months. Spaak's account reminded Jean of an incident that happened while he was filming *Toni* in Martigues in the south of France two years before.

Some aeroplanes were constantly making a racket above them and ruining the sound recording. The producer, Pierre Gaut, suggested they go and see the commander of the nearby airfield at Istres to explain the circumstances and ask them to refrain from flying over the film location. When Jean arrived at Istres, he discovered that the commander was none other than Armand Pinsard, the pilot who had saved his life in the war by shooting down enemy planes before they could get the slow twin-engined Bréguets in which Jean was an observer. Pinsard apologised, telling Jean that the pilots were fascinated by all the film-making equipment and that they were flying overhead to take a look at what was going on, but promised to order them to avoid the area.

The two men subsequently met for meals from time to time to reminisce about the war, and Pinsard would regale Jean with stories of being captured many times by the Germans, and his frequent escapes. Jean thought these experiences would make a good film, and made written notes. Although not many of Pinsard's adventures made it into the screenplay, they were the springboard for *La Grande Illusion*.

After writing a treatment called *Les Évasions de capitaine Maréchal*, the title used right up until *La Grande Illusion* had been shot and edited, Renoir got Spaak to help him create a scenario which they showed to Jean Gabin. Gabin saw in Maréchal a perfect role and started to show it around to various producers, French, Italian and American, who all refused it. It seemed as though war as a theme was now taboo. Immediately following World War I, there had been a number of notable silent films on the subject; Abel Gance's *J'Accuse* (1919), called by the director 'a human cry against the bellicose din of armies', was one of the first. There followed King Vidor's *The Big Parade* (1925), Raoul Walsh's *What Price Glory?* (1926) and William Wellman's *Wings* (1929).

At the beginning of sound, the cinemas were flooded with war films, and in 1930 alone there appeared Howard Hawks' *The Dawn Patrol*, Howard Hughes' *Hells Angels*, James Whale's *Journey's End* and Lewis Milestone's *All Quiet On The Western Front*, seen from the German side. In Germany itself, G. W. Pabst's *Westfront 1918* depicted the horror and futility of life in the trenches. But as the memories of the war and the mood of anti-militarism that marked these films began to fade, so the subject became less popular. Fewer and fewer war films were being made in the 1930s. Thus, although *La Grande Illusion* came out of a tradition of anti-war films, its

release in 1937 was the first for some years, and coincided with Germany and Italy's glorification of their armed forces on screen, which they were attempting to try out for real in Spain.

While *Les Bas-Fonds* was being completed, an offer to produce *La Grande Illusion* was finally made. It came about through Albert Pinkevitch, the general factotum of a financier named Frank Rollmer who was thinking of getting into the film business. Pinkevitch managed to persuade his boss to put money into the film, but only after a series of hard negotiations between Rollmer and Renoir, with Pinkevitch acting as middle-man. Before the producer would put down one centime, he questioned every item, including the stipulation in the script for a silver dinner service. Did they really want genuine silver? Jean eventually agreed to make do with silver plate.

More than ever before in Renoir's films, the casting determined the final form. Originally, the script was about three soldiers – Boeldieu, an aristocratic officer, and two ordinary Frenchmen, Maréchal and Dolette. The name of Boeldieu seems to have been transmuted from Bois le Dieu, referring to one of Jean's favourite figures, the God of the Woods, the faun-like creature that makes an appearance in one way or another in his films from *La Fille de l'eau* through to *Le Déjeuner sur l'herbe*. Boeldieu lets loose by playing the flute high on the fortress to distract the guards, allowing other prisoners of war to escape; the same instrument used in *Boudu sauvé des eaux*, played by the Lestingois' neighbour, intimating another kind of escape.

Pierre Fresnay (born Pierre-Jules-Louis Laudenbach), despite his fame as Marcel Pagnol's working-class Marius, was an actor more inclined to play well-bred gentlemen, frequently opposite his wife Yvonne Printemps. Gabin was now becoming the screen's representative man of the people – a rugged, no-nonsense, brave, yet sensitive Parisian. The smaller role of Dolette was altered to Rosenthal, the son of a rich banking family. It was Pinkevitch, whom Jean describes as 'a plump, dark-haired Jew with very expressive eyes which filled with tears when he was appealing to someone,'[1] who kept making suggestions about the character of Rosenthal that built it up into a plum role for Marcel Dalio.

The short, dark, Mediterranean-looking Dalio, who was born of Rumanian-Jewish parents in Paris in 1900, had played only one previous part of any significance, that of the snivelling little stoolie,

who gives Gabin away to the police in Duvivier's *Pépé Le Moko* of the previous year. It was Jean who gave Dalio the two best roles of his entire career: Rosenthal, and the marquis in *La Règle du jeu*, after which the actor spent most of his time in Hollywood, playing French waiters and the like.

By making the third Frenchman a Jew, the brotherhood theme of the film was significantly broadened. Alexander Sesonske tells of a screening of *La Grande Illusion* in 1951 at UCLA at which Jean was invited to address the students. At the end of the film, the director, who had been sitting at the back of the lecture hall, made his way angrily to the platform. The cause of his anger was an English subtitle which translated the phrase, '*Au revoir, sale juif*' ('So long, filthy Jew'), the affectionate farewell spoken by Gabin to Dalio as 'Goodbye, old pal.' He explained, with some exaggeration, that by eliminating the word 'Jew' from the subtitles, a great deal of the major theme of the film was lost.[2]

Julien Carette as Traquet, the actor, was to make the first of his four appearances in Renoir films, which saw him emerge as one of the greatest of French comic character performers. Here he had a chance to sing one of his music hall hits, 'Marguerite'. As the German farmer's wife who gives the fleeing French POWs shelter, Jean cast Dita Parlo, virtually the sole woman in the film. She had built up a reputation as a romantic star of the German cinema in the early 1930s, and had made a couple of unsuccessful films in Hollywood before coming to work in France, where she rapturously played the young bride on a barge in Jean Vigo's *L'Atalante* (1934). It was after seeing Parlo in *La Grande Illusion* that Orson Welles attempted to get her to star in his projected film of Joseph Conrad's *Heart of Darkness*, but shortly after the outbreak of World War II she was arrested as an alien and deported to Germany, only returning to France and resuming her career in 1950.

The rest of the cast and crew were made up mostly of Jean's buddies from other films: Jacques Becker as assistant and as a British officer, Claude Renoir as cameraman, Marguerite Renoir editing, and Gaston Modot, Jean Dasté, and Sylvain Itkine as French POWs. Jean's good friend Karl Koch had been a German army captain during World War I and was invaluable as technical advisor to check the authenticity of the German scenes.

Since there was no question of shooting the film in Germany, all the exteriors would be filmed on location in Alsace – at the Haut Koenigsberg castle and the artillery barracks at Colmar, both of

which were built by Wilhelm II, and at Neuf-Brisach on the Upper
Rhine. They were just about ready to shoot towards the end of
1936, when a new element was introduced into the film.

The small role of the German commander of the prison fortress was
yet to be cast. Jean was astonished to learn that Raymond Blondy,
one of the producers, had asked Erich von Stroheim to play it.
Stroheim, who had not been able to direct since he had been
prevented from completing his one sound film, *Walking Down
Broadway* in 1933, was at the lowest ebb of his career. When he
received a call from Paris offering him the part of the head of the
German Secret Service in *Marthe Richard*, the tale of the patriotic
French spy of World War I, he immediately accepted – after
consulting his clairvoyant, that is. Stroheim was overwhelmed and
overjoyed by his reception in France. Whereas in the USA he was
considered a has-been, in France he was still respected as one of the
great directors of the cinema. Jean, who had long admired Stroheim
since his frequent viewings of *Foolish Wives*, was reluctant to offer
the distinguished artist such a minor role.
 In the screenplay, there were two German parts of some import-
ance, that of the pilot who shoots down Fresnay and Gabin at the
start and is invalided out of combat, and the prison commandant.
When Stroheim was asked which role he wanted, he replied 'Both'.
Stroheim explained: 'I was offered a role I felt was too small, and at
first refused the offer. As the director was to be Jean Renoir,
however, whom I did not know personally at that time but whose
work and reputation I valued highly, I decided to think over the
proposition, finally accepting with the provision that I might
combine the small role of the aviator . . . '3 So the built-up role of
Captain von Rauffenstein, as finally played by Stroheim, was a
merging of two characters.
 As soon as Jean heard that his idol was in Paris and was to work
on the film, he rushed over to the man's hotel, but it was Stroheim
who was the more nervous. 'I trembled apprehensively while I
waited to meet my director, Jean Renoir,' Stroheim recalled. 'A
heavily-built man entered the room where I was waiting. His eyes
struck me first of all – they are sharp, blue and striking. He advanced
towards me and gave me a resonant kiss on each cheek. In the
ordinary way I am not one for outward shows of affection, yet
without the slightest hesitation I returned the greeting. Then Renoir
seized me by the shoulder and gave me a long and admiring look,

explaining – in German – how much he appreciated my working with him.'[4]

At that stage, Jean spoke very little English, and Stroheim almost no French. They managed to communicate in German, although the 51-year-old Viennese-born Stroheim had been in the USA for 27 years and English was the language he spoke best. Jacques Becker, who acted as interpreter, gave a contradictory account of the first meeting of the two great film-makers. He said that when they were introduced, Stroheim had to have Renoir's name repeated to him twice. 'Explain my role,' Stroheim demanded almost immediately. 'Later. There's no hurry,' said Jean, knowing that Stroheim's role was yet to be written.[5]

At the outset, both Jean and Stroheim were determined that the latter's character should not be a repeat of the 'Horrible Hun', that had earned him the title of 'the man you love to hate'. Jean allowed Stroheim to contribute freely to the character, accepting some of his ideas, adapting others. One of Stroheim's master strokes was his suggestion that the ex-pilot, having suffered injury and removed to a behind-the-lines post, should wear a neck brace. In order to obtain one, he visited a medical appliance shop in Colmar and persuaded the proprietor to sell him a neck brace without the necessary doctor's certificate. He then added a rather elaborate costume and white gloves, which he never removes. (Gabin, on the other hand, wore Renoir's old pilot's tunic, which the director had kept after demobilisation.)

When Stroheim had originally arrived in Hollywood, he claimed to be Erich Hans Carl Maria Stroheim von Nordenwall, an ex-army officer of noble descent. Though some mystery still surrounds his background, it seems that he was, however, plain Erich Oswald Stroheim, the son of a Jewish hatter. However, he had served three months in the Austro-Hungarian army as a young man. Stroheim often extended his film persona into real life, so that he could be a difficult person to get on with.

There were a couple of occasions during the shooting of *La Grande Illusion* which led to some unpleasantness. One evening, at an *auberge* in Alsace, after several glasses of the potent local white wine, Karl Koch and Stroheim started arguing over the uniform of the actress playing the hospital nurse, which Koch complained was over-elaborate. Insults and wine glasses were thrown about before the two men were reconciled.

During the first days, Jean said that Stroheim 'behaved intoler-

ably'. The directer and actor had an argument when Stroheim insisted there should be prostitutes in the German living-quarters, something Jean considered a 'childish cliché'. 'This dispute with Stroheim so distressed me that I burst into tears, which so affected him that there were tears in his own eyes,' wrote Jean. 'We fell into each other's arms, damping his German army officer's tunic. I said that I had so much respect for his talent that rather than quarrel with him I would give up directing the film. This led to further effusions and Stroheim promised that henceforth he would follow my instructions with a slavish docility. And he kept his word.'⁶

Looking back, Stroheim would say, 'This was the first time that a director in whose film I had played, accepted wholeheartedly all the suggestions which I humbly offered. I have never found a more sympathetic, understanding and artistic director and friend than Jean Renoir.'⁷

Lieutenant Maréchal (Gabin) and the aristocratic Captain de Boeldieu (Fresnay) are shot down behind German lines by Captain von Rauffenstein (Stroheim). They are held captive in a prisoner-of-war camp at Hallbach, where they are quartered with an engineer (Gaston Modot), a teacher (Jean Dasté) and Rosenthal (Dalio), whose food parcels keep them going. Each night they work at digging a tunnel, but before it can be used they are transported to Wintersborn, a fortress in the mountains run by von Rauffenstein who is now grounded through injury. Boeldieu creates a diversion so that Maréchal and Rosenthal can escape, but he is fatally shot by the German captain. Maréchal and Rosenthal flee across the cold countryside until given shelter by Elsa (Dita Parlo), a German peasant woman. After staying a short while, during which Maréchal and Elsa fall in love, they leave her and cross into Switzerland.

La Grande Illusion is not only a moving anti-war statement but a rich exploration of class loyalties and transcending friendships. Yet Renoir shows nothing of war-is-hell fighting, neither does he resort to any rhetoric, inspirational speeches, or simple, sentimental pleas for universal brotherhood. In a sense, the internationalism of *La Grande Illusion* ran counter to the current nationalism in Europe and the Far East. At a time when Germany was threatening the world, Jean said that he made the film because he was a pacifist, as well as wanting to show French officers as he remembered them when he was in the army. 'Military style has changed much more than we think. The way a soldier or an officer presents himself today is

completely different from the way this same soldier or this same officer would have presented himself 30 years ago,' he commented. 'People think that behaviour was more rigorous, much stiffer before, but it was the complete opposite. There was a kind of ease that seems to have disappeared. The expression or phrase in the military code on which the military instructors put the most emphasis was the expression "without affectation of stiffness." '[8] This phrase seems to apply to much of Renoir's oeuvre, imbued as it is with a French spirit, defined by Jean as 'an easygoing spirit, a relaxed spirit. It's an aristocratic spirit, whereas this new stiff manner of holding oneself is, in my opinion, more plebeian than aristocratic.'[9] Not a statement that would have endeared him to many of his Popular Front comrades.

Another reason for his making the film was that, with the exception of *All Quiet On The Western Front*, he felt no film he had seen had given a true picture of the men who did the fighting. 'Either the drama never got out of the mud, which was an exaggeration, or else the war was made into a kind of operetta.'[10] For Jean had no time for noble patriotic sentiments, nor did his fellows-in-arms during the Great War. He believed most of the troops to be anarchists, who 'didn't give a damn for anything.'[11]

La Grande Illusion was first shown in Paris at the Marivaux cinema in June 1937, the month that Léon Blum's government fell. Despite its ambiguities, the film was welcomed by the Left at the time as a committed work, and, indeed, the sacrifice of the monocled aristocrat Boeldieu to save the worker Maréchal was seen as a symbol of the moribundity of the ruling classes. As the Stroheim character says, 'The end of the war will be the end of the Boeldieus and the Rauffensteins.' And at his death, Boeldieu says, 'For a common man it's terrible to die in war. For you and me, it's a good solution.'

But this is too simple a reading. Boeldieu sacrifices his life because he puts loyalty to his French comrades, though they be a Maréchal and a Rosenthal, before loyalty to class. An aristocrat, a bourgeois, a worker, an intellectual, an artist and an artisan, a Jew and a black are all united in national kinship. The camaraderie extends to the Russians and British in the camp. In fact, it is an English soldier who asks the band to strike up *La Marseillaise*. The Germans are sympathetic, too – an elderly German woman says, 'Poor boys,' as she watches the prisoners entering the camp. (There is a similar tiny gesture in *Le Caporal épinglé*, when a German child waves at the

French internees.) Elsa shows her French guests a picture of her husband killed at Verdun, 'One of our greatest victories,' she says without irony. As Dalio claims at the end, just as they reach Switzerland, 'Frontiers are made by men. Nature doesn't give a damn.'

However, no thematic or stylistic analysis of *La Grande Illusion* can convey the sheer mastery of the narrative, which is, on the surface, a simple and immensely entertaining POW escape yarn, a paradigm for all subsequent films on the same subject. Behind the labels pinned on the characters – the stuck-up aristocrat, the overly-refined German officer, the salt-of-the-earth proletarian, the acquisitive Jew, the lonely German widow, are the nuances of dialogue and performance that give them individual strength and personality.

Throughout, Renoir subtly describes a series of different loving male relationships, Dalio and Gabin, Gabin and Fresnay, Fresnay and Stroheim. When Fresnay creates a diversion to allow his comrades to escape, Stroheim shouts to him, in English, 'I beg you, man to man, come back', in a voice which Renoir told the actor to speak like a man pleading with his mistress. The two aristocrats often break into English, a sign that links them in breeding and cosmopolitanism and excludes many of the other men, such as Gabin. On the other hand, Gabin and the German woman have no common language in which to communicate.

As the frontiers between people are broken down, so are the frontiers between the tragic and the comic. Nowhere is this better realised than in the scenes of the troop show, when the unreality of theatre intrudes upon the reality of film. While one of the young Frenchmen tries on a wig and a dress, the jocularity is suddenly stilled as the camera pans over the other men's faces, staring at this (false) vision of feminine allure of which they have been deprived. A short while later, men in drag lead the impassioned singing of *La Marseillaise* after news of a French victory, setting up a curious juxtaposition that only increases the poignancy of the moment.

In Germany, Goebbels labelled Renoir 'Cinematographic Enemy Number One' and declared that 'Stroheim's impersonation of a German officer is a caricature. No German officer is like that.' 'Too bad for them,' replied the French critic Jean Fayard. The film was promptly banned in Germany and the negative seized. For some years it was thought that all European prints of the film were destroyed by the Nazis, but American troops uncovered a negative in Munich in 1945, ironically preserved by the Germans themselves.

In contrast, the film greatly appealed to Mussolini when he saw it at the 1937 Venice Film Festival. However, because of German pressure it failed to win the Golden Lion, which went to Julien Duvivier's non-controversial multi-story *Un Carnet de bal*. Instead, *La Grande Illusion* won a special prize for 'Best Artistic Ensemble'.

'C'est la Révolution!'

'In La Marseillaise, *I tried to recount one of the greatest moments in French history in the same way I would have described an adventure that took place next door. I wanted to treat this great moment from an intimate perspective.'*

Although *La Grande Illusion* was free of the naive optimism of Pabst's pacifist companion pieces, *Westfront 1918* (1930) and *Kameradschaft* (1931), and the vague humanism of Romain Rolland's idealistic novels, it did, like these works, display an instinctive sympathy for both German and French culture and a belief in disinterested internationalism, not a view easy to uphold in the world of 1937. For a better idea of what was going on at the time, one would have to turn to André Malraux's great Spanish Civil War novel, *L'Espoir*, or Picasso's *Guernica* painting, both of which appeared in the same year as Renoir's film.

Starting on 4 March 1937, Jean would, however, make his own contributions to the contemporary debate in a column he wrote every Wednesday in *Ce Soir*, the Communist daily edited by Louis Aragon and Jean-Richard Bloch, in which he was given carte blanche to express himself on any topic. The first column was 'A Plea for Laziness', a characteristically humorous and ironic attack on the work ethic. He had once said 'loitering', which he identified as the subject of *Boudu*, was 'the highest achievement of civilisation',[1] and in *Eléna et les hommes*, almost two decades later, Mel Ferrer says,

'My ideal is to achieve perfect idleness . . . universal idleness for rich and poor.'

Until 7 October 1938, Jean's column ranged across subjects such as 'Bourgeois Manias', the music hall, the cinema, 'More Than One Germany', in which he wrote of the culture he loved and of his liberal-minded German friends, the Hindenburg disaster whose victims he compared with 'those other victims of Hitler, the people of Guernica.'[2] He also used the pages of *Ce Soir* to attack Louis-Ferdinand Céline's anti-semitism. (Céline had attacked *La Grande Illusion* in one of his notorious pamphlets, *Bagatelles pour un massacre* in 1937.)

An example of how Renoir was viewed among fellow artists and intellectuals after *Les Bas-Fonds* and *La Grande Illusion*, is to be found in a letter Brecht wrote to him from Denmark dated 17 March 1937. 'Dear Renoir, We are starting a small society, to which you absolutely must belong. But don't be frightened: in joining us you'll be taking on no obligations whatever, and there will be no ballyhoo. We hope in the course of time to receive contributions of varying length (some no more than a single typewritten page). Since we are enlisting only productive people, it will take some time, but little by little the concept of a new, social and anti-metaphysical art will take form. I'm writing at the same time to Auden, Isherwood and Doone in England, Gorelik and MacLeish in the USA, Eisenstein, Okholopkov and Tretiakoff in the USSR, Burian in Prague and Knutzon, Nordahl Grieg and Lagerkvist [*sic*] in Scandinavia. Perhaps you can put me on to a few productive and experimental people in France. With best regards, Yours, Brecht.'[3]

Unfortunately Jean never received his German friend's letter, because Brecht gave it to Walter Benjamin who forgot to post it. In another letter, to Max Gorelik, Brecht refers to the society as the Diderot Society, and adds Erwin Piscator, Léon Moussinac and Hanns Eisler to the list.*

Around the same period, Joris Ivens asked Jean to write and speak the French commentary for *The Spanish Earth*, his effective

* Rupert Doone (English stage director, Group Theatre, London), Mordecai (Max) Gorelik (Editor, New American Theatre Workshop, New York), Archibald MacLeish (American poet-playwright), Nicolai Okhlopkov (Soviet stage director), Sergei Tretiakoff (Soviet playwright), E. F. Burian (Czech stage director), Per Knutzon (Danish stage director), Nordahl Grieg (Norwegian playwright), Per Lagerquist (Swedish playwright), Erwin Piscator (German stage director), Léon Moussinac (French film critic)

documentary supporting the Republican cause in the Spanish Civil War, which Ernest Hemingway had narrated for American audiences.

At a Communist Party rally in 1937, Maurice Thorez said, 'We are the descendants of the *sans-culottes* of 1792 and the soldiers of Valmy.' Therefore, it is not difficult to comprehend why the CGT, the Communist trade union organisation, should have wanted to commission a film on the French Revolution, nor why they approached Jean to direct 'the film of the union of the French nation against a minority of exploiters, the film of the rights of man and of the citizen.'

The idea was to finance the film by public subscription. Besides the distribution of 1,500,000 subscriptions at two francs apiece that was already planned, the Popular Front government was to provide the director with a reimbursable sum of 50,000 francs to 'get things started and to pay for advance publicity.' It was to be ready for showing at the International Exposition at the beginning of June 1937.

Jean was excited by the possibility of directing a large-scale work to be called *La Révolution Française*, resounding with the words and deeds of *Liberté, Égalité et Fraternité*, and continuing the principal theme of *La Grande Illusion*. He would have huge means at his disposal. The army would take part in reconstructing the Battle of Valmy, with technical assistance from qualified officers, and would send trucks to transport extras and provide mobile kitchens to feed all the people involved. The government had also approved the use of the palace of Versailles and some objects from the national museums.

Jean hoped to get Henri Jeanson, Marcel Achard and Marcel Pagnol to co-write the screenplay, and composers Roger Désormières, Arthur Honegger, Georges Auric, Darius Milhaud, Joseph Kosma and Jacques Ibert to contribute to the score. The cast was to include Gabin, Stroheim and Jouvet, and Pierre Renoir would play Brissot, a journalist who was a member of the Jacobin club and a deputy in the Legislative Assembly. To top it all, Maurice Chevalier, back from Hollywood, was going to sing *La Marseillaise*.

But things did not quite work out that way. When Léon Blum's government fell on 21 June, the financial and physical co-operation it was to provide disappeared with it. Also, due to the immense logistics involved, the shooting could not begin until August 1937,

too late to be shown at the Exposition. Versailles was no longer available as a location, so Fontainebleau had to be used instead, and Antibes stood in well for the Marseilles of 1790. The final script was written by Jean, though he stated: 'As a result of my reading, I can almost say that I didn't have to write the dialogue in *La Marseillaise*; almost all of it is taken from existing documents.'[4] He was assisted in his research by Karl Koch (whose wife Lotte Reiniger did the short silhouette theatre sequence in the film), who made sure the German influence at the court was correctly portrayed. Most of the music came from classical composers such as Mozart, Bach and Grétry and, of course, Rouget de L'Isle, who wrote the title song.

Both Louis Jouvet and Pierre Renoir did appear in the film, though in roles other than originally allocated, but there were no other 'names' in the cast, which mainly consisted of what was now a Renoir repertory company that included Charles ('Toni') Blavette, Julien Carette and Gaston Modot. Andrex, formerly a café-concert comic, who had had a role in *Toni*, was given the task of speaking the climactic speech of the film: 'The Prussians can't wipe out what we have given the world. Before we arrived, men just stared at liberty, like a lover forbidden to approach his beloved. Now, thanks to us, he has embraced her. To be sure, she is not yet his mistress, but they know each other and will be reunited.'

On 31 July, an announcement appeared in *L'Humanité*: '*La Marseillaise*, directed by Jean Renoir . . . will be a landmark in the history of film. Support the production by suscribing at two francs each, exchangeable for the price of a ticket when the film is shown in the theatres.' In this unorthodox manner *La Marseillaise* was financed, though the money coming in was not as generous as they had envisaged. A less grandiose approach was needed. Indeed, Jean had already made up his mind, as he told an interviewer at the time, to 'concentrate more on the man in the street . . . What I want to show is the greatness of individuals in the midst of a collective act . . . I would be lying if I said that, in this ideological struggle, I remain impartial. I'm shooting *La Marseillaise* with the firmest convictions; what I want is to make a partisan film in good faith.'[5]

'History with a capital H is a product of historians. They are very useful because they present a synthesis without which we wouldn't understand it. But in a film one can try to make people understand this choppy, irregular aspect that life takes on during great events,'

Jean explained.[6] *La Marseillaise* is one of those rare historical films that demonstrate the Marxist theory that history is made from below, a corrective to the epics in which the common people are either absent, peripheral, unruly mobs or victims. Here they form the events; the monarchy and their aristocratic cronies merely react to them. But, as always, Renoir refuses the simple black and white viewpoint. The King and Queen (Pierre Renoir and Lise Delamare) are seen as a bourgeois couple with servant troubles. The aristocrats are merely prisoners of their own class, holding on to their privileges, many in the misguided but sincere belief that they are the best people to hold power.

Pierre Renoir's unforgettable Louis XVIII is a not-very-bright good sort, wishing to remain undisturbed while eating a new vegetable from the south called tomatoes – 'The stomach ignores the subtleties of politics' – unintentionally insulting his wife's family and trying to make up to her, and confused by the word 'subversion' and its enactment. The stooped figure, mopping his brow, his wig askew, becomes more and more pathetic.

Marat, Robespierre, St Just, though mentioned, do not make appearances. Instead Renoir focuses on a small group of ordinary men from Marseilles marching to Paris. They are like Pagnol characters who, rather than having to cope with a lack of water or bread, suddenly find themselves caught up in the Revolution. Perhaps they are sketched with too broad a brush – the handsome hero (Andrex), the lovable buffoon (Edmond Ardisson), the young lover (Alex Truchy), the *titi* (street arab) Parisian (Carette), the anti-clerical painter (Paul Dullac) – all fine fellows, but they come alive against the real settings, the hills of Haute Provence and the woods of Alsace, which give the film realism and a rough-hewn quality. François Truffaut pointed out that the film was like a collection of newsreels from the period, giving the feeling that we are watching history happening in the present tense. There are sequences, such as the moment when a group of Jacobin friends walk up the Champs-Elysées, chatting quite naturally, unconscious that they are part of a historical fresco.

Some scenes play like *La Vie est à nous* in period dress; the meetings of the revolutionary council in 1792 are similar to those of the central committee of the French Communist Party in 1937, and the factional fighting in the streets between the Monarchists and the Republicans must have been familiar to those who had witnessed the clashes between the Fascist *Croix de Fer* and the Communists.

Nor were the references to the Prussian army amassing on France's borders lost on contemporary audiences.

The stirring future French national anthem is first heard through a window sung by a single baritone. Then it spreads, and in an extraordinary overhead travelling shot, a crowd of people are seen singing it, some of the women on their knees in praise. While concentrating on individuals, Renoir, by the use of deep focus, was able to set them in a wider, epic context. Though the last spoken words are '*Vivre la liberté*', Renoir gives the final say to the German poet Goethe in a caption. It reads: 'Here, on this day, a new era in the history of the world began.'

Forty minutes were shorn from *La Marseillaise* when it first opened in a 95-minute version in February 1938 at the Olympia. It was not a success there, although acclaimed by Louis Aragon in *Ce Soir*. The Right, naturally, unanimously condemned the film out of hand. It had to wait until 1967 to be restored to its full 135 minutes, although one significant sequence was lost on the way. It was a scene when Roederer comes across Marie Antoinette burning letters from her brother, the Austrian emperor. 'It was a very good scene for Jouvet, who acted it with a kind of irony, and it was also good for Lise Delamare, who did it with a rather nasty sort of counter-irony. There was a good contrast between the ironic good-naturedness of Jouvet and the rather acerbic irony of the queen,' Jean told *Cahiers du Cinéma* at the time of the film's release.[7] Jean mentioned elsewhere that 'a drum parade, that I was very proud of, was cut. I was very sad about that. Drums are beautiful.'[8] Actually the film is periodically punctuated by the sound of drums.

La Marseillaise remained one of Jean's favourite pictures, though his affection for it might have attached more to the comradely manner in which it was made rather than to its actual consummation. It was also the last gasp of the spirit of the dying Popular Front. 'It gave me the opportunity to express my love of the French,' he wrote. 'For a short time the French really believed that they could love one another. One felt oneself borne on a wave of warm-heartedness.'[9] As that dream crumbled, Renoir would reflect a darker view of life in his last two pre-war films, *La Bête humaine* and *La Règle du jeu*.

25

On and Off the Rails

'The profession of the railroad man is not a lark; it is a grand métier. For some it is even a priesthood. These men put the safety of their passengers and the respect of the timetable before their own private life and their comfort.'

'We are on the eve of an international war'. This is the opening sentence of a treatment for a film Jean presented to the Association of Film Authors in January 1938. Provisionally entitled *Les Sauveteurs* (The Rescuers), it takes place at sea where a group of large and small ships, from different countries bound in different directions, obey the maritime rules and go to the rescue of a small boat in distress. All the people of mixed nationalities, tomorrow's enemies, make a communal effort to save the passengers on board the vessel. Everybody is saved, and there is rejoicing at the victory of solidarity, when the radio announces that war has been declared. The passengers resume their separate voyages home to prepare to fight against each other.

In outline, *Les Sauveteurs* reads like a simplistic allegory of universal brotherhood being broken by the absurdity of war. But in Renoir's hands, fleshed out textually and visually, revealing nuances of character and theme, it would no doubt have gone beyond the *a priori* reasoning of the treatment. Yet, though Jean was still clinging to the wreckage of the Popular Front spirit, the couple of pages did show that he recognised that events were moving the world rapidly

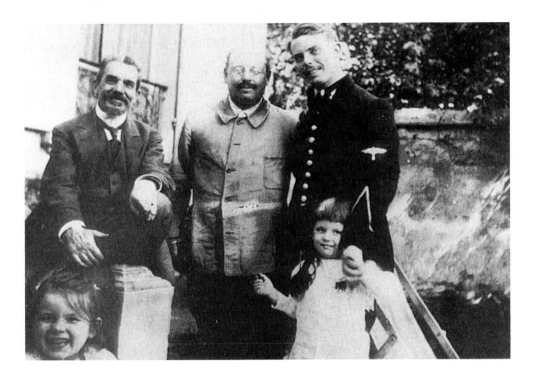

Twenty-two-year-old Jean Renoir (in uniform) on leave from the airforce in 1916 at the home of his friend Paul Cézanne (centre), son of the great painter. With them are Paul's children, Jean-Pierre and Aline, and Georges Rivière, friend and biographer of Auguste Renoir.

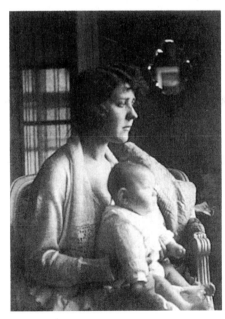

Newly-married man-about-town Jean Renoir, in the early 1920s, still searching for a profession in the arts or in motor racing.

Jean's first wife Andrée Heuschling, soon to become the actress Catherine Hessling, holding baby Alain Renoir with little maternal affection.

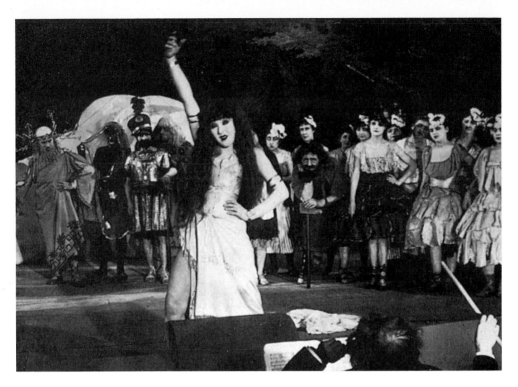

White-faced, kohl-eyed Catherine Hessling in the title role of Zola's courtesan *Nana* (1926), her most stylised performance.

Pierre Renoir, the first screen Inspector Maigret, flanked by Lucie Vallat and Edouard Dignimont, investigating the mysterious goings-on in *La Nuit du carrefour* (1932).

Marie (Jenny Hélia) being comforted by Toni (Charles Blavette, left) and Fernand (Edouard Delmont) after attempting to drown herself in *Toni* (1935), a forerunner of Italian neo-realism.

German commander Erich von Stroheim (centre) welcomes his new French PoW, Pierre Fresnay and Jean Gabin (third and second left), to Wintersborn fortress in *La Grande Illusion* (1937).

An example of Jean Renoir's use of deep focus in *Le Règle du jeu* (1939) with Marcel Dalio (left) and Roland Toutain in the foreground.

Pierre Renoir as a sympathetic Louis XVI in *La Marseillaise* (1938), Jean's tribute to both the French Revolution and the spirit of the Popular Front.

Joan Bennett and Robert Ryan in *The Woman On The Beach* (1947), Jean Renoir's final Hollywood film, the end of seven years of 'unrealized hopes'.

Rumer Godden with Jean (on platform) directing young Richard Foster on location in India for *The River* (1950), the first Renoir film in Technicolor. He became one of the very few European directors to work regularly in colour in the 1950s.

Anna Magnani as star of the *commedia dell'arte* troupe on tour in Peru in *Le Carrosse D'Or* (1953), Renoir's return to film-making in Europe after fourteen years.

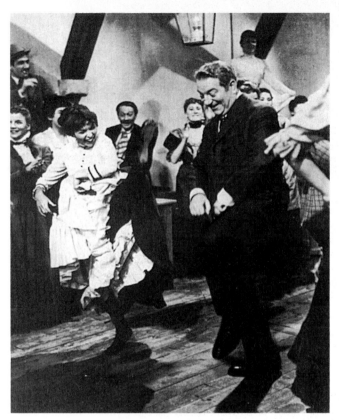

Jean Gabin, as the impressario of the Moulin Rouge, catches the exuberance of the dance in *French Cancan* (1955), Renoir's recreation of the Montmartre of his childhood.

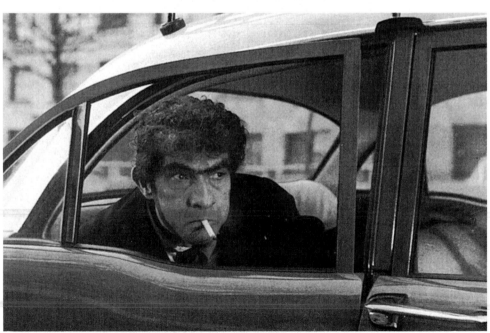

Jean-Louis Barrault as Monsieur Opale, the evil alter ego of the good Doctor Cordelier in *Le Testament du Docteur Cordelier* (1961), Renoir's experiment with TV techniques.

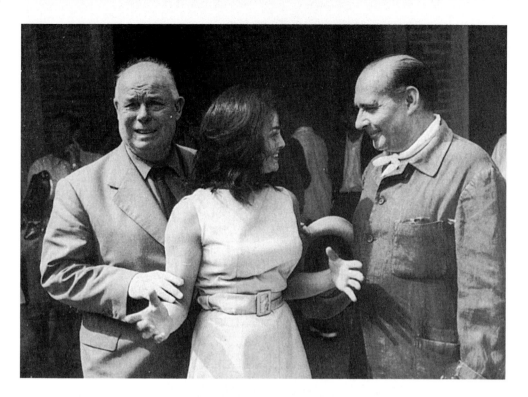

Jean Renoir and Catherine Rouvel being visited on the set of *Le Déjeuner sur l'herbe* (1959) at Les Collettes by Roberto Rossellini, recently divorced from Ingrid Bergman.

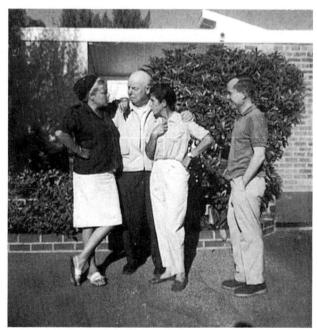

Simone Signoret (left) and Jean Slade, the son of Auguste Renoir's famed model, Gabrielle, with Jean and Dido at their Beverly Hills home in 1964.

A Chaplinesque moment from *Le Caporal Épinglé* (1962) with Claude Brasseur (left) and Jean-Pierre Cassel as French PoWs having locked one of the German guards in the privy.

Jean Renoir in the early 1970s, in semi-retirement at his Beverly Hills home with his wife Dido, who outlived him by eleven years.

towards war, and it would take more than good will of the people to stop it.

The Left was in disarray at the beginning of 1938. Léon Blum's second Popular Front government had resigned, followed soon after by the collapse of the Radicals under Camille Chautemps in March, the month the Germans annexed Austria. On the day the Nazis marched into Vienna, *La Grande Illusion*, which was showing in one of the leading cinemas, was halted in mid-reel by the Austrian authorities.

On 13 April Edouard Daladier formed a new 'Government of National Defence', and thus began the shameful appeasement of the Third Reich by France and Great Britain. In May, while Hitler was making preparations to take over the German-speaking parts of Czechoslovakia, Jean and Marguerite attended the first performance of Brecht's *Fear And Misery Of The Third Reich*, staged by German exiles in Paris. It was directed by Slatan Dudow, who had made the passionate propaganda film, *Kühle Wampe* in 1932, based on a screenplay by Brecht and Ernst Ottwald.

Meanwhile, Jean continued to write synopses for films that he hoped would be made. *Histoires d'enfants* told of a poor working-class family who move to Paris from the North; father, mother, 13-year-old daughter and 12-year-old son. The story concentrates mainly on the boy, his experiences at school, his adventures with friends, and the temptations of a life of crime. When his father is killed in a work accident and his sister becomes a drug addict, he is forced more and more upon his own resources. Nevertheless, he survives to the happy ending when he becomes a hero at school. It is difficult to judge from the few pages Jean offered how he would have handled the somewhat conventional tale of a deprived child-hood. Strangely enough, unlike his two devotees in later years, François Truffaut and Louis Malle, Renoir dealt very seldom with children, a notable exception being in *The River*.

Much easier to imagine on screen was the synopsis for a film called *Les Millions d'Arlequin*, written in May 1938, and for which he had already sketched in the cast he wanted. In August of the previous year, Jean announced: 'After I finish *La Marseillaise* I want to make some comedies. And I'll make them.'[1] Although *Les Millions d'Arlequin* might not be strictly classified a comedy, it seemed to fore-shadow the tragicomic world of *La Règle du jeu*. The similarities lie in the setting of a large house in which a number of bourgeois characters, putting on a façade, are involved in quarrels, intrigues

and romances. The plot also contains one of Jean's pet themes; the *ménage à quatre* – usually a woman courted by three contrasting men – most evident in *La Règle du jeu*, *Le Carrosse d'or*, *French Cancan* and *Eléna et les hommes*. It is more than coincidental that among the classics Jean chose to adapt for the screen, *Nana*, *Madame Bovary*, *La Bête humaine* and *The Diary Of A Chambermaid* all have similar circumstances. The situation is reversed in *The River*, where a young man has three girls from which to choose.

In *Les Millions d'Arlequin*, 25-year-old Valentine is courted by three of her cousins: Jacques (Pierre Renoir), wounded in the war and considered a failure; Paul (Pierre Fresnay), a man of the world who considers himself a leader among men, and Hugo (Erich von Stroheim), the son of an Austrian banker, an ex-soldier, prodigal and ladies' man; also involved is Frédéric (Louis Jouvet), a misanthropic recluse, and Jeanne (Yvonne Printemps), sister-in-law and ex-mistress of Frédéric, described as '*une coquette dévorée par le besoin de séduire*'.

According to Jean, the main subject of this unrealised film was the attitude of the pre-war generation faced with present events, with Valentine the only character representing the younger generation. 'They were all brought up with the idea of "security". When they were children, it was said that if they did their homework well, and learned their lessons, they would pass their exams. Once the exams were passed they would become engineers, lawyers or doctors, the exercise of these professions will bring in enough income to allow them to live a carefree existence. They will have an apartment in the 16th arrondissement, a country house, some antique furniture, two maids, a chauffeur, and some children. Life would unwind before them like a soft ribbon, worthy and monotonous, and from time to time they would say, "Good God, how flat everything is; a war or revolution would change things a little." Well, they had the war in question. And now, not too far from the end of their lives, they find themselves bewildered and incapable of protecting themselves from the upheaval that they once wished for . . . '[2]

In this passage, Jean was speaking for his own class and generation, and, to a certain extent, of himself. But the picture (consolidated by his portrayal of Octave in *La Règle du jeu*) of the portly, slightly naive, non-intellectual, apolitical, cheerful, eager-to-please, *bon vivant* and instinctive artist, swept up in left-wing activities by his friends and mistress, despite himself, is not borne out by either

his life or films during the 1930s. Jean, like his father, believed in feelings above the intellect, but not to the exclusion of it. Politics never interested Jean in the abstract, but when they directly affected people's lives, he was always ready to take up a cause, while eschewing any narrow commitment to a specific ideology or sectarian position. He would, nevertheless, express himself vigorously on topics he felt strongly about, so long as he avoided a personal attack on a friend.

On 30 September 1938, Chamberlain and Daladier returned in triumph after signing the Munich agreement. A week later, Jean delivered his final column to *Ce Soir*, in which he wrote, 'I was a little less proud to be French this week on seeing Parisians acclaiming our President on his return from Munich. This four-sided pact has an element of the white slave trade about it . . . In the place of Daladier and Chamberlain, humble representatives of our so-called democracies in this sideshow, I would feel slightly humiliated . . . So the Germans are going into the Sudetenland. Will our papers publish the pictures as they did for Vienna, of the nice jokes that the Nazis are certainly going to play on the Jews in the regions? Will we see again old men washing pavements with their knees in the mud? Or women forced to walk the streets wearing degrading signs around their necks? In short, will we again be indirect and distant witnesses to those jokes the Nazis play so readily and with such finesse at the expense of those they have defeated?'[3]

Jean's next film came out of the blue, and was in stark contrast to the three stories he had hoped to film after *La Marseillaise*. It was due to Jean Gabin, who wanted to work with Renoir again. Since Duvivier's *La Belle Équipe* and *Pépé le Moko,* Jean Grémillon's *Gueule d'amour*, and *Les Bas-Fonds* and *La Grande Illusion*, Gabin had become the leading male star in France and could pick and choose his roles. With his hat pulled down, a cigarette tucked into the corner of his mouth, and his slightly coarse but handsome profile, Gabin, like Humphrey Bogart, was to become a screen icon of the age.

Unlike most little boys who grow out of the desire to become engine drivers, Gabin retained his aspirations to drive a locomotive. A film in which he would be able to do just that was announced. *Train d'enfer* (Train of Hell), based on a newspaper article by Stéphane Manier and adapted by Pierre Bost with dialogue by Jacques Prévert, was scheduled to be directed by Jean Grémillon. When both Grémillon and the producer, Edouard Corniglion-

Molinier, abandoned the project, it passed into the hands of the brothers Hakim, Robert and Raymond, who, still thinking along railway lines, suggested a screen version of Zola's *La Bête humaine*. A script by recent Nobel Prize-winner Roger Martin du Gard existed but it was too long. Robert Hakim and Gabin therefore approached Jean to write the screenplay and direct the film.

In a short passage, recorded in August 1961 and meant as an introduction to the showing of *La Bête humaine* in an abortive season of 20 of his films on ORTF, Jean commented, 'I have to admit that I hadn't read the novel. I skimmed over it quickly, it seemed fascinating, and I said, "Okay, let's do it." We had to start right away. I'm very proud of the following athletic feat: I wrote the script in 12 days, which isn't bad!'

Nearly three years previously, in December 1957, Jean told *Cahiers du Cinéma* interviewers, Jacques Rivette and François Truffaut, that 'I wrote the script in 15 days . . . I'd read *La Bête humaine* when I was a kid, but I hadn't reread it in maybe 20 years.'[5]

Whatever the exact truth, he had to familiarise himself with the 1890 novel, and wrote the script in a matter of weeks. 'I remained as faithful as I could to the spirit of the book. I didn't follow the plot, but I have always thought that it was better to be faithful to the spirit of an original work than to its exterior form. Besides, I had some long conversations with Madame Leblond-Zola [the author's daughter, who had done the captions for *Nana*] and I did not do anything that I was not certain would have pleased Zola. Yet I didn't feel obliged to follow the weave of the novel . . . I thought of Zola's poetic side. But in the end, people who like Zola declared themselves satisfied.'[6]

Like *Nana, La Bête humaine* is part of the Rougon-Macquart series, with its strong theme of heredity. The hero, Jacques Lantier, represents the most rotten fruit of the genealogical tree, his blood having been tainted by his alcoholic forebears. But this determinist aspect of Zola held little interest for Renoir, although the film opens with a quote from Zola, explaining the cause of Lantier's 'illness'. Also, by updating Zola's 1870 setting to the 1930s, the disaster at the end of the novel – a driverless train filled with drunken soldiers hurtling towards destruction – which clearly symbolises the ultimate breakdown of the Second Empire, disappears from Renoir's screenplay.

What interested him about one of the most gripping of Zola's novels, was its combination of the best elements of a murder

mystery with an intensive study of homicidal obsession and jealousy in the triangular relationship between the engine driver, the station master and his young minx of a wife. Most of all, however, it was a wonderful opportunity for Renoir and Gabin to play with trains.

To prepare for the film, Gabin and Carette, who played the engineer and his fireman respectively, learned how to drive a train with the help of railway workers at Le Havre. Gabin actually drove from Le Havre to Paris with the passengers none the wiser. During the location shooting at Le Havre, the crew and cast lived in the railway buildings of the freight depot, where the SNCF (the recently-established *Société Nationale de Chemin de Fer*) provided them with a locomotive and ten kilometres of track to practise and film on. Jean had to overcome much opposition to his determination to film on an actual moving train. He was told that mock-ups had been perfected to such a point that it was impossible to tell them apart from the real thing. His obstinancy, however, paid off, despite the increased difficulties, because the documentary-like sequences on the engine with no back-projection or tricks, are the most remarkable and vivid sections of the film.

Jean claimed that 'there isn't a detail in the film that isn't exact.'[7] Behind the locomotive they had a flatcar on which two electricity generators were installed. The locomotive, *La Lison*, was lit exactly as if it were a character in a studio, which made it even more complicated because they were moving at 60 miles an hour. To enable them to reach that speed rapidly, another train had to push it from behind.

Claude Renoir, who was in charge of the camera against the side of the locomotive, was almost decapitated when they entered a tunnel. They had slightly miscalculated a measurement, and the camera was knocked off and smashed, while Claude flattened himself against the train.

Only once was Jean forced to use a mock-up. This was when Gabin commits suicide by flinging himself off the tender while the train is travelling at full speed. 'I could not ask Gabin to fling himself off a real tender,' Jean explained. 'As he said when we were preparing the scene "Supposing the film fouls up in the camera during the shooting. I should then have to do the scene again, so it's really better for me to stay alive" – a very sensible remark. So he jumped off the bogus tender on to a thick pile of mattresses.'[8]

Aside from Le Havre, some scenes were filmed at the Gare Saint-Lazare in Paris, not far from the apartment where Jean had lived

with Marguerite and Alain at 105 rue des Dames. Off the rue de Rome, it overlooked the railway tracks, a view not unlike the one from the Roubaud's apartment in the film. Jean had recently moved to a delightful white-shuttered apartment at 7 avenue Frochot, a lovely leafy street in Montmartre, a property he kept until 1972 and to which he returned whenever he was in Paris.

During the making of *La Bête humaine*, the script, which Jean considered fairly superficial initially, kept being reworked and brought closer, he felt, to the poetry rather than the naturalism of Zola. It was the kind of grimy poetry that appealed to Graham Greene, who wrote: 'What is most deft is the way in which Renoir works the depot and a man's job into every scene – conversations on platforms, in washrooms and canteens. Views from the station-master's window over the steaming metal waste: the short, sharp lust worked out in a wooden plate-layer's shed among the shunted trucks under the steaming rain.'[9]

While engine driver Jacques Lantier (Gabin) is travelling as a passenger on a train to Le Havre, he encounters the deputy station master Roubaud (Fernand Ledoux) and his young wife Séverine (Simone Simon) leaving the compartment where Roubaud, watched by his wife, has just killed Grandmorin (Jacques Berlioz), the rich man who seduced her. In response to the pleading look of Séverine, Lantier tells the police nothing, and Cabuche (Jean Renoir), a man with a criminal record, is arrested for the crime. Lantier and Séverine begin a love affair and she persuades him to murder her husband, but he cannot carry it out. A few days later, during the railwayman's ball, Lantier goes to Séverine's apartment and, in the midst of one of his uncontrollable fits, stabs her to death. The next morning, he commits suicide by jumping off the locomotive he is driving.

Fritz Lang, who made a Hollywood version called *Human Desire* in 1954, commented, 'Naturally in an American movie, you can't make a hero a sex killer. Impossible. Jerry Wald [Columbia boss] was very impressed with the Renoir film, in which there are a lot of trains going into tunnels, which Jerry thought was a sex symbol; I doubt Renoir in 1938 ever thought about sex symbols . . . '[10]

Renoir did. Much of the sexual symbolism and imagery of the novel, although toned down, remained in the film, the pulsing locomotives included. In the novel Zola writes of Lantier's love for *La Lison*, his locomotive: 'He possessed her, he rode her in his own way with absolute will, as her master, yet never relaxing his severity,

treating her like a wild animal he had tamed, but whom he could never quite trust.'

The locomotive is filmed as a mechanical Beauty ridden by the human Beast, and Gabin's eyes light up with genuine passion as he speaks of *La Lison*, 'the best engine on the line.' Elsewhere, there is a more blatant sexual symbol – while Lantier and Séverine make love in the railway shed, the camera moves to a overflowing rain barrel.

For the role of Séverine, the producers originally suggested Gina Manès, then pushing 43, who had played the title role in *Thérèse Raquin* (1928), Jacques Feyder's silent Zola adaptation, and who had made a reputation in other *femme fatale* roles. Jean refused vehemently. 'I claimed, and still claim, that vamps have to be played by women with innocent faces. Women with innocent faces are the most dangerous ones! Also, you don't expect it, so there is an element of surprise! I insisted that we use Simone Simon, which we did, and I don't think we were sorry.'[11]

The 27-year-old Simone Simon, who had been in *Mam'zelle Nitouche* (1931) with Janie Marèze, Renoir's 'chienne', had just returned from Hollywood after a dispute with Twentieth Century-Fox over a contract drove her back to France. Simon arrived from the USA in Le Havre on the *Normandie* on 8 August 1938, ten days before shooting began there.

The enchanting pekinese-profiled Simon, foreshadowing Brigitte Bardot's 'sex kitten' looks by nearly two decades, is first seen at a window gently stroking a white kitten. She creates a teasing mixture of innocence, perversity and sensuality against which looms the powerful, brooding presence of Jean Gabin. As Lantier, painfully trying to suppress the dangerous compulsion which leads him inescapably to murder the woman he loves, Gabin becomes a great tragic screen actor; 'Oedipus in a cloth cap,' as André Bazin put it.[12]

Renoir also creates an interdependent working and personal relationship between Gabin and Carette, the latter crying over his buddy's corpse – 'It's the first time I've seen him look so peaceful for a long time.' Jean Renoir himself gives a lively cameo performance as Cabuche, changed to a poacher from the quarry worker of the novel, with a few day's growth of beard, vehemently protesting his innocence and wistfully reminiscing about a love affair.

There are many outstanding sequences in *La Bête humaine*: the opening Paris to Le Havre run on the locomotive; the murder of Grandmorin behind the blinds of the railway compartment; the

love-making in the shed as the rain falls; the lovers' emergence under a clear sky. But perhaps most memorable is the climax when the seductive song, 'Pauvre Petit Coeur de Ninon', sung at the railway-man's ball, ironically and movingly counterpoints the final murder. The melody serves the same dramatic purpose as 'O Ma Belle Inconnue' did in *La Chienne*.

In many ways, both in style and content, *La Bête humaine* prefigures the American *films noirs* of the 40s; witness the scene where Gabin and Simon wait in the dark of the railway yard to commit murder, and the manner in which Gabin is lit as he stands over Simon's dead body before catching a glimpse of himself in the mirror. But away from the shadows, Renoir could not resist a typical shimmering river sequence, which might have come from *Une Partie de campagne*.

La Bête humaine, like Marcel Carné's *Quai des Brumes* of the same year, also starring Gabin, caught the dark, fatalistic *Zeitgeist*. The Carné film, released a few months before *La Bête humaine*, was the first film in which the distinctive 'poetic realism' of Carné and Jacques Prévert expressed itself. The melancholy Gabin, the army deserter in his French colonial uniform and *képi*, trying to find some happiness with the Modigliani-eyed Michèle Morgan, in trench coat and beret, in a sombre fog-bound port, are quintessential images associated with the world-weariness prevalent in pre-war France.

Despite the dominant pessimistic tone of *La Bête humaine*, Renoir's underlying philosophical and political optimism comes through, whereas the Carné-Prévert characters are without hope, living in an essentially irredeemable society – that both the Left and Right found unacceptable. In *Quai des Brumes*, Gabin represents a tired and defeated proletariat; in *La Bête humaine*, he is an active member of 'a great calling', in which there is strength and solidarity. Compared with Renoir's open-air realism and expansiveness, the confined world of Carné, filmed against studio sets by Alexander Trauner, seems artificial and theatrical.

It was quite natural that Jean would feel antipathy towards the Carné film, calling it *Cul des Brèmes* (a bream's arsehole), though it was rather indiscreet of him to telephone his friend Prévert to tell him that he thought the film fascist. Prévert, who considered himself violently anti-fascist, replied that if he caught Jean saying that again he would punch him in the face. Jean explained that he had meant, in his clumsy way, that the characters were fascist at heart.

In the opinion of Marcel Carné, 'Renoir was very jealous that

Prévert was working with me. He wanted to work again with Prévert. I've always had a great admiration for Renoir, but he does have a Jesuitical side, and likes to make mischief. I was a film critic at the time *La Chienne* came out, and I was the only one who defended the film. But later he joined with Truffaut and his young friends of the New Wave in a moral assassination of me, saying I made any film that came along.'[13]

In the 1980s, bitter from years of neglect, Carné, like Claude Autant-Lara, turned to the extreme right, blaming their lack of acclaim and difficulties in getting films made on 'the government too close-knit with the Jews. They stick together.'[14]

Le Bête humaine opened in Paris at the Madeleine on 29 December 1938 and was an immediate hit, playing to full houses for months. Renoir had finally won the reputation he had been seeking for 14 years since he entered the film industry.

26

Everyone Has His Reasons

'La Règle du jeu is a war film, and yet there is no reference to the war. Beneath its seemingly innocuous appearance the story attacks the very structure of our society. Yet all I thought about at the beginning was nothing avant-garde but a good little orthodox film.'

Despite the Munich agreement, against which only the Communists voted, war increasingly seemed inevitable, yet the end of the decade saw the French film industry booming, producing an average of 130 pictures a year. Jean had enough optimism in early October 1938 to join his brother Coco (who had been assistant director on *La Bête humaine*) and three friends, André Zwobada, Olivier Billiou and Camille Français, to form a production company called the *Nouvelles Editions Françaises*. The co-operative, for which each of the five partners put up 10,000 francs, planned to make two films a year. The commercial success of *La Bête humaine* made fund-raising easier.

Jean also contacted René Clair (just back in France after making two films in England), Julien Duvivier (recently returned from Hollywood where he had directed the vastly successful *The Great Waltz*), Jean Gabin and Simone Simon, all of whom considered joining. The NEF envisaged signing an agreement with Marcel Pagnol Films, from whom they rented the Paris offices at 18 rue la Grange-Batelière, to acquire the exclusive rights to a large Paris cinema where they would only show their own films.

In January 1939, Jean went to give a lecture at the London Film

Society, a group set up in 1925 to project influential films denied commercial release. In his speech, delivered in French, he spoke warmly of co-operatives as the way forward for film production.

While in London, he met Robert Flaherty, 'the father of the documentary', whose work he so greatly admired. Flaherty had seen *La Bête humaine* in Paris and adored it. The two independently-minded film directors, the American-born son of a gold prospector and the 10-years-younger French-born son of an Impressionist painter, took to each other immediately. Flaherty, who had recently been filming *Elephant Boy* in India, spoke glowingly of the country that Jean would one day discover with the same sense of rapture. Unfortunately, much of Flaherty's location work on the film was scrapped by producer Alexander Korda when the unit returned to England, leaving the director bitter and bewildered.

One evening, Jean paid a visit to Flaherty's apartment in Chelsea, where the guests included a group of IRA members who plotted the struggle for independence over bottles of Irish whisky, of which the visiting Frenchman partook with pleasure.

Immediately on his return to France, Jean, with Karl Koch and André Zwobada, left for Marlotte where they could work in peace on the script of Jean's new picture, the last French film he would make for 15 years.

Nouvelles Editions Françaises first announced that Jean was to direct a film version of Alfred de Musset's 1851 comedy, *Les Caprices de Marianne*. Working on *La Bête humaine* 'inspired me to make a break, and perhaps get away from naturalism completely, to try to touch on a more classical, more poetic genre.'[1] Musset's fusion of the romantic and classical traditions, poetry and fantasy, under the influence of Shakespeare and Marivaux, presenting a world in which anything can and does happen, reflected Jean's own nature more than the dark romantic realism of Zola. It would also satisfy his need to make a comedy. Auguste Renoir had liked Musset, who 'spoke a language I can understand,' preferring him to Octave Mirbeau, who was all the rage at the time. For him, Musset, however exaggerated and sentimental, 'at least did not try to cheapen human relationships.'[2]

Jean's initial thought was to update the Musset play to contemporary France, as he had the Zola novel, but he changed his mind. He did, however, retain the name and many of the characteristics of Octave from *Les Caprices de Marianne*. What was needed was an

original script in the spirit of the work. So he read more Musset, Marivaux and Beaumarchais ('Why else does love bear wings if not to fly?' from Act IV Scene X of *Le Mariage de Figaro* is quoted at the beginning of *La Règle du jeu*), as well as Jean Giraudoux to help him establish 'a style, halfway between a certain realism – not exterior, but realism all the same – and a certain poetry.'[3]

The germ of *La Règle du jeu* was born out of his listening to French baroque music – Couperin, Rameau, Lully – and that of the eighteenth-century *opéra comique* composer André Grétry, whose aria 'O Richard, O Mon Roi' from *Richard Coeur de Lion* is used so effectively in *La Marseillaise*. (In the event, the only background music used in the film was by Mozart and Pierre Alexandre Monsigny.) The music made Renoir wish 'to film the sort of people who danced to that music . . . By degrees my idea took shape and the subject became simplified, and after a few days, while I lived to baroque rhythms, it became more and more clearly defined.'[4]

Jean's absorption of these composers and authors provided the structure, setting and plot with a dynamic juxtaposition of past and present, comedy and tragedy, melodrama and farce, as well as realism, that gives *La Règle du jeu* its uniqueness. Additionally, he could not but be influenced by the political events around him, though writing a screenplay that ostensibly seemed as if it would be escapist entertainment.

On 26 January 1939, while Jean was writing the screenplay for *La Règle du jeu*, Barcelona fell to the Fascists, opening the way to Franco's taking of power. A month later, the French government of Daladier recognised the new Spanish regime. Italy entered Albania, and Hitler began preparing his invasion of Poland. It was against this background that *La Règle du jeu* was written.

Jean wished to continue with the same lead actors he had cast in *La Bête humaine*, and wrote the roles of the marquis and marquise de la Chesnaye with Fernand Ledoux and Simone Simon in mind. He wanted Jean Gabin to play the pilot (changed from an orchestra conductor the better to suit Gabin's persona) in love with the marquise, and Carette, who was being given larger and larger parts by Jean, was cast as the poacher. But, Carette aside, none of the other three appeared in the film, and as Jean had followed his usual practice of writing roles to suit performers, he had to re-adapt his script.

Gabin had accepted a better part offered him by Marcel Carné in

Le Jour se Lève, a good decision for him as it turned out, and was replaced by Roland Toutain. Because Toutain had made a reputation as a dashing screen hero, most famously as the intrepid journalist hero of Marcel L'Herbier's detective thriller *Le Mystère de la chambre jaune/The Mystery Of The Yellow Room* (1930) and its sequel *Le Parfum de la dame en noir/The Perfume Of The Lady In Black* (1931), based on Gaston Leroux's novels, he could convince as a pioneering aviator. However, he is forced to spend most of the film mooning over Christine de la Chesnaye, finally becoming the accidental victim of a *crime passionnel*.

After the glowing reviews she received for her performance in *La Bête humaine*, Simone Simon asked for 800,000 francs, almost one third of the projected budget and much more than Camille François, the general administrator of the NEF, was willing to pay. With Simone Simon too expensive, the husband and wife pairing from *La Bête humaine* no longer applied. Thus Fernand Ledoux was asked to play the jealous gamekeeper Schumacher, but he opted rather for the role of Corvino in Maurice Tourneur's *Volpone*. The trusty Gaston Modot took over. Claude Dauphin refused the role of the marquis de la Chesnaye, joining Simone Simon in the cast of Raymond Bernard's *Cavalcade d'amour* instead.

Jean then turned to Marcel Dalio to play the role of the marquis, going against the convention of how aristocrats should look in films. 'I had been more of a burlesque character, a traitor, or even a Rosenthal, and that always surprised people, as if a marquis or a count had to have a certain face,' commented Dalio. 'Maybe they have one in magazines. Why don't I look like a marquis? Tell me: my frizzy hair? My eastern look?'[5]

While seeking a new Christine de la Chesnaye, Camille François suggested Jean attend a performance of a play in which a young actress called Michèle Alfa was making her debut. Jean, who took Marguerite and André Zwobada with him to the theatre, was disappointed that the actress, though talented, was not the type he had in mind for the role. Out of boredom, his eyes wandered around the auditorium until they alighted on an elegant-looking woman in a box. She was just the type he wanted for the marquise. At the interval he made enquiries and discovered that, coincidentally, she was both an actress and carried a title.

Nora Grégor was the wife of Prince Stahremberg, an Austrian nobleman and political leader of an anti-Hitler peasant party, who had fled his country at the time of the *Anschluss*. Jean introduced

himself, and after a couple of dinners (one at Maxim's for which he and Marguerite had to dress formally, something they always found a bind), he offered the Princess Stahremberg a leading role in his new film, much to the consternation of his colleagues.

Over the years an impression has been formed in some quarters that Jean gave the role to the Austrian princess, who had done little acting, because he was dazzled by her and the title. It is more than likely that he was attracted to Nora Grégor, but she was not inexperienced. Before her marriage she had been on the stage in Vienna in the 1920s, and had appeared in several silent films in Germany, including Carl Dreyer's Freudian *Mikaël* (1924), in which she played Princess Zamikoff, and Paul Czinner's *Der Geiger von Florenz* (1926) alongside Conrad Veidt and Elisabeth Bergner. She had also acted in five German sound films, and one in Hollywood, *But The Flesh Is Weak* (1932), adapted from an Ivor Novello play and starring Robert Montgomery. She was rather older than Renoir had imagined for the role and spoke little French, but then neither did Erich von Stroheim when he was cast in *La Grande Illusion*. Making a virtue of necessity, Renoir rewrote Christine as the daughter of a great Austrian conductor, and used her foreignness to dramatic effect.

While still working on the screenplay, Jean went off to the Château de la Ferté-Saint-Aubin in Sologne for location filming in February 1939. His team included his now 19-year-old son Alain, graduating from trainee assistant cameraman on *La Bête humaine* to assistant cameraman, and Dido Freire, who had become a good companion to both Jean and Alain, in charge of continuity. But the hazards of Jean's al fresco method were exposed once again as they had been on *Une Partie de campagne* – the rains came and kept on for weeks, and the crew sat around eating, drinking and playing cards at the Hotel Rat at La Motte-Beuvron, while Jean continued to alter the screenplay to meet changing circumstances. For example, he included an effective scene when the guests arrive at the château during a downpour.

Due to the weather, Pierre Renoir, who was cast as Octave, everybody's friend, had to forgo any further participation in the picture because of his stage commitments. Jean tried desperately to get Michel Simon, but he was tied up in films for the year. It was then that Jean decided to play the part of Octave himself. 'I really didn't look very hard. I was just waiting for the moment when

Pierre would say "Why don't you play the role yourself, Jean?" He didn't have to ask me twice.'[6]

As the brothers Renoir were so different in physique and personality, the role of Octave had to be significantly changed. One could never imagine the cool and dignified Pierre running around in a bear costume, or playing the buffoon as Jean does so disarmingly.

Meanwhile, expenses mounted as shooting was delayed, and the huge, elaborate and costly sets designed by Eugène Lourié and Max Douy, on two adjoining sound stages at the Joinville studio, lay idle. One wonders why the interiors were not shot first, but whatever the reason, André Zwobada, in search of increased finance, had to negotiate with Jean Jay, director of the Societé Gaumont, for an advance on the rights to exhibit *La Règle du jeu* in the Gaumont cinemas. The advance was forthcoming, but Renoir now found himself at the mercy of Jean Jay.

When the weather finally cleared, Jean was able to shoot the exterior scenes that take place in the grounds of the château, capturing the grey, misty beauty of an area which Auguste regretted never having had the opportunity to paint. 'How well I understand the sincerity of those regrets before these beautiful landscapes of Sologne, in astonishing colours, of a grace so melancholy and yet so gentle.'[7] In fact, Jean had originally wanted to film *La Règle du jeu* in colour. But as the cost of the process was exhorbitant – and rare even in Hollywood in 1939, the year of *Gone With The Wind* and *The Wizard Of Oz* – he tried to arrange for Technicolor to pay for all costs over the usual black and white. They refused. Naturally, being his father's son, Jean would have loved to make a colour film, but he had to wait another 11 years before he did so. This long deprivation might explain why he feasted so voraciously on colour when he ultimately had the chance to use it.

Filming in the Sologne moved at a slow pace, mainly because much of it was being improvised, and also because Jean was having trouble getting the performance he wanted from Nora Grégor – he found her too stiff, and she was having difficulty with her French. This forced him to build up the two other principal female roles, that of Geneviève (Mila Parély), the marquis de la Chesnaye's mistress, and Lisette (Paulette Dubost), the coquettish maid. Besides directing, Jean also had to play his substantial role as Octave.

Jean Jay came down to see how the location shooting was progressing, and despaired at what he saw in the rushes. He told Jean that he was not happy with his performance, and wondered if

it were not after all possible to get Michel Simon at this stage. But when it was explained that this would mean reshooting almost two thirds of the film, Jay requested that the role of Octave be considerably reduced. He also urged Jean to return immediately to Paris to the studio sets waiting for him at Joinville at such expense. This he did reluctantly, leaving Zwobada, Henri Cartier (later Cartier-Bresson), arms specialist Antoine Corteggiani, and a small crew to capture the hunt scene.

Once at the studios, contrary to Jay's desire to see the role of Octave reduced, Jean mischievously, though born of artistic instinct, built up its importance. By April, *La Règle du jeu* was complete, at a cost of five million francs, and running 113 minutes, after Marguerite had cut it down from some three hours. When Jay saw the film, he thought it far too long and demanded it be cut further before release, especially many of the scenes featuring Octave, otherwise it would fail at the box office. 'I gave in to commerce,'[8] said Jean, although only 13 minutes were cut before its opening at two Gaumont cinemas, the Colisée and the Aubert-Palace in Paris at the beginning of September 1939.

Most of the action takes place during a lavish weekend party at La Colinière, the country château of Robert and Christine, the marquis and marquise de la Chesnaye (Dalio and Grégor). Among the guests are André Jurieu (Toutain), an aviator who has just flown the Atlantic in record time, mainly out of love for Christine; Geneviève de Marras (Parély), Robert's mistress; Octave (Renoir), a friend of André and Christine's, who is ostensibly trying to bring them together, though he loves Christine himself; and various other members of the aristocracy and bourgeoisie. Below stairs are Corneille (Eddy Debray), the major domo; Lisette (Dubost), Christine's maid, married to Edouard Schumacher (Modot), the jealous gamekeeper, and Marceau (Carette), poacher turned servant, who flirts dangerously with Lisette. Sexual tensions are simmering among the hosts, guests and servants, until they boil over at *une grande fête* during which Schumacher tries to shoot Marceau, and Christine arranges to run away with André and then Octave. Finally, Schumacher kills André in the gardens mistakenly thinking he has an assignation with his wife. The incident is explained away by Robert as an unfortunate accident.

Subtitled a *Fantaisie Dramatique*, *La Règle du jeu* is perhaps Renoir's most archetypal and perfect film. It is also his most complex in style

and subject. Within the format of classical comedy (its title echoes Marivaux's best-known play, *Le Jeu de l'amour*), it reveals modern French society being disembowelled from within. In the great set-piece of the hunt, the callous cruelty of the guests is laid bare as they fire at any rabbit and bird that moves after the beaters have lead the game to slaughter. There was no need for Renoir to accentuate the analogy with world events.

The ruling classes gather behind a paper-thin façade of civilisation and respectability, which takes a very short time to peel off. Their snobberies and prejudices are echoed by the servants, some of whom display anti-semitism. (The marquis turns out to be a Rosenthal, a reference to Dalio's preceding role in *La Grande Illusion*.)

Animosity reigns among both the upper and lower classes, gone is the workers' solidarity of the Popular Front. Like a cat and dog, the gamekeeper and poacher are eternal enemies – the latter naturally viewed more warmly in Carette's sly and comic performance, but it is the absurdly rigid Schumacher, the pitiful outsider and cuckold, who is led cynically by the poacher to kill at the end.

With eight principal roles and 12 lesser ones, all interacting in the same space, it was even more of an ensemble work than *Le Crime de Monsieur Lange*. In order to choreograph this ensemble, Renoir used every technical possibility. '[Jean] Bachelet and I ordered some special lenses, very fast lenses, but ones that still gave us considerable depth, so that we could keep our backgrounds in focus almost all the time,' Renoir explained.[9] This allowed for moments such as when Schumacher is seen approaching from far in the background towards Lisette and Marceau making love in the foreground; the servants are visible moving at the far end of corridors as the guests gather in front, and the impression of the spaciousness of the château and the de la Chesnayes' town house is captured.

During the after-dinner entertainment, in what has come to be known as The Walpurgis Night sequence, a *danse macabre* takes place on stage, while Renoir traps his contrasting couples in spotlights and tracks them down with his camera through the large rooms and along corridors as they perform their absurd acts. The sequence, one of the most breathtaking in all cinema, was described by Richard Roud as something from 'a Marx Brothers film scripted by a Feydeau who had suddenly acquired a tragic sense.'[10]

Jean once said that none of the characters in the film was worth saving. Certainly this now seems a stern judgement, but one that was coloured by the fact that these people, who might have had an

influence in shaping the world, did nothing to prevent the advance of Fascism; some of whom, indeed, actually welcomed it. As Octave says, 'Everyone lies, the newspapers, the radio, the government . . . '

Nevertheless, the characters, as in Marivaux and Beaumarchais, are members of a sheltered and sophisticated society that was only swept away by the French Revolution, and are drawn by Renoir with understanding, comic irony and realism.

Despite the problems Jean had in directing Nora Grégor, she presents a touching, fragile, rather vain Marschallin. (Sadly, Grégor committed suicide in 1949.) Dalio, with his artificial make-up and pencil-thin eyebrows, gives an extremely sensitive performance in portraying a man who, conscious of being a Jew among his peers, feels some affinity with the poacher. He has no better moment than when he stands with pride and slight bashfulness in front of his Limonaire, or mechanical orchestra, knowing it is more trustworthy than the human heart.

However, at the core of the film is the character of Octave. The badly-dressed, shambling, bulky figure (Jean had put on weight since his appearance in *La Bête humaine*) bustles around like the proverbial bull in a china shop. He sprawls on a bed, breaks into a little run with a sudden burst of enthusiasm, dances on impulse, cuddles the maid, and jokes behind people's backs. Jean Renoir makes Octave a lovable buffoon, everybody's friend and confidant, perceived as a cuddly bear, the costume he wears for the show and in which he is trapped. But gradually the carefree clown is, in his own words, exposed as a 'failure and parasite', willing to betray his friend André and run off with Christine. At the end Octave is a lonely, broken figure.

The performance may at some moments seem a little crude and broad in the midst of a cast of professional actors, but it is so truthful that audiences over the years have formed their image of Jean Renoir the man through the character of Octave, and the phrase, 'The terrible thing about this world is that everyone has his reasons,' is often attributed to the director himself. As someone says, 'Octave is no ordinary person.' Of course, much of the pleasure in watching him on screen comes from the knowledge that, unlike a more experienced actor, Jean was unable to disguise his own personality, and when Octave starts to conduct an invisible orchestra, it is a symbol of the director at work, and when he speaks passionately of wanting to communicate with audiences, it is the voice of Renoir

filtered through Octave. Richard Roud suggests, 'It is though he included himself through a kind of scrupulous honesty: he could not exempt himself from this portrait of society; he did not wish to stand outside. And Renoir/Octave serves as the standard against which reality and fiction can be measured.[11] It was Jean's longest and most important acting role in films, and it was also (discounting his few later appearances as himself) his last.

When *La Règle du jeu* opened at the Colisée on 11 July, in the presence of some of the company and crew of the film, it was preceded by a flag-waving documentary glorifying the French Empire. The audience – among whom were members of right-wing organisations – cheered. But a little way into the main picture, they began to whistle and boo. One spectator set fire to a newspaper and tried to ignite the back of a seat, declaring that any theatre that showed such a film should be destroyed. Deeply upset, Jean left the cinema in tears.

'I was utterly dumbfounded when it became apparent that the film, which I wanted to be a pleasant one, rubbed most people up the wrong way,' Jean wrote years later. 'There was no question of contrivance; my enemies had nothing to do with its failure. At every session I attended I could feel the unanimous disapproval of the audience.'[12]

The obvious loathing that most audiences felt for the film in 1939 may seem puzzling today. But so many elements came into play in the feverish climate of those days leading up to the war. Jean Renoir's known support for the Communist Party, and the casting of Dalio as a Jewish marquis and of the Austrian Nora Grégor might have provoked right-wing, anti-semitic and xenophobic emotions, but it went deeper than that. Jean believed that his portrait of people 'dancing on a volcano' was too truthful to be comfortable. 'They recognised themselves. People who commit suicide do not care to do it in front of witnesses.'[13]

In order to minimise its failure, Jean shortened the film from 100 mins to 90 and then to 85, cutting out as much of himself as possible 'as though I were ashamed, after this rebuff, of showing myself on the screen.'[14]

On 28 August, after a month's run, the film was banned by the government as being 'demoralising.' The Ministry of Foreign Affairs explained: 'We are especially anxious to avoid representations of our country, our traditions, and our race that changes its character, lie

about it, and deform it through the prism of an artistic individual who is often original but not always sound.'[15] *La Règle du jeu* was in good company; *Le Mariage de Figaro* was also banned for a similar reason. Beaumarchais had made the mistake, through the mouth of Figaro, of not criticising a particular man (as he did in *Le Barbier de Séville*) but society as a whole. The censors took no heed of the marquis' reply to Octave's speech about 'everyone has his reasons.' 'If they do then they should be allowed to express them freely.'

The pristine version of the film is no longer extant. When it re-emerged after the war, it was shown in an 80-minute form, but remained unappreciated. However, in 1956, two young film lab technicians, Jean Gaborit and Jacques Maréchal, who had formed the *Société des Grands Films Classiques*, dedicated to the restoration of forgotten and neglected masterpieces, discovered 224 boxes containing positives, negatives, and sound mixes from *La Règle du jeu*. These were recovered from the ruins of the G. M. Film Laboratories at Boulogne-sur-Seine bombed by British and American planes in 1942. With the advice of Jean Renoir, Gaborit and Maréchal took two years to restore the film to its almost complete original length of 113 minutes. Jean said, 'There is only one scene missing in this reconstruction, a scene that isn't very important. It's a scene with me and Toutain that deals with the maids' sexual interest.'[16]

The newly-constructed version of *La Règle du jeu* was ready to be shown for the first time at the 1959 Venice Film Festival, where it came as a revelation. It was the year in which the *nouvelle vague* was consecrated, and Renoir would become one of the very few European directors to be accorded admiration by the young members of the group, many of whom had graduated to film-making from the pages of *Cahiers du Cinéma*. But it was not until 23 April 1965 that the near-complete print was shown in Paris. However, this was all a long way in the future. As Jean left the Colisée on that warm July day in 1939, with the jeers ringing in his ears, he resolved either to give up the cinema or leave his beloved France.

27

A Shabby Little Shocker

'I was involved without wanting to be. I was involved because the events that revealed themselves to me required that I become involved. I didn't go looking for events . . . I was voluntarily or involuntarily a witness to certain things and it's the outside world that acted on me and led to my convictions.'

Before the disastrous release of *La Règle du jeu* in September 1939, Jean, always planning one or two films ahead, wrote four treatments for a contemporary *Romeo and Juliet*, changing its title, setting and the characters' names each time between May and August of the same year. The main problem he found in updating the violent animosity between the Montagues and the Capulets was that 'the bourgeoisie has long been accustomed to settle its internal quarrels through recourse to legal means.'[1]

The principal setting of one draft was in and around a modern housing estate in Paris, where a feud exists between those who live in the apartment blocks and those who live in the shanty town around it, near the woods. Naturally, Jean's sympathy lies with the poorer group, who subsist on berries and mushrooms, the hunting of rabbits and deer, and who gather wood for their fires.

The title changed from *Ida* to *Tibi* to *Artus*, and finally to *Le Crime de la 'Gloire-Dieu'*. *Tibi*, the most detailed, took place in a Burgundian village not unlike the Essoyes of his childhood, on the edge of a state-owned forest filled with game. On the manuscript, Jean pencilled in the names of performers he would like to cast: A

poacher and seller of rabbit skins (Julien Carette); his '*Très distinguée*' daughter (Gaby Morlay); the powerful mill owner (nobody cast), the latter's respectable wife (Yvonne de Bray or Orane Demazis), and their son (Julien Bertheau or José Noguero), who detests his milieu and is in love with the poacher's daughter; a libertine (Pierre Fresnay), who has fallen on hard times and lives in a hut with Lulu (Yvette Lebon or Jenny Hélia), an orphan girl of the woods.

It seems, however, that Jean was longing to revisit North Africa, and felt the best way to do it would be to make a picture there. Therefore, soon after completing *La Règle du jeu*, and presumably with memories of a string of rainy days, he confidently announced that his next film would be a modern *Romeo And Juliet*, shot in Technicolor on location in North Africa (with 'the star-crossed lovers' belonging to different feuding tribes). His desire was to make '*un véritable film d'aventures*',[2] filmed as much as possible in exteriors and real interiors. This time he would be able to capture all the colours of the country, impossible when he made *Le Bled* in Algeria in black and white. It would be made 'without prejudice, in an objective manner, something which hasn't been done up to now, and would be welcomed by a public who know little of that area.'[3]

During the same period, still with the desire to work in the Maghreb, he wrote a treatment for a film called *Amphitryon*, an updated version of the Greek legend, treated on stage in 1929 by Jean Giraudoux as *Amphitryon 38* (the number signifying the amount of times it had been adapted), in which Pierre Renoir had played Jupiter. Jean's thirty-ninth version eschewed the supernatural element, making Jupiter an important French politician who visits North Africa incognito, with his devoted secretary Mercury, to find out about the local politics and army. Jupiter falls for Alcmène, the faithful wife of Amphitryon, an army captain on duty away from home, and substitutes for him during a power failure engineered by Mercury. Alas, these were another two Renoir films that were never to be. Yet, though producers did not allow him to work in North Africa, an offer came to visit Fascist Italy, that he found difficult to refuse.

In the summer of 1939, Renoir was invited to Rome to make a film of *La Tosca*, the 1887 Sardou play that inspired Puccini's opera, and to give a series of lectures at the *Centro Sperimentale di Cinematografia* as part of the cultural exchange to promote Franco-Italian relations. The request came from Scalera Films and the Italian government,

which meant Benito Mussolini himself. *Il Duce* was particularly anxious to develop the Italian motion-picture industry, had worked to make Rome the movie capital of the world, and had inaugurated the Cinecittà studios – seen as the new Hollywood – with great pomp in the spring of 1937. Almost every evening, private screenings were held for father and son (Vittorio), a film fanatic, in Villa Torlonia. Among the films shown was *La Grande Illusion*, so disliked by Goebbels but which moved the Italian dictator to invite its director to the *Centro Sperimentale* to help increase its prestige.

The invitation to make a film in Italy came at a time when Jean was ready to take a new turning in his life, and his decision to go hastened the change. It was while delving into the gloom of *La Bête humaine* that three interrelated things happened to him, creative, political and personal. First was his need to make brighter, more entertaining films. Like the character of Octave, he wanted to feel the thrill of contact with a wider public. There was also a compulsion to return to the world of his father, who hated anything grim or depressing. This made him move towards the baroque-inspired *La Règle du jeu*, which turned out darker than he originally intended and repulsed rather than attracted the audiences whose affection he sought.

Neither *La Règle du jeu* nor the North African subjects were initially motivated by any direct political commitment as were *Le Crime de Monsieur Lange*, *La Vie est à nous* and *La Marseillaise*, or by the large ethical or philosophical notions underlying *La Grande Illusion*. It is also significant that at the same time as he stopped being the film voice of the Popular Front, he gave up his polemical weekly column in *Ce Soir*. There is no doubt that Jean felt uncomfortable with the left-wing label pinned on him; it was as though it restricted his own expansive all-encompassing personality. All of this affected his relationship with some of his Communist friends, and with Marguerite who remained faithful to the party line. His intimate companions, like Karl Koch and Pierre Braunberger, belonged more to the European liberal humanist tradition in which he himself was brought up.

Although the Montmartoise Renoir was never very close to Jacques Prévert and his surrealist friends of Saint-Germain-Des-Prés, he had strayed further from them in the last few years. Jacques Becker had been drafted, and Jean would not see his friend and protégé again until the 1950s. Becker, who had been given the chance to direct a feature film, *L'Or du Cristobal*, in 1939, for which

Jean was to said to have written the dialogue, walked off after three weeks shooting, and was only to make his first film in 1942, after he had spent a year in a German POW camp. Jean's link with his childhood remained strong but he seldom saw Gabrielle, who lived a great deal of the time at Berck Plage on the Atlantic coast with her son Jeannot, who suffered from osseous tuberculosis. On one visit, Jean and Karl Koch went camping there, and decided to use the beach for the last scene of *Le Crime de Monsieur Lange*. He did see Pierre and Elisa Renoir in Paris, and Coco and Paulette Renoir at Les Collettes from time to time.

It was during the making of *La Règle du jeu* that the final rift with Marguerite came about. At first, there was his temporary infatuation with Nora Grégor, but his attention soon turned to Dido Freire, who was most often quietly standing at his shoulder as script girl. He had known the raven-haired, dark-eyed Dido for 12 years, since she was 18. Now he turned for affection and solace to this 30-year-old woman, who had already long been adopted by Alain as his mother. There had never been any man of importance in her life other than Jean, whom she had observed over the years with Dédée then Marguerite, with both of whom she had been genuinely friendly. Her patience was now rewarded. Unlike Dédée, she was unconceited, had few professional goals, and was sensible with money. Unlike Marguerite, she was a practising Catholic and unallied politically. It mattered not that Jean was 15 years her senior; in many ways Dido seemed the more mature.

Jean's work can be divided into three sections, each related to the three women who played important roles in his adult life: the Dédée period – the silent films from *Catherine* to *La Petite Marchande d'allumettes*; the Marguerite period – the pre-war talkies from *La Chienne* to *La Règle du jeu*; the Dido period – the Hollywood and post-Hollywood films from *Swamp Water* to *Le Petit Théâtre de Jean Renoir*.

It was with Dido that Jean made his controversial trip to Italy in August 1939.

Two days after Jean left Paris for Rome, Louis Aragon, in *Ce Soir*, ending his review of André Malraux's *Espoir*, wrote, 'I'm writing these words for you, Jean Renoir, who left Paris without wanting to say goodbye to me . . . for all those who are weak and cowardly . . . for all those who had despaired of France too soon and whom perhaps I will never again be able to look at calmly after this film,

and this war, and the great Passion of the Spanish people, my brothers.'

'The terrible thing about this world is that everyone has his reasons.' What was Jean's reason for going to Italy at that time? The various contradictory explanations he subsequently offered for his decision to work in Italy, reveals some of the contradictions in himself. 'I really wanted to shoot in Italy, next I was asked to shoot in Italy,' Jean said,[5] a statement that seemed blithely oblivious to any moral aspects concerned with the trip. Elsewhere he took a purely aesthetic line. 'Working on *La Règle du jeu* brought me fantastically close to Italy, and I wanted to see baroque statues, the angels on bridges, with clothes with too many folds and wings with too many feathers. I wanted to see the kind of complex interplay of Italian baroque. I should add that later on I quickly learned that the baroque was not the essence of Italy. I am now much more drawn to previous periods, even those before the *Quattrocento*.'[6]

Two years earlier Jean, carried along by the fervour of the Popular Front, had not thought it right to go to Venice to accept the prize awarded to *La Grande Illusion*, and his first instinct was to decline the second invitation. 'I refused, and I was told, "You know, this is a very special time, and one must forget personal preferences. Do us the favour of going there."'[7] Actually, it was his friend Jean Giraudoux, now head of the General Information Board under Daladier, who urged Jean to accept Mussolini's offer. The leading French dramatist of the period, who had written *La Guerre de Troie n'aura pas lieu* and whose *Ondine* had just opened, was soon to have few qualms about lending his services to the Vichy collaborationist government during the war.

But leaving aside the political and ethical considerations of making a film in Rome under the aegis of Mussolini, if that was possible, the temptations for Jean to go were immense. *La Règle du jeu* had just been greeted vituperatively, and there did not as yet seem to be another film in the offing in France; he had never been to Italy before; the weather was bound to be warm and he would be alone with Dido, away from Marguerite and her circle. He would have carte blanche as director, Karl Koch to co-write the script with him, and Luchino Visconti as his assistant. The cast would include Michel Simon, with whom he wanted to work again; and he was delighted with the idea of tackling *La Tosca*, which he had wanted to make starring Dédée in 1925, and which he imagined as 'an extraordinary police film with chase scenes and everything that goes with it.'[8] Not

forgetting that the hero, Cavaradossi, rages against all tyranny. (Ironically, there have been opera productions since that sit snugly in Fascist Italy.) Jean was also enticed by the thought of imparting some of his experience, knowledge and ideas to young film-makers.

On 14 August, Jean and Dido were welcomed in Rome by Visconti. The 32-year-old Marxist aristocrat had not worked in the cinema since his participation on *Toni* and *Une Partie de campagne* three years previously. Visconti started to show them around the Eternal City, which both Jean and Dido found exciting and romantic. However, the trip was cut short abruptly when Hitler invaded Poland on 1 September, and two days later England and France declared war on Germany. Jean had to return to France immediately where he was called up as an army reserve, put into uniform again and given the rank of lieutenant in the cinematographic services of the French army. At the same time, his son Alain, just turned 20, joined the cavalry, following in his grandfather and father's illustrious footsteps.

Jean, whose duties included the making of propaganda documentaries, shot a short film about troops 'yawning from boredom'[9] in front-line villages during the 'phony war'. This addition to the Renoir oeuvre has since been lost.

Italy had as yet refrained from entering the war, and the invitation to Jean to return to Rome to shoot *La Tosca* was renewed. Years later, again explaining his decision to take up the offer, Jean said, 'I was not anxious to go; in fact I refused. But at that time the French government was willing to do anything to keep Italy neutral, to dissuade Mussolini from entering the war on Hitler's side. I was in uniform; the French government decided I should go. So I went.'[10]

Once more, in mid-January 1940, Jean and Dido left for Italy in their Delahaye convertible. With Karl Koch, they rented a large, luxurious apartment, covering the walls with murals of Amazonia as a reminder to Dido of her native Brazil. They had a cook and servants, they entertained, and lived well.

In between looking for locations and working on the script of *La Tosca*, Jean gave a number of lectures on film-making to large audiences, and also to small groups, among whom were Visconti and the 27-year-old Michelangelo Antonioni, who was then a student at the centre and writing articles for *Cinema*, the official film magazine of the Fascist party.

The *Centro Sperimentale di Cinematografica* was founded in 1932 as

a department of the Rome Academy of Music and emerged as an independent establishment under its present name in 1935. From 1937 it published the influential journal *Bianco E Nero*, edited by Luigi Chiarini, one of the first Italian publications to promote the study of film aesthetics and serious criticism. Although founded by the Fascist government, the *Centro* lived up to its name and managed to retain a certain experimental spirit even during the war.

While Visconti guided Renoir and Koch through Hadrian's villa and other places that might serve as locations for *La Tosca*, Michel Simon spent his days photographing the frescoes in Rome's baroque palaces, and his nights visiting the city's brothels where he would show the girls his snapshots. One evening, he found his favourite corner occupied by some German civilians. When he complained to the Madame, she said she was afraid to get involved. The actor left the brothel in a temper, railing against Germans and Italians. 'Fuck them and their ceilings!', he told Jean.[11]

Simon was cast as Scarpia, the dreaded chief of police, a rare villainous role for him; Viviane Romance, the popular 'vamp' of French cinema, who had made her screen debut in a bit part in *La Chienne*, was to play the title role, and Georges Flamant, the pimp in *La Chienne* who had enraged the jealousy of Michel Simon on screen and off, would be Cavaradossi. But Romance failed to get a visa to leave France, and Flamant was drafted. Replacing them were the Argentinian dancer–singer–actress Imperio Argentina, already in her fifties, and the 23-year-old Rossano Brazzi.

At the beginning of May, a picture of a smiling Jean standing beside Michele Scalera and Vittorio Mussolini at the Castel Sant'Angelo appeared in the Italian newspapers, above an announcement that filming had begun on *La Tosca*. Jean had completed the opening scene with two horsemen galloping through a large gateway into the city at night, the camera following them through the deserted streets, past monuments, fountains and statues until they cross the bridge into Scarpia's palace, the Castel Sant'Angelo. Unfortunately, this impressive sequence remains the only visual contribution to the film that Jean was able to make.

On 10 May the Germans entered Belgium and Holland, pressure was put on Italy to come in on the side of their Nazi allies, and anti-French feeling was running high. One evening, Jean was attacked by a group of Fascist thugs when he asked for a copy of *Osservatore Romano*, the only Italian newspaper sympathetic to France, and though he was not seriously hurt, the French ambassador advised

him to return home on the next train. Dido decided to stay on a few days because she hoped to obtain a print of La Grande Illusion and tie up some business arrangements.

Visconti saw his idol off at Rome station, a parting Jean described as 'heartrending'. He said that without the erudition and aesthetic sensibility of Visconti, Rome would not have been the revelation it was to him. Visconti valued Jean's 'rich humanity, his affection for people and their work, his extraordinary skill at directing actors, his meticulousness, his technique.'[12]

On 10 June 1940, Italy finally entered the war, and Dido caught the last train back to France before the border closed. Michel Simon, being Swiss, stayed on, and so did the German Karl Koch, who carried on the film to its completion, assisted by Visconti. La Tosca turned out to be a rather uninspired version of the 'shabby little shocker', as Joseph Kerman called the opera, but there are some well-used views of the baroque splendours of Rome. The film, however, had its admirers, among them Jacques Rivette and François Truffaut, and when Jean saw it for the first time in March 1978, he thought it was a good film despite its departure from his original conception.

Jean had returned to Paris from Rome two weeks before the humiliating surrender of France to the German army on 22 June 1940, when Maréchal Pétain signed the armistice. The news that the Germans were approaching Paris caused thousands of Parisians to take to the roads in flight. Jean and Dido decided to join Paul and Renée Cézanne at Marlotte, from where they would make for Limoges. Having had to abandon his Delahaye in Rome, Jean drove Paul and Renée in a three-seater Peugeot he had hired, while Dido, Jean-Pierre Cézanne, and his Jewish wife Marjorie, rode behind them on bicycles. Strapped to the back of the car were as many Cézanne paintings as they could manage to take. Aline Cézanne decided to stay on at Marlotte to look after some of the treasures they were unable to fit on the car, including Aline Renoir's piano and the Auguste Renoir painting of Jean dressed as a hunter.

Surviving light bombardments from Italian planes, they reached La Creuse in the Limousin, the area where Auguste had been born. The refugees were given accommodation in the big hay-filled barn of a saddlemaker, on the rustic stone walls of which they hung the Cézanne paintings. 'My very dear friend, Paul Cézanne, was able by a freak of international politics to give his father's work a setting

which the latter would have relished. At night in that barn we fell asleep amid the great peace that emanates from masterpieces.'[13]

Jean and Dido then decided to continue the journey on to Cagnes. When they finally reached Les Collettes, a telegram from Robert Flaherty was awaiting them, telling Jean to go to the United States Consulate in Nice where an American visa had been arranged for him. This was a response to a letter Dido had written to Flaherty a few months before from Rome, expressing her wish that she and Jean could get to America, something they had discussed previously.

However, there were reasons why Renoir hesitated in accepting the offer immediately. He was uncertain as to his position *vis-á-vis* Scalera Films in Rome, where he was still under contract to complete *La Tosca*. He also wanted to wait and see whether he could do anything to assist the situation in occupied France. But it did not take long before he made up his mind to get to the USA as soon as possible.

Although Cagnes was in the Free Zone, it nevertheless was under German influence. One day at Les Collettes, Jean received a visit from two Frenchmen representing Nazi cultural institutions, who attempted to persuade him to make films for the New France. Jean could have quite easily accepted their proposal and probably would have been able to direct many of the sort of non-political films he had recently expressed a desire to make.

A few months earlier he had spoken about his reading of St Francis of Assissi, and how he would have liked to adapt the writings to the screen. Not long after, he wrote the first treatment of *Magnificat*, derived from a true story told to him by Dido about a group of French monks attempting to bring Christianity to a savage Indian tribe in the Brazilian jungle. It was a project which he would attempt to film over the years. These subjects indicate that, just as he had been influenced to go into film-making by Dédée, and to take a more active part in politics by Marguerite, he was inclining more towards the spiritual as he grew closer to Dido.

He could have joined Marcel Carné, Jean Grémillon, Claude Autant-Lara, Henri Clouzot, Robert Bresson, Jean Delannoy, Sacha Guitry, Marcel L'Herbier (who founded the celebrated *Institut Des Hautes Études Cinématographiques* in 1943) and Jacques Becker, all of whom made successful films under the Occupation, including Carné's *Les Enfants du paradis*, in which Pierre Renoir played an important role.

How Jean would have coped with the censorship is not easy to

imagine. He might have found ways of getting around it, but it was a moment in French history when stark choices had to be made. For many it was a matter either of collaboration with the invader or active resistance. There were other means of resistance than going underground; there were those who worked outside France for its liberation, some joined De Gaulle's Free Forces, others continued a propaganda offensive by whatever means.

Jean decided to join many of his countrymen and women who took their chances in foreign lands rather than submit to the indignities and restrictions of the Occupation. He would follow directors René Clair, Julien Duvivier and Max Ophüls to Hollywood. But it was not as easy as it sounded.

Jean and Dido had to wait for some months at Les Collettes while they struggled to get him an exit visa from the French authorities; she, being Brazilian, had less trouble. The document could only be issued by the Interior Ministry in Vichy so, on 2 September 1940, Jean made a trip to the spa town to make a direct appeal to the authorities. They argued that as he was just about to turn 46, he still had two years eligibility for the draft. However, Jean's wounds from World War I that had resulted in his pronounced limp, finally decided them to grant him the visa.

He returned to Cagnes to prepare his departure from France with Dido. This circuitous journey began on 6 October when the couple left for Marseilles. From there they travelled to Algiers, Rabat, Casablanca and Tangier, where Dido was delayed while getting her papers in order. Jean went on to Portugal and the couple finally met up again in Lisbon on 5 December.

Charles Boyer, who had become active in cementing Franco-American cultural relations, and worked for the British government, used his influence to get Jean and Dido a passage out of Lisbon. On 20 December they boarded the American liner *Siboney* bound for New Jersey.

PART V

DRIVEN INTO PARADISE
(1941–1949)

28

Fifteenth Century-Fox

'I argued endlessly with Darryl Zanuck, the big chief, that if all he wanted was the sort of film he was in the habit of making he should not apply to me. . . . In the field I should be nothing but an imitator, whereas in my own field I might come up with something new.'

On board the *Siboney*, Jean shared a stateroom with Antoine de Saint-Exupéry, the test pilot, reporter for *Paris Soir* and author, an example, like Ernest Hemingway and André Malraux, of a writer of thought and action. Despite many injuries received in flying accidents, he was a military reconnaissance pilot until the fall of France. Saint-Exupéry's philosophy at that critical time was expressed by Malraux: 'A man is the sum of his acts, of what he has done and of what he can do – nothing else.'

The two cabin mates – Jean was the senior by six years – got on very well, and admired one another. Neither, however, had any English and found themselves depending more and more on Dido for the least thing. While Jean was beginning to pick up some basic principles of the language of the country he was going to live in, Saint-Exupéry refused to learn English, telling Jean that he had quite enough trouble speaking and writing French correctly. Jean's reason for not having learned English was typical. When he was around 12 years old, he used to play tennis with several upper-class youngsters who made a great issue of being able to speak English, and refused to answer Jean when he spoke to them in their native tongue.

Consequently, Jean acquired the belief that English was a sure sign of snobbery.

The *Siboney* docked at Jersey City on 31 December 1940. Robert Flaherty was on the dockside to meet them, hugging both Dido and Jean warmly. He then roared with laughter on noticing the narrow-brimmed felt hat that Jean was wearing, because the fashion in America was of the broad-brimmed style. Suddenly, Flaherty grabbed Jean's hat and flung it into the water, taking off his own and planting it on Jean's head.

Flaherty drove them to New York, where they stayed at the Hotel Royalton at 44 West 44th Street, opposite the Algonquin, where the producer Louis de Rochemont had found them rooms. 'The sight of the streets on that New Year's Eve was enough to amaze any newly arrived Frenchman,' Jean wrote. 'The brilliant lighting in Times Square was in itself bewildering after the blackout in European towns, to say nothing of the streets teeming with cars and pedestrians, compared with the empty streets of towns under curfew law.'[1]

On the first morning, Flaherty took the visitors to the Hotel La Fayette to sample their famous 'breakfast', which consisted of smoked fish, salads, steak, desserts, all accompanied by French wine. The La Fayette, which Jean often stayed in on subsequent visits to New York, dated from the eighteenth century, but was demolished in the 1960s. Renoir always preferred the older hotels to the efficient splendour of the newer ones. Because the Royalton was built in the late nineteenth century, and the Chelsea Hotel, where Flaherty had an apartment, was even older, Jean and Dido 'got the impression during our first days in America, that the Americans lived in the past, a recent past but one whose rites were lovingly preserved.'[2]

Jean was not the first of his family to come to America. His maternal grandfather, M. Charigot, fled there from his wife in Essoyes after she complained about his soiling of her shiny waxed floors. He was one of the first settlers in the Red River Valley in North Dakota where, except for himself and a Jesuit priest, the only other inhabitants in those parts were Indians. He obtained a divorce and married a young Canadian girl. Jean's many American cousins were M. Charigot's great-grandchildren.

Flaherty, who was then working on the documentary *The Land* for the Department of Agriculture in Washington D.C., drove Jean and Dido down to the American capital, where Jean presented

himself to the French ambassador from whom he tried to get authorisation to bring Alain to the United States. Alain was still in the defeated French army when Jean left Cagnes. After being demobbed, the young man made his way to Casablanca, which, as most film-goers know, was a Free French port, where he worked as a cameraman in a local film enterprise. But it would take almost a year before he would be able to join his father in America.

On the plane to Hollywood, Jean and Dido discussed what they imagined was awaiting them there. 'I dreamed of myself installed in that paradise, with Griffith, Charlie Chaplin, Lubitsch and all the other great figures in the world-cult of the cinema.'³ He also longed to meet Mae Murray, the actress who had influenced Dédée more than any other, Gloria Swanson, Lillian Gish and Mary Pickford, all visions from the Old Hollywood. But the Hollywood of the 1940s was a very different place.

They arrived there on 10 January 1941, and what looked like 'a river of diamonds' flowing beneath them from the air, turned out to be an outer boulevard full of petrol pumps and supermarkets. It was inevitable that, like thousands of pilgrims to Tinsel Town before and after them, Jean found it disappointing. He had not realised that Hollywood is not a real place but a state of mind, a mythical kingdom, like Disneyland, in which America likes to see itself reflected.

At first Jean and Dido stayed in a furnished apartment at Sunset Towers, 8358 Sunset Boulevard. Five days later, through two agents, Charles Feldman and Ralph Blum, Jean signed a contract with Twentieth Century-Fox to make two films. When he was first introduced to some executives, Jean said, in a slip of the tongue, that he was delighted to be working for Fifteenth Century-Fox, a remark that was truer than he knew.

'Dazed by my salary, and never doubting, in my innocence, that I should receive it regularly for the rest of my life, I had not hesitated to rent a very nice house, large enough for us to entertain our friends,' wrote Jean.⁴ The house Jean moved into was a large estate at 8150 Hollywood Boulevard, which once belonged to George Eastman, the inventor and industrialist who founded the Kodak Company.

In contrast to Europe at war, Jean and Dido found it difficult to get over the abundance of food in the shops and markets. Jean was also pleasantly surprised to find that his black servants drove a new

Chevrolet automobile, and wanted one just like it. No, that would be inappropriate for a man in his position, he was told, you must get something better than your servants; not the best introduction to the 'classless' society of the USA. He bought a Buick convertible that he hated, while Dido drove around in a Packard. She would be constantly at his side in the first months, acting as interpreter and translator.

When the French director arrived at the Fox studios, he was given a pile of scripts to choose from for the films he was going to shoot, most of which were set in Europe. But he still retained his conviction that films should be made in the area or country where the action of them is set. In the 22 features he had already directed, only rarely did he stray, and then not too far, from the place in which the story unfolded. He knew it would be difficult to persuade the Fox executives of his belief in location shooting, not something that was encouraged at that period. 'Because I was a Frenchman, Fox gave me a lot of films on France or on Europe, thinking "He knows France, he knows Europe, he's going to do fantastic things." But I wanted no part of it. I shuddered at the idea of directing sequences with moustached policemen and gentlemen in velvet jackets and imperial beards parading against a bogus-Montmartre, bogus-café background. René Clair suffered the same problem.'[5] It is quite possible that Renoir's compatriot had been offered screenplays of a similar nature, but in fact the very different Clair, who enjoyed working in artificial studio conditions, never made a Hollywood film set in France.

Ignoring most of what he was offered, Jean came up with his own ideas for films, ironically many of them taking place in Europe. These included adaptations of Knut Hamsun's famous 1890 novel, *Hunger*, about a writer driven insane by starvation (eventually filmed by Henning Carlsen in 1966); *My Uncle Benjamin*, Claude Tillier's portrait of a French provincial town before the Revolution; and *Children Of The Storm*, an original idea of his about the effects of war on youngsters, which he began to write. At first he wanted to make a film of François Boyer's novel *Les Jeux interdits*, the story of a five-year-old girl orphaned by Nazi planes strafing the fleeing refugees, which René Clément directed so movingly in 1952. Later, however, he began to wonder how he could get round the problem of convincing Darryl Zanuck, head of production at Fox, that the only way it would avoid being spurious would be to cast French children who would play it in French. Later the treatment developed

into *Flight South*, which concerned boys liberated from a home for delinquents by the advancing German army.

Zanuck turned this project down, as he had everything else Renoir had proposed so far. It was not going to be easy, but Jean was drawing his salary and, besides, he was suddenly struck by what he believed to be something Zanuck could not refuse. On 29 March 1941, Jean wrote to Zanuck, 'I am sure now that I've hit upon the idea for a very great film.'[6] Saint-Exupéry had given him a copy of his *Terre des hommes* to read, and Jean thought it 'will be the most beautiful film of my life.'[7]

Because he wanted the author to collaborate with him on the screenplay, and felt that they had better act quickly before someone else snatched it up, he wrote to Saint-Exupéry in New York, asking him to fly out to Los Angeles to negotiate film rights.

Saint-Exupéry duly obliged, and he and Jean visited a big Hollywood agent with the synopsis. The man, whom both the Frenchmen found extraordinarily graceless, turned to Saint-Exupéry and said, 'So you're a writer?' When Saint-Exupéry replied, 'Actually, my real job is piloting an aeroplane,' the agent thought he was being kidded. Nothing came of the visit, and Saint-Exupéry exclaimed as they left the office, 'What a creep!'[8] and flew back to the East Coast.

Jean's belief, during his first months in Hollywood, that Fox would be interested in making a film of Saint-Exupéry's beautifully written autobiographical meditation on the self-realisation that comes from danger, and the unity established between man, his experiences and the environment in which they occur, revealed his ingenuousness as to the way the industry thought and functioned. It was not long before some cynicism crept into his views of his new masters.

Zanuck then put pressure on Jean to seriously consider two films written by studio writers. The first script was a thriller entitled *I Wake Up Screaming*, a project for Charles Laughton, Henry Fonda and Alice Faye, written by Dwight Taylor from a novel by Steve Fisher, but Jean rejected it. (In the event it was directed a few months later by studio hack H. Bruce Humberstone with Laird Cregar, Victor Mature and Betty Grable. It contains a line, which Jean must have smiled at, delivered by Mature while dining in a posh restaurant with Grable. Addressing the waiter, he says with sophistication, 'We'll have wine with the meal and coffee afterwards.')

The other script offered to Jean was something called *Venezuela*

by Nunnally Johnson, one of Fox's most respected screenwriters and an associate producer, who had recently completed John Ford's *The Grapes Of Wrath*. Based on a novel by Stefan Wendt, *Venezuela* was a steamy adventure-melodrama, featuring an earthquake and a prison riot. Jean Gabin, recently arrived in Hollywood, had declined the lead, and George Raft was being considered. But Jean found little in it to inspire him, and diplomatically refused it, claiming his talents were not suited to such a story. However, as he had now been on the studio's pay roll for almost four months and no film seemed forthcoming, he reluctantly accepted the film, now called *The Day The Earth Shook*, and suggested James Cagney for the hero. When it was postponed due to casting problems, Jean breathed a sigh of relief and again brought out *Terre des hommes* for consideration, insisting that it had to be shot on location. (Morocco, French West Africa, Indo-China, South America and Spain!). But, despite the book's success in the States under the title *Wind, Sand And Stars*, no producer or agent showed any interest. It was then that a script called *Swamp Water*, written by Dudley Nichols, came floating by.

When Jean joined Twentieth Century-Fox, the company was only six years old, having come about by a merger between the Fox Film Corporation and Darryl F. Zanuck's Twentieth Century Productions. In 1941, it had cut back on feature production by about forty per cent, Spyros P. Skouras had just been nominated its president, and John Ford's *How Green Was My Valley*, which would win five Oscars, was released. The studio's big stars were Sonja Henie, Don Ameche, Tyrone Power, Alice Faye, Loretta Young, Betty Grable, Carmen Miranda and Henry Fonda, and the best directors, aside from John Ford, were Fritz Lang, Rouben Mamoulian and Henry Hathaway, who had been hired the previous year.

Fritz Lang, who had already successfully made *The Return Of Frank James*, had originally been assigned to *Swamp Water*, but when Jean showed some interest in the script, Zanuck immediately switched it to Renoir, and the German *emigré* director went on to make a second Western. Perhaps Jean's choice for his first Hollywood film was a question of *faute de mieux* though he wrote, 'Finally I found this essentially American story, and I was enchanted.'⁹ He realised that nobody was going to make the Saint-Exupéry book, and *Swamp Water* was certainly an improvement on *The Day The Earth Shook*. He also saw an opportunity to film on location in the swamps of southern Georgia, and felt he might be able to create

truthful characters. The awkward relationship between father and son, and the loving one between stepmother and son at the heart of the film, might have struck a chord with Jean, thinking of his and Dido's situation *vis-à-vis* Alain.

On one of the first, and rare, occasions Jean got to see Zanuck face to face, the studio chief told him, 'Jean, if you want to succeed in America, you have to work with stars. Seeing as how I like you, take your pick. I'll give you the best stars we have.' Jean declined the offer, saying 'If you give me actors whose success is guaranteed, they're exactly like ducks: You throw water on them and they never get wet, they're impermeable, they're protected by their success. I would rather have people who are still hesitant so that I can work with them, so that I can direct them. That's my profession, that's what interests me.'[10] At the same time, he met John Ford at the studios, who took Jean aside, and told him in French, '*Mon cher Jean,* don't ever forget what I'm going to tell you. Actors are crap.'[11]

Without any consultation with the director, Zanuck cast Fox's new glamorous star Linda Darnell, and the virtually unknown Dana Andrews as the young lovers, Julie and Ben; Dean Jagger as Ben's unbending father, and Walter Brennan as Julie's fugitive father, Tom Keefer, a wanted man hiding out in the swamps. However, after seeing Darnell in Mamoulian's just released *Blood And Sand*, Jean thought her unsuitable for the role. He preferred 18-year-old Anne Baxter, whose screen tests he found a 'revelation'. The granddaughter of architect Frank Lloyd Wright, Baxter had previously been a sweet young thing in a couple of films, and was under contract to Fox. Zanuck agreed, but then changed his mind about Andrews, suggesting newly-signed John Shepperd (later Shepperd Strudwick). But Jean managed to persuade Zanuck to stick with Andrews. When Dean Jagger moved over to Fritz Lang's *Western Union*, Walter Huston came in.

Because the story was set in the Okefenokee swamp of Georgia, Jean naively assumed that it would be shot there. 'When are we leaving for Georgia?' he asked the studio. 'They were quite surprised. They said, "Do you think we built a studio worth so many millions, in which we can reproduce anything, so that we would have to go to Georgia? We're going to build Georgia right here." I didn't buy this, and protested mightily. The problem was presented to Zanuck, who squirmed. He said to himself, "Boy, these French people have some crazy ideas." I told him, "I may have some crazy ideas, but I'd rather do nothing than do this film in the studio. It

seems to me that in Georgia we'll at least find some exteriors. I'm not saying we shouldn't do the interiors here, or even some atypical exteriors – but everything that expresses the character of the Georgia countryside, I want to do in Georgia." '12

One gets the impression from these comments that most of the exteriors of *Swamp Water* were shot on location. Far from it. Zanuck would only allow Dana Andrews and his dog, Trouble, among the cast, to go with Jean to Georgia. As a result, a mere five minutes (the best in the picture) out of the 86-minute running time, were actually filmed in Georgia. The rest of the exteriors were shot at a studio ranch near Los Angeles, so the bold legend at the end of the film: 'The actual photography of scenes in the Okefenokee Swamp of Georgia was made possible through the Okefenokee National Wildlife Refuge', though true, is somewhat misleading.

However, Jean was happy for the two weeks he spent in the small town of Waycross, where Dido, who acted as his interpreter, producer and dialogue director Irving Pichel, cameraman Lucien Ballard, Dana Andrews, Trouble, and a small crew, were warmly welcomed. Aside from the scene of Andrews searching for his dog in the swamp, some sequences were shot which would be used for back projection.

Although Jean had been studiously taking English lessons almost daily in Hollywood, and had made some progress, his accent was still some cause of amusement among the locals and crew. One day, while giving instructions to Anne Baxter's stand-in who was on the other side of the river and had to get into a boat, he told her to 'wait a little', but it came out like 'wet a little'. She looked at Andrews and said, 'Does he really want me to . . ."' "These foreign directors sometimes have strange ideas," Dana said wickedly.'13

It was back in Hollywood that the terrible reality of the medieval ('Fifteenth Century-Fox') autocracy of the front office personnel over the creative team really hit Jean with crippling force. 'One has more the impression of working in a shoe factory than in cinema . . . I realised that I had landed not in the land of Mae Murray but in that of Alfred Jarry's farcical monarch, Père Ubu.'14

Zanuck complained that Jean was wasting time shooting the same scene in different ways; moved the camera too much; worried too much about atmosphere and background; and encouraged too much discussion with the cast and crew. When Peverell Marley, one of the two directors of photography, was criticised for being slow, Jean protested. 'Listen, the cameraman isn't slow. I am. I'm a slow

director, and if you don't want a slow director, don't use me.'[15] This from the Jean Renoir who had shot *Le Crime de Monsieur Lange* and *Les Bas-Fonds* each in less than a month, and *La Bête humaine* in only a slightly longer period.

There were incessant meetings devoted to the budget of the picture, the head office concerned with cutting costs wherever they could. When he was asked how many hens he wanted for the farm, Jean said one. The man, used to bargaining, was taken aback, and offered five. When Zanuck objected to the scene of the dispute between Walter Huston and Dana Andrews being shot in one take, Jean agreed to reshoot the scene in several takes. 'This was my first surrender to Hollywood', he commented.[16] Actually, the scene still contains a fairly long take.

As indicated by the many letters Jean wrote at that time to friends, he was an artist in torment. To Halley des Fontaines, the producer of *Le Crime de Monsieur Lange*, he wrote, 'The work I'm doing here presents no artistic interest at all. Hollywood is an immense machine, an admirable mechanism without a soul . . . My great hope is to return soon and be up to my teeth in making a great French film.'[17]

To Saint-Exupéry: 'My first real contact with the American cinema has convinced me of the impossibility of bringing to it what little there may be of myself. I don't think I will make a bad film, but I am sure the result will be perfectly neutral, impersonal, odourless and conventional.'[18]

To Dudley Nichols: 'I am not at all enthusiastic about my work at Fox. It consists of being seated in an armchair and saying "Action" and "Cut". It is useless to tire oneself out trying to present the scenes according to a personal conception, for everything is decided by Zanuck and when the rushes don't conform to his ideas he has the scene reshot. I ask you not to judge my work in America by this film, which will be Mr Zanuck's and not mine . . . I would rather sell peanuts in Mexico than make films at Fox. I am not a eunuch and the joys of the harem do not constitute an ideal which can satisfy me.'[19]

To Charles Boyer: 'I am managing very badly the work that Zanuck has assigned me. He wants me to make this film very quickly and to be content to execute only what is in the scenario, without anything contributed by me. Now that is a *métier* about which I know nothing. The result of this misapprehension with regard to my occupation is that I am making Zanuck desperate by

my slowness. I wait from one moment to the next for him to dispense with my services, for which I wouldn't blame him at all.'[20]

Again to Saint-Exupéry: 'I have never been as bothered in my life. I am afraid of having lost all enthusiasm for my profession, or rather, it's that the *métier* of cinema has become too old, too organised, too immobile and that it may require of its adepts a bureaucratic soul that I have striven in vain to acquire.'[21]

To Eugène Lourié, Jean's set designer on *Les Bas-Fonds*, *La Grande Illusion*, *La Bête humaine* and *La Règle du jeu*, who had just arrived in New York: 'I would never have believed that one could come to detest one's *métier* as I do now.'[22]

At the end of July, with the film five days behind schedule, Jean wrote to Zanuck. 'The fact is that I've been too long in this profession to change the methods in which I have come to believe sincerely and which are adapted to my temperament . . . Since my method seems to be at variance with your ideas, why prolong a collaboration which gives no enthusiasm to either of us?'[23]

A few weeks later, Jean was told by the studio officials that he was to be replaced and should cease shooting. He then received a call from Zanuck. 'No, no Jean; of course they were kidding, but I'm taking responsibility for it. I explained to the board of directors that despite the added cost, you're going to continue the film.'[24] In reality, the film was taken out of his hands, with Zanuck himself supervising the editing, although Jean did shoot one new scene to replace one that had been cut.

After Jean's services were no longer required, he and Zanuck mutually agreed to terminate the contract. In order to get away for a few days, Lucien Ballard, the cameraman on *Swamp Water*, who was part Cherokee Indian, took Jean to a reservation in Arizona, from where he brought back many watercolours done by young Indians, almost all of which had pictures of Santa Claus with a white beard.

What then of Jean Renoir's first American film? The screenplay of *Swamp Water* still has the strong whiff of its origins – a *Saturday Evening Post* romantic adventure tale by Vereen Bell. Tom Keefer (Walter Brennan), falsely accused of murder, is tried, convicted and sent to jail. He escapes and takes refuge in the overgrown swamps of Georgia, determined to bring the guilty to justice. Ben Ragan (Dana Andrews), who finds communication with his father Thursday Ragan (Walter Huston) difficult, but gets on with his stepmother

(Mary Howard), is out looking for his lost hound when he comes across the fugitive. He believes the man's story and they begin trapping animals for their pelts. Tom tells Ben to give his share of the profits to his daughter Julie (Anne Baxter), with whom Ben gradually falls in love. By the end, the real culprits are exposed, and Tom Keefer is able to 'live like folks again'.

A skull on a stick in the middle of a river is the striking first image of the film. The atmosphere of the mysterious and lovely swamp-lands is immediately established. It then switches smoothly, but nonetheless noticeably, to back projection and the studio backlot. When Dana Andrews returns to look for his dog Trouble, gliding on the river in his canoe, blowing his horn through the mossy trees, the camera tracking him through the swamp, one realises what kind of a film it could have been if the director had been allowed to shoot it on location, and in his own manner. Yet it could be seen as a forerunner of Robert Flaherty's last picture, *Louisiana Story* (1948), poetically filmed in swamplands, and Nicholas Ray's *Wind Across The Everglades* (1958), with its ecological concerns. But Renoir's intense response to landscape and the human relationship to it, becomes muted in scenes that are obviously studio reconstructions divorced from real surroundings.

Still, the depiction of the labyrinthine wilderness and the small enclosed community that surrounds it – the square dance, the local store, the family conflict, the use of folk melodies, especially 'Red River Valley', on the soundtrack – gives it moments reminiscent of minor John Ford. Unfortunately, it is also minor Jean Renoir, obviously struggling in the quicksands of Hollywood conventions. Having to remain faithful to someone else's script, and working in a foreign language with which he was ill at ease, he was in no position to tone down Nichols' folksy dialogue, or melodramatic and corny situations. The director, who always fought against cliché, is here defeated by it.

Despite the language barrier, Renoir obviously communicated well with his actors – both Dana Andrews and Anne Baxter give fresh performances, the latter in a variation on the barefoot gamine roles of Mary Pickford, and of Catherine Hessling in *La Fille de l'eau*. Though Walter Huston is under-used, there is a touchingly played reconciliation scene between him and Andrews. Earlier, the audience had been shown Huston's hitherto undisplayed paternal affection when he smiles with relief on seeing Andrews has returned safely from the swamp, before turning a stern exterior towards his

son. Walter Brennan plays down his mannerisms in the role of the outlaw. He handles a purple-patchy speech about the transmigration of souls with real feeling, expressing what might be the theme of the film: 'Most people's a whole lot better than we think they are, some's a whole lot worse.' Brennan became one of the very few actors to play the same role in a remake. This he did in *Lure Of The Wilderness*, directed by Jean Negulesco 11 years later.

The American critics were less than welcoming when *Swamp Water* opened on 15 November 1941 at the Globe Theatre on Broadway (running until Christmas Eve). According to *Variety*: 'This is French director Jean Renoir's first job for an American company. That it's something less than an auspicious beginning for Renoir over here is not entirely his fault. Giving him a story dealing with a segment of the US population with whom not even many Americans are familiar appears open to debate.'

Theodore Strauss in The *New York Times* commented: 'The fact that Jean Renoir's initial screen exercise in this country was completed before he learned the ABCs of our language will mitigate somewhat his responsibility for *Swamp Water*. Unfortunately, no one else has nearly so good an excuse for this melodramatic mess about Georgia crackers . . . Nichols is guilty of as fraudulent a scenario the year has seen . . . It hovers between *Desire Under The Elms* and *The Perils Of Pauline* . . . pretentious hokum, sentimental bosh. Instead, we continue to await Mr Renoir's first American film. In *Swamp Water* his great talent has been betrayed by his own, and what is less explainable, his author's ignorance.'

29

Occupation Therapy

'The story was intended to show that life for the citizen of a country occupied by an enemy Power was not as simple as Hollywood in the year 1943 seemed to think. The heroic utterances of French emigrés *seemed to me in bad taste.'*

Jean Renoir's problems with Twentieth Century-Fox were hardly unique in the history of Hollywood battles between producers and directors. Stroheim had told him enough tales of his shameful treatment at the moguls' hands to know what to expect, though Jean might have thought that there was an aspect of Stroheim's personality that contributed to his downfall. Jean, who saw himself as an independent but reasonable and professional artist, never imagined that he would suffer similar humiliations.

Of course, he had had problems with producers in the past – there were the confrontations with Roger Richebé on *La Chienne* and Jean Jay on *La Régle du jeu*, but in the end, he was the *auteur* of most of his sound films. For him, despite the communal nature of the medium, he considered it should be as personal an art as, say, painting. To have Zanuck telling him that he could not use a long take where he felt it right, or not move the camera on a dolly in a certain scene, or not to have too much background detail, was almost as if someone who had commissioned a painting from his father, had stood at Auguste's elbow and told him what colours to

use and what to expunge, and then found another artist to put the finishing touches to the picture.

Jean had grown up in a highly cultured atmosphere and had known many of the great men of the day – writers, artists, politicians, composers – and was admired by many of them. When he arrived in Hollywood as a mature man of 46, having directed over 20 features, several of them masterpieces, he was treated as a novice who needed to be taught the 'American way' of making films by crass men who saw films merely as products to be manufactured within certain commercial guide-lines. Many of the people with whom he had dealings had never seen any of his work and never cared to. Some looked upon him as a spoiled brat who expected to have his whims satisfied, a situation worsened by his poor command of English which he felt reduced him to the linguistic level of a young child, and this despite his almost daily lessons.

Jean's case was one representative example of the lot of many *emigré* artists who found their way to Hollywood with the rise of Nazism and the outbreak of war. They were, in Arnold Schoenberg's phrase, 'driven into Paradise'. It was easier for Jean's compatriots of lesser genius, René Clair or Julien Duvivier, for example, to adapt to the changing working conditions. More analogous to Renoir was Fritz Lang, who was engaged in a continuous struggle against the Philistines of the big studios.

However, although the *emigrés* faced extra difficulties, having been torn from their cultural roots, many home-grown free-spirited directors had also had – or would have – similar problems, among them D. W. Griffith, Robert Flaherty and Orson Welles, who became Jean's friends.

The bitter 66-year-old Griffith, then living modestly with his second wife Evelyn at the Roosevelt Hotel, was one of the first of Jean's American heroes that he went to meet in Los Angeles. 'I found myself confronted by a very well-preserved elderly man. His excellent state of physical and mental health caused him to resent the way the studios neglected him. The strictly commercial period was at its peak and the industry had no use for an individualist such as he,' recalled Jean,[1] who might have been speaking of himself.

However, in that first trying year in Hollywood, Jean tried to surround himself with members of the French community and other European colleagues. He was plainly homesick. In June, he wrote to Gabrielle. 'Dear Ga . . . It often happens that I fall asleep with a terrible longing to be near you. Write to me, perhaps that will make

me forget a little the distance that separates us.' He referred to his Hollywood home 'as a kind of Marlotte in America'; some of the people of Georgia reminded him of 'the inhabitants of very isolated corners of Brittany', and the Okefenokee swamp as 'a sort of tropical Sologne.'[2]

To Alain, he wrote, 'Hollywood Boulevard is the boulevard des Capucines of Hollywood . . . The place we're in is almost as rural as Les Collettes . . . At the foot of the hill, about the same distance as Le Béal is from Les Collettes . . . '[3]

Among Jean and Dido's French guests in those early days were new arrivals Gabin, Michèle Morgan and Marcel Dalio, all of whose talents were ill-used by Hollywood, Darius Milhaud, and Charles Boyer, who became the leader of the French community there. Other visitors were the documentary film-makers Joris Ivens, who had just completed *Our Russian Front*, Pare Lorentz, head of the United States Film Service, and Robert Flaherty and his brother David, who helped Jean with his English correspondence.

Boyer, who had established the French Research Foundation in Los Angeles, was also working for French War Relief and France Forever, an organisation set up to support General de Gaulle. French members of the Hollywood Resistance Movement gathered at The Players restaurant, owned by director Preston Sturges.

Jean gave generously to the various appeals, though he told Boyer, 'I am not at all a Gaullist, but all the same I'm going to send some money.'[4] There were other demands on his generosity, but he could not hope to answer all of them. When, however, he heard that André Malraux's life would be at peril if the Germans entered the southern zone of France, where Malraux was living in a villa at Cap d'Ail, Jean wrote to Zanuck (for whom he was still working) asking him to offer the distinguished French writer a contract 'even at a very low or even imaginary salary'[5] to help him get a visa for the United States. Zanuck refused without giving a reason, but Jean suspected that Malraux was listed as a Communist. Malraux stayed in France and joined the Resistance.

Jean's main concern, however, was getting Alain, who was 'in the midst of the Arabs, free from father, free from uncles',[6] to join Dido and himself in California. But it was far from easy to obtain either an exit visa from Morocco or an entry visa to the United States. He first managed to persuade Fox to offer his son a contract as an actor, but Alain wrote back to his father that he was a cameraman and not an actor, and had no intention of becoming one.

Jean then tried other avenues. One stipulation of the French officials, if Jean was to get any assistance from them, was his having to swear allegiance to Maréchal Pétain, a requirement he yielded to in his desperation to be reunited with Alain.

Then the Russian-born director Léonide Moguy, who had made most of his films in France and had also sought refuge in America, offered Alain the job of cameraman on his first Hollywood film, which was to be *Paris After Dark* for Fox. Alain had already worked for Moguy on a film at the beginning of the war. The French ambassador, however, wrote to Jean informing him that a young man of Alain's age could not be allowed to leave French territory. It took a few more months before all obstacles were overcome, and Alain was permitted to come to the USA. He sailed from Casablanca to New York on 19 November aboard a Portuguese ship, the *Serpa Pinto*, and arrived in Los Angeles in time to celebrate New Year's Eve with his father and Dido. 'After a year and two months separation, I'll have my kid back,' Jean wrote in a letter to friends.[7]

Meanwhile, Saint-Exupéry had arrived from New York to live with Jean and Dido at their Hollywood home. He stayed from August to October, working on *Pilote de guerre (Flight To Arras)* writing through the night, dining in the morning, and sleeping during the day. (Jean, in his memoirs, erroneously refers to the book he was working on as *Vol de nuit*, published in 1931.) But Saint-Exupéry had to go when Gabrielle and Conrad Slade, with their son Jeannot, arrived to stay.

In July, Jean had received news that the Slades were leaving France for America, but were to live in Boston, Slade's birthplace. After Gabrielle complained in a letter to Jean about the wine, Jean cabled her to come to California. 'It is just like southern France and they have good wine here.'[8] During the years of Jean's marriage to Dédée, Jean and Gabrielle did not see a great deal of each other, because Gabrielle disapproved of Dédée's character and way of life, and thought the marriage a mistake. The last time Jean had seen Gabrielle was in Cagnes in August 1940, a few months before his departure from France. The arrival of his former nurse made all the difference to his outlook, and they sat for hours together, reminiscing about Auguste Renoir, Jean's childhood, Essoyes and Les Collettes.

In December 1941, shortly before Alain's arrival, Jean received a letter from the playwright Marcel Achard, then French consul in

Los Angeles, insisting, through the Vichy government, that he return to France, where he would be guaranteed work. (Letters were also sent to Gabin, Morgan, Duvivier and Clair.)

Jean replied, 'For personal reasons, I would be very happy to make a film in France. So I am at your disposal to look over proposals that a truly French firm might offer me. At the moment, I am committed to two films, and, moreover, I am in the hire of Feldman-Blum Corporation. First I must make the two films in question. Then, or even during the filming, the French firm in question could discuss practical matters with Feldman-Blum Corporation.'9 Jean then asked that his passport, which was about to expire, be renewed. Of course, Jean had no contracts to make any films nor any intention of returning to France, but he was stepping warily.

Despite the trials and tribulations Jean had to face in America, the bitter taste of his time at Fox was starting to fade, and he wrote to Paulette Renoir, Coco's wife, 'I'm beginning to understand and like this country.'10 This sentiment had been strengthened on 9 December when the Japanese Air Force bombed Pearl Harbour, described by President Roosevelt as 'a date that will live in infamy.'

When Alain arrived in Los Angeles, he announced that he had visited the Gaullist headquarters in New York and had signed up to fight for the Free French. Jean, who was beginning to feel more and more affection for his adopted country, convinced his son that, out of gratitude for the hospitality given them, he should rather enlist in the US army. Before he knew what had hit him, Alain had done just that.

Explaining this decision to the French ambassador, Jean wrote: 'When you're 20 years old and you're French, either you stay in France and you share the suffering of your compatriots and you do what you can to help the government in the arduous task of putting the country back on its feet; or, if you leave the country, you enlist and you fight. Whichever it is, the idea of an easy life in Hollywood while his compatriots are unhappy seemed to him untenable.'11

With only a smattering of English, and having been a mere two months in America, Alain was sent to Camp Roberts, 240 miles north of Los Angeles, where he was trained in the artillery. Two months later, he was somewhere in the Pacific fighting, his life on the line, for a country he hardly knew and felt little for. The only justification was that the USA had given his father shelter.

*

Although Jean was corresponding with Dudley Nichols in Connecticut about a number of projects, it would be almost a year before he made a film again after his departure from Fox. Nichols thought that Jean would be ideal to direct a scenario of his called *Hunky*, about a Hungarian worker trying to adapt to life in America. John Ford had turned down the project five years previously. Jean, meanwhile, reworked his synopsis for *Magnificat*, the tale of the French monks in the Brazilian jungle, hoping that he would be able to visit Dido's birthplace. This time he thought he would make the monks American. 'Most motives for propaganda against the United States are based on the affirmation that the country is anti-Catholic. Perhaps it wouldn't be uninteresting to respond to this propaganda with a great film, at the same time Catholic and American.'¹² Jean also wished to set a version of Hermann Sudermann's nineteenth-century novel *A Trip To Tilsit* on the island of Marajo in the mouth of the Amazon. It would have been the third version of the work after F. W. Murnau's silent masterpiece, *Sunrise* (1927), and Veit Harlan's *Die Reise Nach Tilsit* (1939), made with Goebbels' approval.

Pare Lorentz, who had produced Flaherty's *The Land*, had spoken to Jean about making a semi-documentary film in South America. There were also rumours that David O. Selznick was thinking of getting Frank Capra (American), Alfred Hitchcock (British) and Jean Renoir (French) for a three-part film omnibus, each of them to direct a contemporary story set in three different countries. Then there was talk of a remake of *La Chienne*, with the Michel Simon role going to the vastly different and highly unsuitable Cary Grant, who was said to have expressed his admiration for Renoir's film. (Edward G. Robinson fitted the bill better in Fritz Lang's *Scarlet Street* in 1945, for which Dudley Nichols provided the script.)

Finally, in June 1942, an offer came to Jean from Universal to make a film entitled *Call Me Yours*, starring the studio's money-making songbird Deanna Durbin. Now 21, everybody's ideal teenager was blossoming into young womanhood, and trying to match her screen image to her growth. 'I couldn't go on forever being Little Miss Fixit, who burst into song', Deanna explained. She had just made a romantic comedy called *It Started With Eve*, opposite Charles Laughton, an unlikely but successful pairing. Now she was looking for something more challenging.

Frank Ryan and John Jacoby had written a scenario in which Durbin would play an American schoolteacher in China whose mission it was to smuggle nine recently orphaned Chinese children

back to the States. En route, the ship is torpedoed, and after being rescued, the only way they would be allowed into America is by lying that her husband is the missing owner of the ship. She would also get to sing 'Vissi d'arte' from *La Tosca* and 'Mighty Like A Rose'. The fact that the director of *La Grande Illusion* and *La Bête humaine* was considered by Universal to be the right man for this sentimental vehicle for the wholesome star, is an example of the mysterious ways in which Hollywood moguls' minds work.

Jean's agents knew of his desire to make a film about children caught up in the war, and might have put it to the studio. Either way, he needed to make another film, and he was prepared to take it on. He was introduced to Durbin, who had just got married, and he liked her. 'She is particularly ravishing, and I was very excited about it.'[13]

Before Jean began filming, he sat through all of Deanna's films, and considered she was imprisoned in the genre that had made her a star. Yet, if he had the liberty to use his own methods of improvisation on the set, he felt he might be able to create something more interesting than the usual conveyor-belt stuff. Despite his experiences to the contrary on *Swamp Water*, he still clung, however tentatively, to the belief that his ideas would be respected and he would be given the chance to make the film as he wanted.

'I have begun a film, and here that's not a joke,' Jean wrote to his brother Pierre, who had remained in Paris, and had just finished playing in Jacques Becker's first feature, *Dernier Atout*, a taut crime thriller. 'You immediately feel that you are a cog in a machine so big that you fear creating catastrophes by not giving every thought to the enterprise and risk stopping everything.'[14] To Coco, he wrote 'Every once in a while I meet a big boss, and I think I'm going to get bawled out. On the contrary, I get consolation and pats on the back that would bowl over a bull. I can't figure it out. They have a strange combination of complete confidence and complete distrust in me. They get involved in a feeble story that won't, at least in my opinion, make a good film, but they accept the most outrageous ideas I propose as long as they don't conflict with their established rules. If I want, I can have Deanna Durbin make an entrance for her love scene doing a handstand, but if I want to make her laugh in a dramatic scene, for the sake of contrast, that would be revolutionary.'[15]

From the very beginning, Jean felt constricted by the system. 'Each decision . . . even a smile, a wink, was discussed by ten people

around a green rug. It was difficult for me to work with such seriousness.'[16] In addition, Jean's World War I leg wound, which had not given him much trouble over the years, became painfully inflamed, making it difficult for him to stand. After over four weeks work on the Durbin film, now called *Forever Yours* and finally *The Amazing Mrs Holliday*, Jean decided to withdraw on grounds of health and allow Bruce Manning, the producer and Universal Studio hack writer, to take over the direction. There is no doubt that Jean would have provided something better than the synthetic, superficial and cloying film, exploiting the theme of war orphans for entertainment, that eventually reached the nation's movie theatres. But it would probably have been even less of a Renoir film than *Swamp Water*, and the leg wound, though nasty, granted him a narrow escape. As far as anyone knows, no frame that Jean shot survived onto the screen.

Since America's declaration of war against Germany on 8 December 1941, Hollywood now felt free to produce anti-German films. Every studio started to put out tales of intrigue and derring-do, and even Sherlock Holmes and Tarzan were recruited in the fight against the enemy. Jean felt that the time was now ripe to try once more to awaken some interest in *Flight South*, his story of refugee children. With his passport renewed and Alain in the American army, he felt less apprehensive in his approach to the Vichy government and its lackeys, and began corresponding with Dudley Nichols about a film concerned with the Occupation and the Resistance. Charles Boyer expressed a wish to make a resistance film with Jean and Nichols, opposite Michéle Morgan, but his fee was too high for any of the producers who were approached.

Around the same time Jean had conversations with Charles Laughton about the possibility of their making a film together. They had first met in 1937, when Jean was on a visit to London for the opening of *La Grande Illusion*. Erich Pommer, whom he knew from Berlin during the making of *Nana*, introduced him to Laughton on the set of *Vessel Of Wrath* (entitled *The Beachcomber* in the USA), which the German producer was directing.

The English actor and the French director had much in common and became firm friends. Laughton, an art collector, had acquired Auguste Renoir's large-scale *Judgement Of Paris* for $36,000 from the dealer George Keller in New York in 1935. At first, Laughton felt the price too high for him, but he could not pull himself away from

the picture, and after spending several hours each day staring at it, decided he had to buy it. Laughton also revealed a great love and knowledge of French wines, which drew the two men even closer.

Laughton and his wife Elsa Lanchester were frequent visitors at 1615 North Martel Avenue, between Sunset and Hollywood, the smaller house Jean and Dido had moved into in February 1942. It had been built by silent-screen star Agnes Ayres in the 1920s, when she had partnered Rudolph Valentino in *The Sheik* and *The Son Of The Sheik*. The Slades bought a wooden house next door, the back garden only separated from Jean's by a light fence.

Another quality of Laughton's that loomed large in Jean's eyes was the actor's affection for Gabrielle, whom he spoke to in fluent French, while she called him '*le grand matou*' (the big tomcat). In the evenings he would entertain Dido and Jean with readings from Shakespeare, acting out all the roles. The only thing Laughton disliked about the Renoir household were their two dachshunds, Nénette and Tambeau, nicknamed Goering and Goebbels, who would interrupt his performances with their yapping.

It was during these visits that certain ideas for a film were mooted. A few months before, Jean had begun working on a screenplay of John Steinbeck's powerful novel *The Moon Is Down,* about the resistance of a Norwegian village to the Nazis, but it was taken away from him and given to Nunnally Johnson at Fox. A story began to form under the influence of *The Moon Is Down* and one of Alphonse Daudet's *Contes du Lundi* (1873) called *The Last Class,* in which a weak schoolmaster begins to stand up for himself during the Franco-Prussian war. It seemed an ideal role for Laughton, who might have taken the place of Michel Simon in Renoir's American oeuvre, if circumstances had allowed.

Jean put the idea to Dudley Nichols, who came down to Hollywood to work with him on the script, first called *The Children*, then *Mr Thomas*. From 21 August to 13 September they worked on the only screenplay Jean was to direct in the USA that did not derive directly from another source. Most of the writing took place in a small room, with the curtains drawn during the day, because Nichols could only write by lamplight.

The co-screenwriters were also to produce the picture, finally entitled *This Land Is Mine*, as an independent production to be released by RKO. They had the understanding from Charles Koerner, the head of the studio, that they would be left to shoot the film in complete peace, but would have to answer to the studio for

the film's budget, its expenditures and results. Nichols remarked later that they were given 'complete freedom to make a film, without any impediment other than our own shortcomings.'

When it came to casting, aside from Laughton who was definitely to play the schoolteacher, the part written for him, Jean wanted Erich von Stroheim to play Major von Keller, the Nazi officer. But Stroheim, back in America since spring 1939, and whose stock had risen in Hollywood because of *La Grande Illusion*, had many offers and commitments at the time. He had made his American stage debut in Baltimore in February 1941 in the role of murderer and fugitive Jonathan Brewster in the hit black comedy, *Arsenic And Old Lace*, and had replaced Boris Karloff in the same role on Broadway. He also found time to appear as Rommel in Billy Wilder's *Five Graves To Cairo*, and in *North Star* as a Nazi medical officer experimenting on Ukrainian women and children.

Disappointed at being unable to work with his friend again, Jean got the Austrian-born Walter Slezak, under RKO contract, who had just completed his first Hollywood film, *Once Upon A Honeymoon*, in which he played a German baron with Nazi sympathies. At the age of 22, Slezak had acted with Nora Grégor in Carl Dreyer's *Mikaël*, long before Jean had 'discovered' her for *La Règle du jeu*.

Maureen O'Hara would be reunited with Laughton after co-starring with him three years earlier in *Jamaica Inn* and *The Hunchback of Notre Dame*. Both Laughton and O'Hara would feel at home, not only with each other, but because some of the sets employed were left over from *The Hunchback*. These mock medieval streets would be ingeniously adapted by Eugène Lourié, solving the problem of locating the film 'somewhere in Europe.'

In 1942, the Russian-born Lourié had arrived in New York where he was earning a living as a commercial artist when Jean begged RKO and the film union to allow his former colleague to join him. The union gave way on condition that Lourié designed the décor without stepping onto the sound stage during the shooting.

Hollywood was hard on artists like Lourié, who shared with Jean a passion for naturalism. His work in pre-war France leaned towards realism by placing characters in environments that were solidly convincing. Witness the rough bricks, rude stairways and old wooden posts in *Les Bas-Fonds*, Von Rauffenstein's Gothic chamber in *La Grande Illusion*, the platelayers' shed and railwayman's lodgings in *La Bête humaine*, and the corridors and large rooms of the château in *La Règle du jeu*. Although Renoir handled the studio sets with

fluency and aplomb in *This Land Is Mine*, especially in the scenes of trains and the railway yard, they pale beside those in *La Bête humaine*, another stark reminder of the difference between his films in France and Hollywood.

Jean related how he attempted, in a scene between the German officer and the schoolmaster, to differentiate their characters by the sound of their footsteps on the paving stones – the soldier's jackboots and the civilian's soft-soled shoes. 'To my intense surprise I found that this sidewalk was only imitation stone, made of soft cardboard. Lourié had fought hard to get real stone but the sound department had vetoed it. They were afraid that the sound of footsteps on a hard surface would interfere with the dialogue, and it was the rule that the dialogue must always come over clearly . . . I insisted on one point, namely that the actors, having to speak their lines through the sound of footsteps, would do so differently than they would on a silent surface. But it was no use. I was told that by dubbing the sound of footsteps the noise could be kept down to the requisite level. The incident enabled me to put my finger on the precise difference between French and American taste. The French have a passion for what is natural, while the Americans worship the artificial.'[17]

During the shooting, Jean not only suffered pains in his leg, but from what was believed to be chronic appendicitis; he put off an operation until the completion of the film. It turned out to be a fistula.

Significantly, Renoir is not given the usual isolated director's credit, but shares the screen with Dudley Nicholas, whose speechifying screenplay dominates the picture. *This Land Is Mine* tells of Albert, a cowardly, mother-dominated schoolteacher (Charles Laughton), who is secretly in love with Louise (Maureen O'Hara), a colleague of his. She is engaged to George Lambert (George Sanders), a railway superintendent, who betrays her brother Paul (Kent Smith), a resistance fighter, to the Nazi Major von Keller (Walter Slezak). When Paul is shot trying to escape and the headmaster (Philip Merivale) is executed, Albert gains backbone enough to speak up against the enemy, and is arrested.

Because the story is set 'somewhere in Europe' – the town standing for any in an occupied country – the film lacks the urgency and reality that a named place would have given it, shifting into the vaguer world of allegory. All the characters are one-dimensional

symbols (extremely rare in Renoir). O'Hara is the exemplar of noble and defiant womanhood (something she does admirably); Sanders a man who thinks collaborating is the only option; Slezak, the cruel but cultivated Nazi, who quotes Shakespeare and knows Latin (Stroheim might have brought more nuance to the role); the intellectual headmaster believing in the power of the written word; the heroic freedom fighter; the possessive mother, willing to betray the saboteur to save her son. The sentiment that 'everyone has his reasons' is here reduced to its most elementary form.

Only Charles Laughton, a pathetic lump of shaking jelly, clinging desperately to his mother (Una O'Connor) in the bomb shelter, then growing into an unlikely tragic hero, gaining love and respect, is more than just another cipher for ideas. He delivers a moving (seven-minute) speech in court, followed by another to his class in which he reads from The Rights of Man. But repetition and too many climaxes lessen the impact of the film's message that tyranny cannot survive as long as there are people to fight it.

Yet despite the undiluted didacticism of the dialogue, and a certain inevitable staginess due to the studio-confined settings, Renoir managed a few characteristically delicate touches, such as a cat peeing on an official newspaper, Laughton's attempts to smoke a cigarette (a signifier of unmanliness), and the children's carefree attitude to the bombing. Inevitably, the film has to be judged by the period in which it was made. At the time, such phrases as 'sabotage is the only weapon left to a free people', and the film's strong condemnation of collaboration were effective and necessary in the propaganda war. From a personal standpoint, it also answered the exiled Renoir's desperate need to play his part. There are works of art created in order to express a contemporary attitude or reflect on a topical issue; some resound beyond their era, and others remain fixed within it. Despite the eloquent cry of liberty that it contains, *This Land Is Mine* belongs in the second category.

The film opened in New York in March 1943. Bosley Crowther in the *New York Times* wrote: 'Jean Renoir and Dudley Nichols have produced a sane, courageous film, marked only by occasional violences. To the taste of this observer, the performance of Charles Laughton in the leading role is far-fetched, too. Mr Laughton's familiar inclination to blubber and grimace has not been adequately checked and his elocutionary manners in the court room seem much too theatrical . . . ' Crowther also vented his dislike on the rest of the cast, finding that George Sanders gave a 'drab and flat perform-

ance', Slezak acted with 'too much pomposity and accent,' and Una O'Connor was 'shrill and crotchety.'

Despite mixed reviews from critics, there were many other people who were moved by it. When Jean received numerous letters from American soldiers expressing their thanks at enabling them to change their opinions of the French as a nation of collaborators – everyone took the film to be set in France – he felt the film had succeeded in its goal. A group of Russian cameramen, in the USA on leave as a reward for their heroism, told Jean that the film was a truthful representation of an occupied town. A telegram arrived from Louis Jouvet in South America, where he was exiled, which read: 'Congratulate Laughton Friends Very Moved With Love Vivre La France.' When it was finally shown in France in July 1946, in a dubbed version entitled *Vivre Libre*, Renoir was attacked, in those angry post-liberation days, by some journalists, for making a film from the comfort of Hollywood without having known what living under the Nazis was really like. (He was to return to the period in his play *Carola* in 1957.)

In 1943 though, *This Land Is Mine* turned out to be very much part of the well-meaning Hollywood anti-Nazi genre. Among the other films in 1943 that treated a similar subject was Fritz Lang's *Hangmen Also Die*, based on a story by Bertolt Brecht. In the latter, despite the uninspiring cast, and the Nazis played without nuance as heavies who actually deliver lines like 'Ve haf vays of making you talk', an atmosphere of terror was created and the tension mounted with true Langian skill.

Jean's old friend Brecht had arrived in California in July 1941, and was finding difficulty in earning any money – 'For the first time in ten years,' he wrote, 'I am doing no proper work'[18] – until Lang's offer, and a few other commercial film scripts, rescued him. Coincidentally, Brecht met Charles Laughton a little after the release of *This Land Is Mine*, a meeting which would later lead to their fruitful collaboration on *Galileo*.

Laughton and Brecht were introduced at one of Salka Viertel's Sunday night suppers at her home in Santa Monica, at which Jean and Dido were frequent guests. The bisexual Salka Steuermann, then in her 50s, was the Polish-born actress and writer who had been married to the Austrian film director Bertold Viertel, and had co-written a number of screenplays for her friend Greta Garbo. She was friendly with most of the artistic *emigrés* in and around Hollywood in those days, including Arnold Schoenberg, Hanns Eisler,

Heinrich and Thomas Mann, Paul Dessau, Oscar Homolka, Peter
Lorre, Lion Feuchtwanger (an escapee from a French concentration
camp), Franz Werfel and his wife Alma Mahler, Aldous Huxley,
W. H. Auden and Christopher Isherwood. (Bertold Viertel was the
model for 'Bergmann' in Isherwood's short novel on the film
industry, *Prater Violet*.) Among the few Americans admitted to the
circle were Robert Flaherty, Albert Lewin, the sophisticated and
intellectual producer-director, and the playwright-screenwriter Clif-
ford Odets, all three closer to Jean than the other 'foreigners'.

But evenings with these stimulating and dazzling people, his
comfortable American-style home, with its garden full of roses and
a drooping mulberry tree, and his beloved Gabrielle next door,
failed to compensate Jean for the difficulties of making a film he
really wanted. At the end of June 1943, in a letter to Jean Benoît-
Lévy, the French film director also exiled in the USA, Jean wrote:
'Since I finished *This Land Is Mine*, I've been working on projects
that I don't believe in. The result: big depression, doubts about the
profession that you know only too well, and poor relations with the
people in my trade.'[19]

30

Americana

'The result of my experience is that, quite apart from the cinema, the Americans and their country have quite conquered me . . . I've become very enthusiastic about California. One breathes easily here.'

Jean thought that because *This Land Is Mine* had been shot quickly and cheaply and did well at the box office, it would make it easier for both him and Dudley Nichols to get some of their stories accepted. One of their ideas was to make a film called *Sarn*, adapted from Mary Webb's novel, *Precious Bane* to star Ingrid Bergman, who had expressed a desire to work with Jean. She had just made her big breakthrough with *Casablanca* and *For Whom The Bell Tolls*, and was under contract to David O. Selznick. The producer rejected the idea because the heroine has a harelip, an unthinkable impediment to impose on a glamorous film star, although Bergman herself was prepared to disfigure herself for the role.

Selznick, however, was keen to make *Joan Of Arc* with the Swedish actress, and offered it to Jean, who refused because of his memories of Carl Dreyer's *The Passion Of Joan Of Arc*. 'I lacked the courage to follow in the footsteps of my brilliant colleague,' he explained.[1] (Bergman did play the role in the stodgy 1948 RKO production.) Though nothing came of either project, Jean was to become firm friends with Ingrid Bergman, then married to Swedish dentist Dr Peter Lindstrom.

Renoir and Nichols also tried to arouse interest in a remake of *The Lower Depths*, set in modern LA; a version of Turgenev's *First Love*, and a film called *The Poachers*, about a girl who lives wild in the woods. 'Projects failed to come off for what looked like practical reasons – the star we wanted was not free, or the distributors decided that the story was out of date. The early discussions were always favourable; generally speaking the producers thought well of me. But on further thought they had their doubts, and finally after a number of conferences, they told me that my idea was not "commercial" – a song I knew by heart. There was nothing to be done about it; in spite of the money my films made I was not "commercial". It was worse than a label: it was like a tattoo mark on my forehead.'[2]

Eventually Nichols accepted an offer to write a couple of scripts for René Clair, and Jean and 'the first friend he made in Hollywood'[3] never worked together again. This was probably no bad thing, given Nichols' penchant for rather pompous prose that weighed down the two films he made with Jean.

A change of agents from Feldman-Blum to Berg-Allenberg did not make finding work any the easier. The only firm offer that came to Jean was from the Office of War Information, to help with the production of an instruction film for American troops being sent to France. Called *Salute to France*, it would teach them that 'not all Frenchman wear berets and not all Frenchwomen are of easy virtue.'[4] Shooting was due to begin in New York in February 1944.

On 6 February Jean Renoir and Dido Freire were married by a justice of the peace at the Laughtons' house. Among those present at the ceremony were Gabrielle and Dudley Nichols as witnesses and Charles Laughton as best man. For the wedding feast, Jean and Dido had gathered all their food stamps together to be able to buy a precious fillet of beef, but, sadly, it was ruined by overcooking.

The newly-weds decided to consider the trip to the East coast for the film as their honeymoon. The screenplay of *Salute To France* was written by Renoir, Philip Dunne, a screenwriter at Fox, and Burgess Meredith, the actor who had just married Paulette Goddard, his third wife. While Goddard shepherded Dido around the Manhattan stores during the day, Jean worked on the film, in which Meredith and Garson Kanin played two GIs, and Claude Dauphin, as well as narrating, portrayed various Frenchmen – a peasant, a soldier, a worker and so on. Kurt Weill composed the music. It was shot in two versions, English and French, both directed by Renoir.

During their stay in New York, where they stayed at the Algonquin, besides enjoying the theatre in the company of Garson Kanin and his wife Ruth Gordon, and Burgess Meredith and Paulette Goddard, Jean and Dido used to meet Jean Gabin and Marlene Dietrich, who were living together. Gabin had completed the only two films he was to make in Hollywood, *Moontide* (opposite Ida Lupino) and Julien Duvivier's *The Imposter*, in which he played a Free French hero; Dietrich was appearing in cabaret, where she included patriotic French songs in her show, ending with *La Marseillaise*. The lovers would often have heated arguments, usually ending with Marlene, whom Gabin called 'Ma Prussienne', tapping the actor on the forehead and saying, 'You haven't a single idea in your head, not one, and that's what I like.'[5] At that time Jean could not have believed that he would ever make another film with Gabin.

Some years later, when Gabin and Dietrich had split up – after they had co-starred in *Martin Roumagnac* (1946) in France – Renoir continued to see Dietrich, whose *chou farci* he much admired. 'Renoir loved stuffed cabbage, had an enormous appetite and left almost immediately after the meal,' Marlene once commented. 'At that time I was known in Hollywood for not taking offence at such behaviour: You could come dine with me and leave when you pleased. No fuss, no fawning; Renoir appreciated that. He was a frequent guest, and I made stuffed cabbage for him every time.'[6]

Dido and Jean returned to Hollywood in April 1944, leaving *Salute To France* to be edited by Helen Van Dongen, the brilliant Dutch documentary editor, who worked closely with Ivens and Flaherty. However, the English version was cut by unknown hands from 95 to 37 minutes. Jean, who never saw the French version, which was shown in Paris after the Liberation but has since disappeared, said, 'There is little of me in the film.'[7] Burgess Meredith recalled: 'The copy of the film *Salute to France* that we received had nothing to do with the film that Jean Renoir and I made with Garson Kanin. There are maybe one or two scenes from the original, and that's it.'[8]

Back home on North Martel Avenue, Jean was faced once again with trying to get a film off the ground. Louis Jouvet, who spent the war years touring South America with his theatre company, wrote to Jean from Mexico saying that he had managed to get backing for a film to be made in French there, and would Jean come over to direct it. Jean refused for fear of losing any interesting offers of work his agents kept assuring him were forthcoming; neither did

he want to leave California while Alain was 'fighting in wretched jungles for months on end. A little while ago he received a "Soldier's Medal". . . in short, it wouldn't please him very much to see his Dad cut off from the country for which he is fighting.'[9]

While Jean waited for Alain to return on leave from the Pacific front, he and Dido continued to entertain their friends. One evening they gave a dinner for D. W. Griffith, at which the other guests were Lillian and Dorothy Gish, Rex Ingram and his wife Alice Terry, and Erich von Stroheim. It was an occasion that had the air of *Sunset Boulevard* about it.

Ingram, whom Stroheim considered 'the world's greatest director', still only 52, had retired from films and was living in semi-seclusion on the outskirts of Hollywood, where he devoted himself to writing, sculpting and philosophical meditation. After his disappointment at not being given *Ben-Hur* to direct, the man who made Valentino into a superstar in *The Four Horsemen Of The Apocalypse* (1921), setting his Latin looks against Alice Terry's Aryan beauty, had left Hollywood with his wife for Nice where he set up his own studio. Ingram, who had been converted to Islam on one of his frequent visits to North Africa, spoke bitterly of the vulgar men who had taken over the motion picture business, which they were running for quick profits. Griffith, older and more aloof than ever, seemed to Jean to be overplaying the role of the great man in decline. He also felt that Griffith, when speaking about his own films, put too much emphasis on his technical contribution to cinema and not enough on his poetic qualities.

Jean was expecting an absorbing conversation between Griffith and Stroheim, who had worked closely together in the early days, but they ignored each other throughout the evening. Suddenly Jean leaned over to Stroheim and asked him what film he would most like to make, if he were given carte blanche as a director. 'Octave Mirbeau's *The Diary of a Chambermaid*,' replied the ex-director without hesitation.[10] His curious choice for the title role was Myrna Loy, then known mainly as the sophisticated wise-cracking Nora Charles in *The Thin Man* series; he saw himself as the sadistic valet Joseph, and Tully Marshall, who played the loathsome old planter in Stroheim's *Queen Kelly*, as the country gentleman with a fetish for women's shoes. Apart from the fact that Marshall had died recently, there was no possibility of Stroheim ever realising this intriguing subject. Coincidental or not, Mirbeau's novel would, however, be tackled by Jean Renoir the following year.

During the bizarre meal where gathered ghosts of Hollywood's past, Stroheim, always a heavy drinker, asked Dido for a whole bottle of Scotch to be put down on the table in front of him. A little later, though, Dido noticed that he had turned green, and had to quickly propel him towards the bathroom.

Only a few days later, Stroheim was being cared for in the Queen of Angels Hospital. So seriously ill was he that both his sons, Erich Jr and Josef, then serving in the army, were given emergency leave to be at his bedside. Stroheim made an amazing recovery, but cut down considerably on his alcohol thereafter.

George Cukor had wanted Stroheim to play Ingrid Bergman's villainous husband in *Gaslight*, but was over-ruled by MGM in favour of Charles Boyer. After Bergman had won the Oscar for her performance in this Victorian psychological thriller, she and Jean met at a dinner party. She then repeated what she had often said to him since they were first introduced. 'I'd love to work with you. We must make a film together soon.' At their first meeting, he had modestly replied, 'No, you're at the top. I've just arrived here. I'm a new boy. I'm still feeling my way. But if one day you need me, I'll be ready to work with you.' This time, having been in Hollywood for over four years, and having made two films, Jean replied in a similar way. 'No, the time is not yet ready, Ingrid. You're too big a star for me now. But I shall wait until you are falling and then I shall be holding the net to catch you. I shall be there with the net.'[11] Those words of his would boomerang with force 10 years later.

The Hakim brothers, Robert, Raymond, André and Raphael had, before the Occupation, moved with their families to the United States, where they set up their production company. One morning, Robert Hakim, who had produced *La Bête humaine*, came to see Jean with the proposal that he should direct a film based on George Sessions Perry's novel, *Hold Autumn in Your Hand*, for which he already had a script by Hugo Butler. Hakim was in partnership with David L. Loew, one of the twin sons of Marcus Loew of the huge Loew Theatrical Enterprises. David had branched out on his own as an independent producer, mostly with his friend Albert Lewin, with whom he had produced *So Ends Our Night* (1941), in which Stroheim played his first Nazi role, and *The Moon And Sixpence* (1943), based on the Somerset Maugham novel inspired by the life of Gauguin. Loew was a man of culture and one of the few producers who brought Jean 'the fruits of a genuine experience.'[12]

Jean read the Sessions Perry novel, which is really a linked series of short stories set in rural Texas. The title, *Hold Autumn In Your Hand* (changed to *The Southerner* on the distributor's insistence), implied the need to store fruit and vegetables for the winter in order to retain vitamins in the diet of farmers, the lack of which could lead to an illness known as pellagra or 'spring sickness'. He also read the adaptation by Hugo Butler, a Canadian, who had just had a success at MGM with his screenplay for *Lassie Come Home*. However, he felt the screenplay failed to convey 'the calm grandeur of the theme.' It laid too much stress on the leading character. 'What I saw was a story in which all the characters were heroic, in which every element would brilliantly play its part, in which things and men, animals and Nature, all would come together in an immense act of homage to the divinity.'[13]

Renoir conveyed these thoughts to Butler with such enthusiasm that the writer suggested Jean write it himself, and graciously bowed out. Jean then asked David Loew if he could rewrite the script, warning him, at the same time, that it would change considerably during the shooting. Loew gave him the go-ahead. It seemed too good to be true. Here he was in Hollywood, and about to make a film in his own manner. Eugène Lourié, who had overcome his problem with the union, would be his designer, and the veteran French-born Lucien Andriot, in the USA since 1916, would be his cameraman. Robert Aldrich was Jean's assistant, giving the 26-year-old future director his first real break. Aldrich, like Jacques Becker and Luchino Visconti, served an indispensible apprenticeship at Renoir's side.

Although Jean would be working alone on a script in English for the first time, he initially had some assistance from the experienced Nunnally Johnson, who had written the screenplay for John Ford's *The Grapes Of Wrath*, which lay vaguely in the same area as *The Southerner*. But when he had to leave because of other commitments, Jean sought the advice of William Faulkner, who gladly gave of his time. Although the great Southern novelist does not get a screen credit, 'the influence of that man of genius had certainly a lot to do with the success of the film.' Faulkner, who had just completed *To Have And Have Not* for Howard Hawks, remarked that working with Renoir had given him more pleasure than any other of his Hollywood work.

For Jean, *The Southerner* 'offered me a second chance, my return to the American film industry depended on it . . . My ambition was

to be accepted without having to throw my own ideas overboard. *The Southerner* would enable me to realise my chief aim, which was to run a small company specialising in low-budget, experimental films, with casts either of beginners or of actors who were down on their luck.'[14]

The script was first offered to Joel McCrea and his actress wife, Frances Dee, but they rejected it, presumably thinking that a film about poor, struggling farmers would not enhance their careers. United Artists, who were to release the picture, then decided that without star names they would drop it. Loew told them bluntly that if they did not distribute the film fairly, he would take his other films away from them.

For the role of Sam Tucker, the farm worker who decides to buy his own land, Jean unaccountably chose Zachary Scott. The 31-year-old Scott had just made an impressive screen debut in *The Mask Of Dimitrios*, in which he played a notorious scoundrel. It was the only film Jean could have seen him in, though, wise after the event, he later claimed that he had chosen Scott, who 'had hitherto specialised in polished gangster roles', because of 'my belief in getting actors to play parts beyond their range.'[15] Also because he 'came from the South, so I could be sure his accent would be genuine' and 'was the son of a cotton farmer.'[18] Scott was indeed born and educated in Texas, but was the son of a prominent surgeon in Austin, and knew nothing of farming, though so convincing was the university-educated actor, that Jean later confused the man with the role.

The rest of the cast were far more experienced: Betty Field was the wife of Elmer Rice, who wrote several plays for her; Beulah Bondi had started her film career in 1931 in *Street Scene*, adapted by Rice from his play, and J. Carrol Naish, Percy Kilbride, Blanche Yurka and Estelle Taylor were all veterans of the screen.

Unlike his experience on *Swamp Water*, Jean was able to film on location. Because of transport difficulties during the war, however, he was unable to shoot the film in Texas where it was set, but they found a cotton field not far from the small town of Madera on the bank of the San Joaquin river in California. Lourié built the ramshackle house on it, and the cast and crew lived in a village of tents erected along the edge of the field. In the area was a large Russian colony, as well as Mexicans, and in the evening the locals would entertain them with Russian and Mexican folk songs. 'Our rather sombre story was shot in an atmosphere of serene gaiety,'

Jean recalled.[16] *The Southerner* began shooting in September 1944 and was completed around the following January.

The film tells of one year in the life of Sam Tucker (Zachary Scott), a farm hand who, tired of working for others, rents land from his boss in order to go it alone. With his wife (Betty Field), a grandmother (Beulah Bondi), two young children and a dog, they take off in an old truck, and settle in a broken-down house on an out-of-the-way plot of waste land. Despite having to get water from the well of a malicious neighbour (J. Carrol Naish), Sam manages to plough the land ready for a cotton crop. But after his son nearly dies during the winter because of lack of milk and vegetables, and the crop is destroyed by a rain storm, he asks his city friend (Charles Kemper) to get him work in a factory. However, when everyone pitches in to help, and the sun comes out, he decides to stay and fight.

By shooting on location, and having more space and freedom, Renoir achieved the effective slice of Americana that escaped him on *Swamp Water*. And by writing the screenplay himself, he was less hamstrung by plot and dialogue, allowing him a greater confidence and fluidity than in his first two Hollywood ventures.

The story and style have an affecting simplicity and directness, skilfully skirting the edges of melodrama and rhetoric. Any messages the film contains ripple gently under the surface. Among the memorable images are the family clustered around the fire of a stove; Granny on her rocking chair at the back of a truck; the landing of a huge catfish, a moment that brings the antagonistic neighbours together, and the search for a cow lost in a flood. And always there is the land – hot, dusty, unyielding or shady, green and bountiful. Slightly less successful, because more familiar, are the Fordian elements – the fight in a bar, and the wedding party.

The unstarry Zachary Scott and Betty Field bring a touching sincerity to their roles, generating a feeling of true affection for one another. Only Beulah Bondi's grumpy, spitting Granny, though a colourful creation, is too unrestrained, and her sudden transformation into willing helper at the end, too pat.

The theme and much of the imagery of the film is in the noble tradition of the rural dramas and documentaries of the Depression and pre-war period: King Vidor's *Our Daily Bread* (1934), about the struggles of a farming co-operative started by a destitute young city couple; Pare Lorentz's *The Plow That Broke The Plains* (1936), on

farmers of the Dust Bowl and *The River* (1937), a film which Jean must have seen or been aware of, being a friend of Lorentz. The Renoir film appeared not long after Robert Flaherty's *The Land* was suppressed by the US government at home and abroad in 1944, because its depiction of starvation, unemployment and erosion was considered harmful to the war effort, and outdated owing to the reduction of unemployment during the war.

The Southerner was first shown on 30 April 1945 at the Four-Star Theater in Beverly Hills. However, because of the war, there was an implicit agreement that Hollywood had to present a glamorous image of the United States to the world, and the film was not released in France until 1950, despite its having won the Best Film award at the 1946 Venice Film Festival. Its French première was at the 1949 Biarritz Festival, when the critic of *Combat*, Henri Magnan, phoned in his copy to Paris. Magnan's French pronunciation of the film's English title came out as *Le Souteneur* (The Pimp), 'un film de genre noir', instead of 'un film de Jean Renoir'. It sounded like a remake of *La Chienne*.

31

What the Chambermaid Saw

'Hollywood was very well disposed towards me; indeed, I will go so far as to say that they were fond of me . . . They love me like a small girl loves her doll, provided she can change its clothes and, at a pinch, the colour of its hair.'

On 6 June 1944, the Allies finally landed on the Normandy beaches and the liberation of France began. On 26 August, General Charles de Gaulle marched down the Champs-Elysées with General Philippe Leclerc and other heroes of Free France. Then followed the time of bitter recriminations and what was called *épuration*, the punishment of persons known or suspected of having assisted the enemy. Almost every writer, painter, *cinéaste*, actor and actress who had worked during the Occupation came under scrutiny. Of Jean's former colleagues, Michel Simon was accused of making anti-patriotic statements. He denied the charge, adding that he had even been denounced to the Gestapo on the false allegation that he was a Jew. He was exonerated. Pierre Fresnay was inculpated for having starred in films by the German company Continental and for having displayed pro-German feelings, but in his defence was the charitable work he had done for fellow actors during the Occupation.

There was a temptation for Jean to return to France and play a part in the regeneration of his newly liberated country. Simon Schiffrin, head of the Free French Cinema, asked him if he would return to make a film of *L'Armée des ombres,* Joseph Kessel's novel of the French Resistance in German-occupied Lyons, but Jean replied

that he wished to be at home when Alain returned, because he had not seen his son for three years, and he had also applied for American citizenship. In any case, as he had written a few years before to Coco: 'I feel more comfortable in this big country than in the confines of Europe.[1] (*L'Armée des ombres* was made into a moving, truthful and tragic film by Jean-Pierre Melville in 1969.)

With the war over in Europe on 8 May 1945, letters began to flow freely once more between France and the USA, and Jean was able to re-establish communications with his family and friends. From Coco, who had been in the Resistance with his son, he learned that a bomb had landed in the yard at Les Collettes, but had done little damage. Jean and Dido sent money and food parcels to his brothers, to the Cézannes and to Dédée's mother, Madam Heuschling, who was being looked after by her other daughter in Nice.

A few months before VE day, Jean wrote to Louis Guillaume, his financial adviser in France since the 1920s, 'I'm dying to go back to France, since at 50 you're too old to change your habits. What's more, perhaps our country will need all the energy it can get.'[2] But in July, again to Guillaume, he explained his reluctance to return just yet. 'I can't get rid of the idea that producers who made films during the Occupation did so by somehow coming to terms with the Germans. I have nothing against them for it; you're free to save your skin and your money as you think best, as long as it doesn't mean selling your friends down the river. But I'm not eager to go and work for them. I can see their names in the newspapers; they get along with the Americans the same way they did with the Nazis. It all disgusts me a little, and I'd prefer to go and work in France once the film industry is in other people's hands.'[3]

Jean's fears were expressed despite his knowing that immediately after the liberation of Paris, The *Comité d'Organisation de l'Industrie Cinématographique* (COIC), founded by the Ministry of Information in 1942, was replaced by the *Comité de Libération du Cinéma Français* (CLCF) which purged the industry of collaborators. It was headed by the actor Pierre Blanchar, and its members included Louis Daquin, Jean Grémillon, Jacques Becker and Pierre Renoir, all of whom had worked during the Occupation, but were unstained by any hint of collaboration.

The closest Jean was to get to France in 1945 was the French provincial town built by Eugène Lourié in the General Service Studios in Hollywood for *The Diary Of A Chambermaid.*

*

Octave Mirbeau's *The Diary of a Chambermaid* had impressed itself upon Jean's mind in adolescence, and he had first envisaged it as a silent film vehicle for Dédée, rather in the style of *Nana* – short scenes added one to another. He returned to the subject while looking for a part for Paulette Goddard, then one of Paramount's top stars, with whom he wanted to work, mainly because of her link with Chaplin, whom she divorced in 1942. For Jean, she was 'still the waif of *Modern Times*, except that her rags had given place to clothes of the utmost elegance.'⁴ Goddard, too, was enthusiastic about doing a film with Jean, and so was her husband Burgess Meredith, who saw himself in the part of the eccentric Captain Mauger.

Renoir and Meredith tried to get RKO interested in producing the picture, but the studio thought the subject too risqué. Fortunately they got financial backing from Benedict Bogeaus, a Chicago real-estate dealer who had come to Hollywood in 1940, and become an independent producer. Of the handful of films he had made, the first and best was Josef von Sternberg's *The Shanghai Gesture* (1941), and the worst (and most recent) was *Captain Kidd* (1945), which allowed Charles Laughton, complete with stage cockney accent, to ham it up as the bloodthirsty pirate. Bogeaus rented out his General Service studios to individual producers, and usually left them to get on with it.

When it came to tackling the script, Jean toyed with the idea of approaching Anita Loos, primarily celebrated for her 1925 novel, *Gentlemen Prefer Blondes*, which she also adapted for the stage and screen. The 58-year-old Loos was one of the most experienced screenwriters around, having started her career in films with D. W. Griffith and Douglas Fairbanks. This intriguing choice denoted that Jean was thinking of *The Diary Of A Chambermaid* in a lighter vein. In the end, Jean and Meredith opted to write it themselves, using the play adaptation by André Heuzé, André de Lorde and Thielly Nores as a basis, and blithely taking liberties with both it and the novel. The screenplay went through further changes during the shooting, when a great deal of improvisation took place, including the climactic sequence when the mob attacks Joseph, an incident not in the book or the original script. This turned out to be a splendidly staged scene, viewed from the back of the crowd moving in frenzy, then revealing the body of Joseph as they drift away. It was filmed almost identically to the killing of the landlord Kostileff in *Les Bas-Fonds*.

As there was no possibility of shooting the film on location like *Madame Bovary* – and certainly not in France – Jean was happy to have Lourié recreate France on a Hollywood sound stage. The shadowy mansion with its large, detailed kitchen helped capture the atmosphere of nineteenth-century provincial French life. But Jean explained that the film came out of one of his 'anti-realist crises', the same crisis which led him to *La Régle du jeu* after *La Bête humaine*.

'There are times when I wonder whether the only truth isn't interior truth, and whether the accuracy of make-up, of costumes, of appearances, of furniture, the exterior truth, if all that shouldn't be neglected so that we can plunge a little deeper into this interior truth. *The Diary Of A Chambermaid* represents this concern,' Jean remarked.[5] He claimed that during the shooting he was thinking of both *commedia dell'arte* and classical tragedy. 'I situated it at the time of Mirbeau, not so much to be faithful to Mirbeau, but because I believe that if one day we arrive at a kind of *commedia dell'arte* style in cinema, the period to choose, the only period, the period that would allow us to abandon our concern with exterior truth, the right period to choose just might be this 1900 period. I can see all films taking place in 1900 . . . There would be no more research, there would be no more concern with exterior accuracy. We'd be set, we'd have to worry only about what happens within the characters shown on the screen.'[6]

This ideal period was one that he celebrated with such gusto and bravura in *French Cancan*, and *Eléna et les hommes* when he returned to France, and he confronted the *commedia dell'arte* head on in *Le Carrosse d'or*, after only having codified it previously. Jean saw *The Diary Of A Chambermaid* as having virtually the same subject as *La Règle du jeu*. 'These people represent a bourgeoisie that no longer exists, for the bourgeoisie that replaced it is a business bourgeoisie, an active bourgeoisie, a bourgeoisie that earns money, that declares war, that orders films, that makes films, that lives it up and does so openly. The bourgeoisie in *The Diary Of A Chambermaid* is the bourgeoisie of the nineteenth century, which was in the process of crumbling in its uselessness, and its desire to do nothing.'[7] In 1954, during their *Cahiers du Cinéma* interview with Renoir, Jacques Rivette and François Truffaut expressed a preference for *The Diary Of A Chambermaid* over *La Règle du jeu*, though the critics, still in their twenties, had only seen the 80-minute unreconstructed version of the latter. It is a revealing comment because it shows what little reputation *La Règle du jeu* had at that period, and how it was only

accepted as a masterpiece after 1959, 20 years after it was made, becoming a landmark for young filmmakers like Truffaut.

Célestine (Paulette Goddard), arrives from Paris to take up a job as chambermaid in the Lanlaire household in a small provincial town. Determined to improve her position, she allows M. Lanlaire (Reginald Owen), the ineffectual master; George (Hurd Hatfield), his tubercular son; Captain Mauger, the omnivorous ex-soldier neighbour (Burgess Meredith), and the scheming valet Joseph (Francis Lederer), who wishes to steal the family silver and set up a café in Cherbourg, to flirt with her. She is kept an eye on by the domineering Madame Lanlaire (Judith Anderson), clinging to her son and her silver, and losing both. After Joseph has killed the Captain for his savings, he tries to leave with Célestine, but is stopped by George and the villagers. George and Célestine go off to Paris to be married.

Despite the predominantly American accents and the Hollywood studio sets, Renoir still managed to make a film that is French in spirit and which, among his American films, comes closest to his pre-war work, as well as looking forward to the Technicolor period burlesques of the 1950s. After the excursions into rural Americana and didactic melodrama, *The Diary Of A Chambermaid* found him more comfortably on home territory; in time (1900), place (France), subject (love across social barriers, the moribund bourgeoisie, a woman courted by a number of men) and style (sweeping camera movements and nineteenth-century boulevard comedy techniques).

Although the tone is one of comedy, especially in the performances of Burgess Meredith's jumping-bean captain, Florence Bates as his adoring housekeeper, and Irene Ryan's plain scullery maid romancing a fat, simple-minded villager, the dark side and social comment is not neglected. The Czech-born Francis Lederer invests Joseph with a sinister and sadistic nature; he pierces geese's throats with a needle (the camera cuts away at the crucial moment) and has *petit-bourgeois* ideals. He shares Madame Lanlaire's distaste for the Revolution as she drinks to the death of the Republic every 14 July.

'You and I are alike,' says Joseph to Célestine. 'Underneath we're the same.' There is nothing in Paulette Goddard's glamorous and warm-hearted chambermaid to suggest anything of the sort, nor is it easy to believe that she has ever been a servant before; she is definitely lady enough to marry the son of the household at the upbeat ending, which could be interpreted as a sop to Hollywood convention. But it is in keeping with the airy nature of the film, in

contrast to Luis Buñuel's 1964 version. Whereas Buñuel's film is black and cynical, Renoir's is shining and optimistic. Nor is there any foot fetishism or sexual activity present in the less acid and more genial earlier film. Renoir's Célestine discovers that money and position mean nothing compared with love, and she gives the silver away to the villagers. Jeanne Moreau, Goddard's successor in the title role, is unscrupulous enough to be like Joseph, with whom she ends up. By updating the story and making Joseph a member of the French Fascist party, Buñuel brought the social satire into sharper focus.

When Rivette and Truffaut expressed their enthusiasm for *The Diary Of A Chambermaid*, they were going against the tide. The film was neither a success in America, where it was considered too French, nor in France, where it was considered too American.

32

The End of the Dream

'The drama for me was that the elements which had
hitherto constituted my life were changing, so that I was in
danger of becoming as much of an outsider on the Place
Pigalle as on Sunset Boulevard.'

In August of 1945, a month before the completion of *The Diary Of
A Chambermaid*, Japan surrendered and World War II was over. Jean
heard that Alain, now a second lieutenant, was helping to run an
occupied Japanese village. His son finally returned home in Decem-
ber 1945, having been decorated three times. On his arrival, the
young officer came down with a violent attack of malaria, having
abruptly given up quinine which he had been taking for three years.
He soon recovered, and before accepting a university scholarship to
which he was entitled under the GI bill, Alain took various odd jobs
– bricklayer, garage mechanic, stableboy.

Early in 1946, Jean and Dido bought a plot of land near Lillian
Gish's house along Benedict Canyon, where they had decided to
build their own home. Meanwhile, Jean was in urgent search of
another project. He had often spoken to executives Charles Koerner,
Jack Gross and Val Lewton at RKO, the studio that had released
The Land Is Mine, about his making some low-budget films for the
company. He explained to them that savings could be made by a
rapid method of shooting, by reducing the number of takes within
a single sequence, and the hiring of non-stars. Ironically, Joan

Bennett was set to do a film for RKO called *Desirable Woman*, based on the novel *None So Blind* by Mitchell Watson adapted by Michael Hogan, and she asked for Renoir as her director. She and her third husband, producer Walter Wanger, were friends of Jean and Dido's, and she had wanted to work with him for some time. Bennett had already made three films with Fritz Lang, one of them being *Scarlet Street* (1945), the remake of *La Chienne*.

In his memoirs, Jean wrote: 'It was agreed that Gross [Jack] and I would collaborate on the script of the new film. But Gross died, and I had to take over the entire responsibility. His death seemed to me a bad omen, nor was I mistaken.'[1] Actually, it was production chief Charles Koerner who died, on 2 February 1946, of leukaemia, leaving corporate president, N. Peter Rathvon to take over as studio chief. Jack Gross was alive to produce the film, and remained so for some years to come. This is a surprising lapse of memory since Koerner was someone Jean greatly admired. 'He was an understanding man, a man who knew the film market, who understood the workings of it very well, but who allowed for experimentation just the same.'[2]

Jean worked on the script of *Desirable Woman* with Frank Davis, allowing more room for improvisation than he had ever done. On the set he was given a completely free hand, but found that it took longer than expected. 'I wanted to try and tell a love story based purely on physical attraction, a story in which emotions played no part.'[3] To express this, he found that he required a great many close-ups, which 'take time in film and are expensive'. Jean also found it difficult working in a new area. 'In all my previous films I had tried to depict the bonds uniting the individual to his background . . . I had proclaimed the consoling truth that the world is one; and now I was embarked on a study of persons whose sole idea was to close the door on the absolutely concrete phenomenon which we call life.'[4]

Although this existential Langian world was not Jean's natural habitat, he was able to identify to a certain degree with the subject. Despite the presence of Dido, Alain, Gabrielle and a host of friends, Jean still felt a linguistic and cultural outsider in Hollywood, and was also isolated from his own country. In April 1946, *Desirable Woman* was shown to the RKO bosses, who were 'thoroughly displeased' (*My Life And My Films*) or 'very happy' (*Cahiers du Cinéma* interview) with it. Actually, it was the former. They decided the film should be tried out before release in Santa Barbara, but an audience made up mainly of young students reacted towards it in a

depressingly negative manner. Unwisely judging the film by that first unrepresentative occasion, panic ensued.

With advice coming from all quarters, including Walter Wanger, Jean was forced into re-cutting and re-dubbing certain scenes. He got Bennett to lower her voice, as he thought it too high-pitched, and changed the emphasis in a number of other sequences, mainly those between Bennett and Robert Ryan. But he was working under pressure, and both he and RKO began to lose confidence as time progressed. The studio waited some months after the film's completion before finally releasing it under the new title of *The Woman On The Beach* in May 1947, to general public indifference.

Lieutenant Scott Burnett (Robert Ryan), a Coast Guard Officer who suffers nightmares after his ship had been torpedoed, meets Peggy Butler (Joan Bennett) gathering driftwood on the beach. He accompanies her home, and meets her husband Todd Butler (Charles Bickford), once a painter of renown, now blind. Scott and Peggy are attracted to one another, but she cannot leave her husband whose blindness she accidentally caused. Scott, doubting Todd's inability to see, takes him to the edge of a cliff and leaves him to find his own way. Todd falls over the edge, but is not seriously hurt. However, Todd decides to burn his paintings, setting himself and his wife free at the same time. 'I clung to her as I did to the paintings,' he says.

The surreal images of a man drowning which begin this haunting film (reminiscent of the underwater sequences in Vigo's *L'Atalante*), form part of a recurring nightmare of the slightly shell-shocked Robert Ryan. But the waking existence that follows is barely less dreamlike – the mist-shrouded beach, the hulk of a wrecked ship on its sands, the painter's beach house, the small remote fishing community. Renoir uses these elements as the background against which to build an intriguing triangular relationship consisting of the dark, sensuous and mysterious Joan Bennett, her looks and intonation filled with suggestiveness; the disturbing Ryan, violence and insanity running like veins under the surface, and Charles Bickford, acutely listening and eyelessly watching his wife. 'You're so beautiful outside, so rotten inside,' he says, an echo of Laughton's descripton of himself in *This Land Is Mine* as weak outside but strong within.

At the dinner table Ryan leans over to light Bennett's cigarette in front of Bickford sitting between them, and in that simple gesture is their desire for each other, the husband's jealousy, and the question

that hovers over most of the film – is he blind or not? A little later, Ryan follows Bennett's footsteps in the sands, like Crusoe tracking Friday, and finds her perched inside the wrecked ship. As they kiss, they catch sight of the blind painter through a porthole, coming towards the guilty lovers.

For Truffaut, the moment when Joan Bennett, in white blouse and tight skirt, runs out in the wind and falls to her knees as she tries to stop Ryan taking Bickford out on a dangerous fishing trip, was 'among the nine essential erotic scenes' in cinema.[5]

The performances, and Renoir's firm and uncluttered direction, brings clarity to a murky, oblique and overly-symbolic screenplay. Despite, or because of, the re-cutting, *The Woman On The Beach* remains a fascinating example of 1940s Hollywood *film noir*, the other side of the American Dream.

It may not have been merely coincidental that Jean's career in Hollywood ended with the resurgence of the House UnAmerican Activities Committee. The objective of the hearings was to uncover 'subversion' in Hollywood, and some of the most distinguished and talented members of the film colony were called and questioned to co-operate. Nineteen 'unfriendly' witnesses were subpoenaed, 10 of whom invoked the First Amendment and were indicted and imprisoned.

As far as anyone knows, Jean was never approached to give evidence, not was he on the official black list. Given his past close association with the French Communist Party, his support for the Popular Front, his visit to the Soviet Union, his friendship with Brecht, Hanns Eisler, and other leftwing intellectuals, it is a mystery why he was overlooked by such a zealous body.

Two months after Brecht's *The Life Of Galileo* was performed in Los Angeles and on Broadway in July 1947, with Charles Laughton in the title role, the playwright was cited before the Committee. The play's director, Joseph Losey, was blacklisted, and Hanns Eisler, who wrote the score for *Galileo* and *The Woman On The Beach*, was deported from the USA after he had protested against the denunciation of his friend Chaplin by the Committee.

In a letter to Alain at the University of California, Jean wrote: 'The same thing could happen to me, even though I stay away from politics, not out of fear, but from boredom. There's nothing more boring than an American Communist.'[6]

There was also, however, an unwritten boycott that operated

around the studios. A few days after the première of *The Woman On The Beach*, Jean's agent, Ralph Blum, informed him that RKO, who had the director under a two-film contract, was willing to buy him out for a fixed sum. 'I am no fighter; I accepted, and that was the end of it,' Jean recalled.[7]

After that, wherever Jean turned, he ran into a blank wall. He tried to form an independent company to film an adaptation of Clifford Odets' 1940 play *Night Music*, a love story of a lower-middle class couple in New York, which was to star Dana Andrews and Joan Bennett. But bank loans and financing were difficult to come by. Albert Lewin and David Loew had already tried and failed to get it made some years back.

In January 1948, Jean formed a small co-operative company called the Film Group, in order to shoot classical and good modern plays on a low budget. But the company had to be dissolved through lack of finance before a film could be shot. Other projects that failed to come to fruition over the next few years were two films in Italy, one based on Jean Anouilh's *Eurydice*, and the other on the life of Goya, with Paulette Goddard intended for a leading role.

James Mason, who was beginning a career in the USA, commented: 'I tried to get Renoir involved in making films with me in Hollywood but at that time people had decided that Jean Renoir was not the kind of director that they wanted to work with. He'd done two or three films in Hollywood which were unsuccessful and they did not like his manner. His method of working was very unHollywood. He didn't like to plan things, he liked to improvise a little.'[8] It was Max Ophüls who got the chance to direct Mason's first two American films. According to Darryl Zanuck, 'Renoir has a lot of talent, but he's not one of us.'[9]

A few years later, Jean said, 'Although I don't regret my American films, I know for a fact they don't even come close to any ideal I have for my work . . . they represent seven years of unrealised works and unrealised hopes. and seven years of deceptions too . . . '[10]

If Hollywood wanted no truck with Jean then he would have to go elsewhere to continue his profession. He was longing to take up a few offers in France and also to see his family, friends and country again. Unfortunately, he could not return to France without being arrested for bigamy.

Before his marriage to Dido in February 1944, Jean had applied

for a divorce from Dédée, which was granted under Californian law due to their having been legally separated for 12 years. He later discovered that the divorce was not recognised in France. But when proceedings were instigated on his behalf, Jean was astounded to hear that Dédée, who was still receiving money from him, had decided, seemingly out of pure spite, to contest the divorce.

After Dédée gave up the cinema, she had devoted herself to realising her ambition of becoming a dancer, and worked very hard at the *barre* in a dance studio in Montmartre. She always had a taste for physical exertion, and was extraordinary supple. As can be seen in *Charleston*, the untrained Dédée, more so than the superbly professional Johnny Huggins, had 'natural rhythm'. When she felt confident enough, she approached the dancer, Spandolini, and asked if she could become his partner. He accepted, and they toured together for about a year.

By the time Jean started the divorce proceedings, she was 46 years old and retired. Ironically, he had to pay for her lawyers, as she was still financially dependent on him. As the court case dragged on, she was making him pay in more ways than one.

In desperation, Jean and Dido considered getting divorced so as to permit his re-entry to France to fight the case in person. But, as Jean explained, 'We have no grounds for divorce in the California courts, so that way out wouldn't work for us. The only reason could be Dido claiming that she had been deceived in marrying a man who wasn't really free. But California law wouldn't recognise that reason since it is, in fact, this law that made me free to marry.'[11]

Jean considered going to France anyway, and accepting the consequences, but Jacques Masse, his divorce lawyer, strongly advised him against it. As Jean commented in a letter to his childhood friend, Jacques Mortier, the chief of police at Martigues where he had filmed *Toni*: 'I cannot come because I've discovered my divorce from Catherine is not final. In France I'm a bigamist. And if I were to come to France, you would be obliged to throw your oldest friend on the damp straw of a dark dungeon.'[12]

Sadly, Dédée's obstinacy prevented Jean from seeing Paul Cézanne before his death in October 1947. 'I spend my waking hours regretting that I wasn't at his side when he was sick, and I wonder why I didn't go,' he wrote.[13]

While the appeal was continuing, news of another woman from his past reached him. After Jean had left Marguerite Renoir for Dido, she had married. It was not a happy marriage, and one night

in 1948, while being seriously assaulted by her husband, she shot him dead with a pistol. Marguerite pleaded legitimate self-defence, and after a month in detention, the case against her was dismissed. On hearing the news, Jean wrote to Pierre Lestringuez: 'One fine day two parallel roads diverged and ended up in totally different places. If you see her again, tell her I hope she puts all that behind her and that her life gets back together very soon.'[14] Gradually, thanks to Jacques Becker, she resumed her work as film editor on all his films up to his premature death in 1960.

Finally, in June 1949, almost four years after the divorce proceedings began, Jean's financial advisor wrote: 'I hasten to inform you that the court of appeals has transformed the separation agreement into a divorce and ordered their decision to be transcribed into the civil acts.'[15]

Dédée had lost the case. She tried to appeal against it, but was prevented from taking further action. In 1955, she married Robert Beckers, whom she had met 15 years previously, and with whom she had a long platonic relationship. She and Beckers, who was homosexual and no threat to her sexually, lived in modest circumstances in a bizarre ground-floor Paris apartment. When Alice Fighiera visited her there, she told her, 'You know, Alice, I have to work hard. I had to wash a linen blanket in the bath. It was so heavy, heavy. You see I've become a domestic. I was once served now I have nothing.'[16]

Yet, whatever her diminished circumstances, Dédée retained her boundless energy into her seventies. Despite being riddled with arthritis – plastic tubes replaced many of her arteries – she would walk 10 kilometres every day along the banks of the Seine.

The *houri* that lured Jean into becoming a film director in order to make her name, and whose faded fame rests only on a handful of his early films, outlived him by only a few months, dying forgotten in October 1979, aged 79.

PART VI
HOME FROM HOME
(1950–1969)

33

Way Out East

'One year spent in India cannot help but leave its mark, and when I start talking about it, I can go on endlessly, there's so much to say.'

When the divorce from Dédée finally came through, Jean was free to return to France whenever he wished. But it was to India that he would make his way first.

As long ago as October 1946, Jean had read a review in *The New Yorker* of a novel called *The River* by Rumer Godden. It attracted his attention not only because of the title but because the book was set in India, a country he had dreamed of visiting for many years. It made him curious to see whether it might form the basis for a screenplay. He got hold of the book, was not disappointed, and bought an option on it. After writing a short summary, he went to see various producers at different studios, but they were not interested because they felt that a film about India must have a tiger hunt and elephants. Time passed and the option had lapsed before Renoir found his opportunity to make the film.

Kenneth McEldowney was a Beverly Hills florist who had made a fortune by starting up a chain of drive-in flower-shops. His wife, Melvina Pumphrey, worked in the publicity department at MGM, and Kenneth had ambitions to get into the film business himself. He also had high connections in India, where he had been stationed for

a while with the US Air Force. Godden's novel was recommended to him, but when it came to taking an option on it he was referred to Renoir. They met, and agreed to form a partnership to produce *The River*, with McEldowney managing to persuade the British National Finance Company to put up the money. However, before Jean would commit himself to the project, he insisted that McEldowney pay for a trip for him to go to India with Dido and see for himself what the possibilities of shooting there would be like, insisting that there was no way he would make the film in a Hollywood studio with fake sets. McEldowney duly obliged.

Dido and Jean left for India on 29 January 1949. During their two-month stay they made contact with a wide variety of people and travelled to Calcutta, Bombay, Delhi, Benares, and to Narayangunj, the place in Bengal where the author of the book had grown up and set her semi-autobiographical novel. Jean had actually sought out the old house where Rumer Godden had lived, and slept the night in the nursery.

He also renewed his acquaintance with Hari Das Gupta, who would be one of his assistants on the film. They had met a few years previously when Das Gupta, who resembled Jean physically, was a student at the University of Southern California. In 1947, he and a cinéphile friend called Satyajit Ray, founded the Calcutta Film Society. The 27-year-old Ray, who was a great admirer of those films of the French director he had been able to see, especially *The Southerner*, called on Jean in the Royal Suite on the second floor of the Great Eastern Hotel in Calcutta to introduce himself. 'Renoir was not only approachable, but so embarrassingly polite and modest that I felt if I were not too careful I would find myself discoursing upon the Future of the Cinema for his benefit,' Ray recalled.[1] Jean found Ray's approach to him 'very Anglo-Saxon, very correct.'[2]

The young man had graduated with honours in economics at the University of Calcutta, then studied painting and art history at Shantiniketan, the university run by Rabindranath Tagore, a friend of his family. When he met Jean, Ray was working as an art director for a British advertising firm, and was also illustrating books. Cinema was little more than a hobby to him until his meeting with Renoir, the first great film director he had come to know, an event which sparked off his desire to make films himself.

Ray's knowledge of his birthplace, Calcutta, proved invaluable to Jean and Dido on the many trips they took around the city and its environs, by car and on foot, during which he was able to answer

most of Jean's flood of questions. Ray, who was astonished by the older man's curiosity and energy, introduced him to Majumdar, a Francophile friend of his whose knowledge of Bengali village life was unrivalled.

However, at a press conference, Ray was disappointed to hear 'Jean declare that *The River* was being made expressly for an American audience, that it contained only one Indian character – a servant in a European household, and that we were not to expect much in the way of authentic India in it. Of course, the background would be authentic, since all the shooting was to be done on location in Calcutta. I could not help feeling that it was overdoing it a bit, coming all the way from California, merely to get the topography right.'[3]

One thing immediately became clear to Jean – *The River* would have to be shot in colour. 'I saw the colours in India as marvellous motifs with which to test my theories about colour films. I'd been wanting to make a film in colour for a long time, even though I believe that black and white are powerful factors in making a film into a spectacle. Black and white profits from the advantage that lies in the impossibility of its being realistic: whether you want it or not, the world outside is in colours.'[4] It is paradoxical that Jean saw colour as more realistic than black and white, a case he makes logically, whereas in the cinema of the 1940s and the early 1950s, colour was mainly associated with musicals and costume dramas, bringing out the brilliant, and often brash, artificial sets and designs, creating a fantasy world far from reality. Contemporary 'realistic' subjects were largely treated in black and white.

In order to learn the techniques of Technicolor, Claude Renoir, who was to be director of photography on his uncle's film, went to London for a training course at British Technicolor. Claude was joined in London by Jean and Dido, and Romananda Sen Gupta, whom Renoir had selected as the cameraman. One of the principal reasons for the London visit on the way back from India in March 1949 was to meet Rumer Godden, whom Jean had asked to collaborate on the screenplay.

When Rumer Godden was telephoned by her agent and told about the offer to film *The River*, she replied that she wanted no further screen adaptations made from her novels. Since she had so disliked the two that had already been filmed – Michael Powell's *Black Narcissus* (1946) and the Samuel Goldwyn production of *Enchantment*

(1948), adapted from *A Fugue in Time*. When Godden was informed that Jean Renoir was to direct *The River*, she had to admit to never having heard of him, even though, her agent informed her, he was 'simply the finest film director in the world.'[5] As Godden had lived most of her life in India, and was not a filmgoer, her ignorance was excusable. What finally convinced her to change her mind, however, was not Jean's reputation but the fact that he had taken the trouble to spend the night in her old home in Bengal. Another factor in Renoir's favour was his insistence that it be shot on location in India, unlike *Black Narcissus*, for which Hein Heckroth and Alfred Junge had created a convent high in the Himalayas at Pinewood Studios.

According to Jean, his very first meeting with the 42-year-old British author was at a Thames-side pub called The Perfect Angler. Godden, who was living in a seventeenth-century cottage in Buckinghamshire with her two young daughters, remembers Jean telephoning her and asking if he and Dido could come to dinner. She panicked, not only because she couldn't cook – she was told of Jean's reputation as a great gourmet – she had no wineglasses and no wine. In her naivety, she rang Harrods wine department and ordered one bottle of pink champagne.

'Jean was so enormous he hardly fitted into our cottage – the children called him Babar the elephant,' Godden recalled. 'Almost bald, his small shrewd eyes were hidden in roles of fat which shook gently when he laughed; he had the most genial disarming face and voice and spoke the most endearing English . . . Dido was a little fiery Brazilian, proud with fine bones, nostrils that could dilate with fury or amusement, almost monkey-quick, and brilliant dark eyes.'[6]

After the modest meal, Jean insisted on washing up with the children, and tipping them a pound note each. Then he lay on the floor of the cottage, the chairs being too small to hold his frame, and talked about the film. Godden was invited to stay with the Renoirs in Beverly Hills during the writing of the screenplay.

Jean and Dido returned to California in April, just in time to move into their newly-built home in a cul-de-sac at 1273 Leona Drive along Benedict Canyon. The one-storey, green-shuttered open-plan house, which stood on two acres of ground, was designed by Jean himself in a semi-provençal style, and cannot be seen from the street. It was very simple and small by Hollywood standards, and

had no swimming pool. Jean claimed that it was the only house in Beverly Hills with proper stone foundations.

In those days the area was still very wild, and there was no other house within sight. Dido regretted that they had not bought the whole hill, which she could have obtained relatively cheaply then. (Now there is barely any land available to buy in Beverly Hills.) There would soon exist a gorgeous garden, full of white gardenias and orange, palm and olive trees, including one brought over from Les Collettes. It seemed to be dying after the transplant, but recovered and started spreading from the bottom. There was a large terrace overlooking the garden, and a feeling of the south of France pervaded the house. On Sundays, Jean kept open house in the tradition of his father.

The interior was uncluttered. The long open living room that led into the dining and kitchen spaces was dominated by the Auguste Renoir painting of the 14-year-old Jean as a hunter, which Aline Cézanne had hidden in her home at Marlotte during the Occupation. There were smaller pictures of him and Coco and many of Gabrielle. Over the mantelpiece was a Cézanne water colour, to which there was a story attached. According to Jean, his father and Paul Cézanne were out painting in the woods one day, when Auguste said he needed to shit. Cézanne handed him a page of his sketch paper with which to wipe himself. While in the bushes, Auguste noticed that on the paper was a rather attractive water colour, and decided to keep it rather than waste a work of art on his arse.

The house was always full of colour – paintings, Mexican rugs, flowers and fruit. The kitchen-cum-dining room had a huge square wooden table with an overhanging lamp wrapped round with a piece of paper to provide soothing light. Good sharp knives hung on the wall. The table was always laid absolutely simply without a table cloth, but covered with bowls of salad, cheese and fruit. When they entertained, each guest was usually supplied with a bottle of French wine. Jean believed in having only one main course. Over the large open fire was an electric spit, on which he would thread chickens and legs of lamb. Dido hated cooking. She had Bessie to do that.

A few years before, Dido had brought over Bessie Smith from England. Her father had been Dido's father's secretary in the Brazilian consulate in Liverpool. Bessie's mother had died when she was very young and, as the oldest of five children, she looked after the family. When they started to grow up and move away, Bessie

became unsettled. Dido at the time was looking for someone to help run the house and take it over when she was abroad with Jean, though hardly realising just how many long absences there would be. Bessie was far more than just a cook-housekeeper. Dido trusted her with everything, even finances. She was a little ball of energy and a superb cook, especially of cakes and scones, which Dido would not allow her to make for Jean who was overweight. As soon as Dido was out of the house he would get her to bake him some.

Gabrielle, who constantly called in, became great buddies with Bessie, although neither spoke the other's language. In fact, Gabrielle would frequently strike up friendships with people who spoke no French, both parties conversing quite happily in their own tongues, not understanding what the other was saying. Certainly a case of non-linguistic communication. The former model of Auguste Renoir still had a beautiful face, but had become as dumpy as Bessie. In the heart of very sophisticated Hollywood, Gabrielle had remained an earthy Burgundian. The three women, Dido, Gabrielle and Bessie, were all devout Catholics, and Jean would often accompany them to Sunday Mass.

As in his childhood, he was surrounded by women who made a fuss of him. When Rumer Godden arrived to work on the script of *The River* in June, Jean found himself in the house, almost every day, alone with four women. Alain, who had graduated from the University of California, had married in February 1948, and was at Harvard working for a doctorate in English and Comparative Literature.

'Working with Jean was the best and the richest period I've spent,' said Rumer Godden.[7] They worked together, in the studio of the house, on the first draft for almost two months. 'We will put the book on the shelf,' Jean told Godden at the start. 'Then we can keep the flavour while we recreate it in another medium.'[8] In other words, he made her write the script entirely in visual terms, so that many characters and incidents changed from the original. One character that was invented for the film was Melanie, the Eurasian girl, who acts as a link between the two cultures. Sometimes, Jean, who could be a very impatient man, would sit for literally 30 minutes while Rumer searched for the right word. 'I grew to have such confidence in him, that I didn't mind keeping him waiting, because I knew he'd rather wait.'[9]

Rumer Godden felt that her stay there was particularly hard on Dido. 'I had Dido's bedroom, which I didn't know. I was com-

pletely innocent. It never occurred to me it was her bedroom. She slept on the sofa in the sitting room. They didn't have a guest room. I didn't know this. I couldn't think why Dido was so difficult. She was always extremely possessive of Jean. She was only jealous of the work, and couldn't see why Jean needed me. Why he just didn't take the book and write the script himself, and cut me out. There were often frightful squabbles between Jean and Dido. But they soon blew themselves out. The issue was what was this intruder doing in Jean's life. We were going out to dinner one night and we were all in the front of the car. I was in the middle. They quarrelled across me. It was absolute murder. Finally I screeched and said you must just let me out, I'm going to get out. I'm going back. That sobered them a little. But the fight went on. It was never directly about me, because Dido wouldn't do that. I loved Dido like a sister.'[10]

Gabrielle detested this British intruder into the charmed circle, and hardly ever entered the house unless Godden was in her room. When she came on her almost daily visits, she would look around and ask Dido or Bessie, 'Où est la dame?' She was unhappy about the hours Jean spent locked up in the studio with another woman.

Bessie, however, was extremely hospitable to her fellow country-woman, and used to drive Jean into a fury when she would interrupt their work at four o'clock every day to serve afternoon tea, which Godden, being English, expected. It would all be laid out on the terrace and Jean used to come out and say, 'We have had a good *déjeuner*, we are going to have a good *dîner*, why, why must we have tea and cookies in the middle of the afternoon?'[11]

By the beginning of August, the script was completed, and Rumer Godden was ready to return to England. On the eve of her departure, Jean filled the house with flowers, and he, Dido and Rumer had a barbecue on the terrace and champagne flowed. 'There was a great deal of talk and emotion. It was perhaps the best evening of all as Jean told me so many of his plans.'[12]

The shooting began in India in late 1949, and continued through the first half of 1950. The team was installed in the Great Eastern Hotel in Calcutta; it included Eugène Lourié, Claude Renoir, Kenneth McEldowney and his wife, and Rumer Godden. The casting had yet to be completed. Patricia Walters, the girl who played Harriet, was an Australian living in Calcutta. 'I liked her, but I was a little bit distressed about the teeth. She was supposed to be very plain but the

teeth were very big,'[13] Godden commented of the actress who was, more or less, to represent her as a child. The little boy who dies of a snakebite was Richard Foster, Rumer Godden's nephew, and the other children were recruited from English families. Kanu was a little fisherboy called Nimai Barik they picked up on the beach. The role of Melanie was offered to Radha Shri Ram, an Indian dancer Jean met in the holy city of Benares, through the French cultural attaché in Calcutta. She was engaged to a Swiss photographer Raymond Burnier, who had a passion for India. Radha, whose father was president of the Theosophical Society, introduced Jean to the 'Katakali' dance, and to a vast range of Indian music. She refused, however, to allow them to glamorise her; she did not use make-up, wore her own simple cotton saris, and walked around barefoot. 'If you want me you must take me as I am,' she said.[14]

Most of the other players came over from England, including Esmond Knight, the partially blind actor, and his wife Nora Swinburne, to play the father and mother, and Adrienne Corri, a lovely 19-year-old redhead, making her film debut. Arthur Shields, Barry Fitzgerald's younger brother, who had made a career in Hollywood, came over to play the Eurasian Melanie's father.

Various actors had been thought about for the role of the American soldier Captain John, who had lost a leg in the war, and who becomes the centre of the young girls' passions. James Mason, Robert Ryan, and Mel Ferrer who had just made his screen debut, had all been considered, but were otherwise engaged. Several other Hollywood actors were rejected by Jean because he found their limps exaggerated, an important factor for a man who limped himself. According to Jean, he approached Marlon Brando, but 'Brando was then reaching the height of his powers and his very presence would have transformed the film.'[15] It is not clear whether Jean later confused the role of the embittered paraplegic Brando played in his first film *The Men*, with his intention of casting him in *The River*. From wherever this idea derived, in 1949 Brando was yet to make his screen debut.

Instead, Jean cast the unknown Thomas Breen, who had actually lost a leg in the war. When Godden saw the screen tests, she found him too stiff an actor, though he was extremely handsome, and told Jean that she thought they could do better. Jean replied, 'Tommy Breen is young. He has suffered, but he has the soul of an old man. He is essential.'[16] So she had to give way.

Most of *The River* was shot in Barrackpore some miles outside

Calcutta, at a house which had once belonged to a Maharajah. Satyajit Ray was there on many occasions, lingering in the background, observing and learning. He actually suggested they change the prospective marriage between the American and Melanie, as he felt it would have been improbable and sentimental. Jean encouraged Ray to fulfil his dream of making a film based on a popular autobiographical novel by Bhibuti Bashan Bannerjee, dealing with Bengali village life called *Pather Panchali*. Many years later, while receiving the *légion d'honneur* from President Mitterand in Calcutta, Ray acknowledged that Renoir was his 'principal mentor'.[17]

Jean approached his first colour film in a realistic manner, eschewing any special filters or retouching, avoiding landscapes with too delicate a shade of colour. In India, wrote Jean, 'it is as though a designer of genius had conceived the setting of every day life. Of course, one had to select, but Lourié knew how to do this. He kept on presenting me with pictures which, although absolutely natural, seemed to have been composed.'[18] Although, at one stage, Lourié helped it along a little by having a lawn and some trees painted the shade of green he wanted. It has to be remembered that the Impressionists considered themselves realists, so when Auguste painted shadows blue, it was because they *are* blue, although they appear to be black.

Because the film contained many amateurs and children, and extras drawn from the local community who were bewildered by the whole process, the shooting moved at a slow pace. There was also the problem of illness. Claude got typhoid, others went down with dysentery. The senior sound man collapsed and had to be taken to hospital for an operation, and they had to wait for a replacement to be flown out from England. McEldowney was tearing his hair out at the mounting bills.

There was one scene in which Jean wanted a rabbit to hop across a bed and look down at a child who was sleeping on the floor. It took three days to get the rabbit and the child to do what he wanted. 'Three days,' McEldowney protested. 'Three days wasted.' 'Not wasted,' said Jean. 'We got it.' 'But think of the cost!' 'When you are actually filming,' replied Jean. 'You must not think of the cost. You can always get money, you cannot always get truth.'[19]

There were times when Jean grew terribly impatient with the children on the film. At one stage, during the shooting of a scene with the little English boy, the director let out a roar, scolding the

boy mercilessly for being inattentive. After he had finished, he said, 'Now have you heard me Richard? It's enough of this nonsense.' Richard, who had stood quietly with his head down during the tirade, looked up at the director with an innocent smile and said, 'You know, Jean, on the way here I learned to tell the difference between a boy cow and a girl cow.' He had not heard one word Renoir had said. Jean blew his top once more, until the continuity girl turned round and said, 'But Monsieur Renoir, he's only five.'[20]

There are stories of Jean being very peaceable until roused. In a way, his anger was the cause of a riot. The day after filming scenes of the Diwali Feast of Light, they had set up shots for a sequence in a bazaar. 'The camera was ready to roll when Jean's unfailing eye saw one of the ceremonial garlands of mango trees still hanging from the sacred peepul tree,' Rumer Godden recalled. 'His bellow of rage put the property men into consternation. Each blamed it on the other until it was the third humble property man who was sent scurrying. In his fright and haste to get the offending garland down, he forgot to take off his shoes before climbing the sacred tree . . . it was too late to stop him.'[21]

That night as they took up the Diwali scene again, a crowd of students descended on the set, chanting 'Foreigners out!' Two Englishmen in charge of the Technicolor cameras whipped out revolvers. Jean tapped them on the shoulders and told them to put the weapons away. 'Du calme,' he murmured. The Indian crew linked hands to form a circle around the Europeans in the centre, facing the invading students. But they were met with a flurry of sand and were beaten with lathis (wooden staffs). Jean came face to face with the mob. 'Never had he appeared bigger, more impressive and, astonishingly, genial as only he could be. His voice would have disarmed the angriest young man. "Please", he said, "sit down. Then I can see you all." That alone was such an extraordinary request to make to rioters that those in front obeyed. Slowly the rest sat too . . . "When hundreds speak," said Jean, "no-one can hear them, so please ask three of your leaders, any three to come close and tell me what is your trouble – I can see you are troubled. . . Let us talk, then perhaps you will stay and see what our film is about." '[22] The students watched some of the filming, and found out that the tales they had been told about filming Hindu women naked, and sacrilege, were not true.

The film was made under terrible conditions. They often had to wait as long as 10 days before the rushes could be seen, as they had

to be flown to and from Technicolor in London, and some of the sequences were lost or ruined. When the rushes did arrive they could never be seen in peace and quiet, because they were shown in a little private screening room in the big Empire Cinema in Calcutta, to which the manager had invited his family, their wives and children, who milled around noisily.

By May 1950, the bulk of the work on *The River* was over. But Jean and Dido wished to linger in India a little longer. They took up the invitation of Radha Shri Ram to stay with her at the headquarters of the Theosophical Society in Adyar, where they 'lived the life of Brahmins – no meat, tobacco or alcohol – which did us a great deal of good, although Dido cheated abominably, retiring to the lavatory to smoke cigarettes. Adyar left us with a wonderful picture of religious serenity.'[23]

India certainly left its mark on Jean, although his contact with Hinduism only served to emphasise certain aspects of his philosophy that were already there. The Theosophical Society, founded in America in 1875 by Helena Petrovna Blavatsky, had three main objectives: 1) to form a nucleus of universal brotherhood of humanity, without distinction of race, creed, sex, caste, or colour 2) to encourage the study of comparative religion, philosophy and science 3) to investigate unexplained laws of nature and the powers latent in man. The Society postulated the belief that the knowledge of divine wisdom gives access to the mysteries of nature and man's deeper being.

'India brought me a certain understanding of life. This doesn't mean I understand everything, it doesn't mean I know all the answers, it simply means that I rid myself of quite a few prejudices. India may have taught me that everyone has his reasons.'[24] Yet Jean never allowed his view of the world to overlay the films he made; it exists as a solid foundation on which they are built, you cannot see the foundations of the structure but they keep it firm and steady.

The narrator and central figure of *The River* is the adolescent Harriet (Patricia Walters), the eldest of the five children of a British owner of a jute factory in Bengal. When Captain John (Thomas E. Breen), a young American pilot, who had lost a leg in the war, arrives for a stay, Harriet, her more beautiful and sophisticated friend Valerie (Adrienne Corri), and Melanie (Radha Shri Ram), a Eurasian girl, all fall for him in different ways. By the end, Harriet has learned a great deal about love and life.

The River opens and closes with shots of the Ganges, which runs through the film as a symbol of life, death and renewal. It is one of Renoir's most symbolic and spiritual films made in a country full of symbols and gods. It also achieves a simplicity and serenity that was to be the hallmark of his post-Hollywood films. Renoir depicts a blissful, bustling family life, the kindly father (Esmond Knight), the beautiful, loving mother (Nora Swinburne), and a houseful of lively, rollicking children looked after by an affectionate Ayah (Suprova Mukerjee), who is 'the bridge that brought us back from dreams to life, and from reality to dreams.' But the focus is on the sensitive Harriet, suffering the pangs of first love, and having to face the reality of her little brother's death by snake bite. 'We should celebrate that a child died a child. That one escaped,' says the Irish neighbour (Arthur Shields), who has absorbed the Indian way of life, his whole speech echoing Renoir's own sentiments. 'We lock them in our schools, we teach them our stupid taboos, we catch them in our wars, we massacre the innocents. The world is for children. The real world. They climb trees and roll on the grass, close to the ants . . . '

However, the screenplay is punctuated with rather too many little homilies, such as 'Having a child is the meaning of a woman', and the film suffers from a wordy, tautologous narration and much documentary footage that slows down and sometimes overwhelms the story. It is as if Renoir, having come all this way and become fascinated by the country, was reluctant to leave anything out.

The travelogue inserts seem irrelevant and impersonal compared with the sections when the rituals of India are brought into the foreground and involve the British characters, as in the superbly lit scene of the Diwali, the Hindu Feast of Lights – the fireworks and the girls in pink dresses against the glow of candles.

The best moments come in 'the enchantment in the mangrove' scene, when the plot, the characters and the location are at one. As Weber's 'Invitation To The Dance' plays in the background, Captain John pursues Melanie through the tropical thicket, while Valerie and Harriet pursue him balletically. The sequence concludes with the young man kissing Valerie, while the green-eyed Harriet in a blue dress, and the brown-eyed Melanie in a red sari, watch through the branches of a mango tree. The three girls are united at the end of the film, when the camera rises over their heads towards the river in the background.

It could be argued that a film which centres on a British family, extolling their virtues and those of Hinduism (explained in simplistic

terms), made in India a mere three years after Independence, when bitter conflicts between Hindus and Muslims were still raging, was rather out of touch. Even though Renoir's love of the country and the people comes through, the Indians are mostly seen as servants, fishermen and workers. The British father actually refers to his jute factory, albeit jokingly, as a 'sweat shop'. 'He loved the never-ending procession of men with the jute piled on their heads,' says the narrator. Jean later explained: 'I had to see India through the eyes of a Westerner if I didn't want to make some horrible mistakes . . . It would have been very difficult to do anything else during my first contact with India.'[25]

The River was released by United Artists in the USA, England and France in September 1951. In the same month it shared the International Prize at Venice with Robert Bresson's *Diary Of A Country Priest*, and Billy Wilder's *Ace In The Hole*, both ultimately more perfect films.

Satyajit Ray saw the film for the first time with Jean in Hollywood in 1967. Although he could not express his opinion at the time, Ray did not respond to it with any great warmth, except for the background of the life on the river, and a few other scenes such as Harriet's turning to the fisherman for consolation after her little brother's death. He could not see in it an authentic picture of Indian life, even filtered through the lens of a Westerner. Jean was conscious, despite his influence on much of Ray's work, that his protégé was slightly disapproving of *The River*. When the screening was over, the two men were brought on stage together and introduced with the comment, 'Ray owes a lot to Renoir.' Jean replied, 'I don't think Ray owes anything to me. I think he had it in his blood. Though he's very young still, he's the Father of Indian Cinema.'[26]

Aside from Renoir's importance to Ray, the influence of *The River* cannot be overestimated. Whatever its deficiencies in structure and attitude, it was one of the first Western films to bring back images of the country, other than as an exotic background to Kiplingesque colonial adventures. Indian films were rarely seen in the West; one of the few had been Mehboob's *Aan* (1952), the first Indian feature in Technicolor, a spectacular musical swashbuckling tale. It was only after *The River* that Fritz Lang visited India in 1956 to make *Taj-Mahal*, though the project was abandoned, and Roberto Rossellini went there to direct *India* (1958). *The River* inspired James Ivory to make films in India, and Louis Malle's *Phantom India* (1969) followed.

34

Commedia Delle Magnani

'An admiration for classical Italy replaced India for me in Le Carrosse d'or, *the Italy from before Verdi and romanticism.'*

Happy to be back home in Leona Drive in June 1950, Jean was aware that if he was to make the films he wanted then he would have to travel abroad to do so. His home might now be in Hollywood, but his work would be elsewhere. As usual, various projects had to be sifted through. There was a possibility of two films based on novels by Albert Camus: *La Peste* starring Charles Boyer, and *L'Étranger* with the seemingly perfect casting of Gérard Philipe as Meursault, but both fell through because Camus' publisher wanted too much for the film rights. (*L'Étranger* was eventually made unsuccessfully in 1967 by Luchino Visconti with Marcello Mastroianni.) Philipe, who had already worked with Claude Autant-Lara, Yves Allégret, René Clair and Max Ophüls, was very keen to work with Renoir, and suggested *The Adventures Of Til Eulenspiegel*, but Jean was not attracted to this swashbuckling yarn of the sixteenth-century folk hero. (Philipe co-directed it with Joris Ivens five years later.) As counter offers to Philipe, Jean put forward a remake of the Garbo–Gilbert 1927 love story, *Flesh And The Devil*, and *La Neige était sale*, based on Georges Simenon, but transferred from France to a small American town, revealing that Jean still had expectations of making another Hollywood film.

At the same time, he had been busy writing treatments for two films to be shot in France. The first, and slighter, *Une Nuit à Paris*, focused on Laurent Mercier, a French-Canadian dentist, who goes to Paris to see Lise Daumasse, a French woman, with whom he had been at college in Montreal. But when he arrives, her father, who considers Lise the most perfect being, explains that he does not know where she lives. Laurent sets out to find her, and after a tortuous search through the night spots of Paris, leading him into the world of prostitutes, pimps and clients, he fails to find Lise. Renoir, here, plays on notions of illusion and reality – how we picture people and what they are really like.

The second synopsis, with a French setting, was entitled *Christine* (the same name as the marquise played by Nora Grégor in *La Règle du jeu*) which he hoped would interest Lena Horne. It is quite likely that the gorgeous singer would have jumped at the chance to play a decent role, away from the stereotyped characters that Holly-wood's racial segregation had forced her into. She had just been deprived of the part of Julie Laverne in *Show Boat*, for which she was ideally suited. Jean obviously had the Jerome Kern musical in mind when he wrote *Christine*, because one of the characters is called Julie Laverne and there is a miscegenation theme. It also contained elements of *La Dame aux camélias*, the play Auguste had so disliked.

The constant Renoir theme of love overcoming class barriers widened to include race in *The River*, and was obviously a strain he wished to develop. His visit to India also gave him the desire to explore cultures other than European. *Christine* would have been in tune with the times. Although the film industry was made jittery by the HUAC hearings, liberal themes continued to be treated, how-ever tentatively, and the tenets on which American society was based were being questioned.

Meanwhile, social life continued in Hollywood, which Jean referred to as 'Tonsil Town'. Charles Laughton would often drop by, sometimes dressed in khaki shorts and an outsize felt hat, bearing baskets of fruit from his garden. Among the prestigious guests at Leona Drive were Igor Stravinsky and his wife Vera, who always carried a basket containing anything the *maestro* might need from pills to an extra scarf.

Regulars around Jean and Dido's table were Dudley Nichols and his wife; James Mason and his wife Pamela Kellino, and Paulette Goddard, now divorced from Burgess Meredith and her career on

the slide. The Renoirs' circle was depleted somewhat in the early 1950s. Gabrielle's husband, Conrad Slade, died in September 1950; their nearest neighbour, Lillian Gish, was spending most of her time on Broadway, as was Clifford Odets, who had written *The Big Knife*, a melodramatic but powerful indictment of the Hollywood film industry, which Jean was to direct on stage. However, in 1952, Odets appeared voluntarily before the HUAC, and named names. 'To speak generally, I go to Hollywood to make a living, not to write something . . . to demean or disgrace American people as I believe many people do,' he told the committee. 'But to make an honest living, after writing entertaining scripts.'[1] Of his close friend's actions, Jean kept his counsel.

Katina Paxinou and her husband Alexis Minotis, who had been very close to the Renoirs, had returned to Greece to set up the Royal Theatre there, after finding it extremely difficult to make a living in Hollywood. Jean and Dido had visited them in Athens on the way back from India. Erich von Stroheim had returned to France after playing what he referred to as 'that lousy butler part' in *Sunset Boulevard*; and most of the French wartime exiles had drifted back home. Julien Duvivier was making films with Fernandel, and René Clair was working with Gérard Philipe and Michel Simon. D. W. Griffith had died, almost a forgotten man, in 1948, after leading an obscure existence in Hollywood for 17 years.

Sometimes Charlie and Oona Chaplin would visit, or the Renoirs would go over to their rambling house overflowing with children. Chaplin, of course, had been subpoenaed by the HUAC, and was the victim of a vicious smear campaign. The following year, he and his family left the USA, not to return for 20 years.

Jean had written a vigorous defence of Chaplin's unappreciated *Monsieur Verdoux* in *L'Écran Française*. 'Some day . . . it will stand beside the pottery of Urbino and the paintings of the French Impressionists, between a story by Mark Twain and a minuet by Lully. On the other hand, the films that are full of money, gimmicks, and advertisements . . . they will take their place . . . in the land of oblivion, alongside the rows of fancy mahogany chairs, all alike, spewn from chrome-plated factories.'[2]

Jean's over-estimation of Chaplin's 'comedy of murders' came out of a sense of loyalty and anger at the way his friend had been treated, and the film might also have reminded him of *Le Crime de Monsieur Lange*. When the Bluebeard Monsieur Verdoux is found guilty and sentenced to death for the murder of a number of his

wives, he states, 'If war is the logical extension of diplomacy, then the logical extension of business is murder.'

Altogether, the first few years of the decade were not the best time for liberals to be in Hollywood, with the HUAC investigations hovering over the film industry as thick as the smog over the city. Joe McCarthy, the senator from Wisconsin, was the prime force behind the second series of hearings which began in March 1951. As a result, 212 people involved in film-making were blacklisted. Fortunately, from the point of view of work, Jean was to leave for Europe again in May 1951 to take up an offer he had received from Italian producers. This was to direct a Technicolor film version of Prosper Mérimée's one-act play, *The Coach of the Blessed Sacrament*, which had already served as the basis for Jacques Offenbach's 1868 *opéra bouffe*, *La Périchole*. But it would take almost a year before shooting would begin.

Luchino Visconti, who had made a huge reputation in the theatre, and in the cinema with three features (he was yet to produce an opera) since the days of his apprenticeship with Jean and *La Tosca*, was set to direct the screen version of the Mérimée play. But Visconti had so many disagreements with the producers that he finally withdrew. However, Anna Magnani, who had just completed *Bellissima* with Visconti, remained under contract. When Jean was called in as a replacement, Magnani sought Visconti's advice. 'What should I do' she asked him. 'What do you mean, what should you do? With Renoir, and you're hesitating?' he replied.[3]

The film was to be made in English for the Anglo-American market, not a situation that appealed to Jean, or to Magnani who barely spoke a word of the language. The idea would have been more understandable if a Hollywood star had been cast, but Magnani was not known to the general public outside Italy, despite the recognition she had won in the USA for Roberto Rossellini's *Rome, Open City* in 1946. Her Oscar-winning Hollywood debut in *The Rose Tattoo* was still four years away.

On meeting the fiery actress, Jean told her that he wanted her to deviate from the naturalist style that she had adopted in many of the neo-realist films she had been in. He explained that he would take the *commedia dell'arte* as a model. She was delighted to be given the chance to play light comedy, even in a language she had to learn phonetically. She was brilliantly supported by players adept at performing *commedia dell'arte*, many of them coming from Eduardo

de Filippo's theatre in Naples. Among the cosmopolitan cast, and adding to the babel on the set at Cinecittà, and finally, on the sound track, were Scottish stage actor Duncan Lamont (Ferdinand, the viceroy), in one of his first and largest screen roles; Englishman Ralph Truman (the Duke of Castro); William Tubbs (the Inn-keeper), an American living in Italy who had appeared in Rossellini's *Paisa*, and his compatriot Paul Campbell (Felipe Aquierre); and French actor Jean Dubucourt (the Bishop). When the film was completed, Jean described it as 'not so much an Anglo-American film as a translation into English of a French film in the Italian style.'[4]

Before Jean arrived in Rome, he had warned the producers, Valentino Brosio and Giuseppe Bardogni, that he would not necess-arily stick closely to the Mérimée play, suggesting that it might be more interesting to go back to the tales that had inspired Mérimée. He also insisted that Claude Renoir be his director of photography. The producers assented to these requests, and let him get on with the film unhindered.

One of Jean's assistant directors, Giulio Macchi, suggested Jean listen to Vivaldi before and during the writing of the screenplay. He therefore listened to all the Vivaldi records he could get hold of. '[The music] influenced the entire style of the film, a side that isn't drama, that isn't farce, that isn't burlesque. It's a sort of irony that I tried to combine with the light spiritedness one finds, for example, in Goldoni . . . I wanted to make a "civilised" film, a classical work . . . It seemed to me the best way of expressing the period and portraying the subject was to subordinate my style to a theatrical style.'[5]

Le Carrosse d'or is structured like a three-act play, with the camera often taking the position of the audience. Sometimes a fourth wall is used, but not in the same scene. 'I tried, if you like, to erase the borders between the representation of reality and reality itself. I tried to establish a kind of confusion between acting on a theatrical stage and acting in life.'[6]

Working with Magnani had its problems. Notoriously nocturnal, she would arrive on the set over two hours late, having spent the night at clubs, and looking the worse for wear, with even deeper dark rings under her eyes than usual. She would take one look at herself in the mirror, then say, 'Listen, Claude do you think I can be filmed like this, look at this face, my eyes are down to my mouth, it's impossible, you can't photograph me like this!'[7]

When it came to rehearsals, she would sit chain-smoking and shivering under a mink cape for some time before she could get going. Sometimes when she was depressed, Jean would take her by the arm and they would go for a little walk together while he calmed her. More often than not, the two of them would return onto the set laughing. At one stage, Jean told her that he would rather drop the film altogether than keep the other actors and crew hanging around for her. She promised thereafter to be punctual, and kept her word.

One day, a female relative of the Pope came to visit Magnani in the studio, with her lady-in-waiting in tow, and chattered away much to Jean's annoyance. He told the actress to tell her visitors to keep quiet. Magnani suddenly shouted at them, 'Out you go! Out you go, all the princesses,' and they fled in fear.[8]

Rehearsals were beginning to take shape, when Jean's wounded leg became seriously infected. He tried to conceal it for a while, but he could hardly climb the narrow staircase up to the penthouse apartment he and Dido were renting. Fearing amputation, he refused to have the leg treated until he was rushed off to the hospital in October. He was operated on, and was not well enough to return to work until December. Shooting was resumed on 4 February 1952.

In eighteenth-century Peru, Camilla (Magnani), an actress with a touring *commedia dell'arte* troupe is wooed by a bullfighter (Riccardo Rioli), a soldier (Paul Campbell) and the Viceroy (Duncan Lamont), bored with his work and his mistress (Nada Fiorelli). When the Viceroy presents Camilla with a golden coach from Europe, she donates it to the church and opts for her first love – the theatre.

'Where is theatre, where is life? Where does one finish, where does one begin?' asks the heroine (and by extension the director), and concludes, 'Those two hours on the stage' are more important than anything else, and 'The audience is the only "them" that matters.' This play within a play within a film, ends with the camera tracking back in a magic moment to reveal that the 'reality' in comparative terms, also takes place on a stage.

'I'm sincere in life and on the stage,' Camilla says, and Anna Magnani overcomes the fact that she is rather too stout, too old (she was already 44), and really not attractive enough to have inspired such desire from three handsome men, by her wonderfully natural

and 'sincere' performance. With her tongue firmly in her cheek, she seems to be asking herself, 'What could these men possibly see in me?', and being delighted by their reactions.

The fact that her three suitors are played by rather dull actors unintentionally allows her personality to shine even more. Camilla represents charity and tenderness, against the evil and vanity she finds at the Spanish Viceroy's court. As another variation on the *ménage à quatre* theme, the film could have been entitled *Camilla et les hommes*, because like Eléna, her successor, Camilla has to choose between three men.

Cleverly, Renoir disguises many of the difficulties of making a film in English with a multilingual cast, some underpowered leading players, and the need to create Peru out of a few tropical plants, some sand, a small bunch of Indians in straw hats and a couple of llamas from the Rome zoo. 'I forgot Peru and *La Périchole* to be in Italy. The exterior reality plays no role,' Jean explained.[9] The film was photographed mainly in sumptuous interiors, the problems of the low budget only made obvious in the exteriors, notably a bullfight, which is portrayed by one small stand with a matador standing in front of it. Renoir rather concentrates his efforts on recreating the energy, movement, colour and costumes of the *commedia dell'arte*, which makes the film so enchanting. It is also filled with those tiny moments that so often take place in the corner of Renoir's pictures – a little boy doing somersaults, a young girl pinching cakes from a plate.

Renoir's return to Europe was also a return to his own *esprit* and cultural roots. *Le Carrosse d'or* was as much inspired by Marivaux as *La Règle du jeu* had been, remembering that the French playwright had written for an Italian troupe. In the earlier film, some of the characters, especially the poacher, the maid, and the gamekeeper, could have been Harlequin, Columbine and Pantaloon, while here the plot is mirrored by actual *commedia dell'arte* performances. The film was the first of Renoir's serene and joyous Technicolor theatrical trilogy of love.

Le Carrosse d'or opened to a luke-warm reception in February 1953 in Paris, neither was it welcomed with much enthusiasm elsewhere. Perhaps, in the year when Twentieth Century-Fox's CinemaScope made its first appearance with *The Robe*, and gigantism became the order of the day, the Renoir film might have seemed too small-scale, too gentle, too classical, too 'civilised'. There were some perceptive critics around at the time, among them Jacques Doniol-

Valcroze in *Cahiers du Cinéma*, who called it, 'The first great film in colour',[10] and Truffaut claimed it was his favourite picture.

Before leaving Italy, Jean and Dido paid a short visit to Ingrid Bergman and Roberto Rossellini at their summer beach house in Santa Marinella. Jean had not seen Bergman since she had caused a scandal by leaving her husband and daughter, Pia, in 1949, to join Rossellini in Italy. Pia, in fact, had stayed with the Renoirs during the most difficult period. Now Ingrid was the mother of two-year-old Robertino, and newly-born twin girls, Isabella and Ingrid. The two films the Italian director and his Swedish wife had made together, *Stromboli* and *Europa '51*, were both critical and financial disasters. But Rossellini was busy planning a third film, *Journey To Italy*, at the time of Jean's visit, when the couple gave the impression of being happy together.

Jean and Dido returned to California in time to spend Christmas 1952 with Gabrielle and Jeannot Slade, and Alain, his wife and one-year-old son. While in Italy, Jean had become a grandfather at 57. At the same time, his brother Pierre had died in Paris aged 67 in March 1952. He had been ill for a long period, and was lovingly cared for by his third wife, Elisa Ruis. His son Claude returned to Essoyes for the funeral. A few months earlier, Jean had heard that his dear friend Robert Flaherty had died at the same age as Pierre.

For a while, Jean settled down to wait for a film offer, with the vague hope that one might come from a discerning American producer. He had written three more outlines of films he hoped to make. *First Love*, inspired by the Turgenev novel, had certain similarities with his earlier *Romeo and Juliet* synopses. *The Horrors Of War*, set during Napoleonic times, revolved around two army officers, John Weever, an English lieutenant and Renard, a French captain.

The third précis was called *The Mask*, based on a story that was told to Jean by Saint-Exupéry. A very handsome pilot in the airmail service, extremely popular with the women, had a terrible accident which left his face disfigured. Unable to find a woman who was not repulsed by him, he found a prostitute to make love to. At first she thinks him ugly, but gradually grows to find him good-looking and learns to love him. Jean notes that 'the same story could be transposed to another milieu, such as that of metal workers.'[11]

It is really difficult to believe that any of these three sketchy outlines would have provided much to excite potential producers,

but they do give an inkling of some of Jean's preoccupations. *First Love* harks back to *La Règle du jeu*, set in a country château, where an unhappily married bourgeois finds solace in another's arms, and young love is disillusioned; and *The Horrors of War* has echoes of *La Grande Illusion*, with the themes of universal brotherhood and the self-explanatory one of the title. What attracted Jean to *The Mask* was its theory that beauty comes from within.

In early 1953, he sketched out a scenario called *Vincent Van Gogh*. It is prefaced by a narrator's voice. 'This is the story of Vincent Van Gogh. Today the whole world considers him one of the greatest painters who ever lived. His contemporaries, except for a few admirable exceptions, considered him a failure . . . a madman. Searching for the truth and revealing it necessitates a certain attitude to life that most people fail to understand. Now, what is an artist, if not a witness to the truth and, as the philosopher Kierkegaard says "A witness to the truth is a martyr." Vincent Van Gogh is a martyr.'

Although Jean's innate modesty would never have allowed him to compare himself with Van Gogh, it is easy to imagine that he might have felt a deep affinity with the artist. Jean had spoken to the actor Van Heflin about his playing the title role. Heflin, an intelligent and intense actor, but one who lacked charisma and could be rather dull at times, was enthusiastic about what could have been the part of a lifetime. Hollywood had been interested in Van Gogh ever since Irving Stone's bestselling novel, *Lust For Life*, was published in 1934. It was bought by Arthur Freed at MGM in 1947, but was shelved. This was taken over by John Houseman at about the time Jean was writing his version of the story. Because Kirk Douglas and Vincente Minnelli were determined to film it, there was little hope that Renoir could make his as well, although the MGM film of the Stone book only became a reality in 1956.

There was no point in Jean idly lotus-eating in Hollywood, so he started gathering material, with Gabrielle, for a book about his father. They would sit around in the evenings, often with glasses of beer much to Dido's disapproval, joking and reminiscing for hours. The discussions about Essoyes and Les Collettes awakened in him a desire to go back to the places where he had been happiest. In late October 1953, Jean and Dido set sail for Le Havre, and thus began Renoir's second career in France.

35

The Ballad of the Butte

'French Cancan *answered my great desire to make a film in a very French spirit and that would be an easy, convenient contact, a nice bridge between myself and French audiences. I felt that the public was very close to me, but I wanted to make sure.'*

When Jean returned to France at the end of 1953 he felt as if he were beginning his career from scratch again. His Hollywood films were not highly regarded, and neither *The River* nor *Le Carrosse d'or* were successful enough to redeem his international standing among reviewers or at the box office. The critical consensus declared that he was an artist in decline. There were exceptions, of course, one of the most important being *Cahiers du Cinéma*.

In 1951, André Bazin founded this most influential of film magazines, with historian Lo Duca and journalist Jacques Doniol-Valcroze. During the Occupation, Bazin (born in 1918) had formed a cine club where he showed politically banned films in defiance of the German authorities. After the war he became a film critic, and started *La Revue du Cinéma* which collapsed in 1949.

Among the *Cahiers* writers were Claude Chabrol, Jean-Luc Godard, Jacques Rivette and François Truffaut, all of whom would spearhead the *nouvelle vague* at the end of the decade. It was Truffaut, in the January 1954 issue, who formulated the *politiques des auteurs*, which argued that film, though a collective medium, always had the

personal stamp of the director on it, even of the most menial in the Hollywood studio system.

Cahiers had no specific editorial line at first, though Renoir and Chaplin represented the two figureheads of the periodical. Bazin, as editor, gradually formulated a theory of cinema in opposition to Eisenstein's theory of montage. Bazin considered that the realistic nature of the film image was best evolved through *plan-séquences*, extended shots edited in the camera rather than in the cutting room. One method which assisted this technique was the use of deep focus, which enabled a scene to be shot with both foreground and background in full view. For Bazin, this represented 'true continuity' and 'objective reality', leaving the interpretation of a particular scene to the spectator rather than to the director's viewpoint through editing.

Bazin's interest in the naturalistic cinema led him to concentrate his attention on Hollywood, which led to a revaluation of the contribution made to film by the commercial industry. The directors who satisfied Bazin's criteria were the silent masters Erich von Stroheim and Carl Dreyer, and those contemporaries, such as Orson Welles, William Wyler, Luchino Visconti and Roberto Rossellini, whose work he saw as direct and conscious representations of reality. Jean Renoir was the link between the two generations.

Cahiers contradicted the received opinion that the American Renoir was only a pale reflection of the French. Bazin considered that Renoir's style in Hollywood had been pared down in an almost mystical manner. Maurice Schérer (later known as Eric Rohmer), a contributor to the magazine, claimed, 'Genius knows no decline', and considered *The Southerner* 'the apex of Renoir's work.'[1]

A few years before, Bazin had written a profile of Renoir, on which he was assisted by his 18-year-old protégé Truffaut, who wrote to a friend: 'Bazin will be responsible for the text and I'll do the research, since Renoir made lots of films that he didn't finish or put his name to [sic], and we've got to track them down.'[2]

In January 1952, the magazine devoted its entire issue to Renoir, and did the same in September 1954, to celebrate the director's sixtieth birthday. Whatever the contributors' different opinions on other matters, they all agreed on Renoir, who became their patron saint.

This was all considerably flattering and gratifying to Jean, who warmly welcomed the young film enthusiasts who made the pilgrimage to his home at 7 Avenue Frochot in Montmartre. In April

and May 1954, Jacques Rivette and François Truffaut, armed with tape recorders, interviewed Jean at his apartment for *Cahiers*. Jean had already met Truffaut at Bazin's home during a brief visit to Paris en route to Rome for *Le Carrosse d'or*. Twenty-one-year-old Louis Malle and his great friend Alain Cavalier, both in their last year at the I.D.H.E.C. (*Institut des Hautes Études Cinématographiques*), paid a visit to their idol.

'The thing about Renoir was that he was extraordinarily friendly and jovial, remarkably unpretentious, extremely accessible,' recalled Malle. 'It seemed at the first meeting there was no generation gap of any kind. He was terribly curious and interested in our work. He was enthusiastic about our enthusiasm. He was very modern. He had transcended the generations. I felt somewhat close to him because he was this famous man who had this passion for cinema. We recognised that the generosity he had as a man was evident in his films. Renoir was the inspiration for our generation when we started making our own films. You could say he was the father of the New Wave. There was something about his cinema which was so inventive and spontaneous. Somewhat ignoring the rules and inventing the rules.'[3]

At the time of the first *Cahiers* interview, Jean had accepted two offers made to him, one to direct a play, and the other a film. The play was Shakespeare's *Julius Caesar*, to be performed once only on the night of 10 July 1954 in the Roman arena in Arles, to celebrate the two-thousandth anniversary of the founding of the city by Caesar.

The news that Renoir was to direct his first stage play reached the ears of the young film devotees in Paris, many of whom decided to be present at the special occasion. The 21-year-old actor Jean-Claude Brialy was doing his military service in Germany at the time. He and future director of photography Pierre L'Homme, in the same barracks, got leave to go to Arles to see the production. Ten friends piled into Brialy's old Buick, among them Chabrol, Rivette and Godard, and drove down to Provence from Paris. 'All night they spoke of cinema, in a manner that I hadn't heard before,' Brialy remembered. 'They were like a clandestine group plotting revolution. Most of them were hardly 20 years old. They spoke of Rossellini, Hitchcock and Renoir as connoisseurs speak of Mozart and Beethoven with incredible clarity.

'We arrived at the arena in Arles in the morning. There was a real

atmosphere of the corrida, the dust and 200 extras. And in the centre of all, Jean Renoir, magnificent, and at his side a young man in black with fiery eyes. It was François Truffaut . . . He was already a familiar of Renoir, who spoke to him as a friend. I immediately understood that he was his blue-eyed boy . . . As there were no more seats available, Renoir suggested that we watched the show on the stage. With Chabrol and Godard, we put on togas and we mixed with the Arlesienne extras, representing the people of Rome, shouting at the heroes with an accent from the films of Pagnol. We left the same night all in the Buick.'⁴ (Brialy, who was to become an actor associated with the *nouvelle vague*, would make his first feature film appearance in *Eléna et les hommes*, two years later.)

Also in Arles that evening were Michèle Morgan (there to see her husband Henri Vidal perform), André Bazin, Eric Rohmer and Pierre Kast, then a celebrated director of short films and a critic on *Cahiers*.

In order for the actors to be heard in the vast arena, Jean had 50 microphones installed so that even a sigh would be audible. The cast included Paul Meurisse (Brutus), Jean-Pierre Aumont (Mark Antony), Jean Parédès (Casca), Henri Vidal, Yves Robert, Françoise Christophe and Loleh Bellon.

'On the evening of the performance the actors and I foregathered in the main lounge of our hotel while outside people were flocking into the amphitheatre,' Jean wrote. 'We were all in a state of panic, we hadn't even had time to hold a full rehearsal, and some of the players said they had entirely forgotten their lines . . . Then someone remarked that he envied the Orientals their serenity and someone else asked me if I had handled crowd scenes in India. This prompted me to a disquisition on the Hindu religion . . . As they listened to me their agitation subsided, and when the time came they were almost calm.'⁵

They were less so when the performance was delayed because the sound system went wrong at the beginning, and the 10,000 people in the audience became impatient. By the close, however, the crowd was completely won over. Jean ended the play with the burning of Rome depicted by kerosene fires in different parts of the stone-built arena, and the Roman cavalry (consisting of Carmargue cattlemen) forming around Brutus' bier in the light of the flames.

Bazin, who was enchanted by the evening, wrote: 'It wouldn't have happened without the improvisatorial skills and the reassuring humanity of Jean Renoir. So we weren't surprised to see him appear

in answer to the crowd's appeals and to greet them with the unforgettable lop-sided walk of Octave stuck in his bear suit during the party at the château in *La Règle du jeu* . . . The distance between an ironical, heartrending masked ball in a salon and this *Julius Caesar* played under the stars before the population of the whole town bespeaks Renoir's loyalty to his own goals as well as the spiritual and artistic breadth of our greatest filmmaker.'[6]

French Cancan (pronounced Franche Concon) was to be Jean's first French film for 15 years, and his first original screenplay since *This Land Is Mine* in 1943. Based on the life of Ziedler, the man who founded the Moulin Rouge, it was a story that went back to Jean's roots in Montmartre, the world of his childhood and of his father. (During the shooting, the Ziedler family objected to the use of their name, and the producers had to change it to Danglard.)

In order to gather a cast familiar with the *caf' conc'* milieu, Jean visited a number of Paris cabarets in search of talent. From there he drew Philippe Clay and Jean-Roger Caussimon, as well as famous singers such as Edith Piaf and Patachou; from the theatre Michel Piccoli (who had only made three films since his screen debut five years before) and Jean Parédès, and others Renoir had worked with before the war – Max Dalban, Valentine Tessier (his Emma Bovary) and Gaston Modot.

The morning immediately after he had been to see the Robert Dhéry revue, *Jupon Volé*, at the Théâtre des Variétés, he called Dhéry, Jacques Jouanneau and Pierre Olaf. Dhéry was too busy to take a role, Jouanneau was cast as one of the two pimps, and Olaf was offered the part of the love-sick baker. It turned out that because it was a Franco-Italian production, Jean was obliged to cast Franco Pastorino instead. He therefore gave Olaf the part of the Pierrot Siffleur (Whistling Pierrot). Jean remembered such performers from his youth, and being painted as a Pierrot by his father.

In the lead, Jean Gabin, who had just won the Best Actor award at Venice for Jacques Becker's *Touchez pas au grisbi*, expressed his delight at working with Renoir again after all these years. In the interim Gabin had gained the reputation of being rather a disagreeable, bad-tempered character, always grumbling and difficult to please. When Jean told his journalist friend Jean Griot that he wanted to cast Gabin, Griot warned him of how ill-natured the actor had become. Dido said, 'You'll see, Jean can turn Gabin around his little finger.' Which is exactly what happened. On the set, Griot saw that

Gabin was submissive to every suggestion of Jean's.[7] 'I love Gabin and he loves me,' wrote Jean. 'But we do not know one another. He knows nothing of my private life and I know nothing of his. Our relationship is entirely professional, but I have a feeling that his tastes are pretty much the same as mine. We run across one another in the same restaurants. When we worked together we had no need of lengthy discussion to analyse the situation. We scarcely needed a script to know what we had in mind.'[8]

Mexican star Maria Felix, who was living in France at the time, was cast as Gabin's temperamental mistress, *La Belle Abbesse*, and Françoise Arnoul was her young rival for his affections. Jean had had Leslie Caron in mind when he wrote the part of Nini, the laundress who becomes a Cancan dancer. However, the French producer, Louis Wipf, did not want her, considering her too 'foreign' and too much associated with Hollywood. The French actress–dancer had recently triumphed in MGM's *Lili*, and was a friend of Jean's. Twenty-three-year-old Arnoul, who bore a striking resemblance to Caron, was the only name that would sell the film according to the producers – not Gabin or Renoir. Before Bardot superceded her, Arnoul was known as a sex kitten in films like *Forbidden Fruit*, *The Lovers Of Toledo*, *Inside A Girls' Dormitory*, *Tempest In The Flesh*, *The Bed* and *The Sheep Has Five Legs*, all considered the height of Gallic naughtiness abroad.

Everyone described the filming at Joinville Studios between October and December 1954, as an extremely pleasant experience. Among Jean's assistants were two *Cahiers* critics and would-be feature film directors, Pierre Kast and Jacques Rivette. Some of the cast, including Pierre Olaf, so enjoyed being in Jean's company that they asked Dido, who took charge of these matters, if they could come onto the set even when they were not needed, just to watch the master at work. One of the rare occasions when Jean lost his temper was during a scene at the cabaret when the audience is waiting for the Cancan, and they are reluctantly being entertained by the Pierrot Siffleur. It was a very difficult sequence with over a hundred people on the set. Just after Jean had said, 'Please nobody move', France Roche, a journalist on *France Soir*, who had a very small part, got up and began powdering her face. She received the full blast of his invective.

Paris 1880. The impresario Danglard (Jean Gabin), owner of a rowdy *café-concert* called Le Paravent Chinois, decides to open the

Moulin Rouge in Montmartre where he would present the Cancan. He discovers Nini (Françoise Arnoul), a laundress, and builds her into a star – much to the annoyance of his hot-tempered mistress Lola (Maria Felix), known as La Belle Abbesse. Meanwhile, Nini arouses the jealousy of Paulo (Franco Pastorino), her possessive baker boyfriend, and causes the attempted suicide of Prince Alexandre (Gianni Esposito) when she becomes Danglard's lover. On the opening night, Nini refuses to go on when she sees Danglade kissing another artiste, but she is made to realise that the theatre means more to her than anything else.

Subtitled 'Une Comedie musicale', French Cancan surpasses many of the best Hollywood musicals, climaxing with a spectacular Cancan, the apotheosis of exuberance. Although it contains some of the formula elements of the musical – there is a montage of scenes as a couple goes on a tour of all the Paris nightspots, and Gabin hears a woman singing outside his window and employs her – it is never trivial. The screenplay deals with the dedication and sacrifices needed to art, and the difficulties of romantic relationships, in a manner that few directors have ever been able to carry off – at once profound and light, proving they are not mutually exclusive.

All the various relationships are established during the sequence at a popular Montmartre café, La Reine Blanche, where Gabin, his mistress, the prince and hangers-on go slumming and meet the laundress and her boyfriend – a scene that evokes Don Giovanni's arrival at Zerlina's wedding in the Mozart opera, not as distant a comparison as it would seem. Mozartian is an adjective that often comes to mind when describing a number of Renoir films, especially La Régle du jeu, and the romantic, Technicolor period trilogy of which French Cancan was the second.

The film draws the audience into the world of La Belle Époque, recognisable from many of the familiar paintings, posters and engravings, without imitating any particular style. There is seldom a dead space on the screen, and yet the frame never gives the impression of being busy or cluttered. Here again are the significant small moments that make up the whole. A child passer-by is greeted by his name ('Bonjour Victor' – 'Bonjour Madame') and is never seen again; the old musician tries to comfort Nini, and is pushed away, 'Bon, bon,' he says shrugging his shoulders; the aging dancing teacher (Lydia Johnson, actually an ex-Cancan dancer), gives an energetic demonstration of how the dance should be performed, then a little later clutches her back in pain; and Danglard, sitting

alone in the wings listening to the Cancan, gives a little joyful high kick, and is spotted by a dresser walking by.

Gabin, now grey-haired and portlier than when he last worked with Renoir on *La Bête humaine*, gives a remarkably shaded performance, tender and passionate. As Renoir's surrogate, he says, 'We artists are at the mercy of the men with money.' And in his final speech, justifying his profession and the need for freedom, 'The only thing that counts is what I create; the only thing that counts is to serve the public.'

The final sequences are examples of Renoir at his technical and creative best. At a corner café outside the Moulin Rouge, a couple who had commented negatively throughout on the building of the theatre, suddenly decide to join the queue of eager patrons who crowd in for the première. As the show commences, relationships are being worked out backstage, then the noisy audience is stilled by a singer (the voice of Cora Vaucaire) as she moves among them singing the haunting theme song, 'La Complainte de la butte', written by Georges Van Parys, with lyrics by Jean Renoir. The screen then explodes with music, dancing and colour as the Cancan takes possession of the whole auditorium, the white dresses and black stockings flashing at the camera. The rapid montage of the dance is cut in with close-ups of Gabin, sitting alone backstage, progessively registering anxiety, then contentment, then joy, counterpointed with the faces of various couples in the audience. The last image is a long shot of the exterior of the Moulin Rouge, in front of which a drunk, barely perceptible, is reeling across the road. He suddenly turns, takes off his hat, and bows to the cinema audience.

Most French audiences and critics appreciated Renoir's homage to the painters and popular Parisian theatre of the Second Republic when it opened in April 1955, although the film did less well in the USA under the fatuous title of *Only The French Can*. Nevertheless, what was clear, was that after the American, Indian and Italian experience, Renoir had returned to his artistic home – *La Belle France*.

36

Ingrid and Men

*'I was dying to do something happy with Ingrid Bergman
. . . I wanted to see her laugh, to see her smile on the
screen, and to enjoy, first of all for myself – and to have
the public enjoy – the kind of sexual abundance that is
one of her characteristics.'*

Having been unable to convince the producers of *French Cancan* to
cast Leslie Caron in the film, Jean wrote a play, *Orvet*, especially for
her. It was adapted from a synopsis of a screenplay called *Les
Braconniers* (The Poachers), which he had written a few years
previously.

Orvet was developed from poacher stories he had heard when
living in the Fontainebleau forest, and the incident 27 years before
when his friend Pierre Champagne was killed in a car accident, and
he was rescued by poachers. Caron reminded him of the little girl
who had been with the poachers at the roadside. This girl had
haunted him ever since, and she reappears in different forms in
several of his unborn projects over the years. There is a hint of the
wild girl of the woods in Anne Baxter's Julie in *Swamp Water*, but it
was not until *Orvet* that he was able to build a whole story around
her. For Jean, Leslie Caron had that special feline quality he wanted
for the role.

Their first meeting could itself have formed the basis of a
screenplay. In March 1949, Jean and Dido, who had just returned to
Europe from their preparatory trip to India and had been visiting

Rumer Godden in England, were on the way back to California via Paris. The 17-year-old Leslie Caron, who had been invited to do a three-day screen test for the Rank Organisation at Pinewood studios, was returning to Paris with her mother. But London airport was fog-bound, so the passengers had to make their way to Victoria Station and take the train to France. Caron, a member of Roland Petit's Ballets des Champs-Elysées, had to be back in Paris to perform the next evening.

'I noticed among the crowd this extraordinary couple, a very ebullient and bouncy man, round as a ball, and a tall angular woman who was very beautiful and looked as if she was carved in stone. The contrast between the two was so marked it impressed me very much. I didn't know who they were. She looked taller than him with her high-heels and his limp. When the plane was cancelled, everyone rushed to the railway station for the night train from Victoria. There I saw them again, and my mother told me to sit on the suitcase and look pathetic, and she'd try to get me a seat. I suppose that's the first time I played Lili. Then on the train, was this strange couple again, whom I remember vividly.'[1]

Jean, in turn, noticed the girl sitting on a bench at the end of the platform. He was struck by the shape of her head and profile, which reminded him of some of his father's models. 'We could feel her watching us with a kind of innocent slyness. Her eyes, half-hidden behind long locks of hair, made one think of a look-out post. It occurred immediately to Dido that she would be perfect for the part of Harriet in *The River*.'[2] He had no idea then that she was a professional dancer, nor that she was French (a disqualification for Harriet). However, they lost sight of each other, and the last glimpse Jean caught of Caron was her long hair as it vanished through the crowd at Gare du Nord.

One evening in April 1951, Jean came face to face with Leslie Caron again at a party given for dancers of the Roland Petit ballet by the painter Pierre Sicard at his New York home, when the Renoirs were stopping over on their way to Italy for *Le Carrosse d'or*. 'The little girl had grown into a young lady whom I could not fail to recognise because of the way she sat, hidden behind her hair. At the same time I recognised *Lili* and the dancer in *An American In Paris*.'[3] Actually, *An American In Paris*, which was to launch her career as a Hollywood star, had not yet been released, and neither had her first film for MGM, *The Man With A Cloak*. Jean was not to know that she even had a Hollywood contract, but 'his first

instinct to put me in films was the right one.'[4] In fact, Caron had already been spotted by Gene Kelly in a ballet called *Oedipus And The Sphinx*, which led to his casting her in *An American In Paris*, a year before Renoir laid eyes on her at Victoria Station.

After the party, Caron, Jean and Dido went down the staircase together and stood in the rain under a streetlight waiting for taxis, exchanging addresses and promising to meet again in Los Angeles. It turned out these were not just the usual insincere formalities, because the Renoirs and Caron did get to know each other in Hollywood, with the young actress becoming 'the daughter of the house, who could come in and out as I wanted.'[5]

For some years they tried to set up a film together. Jean thought of *Le Rideau cramoisi* (The Crimson Curtain), a story from the first *Diabolique* of Barbey d'Aurevilly, in which Caron would have played the maid in love with a conjurer who is also a thief. But sometime *Cahiers* critic Alexandre Astruc got in sooner in 1952, making his debut as a director with his stylised 43-minute version in which Anouk Aimée had a leading role. Jean then turned his attention to a Georges Simenon novel entitled *Trois Chambres à Manhattan*, which he wanted to shoot in the New York streets in black and white. Caron was very keen on the idea, and she spent six hours with Clifford Odets trying to persuade him to write the screenplay, but he politely declined. Some time later Jean was asked if he could do it with Aimée, but he remained loyal to Caron, telling the producers that he could not see anyone but her in the role. (The tale was finally filmed by Marcel Carné in 1965.) So after all these disappointments, and *French Cancan* without Caron, the only thing he could do was write a play for her.

At first, Jean gathered the whole cast together at his Montmartre apartment, including Leslie Caron, Paul Meurisse, Raymond Bussières and Pierre Olaf, and asked everyone's opinion. He explained that he would appreciate it if they would bring in their own lines, and he would put them in if they were good. 'I was young and stupid,' recalled Leslie Caron. 'The unconventionality of the play shocked me. I only knew what I had seen so far.'[6]

In order to prepare Leslie Caron for the role of the vagabond girl in *Orvet*, Jean had *Boudu sauvé des eaux* screened for her. Though the contrast between the gamine French actress and the large shambling figure of Michel Simon could not be more marked, Jean wanted her to absorb some of the anarchic spirit of Boudu; he also

hoped this would help her deliver some of the crude language of the character.

Jean had some trouble initially in getting the actress to forget 'the high-class convent where she had been educated' and her inhibiting bourgeois background. 'I came to the theatre one day convinced that I had the answer. It lay in the pronunciation of the word "bois" (wood) in the way a little poacher's daughter would do it, making it sound something like "bouah". Leslie at once grasped what I had in mind, and the other actors, witnessing the rehearsal, were themselves influenced by the effect it had upon her. Before long they had all adapted a key-word pronounced in a manner suited to their parts . . . '[7]

'He had a marvellous way of putting you at ease and trying to get the best out of you,' Pierre Olaf remembered. 'He was more of a director who directed you in the café during a break. You were never aware of being directed.'[8]

What was noticeable to Caron was Jean's acute hearing. 'I remember talking to someone in whispers on the stage and he was talking in the back of the auditorium with someone else and I could hear the drone of his voice and suddenly he replied to what I was saying to that person.'[9]

Jean only once lost his temper badly during rehearsals. Philippe Bouvard, a show business journalist and gossip columnist, had bribed his way past the doorman and managed to get into the wings where he accosted Caron for an interview. Jean called her to make her entrance on stage but when she failed to appear and the stage manager went into the wings and found her with Bouvard, he stormed: '*Foutez-moi le camp, foutez-moi le camp*' (bugger off) to both Caron and the journalist, and berated everyone else within sight.[10]

Orvet, a charming and uncynical play-within-a-play, was about a modern-day dryad (Caron), who lives in the woods with a group of eccentric odd-job workers near the villa of a Parisian playwright (Meurisse) who has come down to the Midi to write a new play. He falls in love with her, and wishes to act as her Pygmalion and transform her into a great dancer, which she has the ability to become. But the play he is writing develops into a tragedy when she runs off with his good-for-nothing young nephew to Paris. On her return he rewrites the play, working towards a happy ending.

In a sense, *Orvet* was a forerunner of *Le Déjeuner sur l'herbe*, with Meurisse as the symbol of tangible reality and rationality finding himself in an imaginary and imaginative world. Inspired by Hans

Christian Andersen, recalling *La Petite Marchande d'allumettes*, and Jean Giraudoux's *Ondine* (in which Caron would star in the 1961 Royal Shakespeare production), it reflected on the relationship between the artist and nature, a concern close to Jean's heart.

The play opened on 12 March 1955 at the Théâtre de la Renaissance to mixed reviews. Though many critics found the cast appealing, especially Leslie Caron, and Jacques Jouanneau as an amusing English butler, some seemed disturbed by the play's unconventional, zany quality, and the way in which tragedy went on on one side of the stage simultaneously with clowning on the other. Others could not see the wood for the Pirandellian trees. Audiences, however, were more responsive, and it ran over 400 performances. Rivette and Truffaut found it remarkable and commented that 'usually in the theatre, you can distinguish between the play and the staging. In this case, it was really impossible to separate one from the other.'[11]

'One night while we were doing *Orvet* in Paris, Ingrid Bergman came backstage after the play, looking like something the cat had brought in,' Leslie Caron recalled. 'She had no make-up on, she looked very rundown, she was dressed in a shabby grey coat and unattractive flat shoes. There was no remnant of the glamorous movie star. It was a shock seeing her coming into my dressing-room looking like that.'[12]

Ingrid Bergman's life had become drudgery. Financially her existence was unstable, with Rossellini's open-handedness bearing little relation to his income. She spent most of her time looking after her three young children, trying to make ends meet. The four films she and her husband had made together were all disasters at the box office. She felt foreign and unwelcome in Italy, and had to cope with Roberto's mercurial temperament and his philandering.

Bergman had arrived in Paris by train with the children and the nanny, and Rossellini followed a few days later in his fast car. On the first evening, after the show, Bergman, Caron and Jean went off to a restaurant. On the way in the car, Bergman, putting on a brave face, said she was so glad not to be in Hollywood any more because life there was so superficial and banal. Caron was quite taken aback by her remarks considering what she knew about the actress' present situation.

But at the end of the meal she reminded Jean what he had said to her all those years ago when he first arrived in Hollywood. When

she expressed a desire to work with him, he had replied, 'No, the time is not yet ready, Ingrid. You're too big a star for me now. But I shall wait until you are falling and then I shall be holding the net to catch you. I shall be there with the net.'

She told him that she needed him to catch her now, because she was falling. When they left the restaurant, she sat down on the pavement and cried. Jean adored Rossellini, but he was angry at what his friend had done to Ingrid.

The following day, Renoir approached Pierre Olaf. 'Pierre I'm going to ask you a favour. Ingrid came to me and reminded me of something I once said to her in Hollywood. She asked me to rescue her. I have to find a film to do with her. I had an idea last night it would be fun to make a melodrama, so would you mind going to theatre bookshops to look for something.'[13] Olaf read through about a dozen melodramas, but around a month later, Jean changed his mind, and decided to do a romantic comedy instead because he 'wanted to see her laugh, to see her smile on the screen . . . '

As Bergman recalled, when Jean told her that he had planned a film for her in Paris, she replied, 'Jean, it isn't possible. Roberto will not let me work with anybody else.' 'Jean looked at me and smiled again. "I shall talk to Roberto," he said. And to my immense surprise Roberto said, "What a great idea! Certainly you must work with Jean" . . . Jean was one of the very few directors in the world Roberto admired.'[14]

The film was originally to be called *The Red Carnation*, but was changed to *Eléna et les hommes* to highlight the principal character. 'I was dreaming of Venus and Olympus. But maybe of a Venus revised by Offenbach . . . I played with political stories, with stories of generals. I tried to show the futility of human undertakings, including the undertaking we call patriotism, and to have fun juggling ideas that have become the serious ideas of our day.'[15]

Jean's first idea was to write a satire around the nineteenth-century General Georges Boulanger, who led a brief authoritarian movement to topple the Third Republic in the 1880s. The general committed suicide in Brussels over the grave of his mistress, Marguerite de Bonnemains. (In *French Cancan*, Maria Felix says, 'General Boulanger often calls on me.') However, the producers decided at the last moment to change it in order to protect the military hero's relatives and heirs. The name was altered to General François Rollan, played by Jean Cocteau's pet actor, Jean Marais, though much of the plot

involving a *coup d'état* which Boulanger had attempted, remained. (The role had been offered to Gérard Philipe, who found it politically weak.)

Mel Ferrer, who had appeared with Leslie Caron in *Lili*, and had just completed *War And Peace* in Italy opposite his wife Audrey Hepburn, was brought into the cast to add another name familiar to American audiences.

The shooting began in December 1955 at the Saint-Maurice Studios and in the Bois St-Cloud, during the coldest winter in Europe for a century. One day, as Ingrid Bergman sat freezing in her dressing room, Mel Ferrer said to her, 'Why are you sitting here with a shawl around you in a dressing room with no heat, waiting to be called to go on a picture that probably will never be released in the USA? I mean, it's not a great picture. Jean is failing now. It's not great Renoir. Why are you sitting here freezing to death?'

'Mel, I work because I like to work,' she replied. 'I'll work until I'm an old lady and I'll play grandma parts.'[16] Bergman was delighted to be working on a well-scripted film with professionals again, in contrast to her films with Rossellini. (Despite his derogatory comments about Jean, Ferrer had no qualms about working on the 'failing' director's play, *Carola*, 18 years later.)

The main difficulty with making the film was the fact that the producers insisted that *Eléna* be shot simultaneously in French and English, which was extremely tiring for everyone concerned. This also created great difficulties for many of the French cast who did not speak English, and for Ferrer whose French was shaky. (He is dubbed in the French version.) On top of which, there were time and money restrictions on the film. 'It was a nightmare to shoot . . . It's a miracle I finished *Eléna* . . . Every day we were in a black hole! The ending alone! I had to improvise the ending in one day, with Juliette Gréco's song, because the song I had planned required words that I could never have spoken. No, I was in a jam; there was no money left. I constantly had to invent short cuts. *Eléna* owes its unity entirely to a certain spirit that I maintained throughout the film, by clinging to the main character. That's the glue, the cement that joins it all.'[17]

Jean Griot witnessed how Jean created this spirit, and was able to make people feel at ease around him socially and on the set. 'There was a scene that took place at a chic café where they had to eat apple tart and drink champagne. Jean made sure it was a genuine tart and real champagne, and that even the crew was supplied with plenty of

it. After each take, he would say, "*C'est bien, c'est tres bien, c'est parfait*, but to give me even more pleasure, could we not have another take. Now could you perhaps . . . could you perhaps do it this way." By the fourth take everyone was in a joyous state as well as the musicians, and this authentic gaiety came across in the film.'[18]

In the Paris of the 1880s, Princess Eléna Sorokovska (Ingrid Bergman), a merry but improverished Polish widow, agrees to marry Martin-Michaud (Pierre Bertin), an elderly but wealthy boot magnate, for money. Meanwhile, she has attracted the attentions of General Rollan (Jean Marais), a soldier-hero being urged into taking power, and Henri de Chevincourt (Mel Ferrer), an aristocratic dilettante. Because of the General's passion for her, Eléna is pressed into becoming involved in political intrigue. Finally, she chooses Henri (love) over Martin-Michaud (money) and General Rollan (power).

This '*fantasie musicale*' opens with Ingrid Bergman, who has seldom been more beguiling, sitting at a piano, looking ravishing in a white lace dress, and smiling. It is she who sets the joyous tone of the operetta-like comedy as she flits from one man to the other.

The film, like *Le Carrosse d'or*, is structured in three acts – the first in Paris, the second at a country château, and the third in a house in the provinces, each act providing splendid bravura set pieces, captured by Claude Renoir's camera as a series of popular colour prints and paintings. *Le Moulin de la Galette* becomes here a '*tableau vivant*' in the truest sense, rather in the manner that *La Balançoire* was recreated in *Une Partie du campagne*. The 14 July celebrations, though brilliantly choreographed, give the impression of ebullient spontaneity as the crowds mill around beneath the Dufy-like array of Tricolours and Chinese lanterns. At one moment a child is passed from one person to another until it returns to its mother.

The action, punctuated by a street singer (Marjane) and the remarks of an elderly woman about the good old days ('*C'était la belle époque!*'), moves to the Château de Maisonvilliers, where a brighter version of *La Règle du jeu* is enacted, the farcical elements hectically building to a climax, with Renoir again translating the conventions of the theatre into filmic terms. The General and Eléna, endeavouring to be alone, are continually interrupted by the antics of his orderly (Jean Richard) and Eugène (Jacques Jouanneau), the son of the house, pursuing Lolotte (Magali Noël), Eléna's chambermaid; the jealous Henri breaks in and challenges the General to a

duel; and all the while a rotund soprano is practising her scales. A little later, as the soprano starts her recital, the assembled company gets up and walks out of the room the moment she opens her mouth. This leaves only the host, the monocled Pierre Bertin, gloomily surrounded by his lackeys, listening to the singer, who seems blissfully unaware of the situation.

The plot neatly works itself out in the third act, which includes a gypsy camp where Juliette Gréco is a psalmist. Towards the climax, she stands forlorn, accompanied by strolling musicians, as if in a blue-period Picasso painting, and sings a poignant ballad, 'O Nuit!' moving forward towards the cinema audience. Everybody falls under the spell of the song, and couples begin kissing. '*La comédie est terminée,*' says someone, and a notional curtain falls.

Eléna et les hommes was the 61-year-old director's tribute to romance, and the French '*l'art de vie*', and sets out to prove, somewhat ingenuously perhaps, that 'Dictatorship has no chance in a country where affairs of the heart are so important.'

It opened in the USA under the title *Paris Does Strange Things*. But America did strange things to it. A new beginning and ending with Mel Ferrer were added to the film, and other parts were re-edited. 'The whole thing makes me sick, it was such a shock!' commented Jean, some months after its release. 'Seeing a film that I liked very much, which I worked on a great deal and shot under horrible physical and even moral circumstances . . . After having gone through so much trouble, to see that the English version was destroyed did not make me optimistic.'[19]

No wonder Jean was not to make another film for three years.

37

The Eternal Debutant

'In the end, the technique consists in taking the actors as seriously as one takes cars when filming a car accident. You always film with three cameras because you're not going to destroy several cars, but actors are treated with less consideration.'

Jean and Dido returned to the USA on the *Queen Mary* in July 1956. After a stay of three months in New York, where Jean did the post-synchronisation of the English version of *Eléna et les hommes*, they arrived back in Los Angeles. They were warmly greeted by their dogs and cats, by Bessie, and by Gabrielle and Jeannot, who had bought a house next door to the Renoirs, and by those few friends who still lived in Hollywood. Dudley Nichols was in Connecticut and Albert Lewin in New York, as were Charles Laughton and Burgess Meredith, who were appearing together in *Major Barbara* on Broadway. Fritz Lang had decided to resume his career else-where, and had left for India to prepare a film. Some years later, he gave his reasons for leaving Hollywood. 'I was disgusted. I looked back over the past – how many pictures had been mutilated – and since I had no intention of dying of a heart attack, I said, "I think I'll step out of this rat race." And I decided not to make pictures here anymore.'[1] Words that could have been spoken by Jean.

In May 1957, Jean heard news of the death of Erich von Stroheim, from cancer, at his country home at Maurepas in France. The previous summer he had been confined to his bed, where he lay no longer able to move his body freely and forced to hold his head in a

rigid position, exactly like Von Rauffenstein in *La Grande Illusion*. About 150 mourners attended the funeral service in the tiny church at Maurepas, among them Jacques Becker carrying the dead man's *légion d'honneur* on a silk cushion. At Stroheim's request, an orchestra of gypsy violinists played Hungarian melodies that he loved. 'I was unable to accompany Erich von Stroheim, my master, to his resting place,' wrote Jean. 'I was kept in America by the shooting of a film. It was a reason which Stroheim would have perfectly understood.'[2]

Would that Jean *had* been busy making a film at the time, but that is how he remembered it. As there were no offers of work in America, he had written a three-act play called *Carola* for Danielle Darrieux and Paul Meurisse to play, respectively, a French actress and a German general during the Occupation. Darrieux herself had acted at that period, and had been marked for execution by the French underground for entertaining German troops and going off to Germany during the war, but she was later exonerated. Unfortunately, the project failed to materialise, and *Carola* had to wait many more years for a production, which eventually came in the form of a television play. Jean also had plans to translate Shakespeare's *Henry V* and stage it with Meurisse in the title role.

He had already translated Clifford Odets' *The Big Knife* into French, a production of which was performed at the Théâtre des Bouffe-Parisiens in October 1957 with Daniel Gélin, Paul Bernard and Claude Génia. Jean relished adapting his friend's hardhitting play, which reveals the movie business as vulgar, greedy and ruthless, while being able, as translator, to keep a certain distance from the ideas expressed. (Robert Aldrich's film version had appeared in 1955, starring Jack Palance, Rod Steiger and Ida Lupino.)

A month before the opening, Jean travelled to Paris to direct the final rehearsals of the play. (Jean Serge, who had assisted him on the screenplay of *Eléna*, had laid the ground.) In the production, a very short extract from a film is projected in which the movie star played by Gélin is seen. This tiny *film noir*, entitled *A Tiger On The Town*, shot by Jean in 16mm, has since been lost.

During his stay in Paris, *Cahiers du Cinéma* took the opportunity of sending Truffaut and Rivette to see him again for a second long interview which formed the centrepiece for their special Christmas 1957 issue devoted to Renoir. In it, André Bazin claimed: 'Renoir alone knows how to compare the cinema with the other arts. He has no system but is full of truths, local, national and international.'[3]

*

It was the first time in 18 years that Jean had been separated from Dido. She was happy to remain in California after so long an absence, but Jean wrote to her almost every day, detailing every event and asking her advice on both financial and aesthetic issues.

Before returning to the USA in December, Jean filed a synopsis at the Screenwriters Guild for a film called *Villa de l'Extra*, an extremely modified version of an earlier treatment called *Paris-Province* (1954). Both seemed to look back nostalgically to his pre-war films, and to the village community within Paris that he remembered from his childhood. *Paris-Province* was set in Montmartre, near the colourful and winding rue Lepic in the shadow of Sacré Coeur. It involved the inhabitants of the Villa Dumas, surrounded by nightclubs, exotic bars and restaurants frequented by drug dealers, prostitutes, and poor working people.

The principal characters were Alice, a cleaning woman in her thirties, her illegitimate teenage daughter Gisèle, and her layabout husband Célestin. Alice escapes her drudgery by having an affair with Gustave Androuet, a celebrated artist who lives upstairs, and Gisèle gets pregnant by a young man in the building who abandons her. Typical Renoir set-pieces are a visit to an open-air café on the banks of the Marne, and a dinner party given by the artist at which an entire ham, a complete round Cantal cheese, and a cask of Sancerre wine is consumed.

Aside from detailing the food and drink, Jean describes the rue Lepic thus: 'At the time of day when the housewives do their shopping, it offers one of the most picturesque sights in the world. When the weather is good, the sun plays over the displays of fruit, vegetables, fish. It is a feast for the eyes. The interruptions of the shopkeepers, the discussions with the shoppers, the ear-splitting cries of the merchants that haven't changed for hundreds of years. It is like a bath of light and noise. The call girls of the *quartier*, who have risen late, for a reason, are still in dressing gowns. One shops for the pleasure of chatting; vulgar jokes spread. It's free-and-easy and lively. Alice and Gustave feel happy in the midst of the crowd, thicker and gayer on Saturday. High on the hill Sacré Coeur stands out, all white.'[4]

Villa de l'extra, unlike the Villa Dumas, is situated near Porte de Châtillon, where 'many of the houses are made of wood. You find artists, plasterers, and set-painting studios.'[5] It is in this artistic milieu that Renoir places his characters. The story begins with a sculptor being found dead, stabbed with his own chisel. His grand-

daughter Aurore is found beside the body with the weapon in her hand. She is arrested, but in an extended flashback, similar to that in *Le Crime de Monsieur Lange*, her innocence is established. *Villa de l'Extra* would have been the first Renoir whodunnit since *La Nuit du carrefour*, although murders abound in his work.

Jean did most of his writing on the ocean liners that shuttled him frequently back and forth across the Atlantic in the 1950s. He was only back in California for three-and-a-half months before he set sail for Europe again in April 1958, this time accompanied by Dido.

In June, they were present at the Brussels World Fair, where *La Grande Illusion* was selected as one of the twelve 'best films of all time'. It came fifth with 72 votes, after *Battleship Potemkin* (100), *The Gold Rush* (85), *Bicycle Thieves* (85) and *The Passion of Joan Of Arc* (78). The others were *Greed* (61), *Intolerance* (61), *Mother* (54), *Citizen Kane* (50), *Earth* (47), *The Last Laugh* (45), and *The Cabinet Of Dr Caligari* (43). The selection was made by a jury of 117 film historians from 26 countries, and contained no real surprises as they consisted of established classics. It is significant, however, that the list included only three sound films almost 30 years after talkies came in. By combining the number of votes obtained by each director for all of his films mentioned in the ballot, Renoir came seventh among the twelve greatest. Chaplin easily topped the list.

Renoir enjoyed the company of so many colleagues, old and young, who had gathered in Brussels for the festival. On their return to Paris, François Truffaut invited Jean and Dido to a screening of *Les Mistons*. It was his first work, apart from *Une Visite*, an amateur 16mm short he made in 1954, photographed by Rivette and edited by Alain Resnais. *Les Mistons* was a delightful 20-minute film about childhood, starring husband and wife Gérard Blain and Bernadette Lafont as young lovers being spied upon in their amorous pursuits by a gang of young boys. It was shown with Claude Chabrol's debut feature, *Le Beau Serge*, considered the first film of the *nouvelle vague*.

Afterwards, Jean, Dido, Truffaut and Madeleine Morgenstern, whom the novice director and critic had married in October 1957, went off to a café in the Champs-Elysées. 'Jean was charming, urbane, and eloquent,' Morgenstern remembered. 'He was very attentive to the younger man. It was more Jean who posed questions of François than the other way round. He never played the great artist surrounded by younger people. He was genuinely interested in their work. Jean's tone was colloquial and *vieux France* at the same

time, while François never called Jean by the familiar "tu", even when they became very close friends. He always spoke to Jean with respect. Renoir was the director Truffaut admired above all, Hitchcock included. Hitchcock, he felt, was able to portray the force of cinema with the image alone, whereas for Renoir, words were more important. Truffaut once said that he wanted to film thrillers like Renoir, and tender stories like Hitchcock.'[6]

On 11 November, the day after Truffaut began shooting his first feature, *Les Quatre Cents Coups/The 400 Blows*, his spiritual father André Bazin died, aged a mere 40. At the time of his death he had been working on a book on Renoir (later edited by Truffaut and published in 1972), and had completed his monumental critical work in four volumes, *What Is Cinema?*

Truffaut was devastated, particularly as Bazin had not lived to see a feature film made by his protégé. Jean wrote two articles in appreciation of the critic who did more than any other to build his own reputation as a great director, even when he was considered on the decline.

One of André Bazin's last interviews, a month before he died, was with Renoir and Roberto Rossellini for the magazine *France-Observateur*, the subject being 'Cinema and Television'. 'If Roberto and I turn towards television,' Jean commented, 'it is because television is rather primitive technically so that it will perhaps restore to directors the spirit of the cinema at its beginnings when all productions were good.'[7]

As films were so expensive and so difficult to get off the ground, Jean had often been tempted by the relatively new medium. At first, he thought of *Le Testament du docteur Cordelier*, his updated free adaptation of Robert Louis Stevenson's *The Strange Case of Dr Jekyll and Mr Hyde*, in terms of a live television play, a common practice in those days. Then he managed to set up the first cinema–television co-production in France, hoping for a simultaneous release of the film on television and in the cinemas. Despite initial hostility from the National Federation of French Cinemas, he managed to persuade Pathé to finance and distribute the picture.

Once more, Jean, the '*éternel débutant*'[8], entered new territory. He was one of the first great film directors to make a film using television methods. From the early 1960s until his death in 1977, the majority of Rossellini's films were made for TV. Jean-Luc Godard later experimented with TV and video techniques. In the USA, in

the mid-1950s, it worked in reverse. Directors such as Sidney Lumet, John Frankenheimer and Delbert Mann moved into feature films from TV.

'It [*Le Testament du docteur Cordelier*] is an experimental film arising out of my work in the theatre,' Renoir wrote. 'My conviction that the system of quick shots in the cinema hampers the actor's performance prompted me to try a system of direction in which the actor would determine his own speed. Under normal direction the actor no sooner got into the skin of his part than the director cuts him short and the take is over. It costs him a great effort to get back into the rhythm. Unfortunately film equipment and particularly the length of reels does not allow of takes without cuts . . . I worked as a rule with three or four cameras, and sometimes, in order to get the necessary close-ups, I had as many as eight going simultaneously. You can imagine the miles of film that had to be thrown away. The editor and her assistants were nearly off their heads. The actors, on the other hand, were delighted. They saw it as a victory over the exasperating director's cry of "Cut!" '9

The film was rehearsed for two or three weeks in the manner of the theatre, with chalk lines marked out on the floor for the actors. Scenes of 10 to 12 minutes were played through, so that the cast knew exactly where the cameras were going to be. The actual shooting took around 10 days at the RTF studios, and on location in the Montmartre streets and at Marnes-la-Coquette in January 1959.

A series of brutal attacks, mainly on women, children, and helpless old people are traced to a mysterious Monsieur Opale, whom the rich and respected Doctor Cordelier (Jean-Louis Barrault) claims as a friend. The doctor has given up his lucrative practice in order to devote himself to studying the effect of drugs on the human personality. One day, Maître Joly (Teddy Billis), the doctor's lawyer, discovers that his client and Opale are one and the same. Cordelier explains to the lawyer and Dr Séverin (Michel Vitold), an eminent psychiatrist friend, that he had created an evil alter ego by means of a drug and, stripped of his inhibitions, he found the freedom irresistible. Finally, appalled by the consequences of his sacrilegious efforts to meddle with the souls of human beings, Cordelier takes a fatal draught.

The use of multiple cameras and microphones gave *Le Testament du docteur Cordelier* the fluid, rough-edged, spontaneous appeal of a

live TV play, and the long takes allowed Jean-Louis Barrault the chance to develop his extraordinary singular performance as the jaunty, twitching, shaggy, prancing, bestial Opale, as well as the silver-haired, dignified and respectable Doctor Cordelier, his finest screen work since *Les Enfants du paradis* 14 years previously.

The switches from comedy to drama, and the contrast between the rather cheap-looking studio interiors and the exteriors, shot in the streets of Paris, produce a curious feeling of displacement and schism that only adds to the strange atmosphere of the story, which is, after all, about a split personality.

Le Testament du docteur Cordelier gave Renoir not only a wonderful opportunity to return to the anarchy and freedom of Boudu, his tramp hero, but also to Lantier, the disturbed train driver of *La Bête humaine*. As Alexander Sesonske has pointed out, Opale/Cordelier is 'the culmination of a long series of Renoir characters who harbour a second self not acknowledged by their everyday world: Legrand [*La Chienne*], Lange, Emma Bovary, Pepel [*Les Bas-Fonds*].'[10] With Cordelier, Renoir created a bored, wealthy man who could only cure himself by creating his antithesis.

Because of a long-running dispute between the theatre owners and the film's producers, *Cordelier* had to wait until November 1961, before it was shown in cinemas in France, over two years after it had been screened at the Venice Film Festival in 1959, the year when *La Règle du jeu* was projected there in its 113-minute print for the first time in 20 years.

A few months earlier, Cannes had seen the consecration of the *nouvelle vague* with François Truffaut winning the Best Director award for *Les Quatre Cents Coups*. Jean sent Truffaut a telegram to Cannes. 'Delighted by your great success.'[11] Alain Resnais' *Hiroshima mon amour* gained the International Critics Award, and in Berlin, Claude Chabrol's *Les Cousins* took the Golden Bear. All of them acknowledged Renoir as their master, underlined by the rediscovery of *La Règle du jeu*. Louis Malle said, 'We were of the generation that saw it 15 times,'[12] and Alain Resnais wrote of the film: 'It remains, I think, the single most overwhelming experience I have ever had in the cinema. When I first came out of the theatre, I remember, I just had to sit on the edge of the pavement; I sat there for a good five minutes, and then I walked the streets of Paris for a couple of hours. For me, everything had been turned upside down. All my ideas about the cinema had been changed. While I was

actually watching the film, my impressions were so strong physically that I thought that if this or that sequence were to go on for one shot more, I would either burst into tears, or scream, or something. Since then, of course, I've seen it at least 15 times – like most film-makers of my generation.'[13]

Satyajit Ray said of the film: 'There is a subtle, almost imperceptible kind of innovation that can be felt in the very texture and sinews of the film. A film that doesn't wear its innovations on its sleeve. A film like *La Règle du jeu*. Humanist? Classical? *Avant-Garde*? Contemporary? I defy anyone to give it a label. This is the kind of innovation that appeals to me.'[14]

While *Le Testament du docteur Cordelier* was being edited, Jean entered yet another arena. Jean Serge, who had just become the artistic director of the Ludmilla Tcherina Ballet at the Sarah Bernhardt Theatre, asked Jean to supply a story for a ballet, which he also wanted him to stage. Renoir obliged with *Le Feu aux poudres*, the argument of which he described thus: 'On the lost map of invisible countries, Strongalia and Molivia are separated by an imaginary border: the border that separates but does not protect the enemy civilisations on the other side. Strongalia is a scientific, strict, austere, virtuous and disciplined country. Molivia is a lost corner of paradise on earth, where laziness, happiness, and love are free and obligatory. Can these two extremely different worlds coexist peacefully?'[15]

It had obviously been an important theme to Jean since *La Grande Illusion*, but it was to dominate his mind and work at this period. *Cordelier* set up the split between the rational and irrational, and *Le Déjeuner sur l'herbe* would be preoccupied with the same subject.

The ballet had music by Mikis Theodorakis (a Greek exile in Paris since 1953), and sets by Jean Castanier, who had designed *Boudu, Chotard*, and *Lange* in the 1930s. Jean found working with the young dancers rewarding but, despite their amiability, thought them not very intelligent compared with actors. He also considered Ludmilla Tcherina's continual presence and interference a great irritant. When he had to enter hospital for a long-postponed hernia operation, Tcherina substituted another set for Castanier's and changed some of Renoir's staging.

Jean had recovered sufficiently to attend the première early in March. *Le Feu aux poudres*, a short ballet, was only part of the

programme which was dominated by Tcherina's most celebrated work, *Les Amants de Teruel* (filmed in 1962), but it was greeted with some enthusiasm.

Just before the opening, Jean received a telegram from Jeannot Slade to inform him that Gabrielle had died on 26 February. To demonstrate how much his old nurse had meant to him, Jean ended his memoirs with this paragraph: 'As I bid farewell to the landscape of my childhood I think of Gabrielle. Certainly it was she who influenced me most of all. To her I owe Guignol and the Théâtre Montmartre. She taught me to realise that the very unreality of those entertainments was a reason for examining real life. She taught me to see the face behind the mask, and the fraud behind the flourishes. She taught me to detest the cliché. My farewell to my childhood world may be expressed in very few words: "Wait for me, Gabrielle." '[16]

The next Renoir film would be an actual return to 'the landscape of his childhood'.

38

Natural Insemination

'The shadow cast by the olive trees is often mauve. It is in constant motion, luminous, full of gaiety and life. If you let yourself go, you get the feeling that Renoir is still there and that you are suddenly going to hear him humming as he studies his canvas.'

After the trilogy of 'theatrical' films, and the TV-conceived *Docteur Cordelier*, all rigidly studio-based, Jean desperately needed to get back into the open air, and where better than the Côte d'Azur where his father had spent his last days. He conceived a story which could be filmed almost entirely at Les Collettes, Auguste's pagan paradise. Instead of taking the title from a Renoir painting, he went to Manet's *Le Déjeuner sur l'herbe*, which might have been equally applicable to *Une Partie de campagne*, another homage to the world of his father.

Since it would be produced by his own company, he had to make it as cheaply as possible, and chose a similar technique to that he had used on *Cordelier*, although it would be shot in colour – how could it be otherwise? – and not with television in mind.

Before departing for Cagnes, Jean rehearsed the cast at the Francoeur Studios in Paris. After two stage plays with Paul Meurisse (*Julius Caesar* and *Orvet*) he was finally able to make a film with the actor he so admired, an actor able to portray pomposity better than most. Catherine Rouvel, whom he had tested for *Cordelier*, was making her screen debut as a seductive wood nymph, a variation on

Orvet. Her face (not her figure) conformed to the elfin type of Simone Simon, Leslie Caron and Françoise Arnoul, with a suggestion of Catherine Hessling. She also had the advantage of having come from the area. Among the cast, playing Gaspard, an old shepherd, was Charles Blavette, Renoir's Toni of 25 years earlier.

They rehearsed with chalk marks on the floor of the studio so that the actors would be familiar with distances and their movements when they arrived at Les Collettes. Some years later Jean cast doubts on this method of filming. 'It permits you to avoid spending too much money, to avoid going over schedule, to shoot the number of shots planned for the day, but in my opinion, it kills one extremely important thing, which is the actor's surprise when faced with the set . . . the actor must assimilate the set himself. If I were a dictator I would forbid all pieces of chalk on stage and on sets. What's really important is to bring to life a certain character, and the rest is a joke, it's not important.'[1]

Le Déjeuner sur l'herbe took about 21 days to shoot during July and August 1959, using five cameras, mainly at Les Collettes where Coco and his family were still living and trying to sustain the place financially. For Jean, who 'had the immense pleasure of filming the olive trees my father had so often painted',[2] the film was 'like a bath of purity and optimism. We felt, in its making, that we had been transformed into fauns and nymphs.'[3]

Etienne Alexis (Paul Meurisse), a supercilious Parisian biology professor, has experimented successfully with artificial insemination, and believes in it as the best means of propagating the human species. Nénette (Catherine Rouvel), a farmer's daughter, becomes a chambermaid in the professor's château in the Midi, in order to get him to give her a child by his test-tube method. In honour of Alexis' candidacy for president of Europe, and his engagement to Marie-Charlotte (Ingrid Nordine), a German countess who is head of the Inter-European Girl Scouts Organisation, a formal picnic is held. But the proceedings are disrupted when a violent wind springs up, caused by an old shepherd (Charles Blavette) playing his pipes of Pan in the Temple of Diana. The professor takes refuge in a ruin with Nénette, and goes to stay with her family, where he learns the pleasures of the countryside, falls in love with Nénette, and gets her pregnant by conventional means. 'Down with science!' he finally shouts.

In this depiction of 'the eternal fight between intellect and feeling',

Renoir pits pagan eroticism against modern science in a colourful lush Provençal setting, with sunlit images that derive from the Impressionists. This hymn to nature is Renoir's most direct homage to his painter father, not only aesthetically but in content. According to Jean, Auguste 'felt that science had failed in its mission by not fighting for the expression of the individual: instead it had put itself at the service of mercenary interests and favoured mass production.'[4] The broad satire of *Le Déjeuner sur l'herbe* not only takes digs at the development of nuclear weapons, space travel, artificial insemination, and a united Europe, but at slimming fads and even decaffeinated coffee. An aeroplane pointedly cuts through the sky twice, disturbing the pastoral scene, as if a plane were to be seen in a Auguste Renoir painting. However, Jean is not being simply reactionary, but is celebrating (as in *Boudu*) the priapic forces, 'the satyr dormant in Man', and the notion that 'perhaps happiness is submissive to the natural order.'

The problem with the screenplay is that it aims to deliver its message too rigidly and simplistically, skimming any dialectic, and creating mere cardboard characters: the German scouting mistress in her severe uniform (military music on the soundtrack); the professor's prim staff; the sympathetic local *curé* delivering his homily against progress and the dictatorship of the scientist, to which the professor provides no response; the group of young campers, with their scooters and *vin ordinaire*, contrasted with the bourgeois picnic with its chairs and parasols; the amiable farmer taking his simple pleasures; the repressed couple whose sexuality is awakened by the pipes of Pan; the sensuous child of nature; and the emotionally suppressed intellectual.

As the latter, Paul Meurisse, his fingers forever poised as if ready to snap them, and his head held at a curious angle, does cover the bones of the character with comic flesh, while the dark-haired Catherine Rouvel, physically similar to the Gabrielle of the paintings, her red dress against the green landscape, is suitably seductive. However, it is ironic that Renoir *père* was able, 40 years previously, to paint *Les Grandes Baigneuses*, in which two healthily plump and shapely female nudes recline beside a pond, while Renoir *fils* was forced to film Rouvel swimming nude in the blue lake discreetly from behind and in long shot. Such were the different attitudes towards painting and films.

During the unseen love-making between Etienne and Nénette in the bushes, trees sway, a river runs rapidly, reeds are seen from an

overhead shot, swaying and rippling like a woman's hair, followed by images of fecundation. It is in the depiction of an unspoiled Provençal paradise that the film is strongest, with its profound sense of the natural world that links it to the work of Auguste Renoir. The opening shots, after a long pre-credit sequence, are of the magnificent olive trees against the sky at Les Collettes, which reappear in a more protracted sequence where ancient faces seem to be embedded in their mighty trunks.

Best of all is the fantasy episode, when the shepherd, accompanied by a majestic ginger goat, plays his pipes, and the winds spring up, forcing the anti-nature group to take to their cars in a comic scene worthy of Buster Keaton; then the sudden lull, as the melody is completed.

When *Le Déjeuner sur l'herbe* opened in Paris in November 1959, it was not greeted with much enthusiasm, neither was it welcomed any better abroad. Disappointed by its reception, Jean and Dido returned to the States again in December 1959.

Two months later, Jean heard that Jacques Becker had died in Paris, aged 53, not long after completing *Le Trou*. 'I cannot get used to the idea that Jacques is dead . . . I cannot believe that he is now rotting in his grave. I would sooner think that he is waiting for me in some corner of the next world, waiting for us to make another film together.'[5] Just as Jean had lost a son in Becker, so François Truffaut had lost a father in Bazin. Thus were Renoir and Truffaut drawn into another surrogate father-son relationship to fill the gap left by their dead friends.

Jean received another severe blow in the same year, when Dudley Nichols, a few months younger than he, died aged 65. Renoir's friends were dying around him, and yet he felt younger and more active than ever. Especially when surrounded by the students at the University of Southern California where he gave several seminars at the English and Drama departments, something he had been doing, on and off, for a number of years.

Some years previously, one of his students had been James Ivory, then in his late twenties. Ivory, who started making films in India in 1960, claimed to have become interested in that country after seeing *The River*. His perception of Jean's courses was that they were completely unplanned, and his work with actors was the springboard from which he could speak of cinema as a whole. In his discussion with the students on films, Jean tried to convince them to

'ignore technology', and 'that the camera is made to serve you and that you're not there to serve the camera.'[6]

He was also invited to give lectures at UCLA by Professor Arthur Friedman from the Department of Film there. They had known each other since early 1946, when Jean directed a 15-minute radio production called *Friendship Bridge*, written by Friedman for the Armed Forces Radio Service.

Around the time of the seminars at UCLA, Friedman invited Jean and Dido over to dinner at his house, courageously deciding to cook a French meal. When the American professor brought in the escalope, Jean stood up at the table and started to applaud. After the meal, he chatted to Friedman's children, and on coming across a plastic model of Frankenstein's monster belonging to the youngest boy, he spoke animatedly about how he would have loved to have made a true horror film (the closest he had come to it was *Le Testament du docteur Cordelier*), because it was the purest form of cinema. The boy was so taken with Jean that he insisted on presenting him with the model as a gift. Back home, Jean placed the plastic monster on his piano, between photos of Chaplin and Truffaut.

In 1961, Jean made the acquaintance of Nicholas Frangakis, a student at Loyola University in Los Angeles. The Jesuit professors, knowing that Frangakis had been an actor and had a knowledge of films, asked him to arrange film showings with the directors themselves present. Frangakis, who had already managed to get George Stevens, Vincente Minnelli and Mervyn LeRoy, told the priests that they should invite Jean Renoir, 'the world's greatest director', to present some of his films at the university. This would be the last of these events he could arrange since he was about to enter the priory as a novice, becoming Brother Basil.

When Frangakis arrived at Leona Drive with fellow student Brian Avery (who later played Dustin Hoffman's 'square' rival in *The Graduate*), Jean, in his gardening clothes, greeted them effusively, putting the young men at their ease immediately. He was more interested in the reasons for Frangakis' decision to take holy orders than in anything else. The fact is, that when Frangakis approached Jean, he had seen the Hollywood films, but knew the pre-war classics only by reputation. 'If I had seen *La Règle du jeu*, I probably would have been too over-awed to have dared ask Renoir to come. It was like going to Mozart.'[7]

It was through Frangakis that Jean met the other brothers at the

Benedictine Monastery at Vallermo in the Mojave Desert, mostly Belgians who had been missionaries in China before the revolution. Jean and Dido visited the monastery a few times, and a number of the monks would come to the Renoir home from time to time, bearing peaches from their orchards.

Aside from his work at the university, Jean kept busy collecting material for a book on his father, a task greatly helped by taped conversations he had had with Gabrielle. There were also his various attempts to get films made.

From the three-page synopsis for a film called *Que deviendra cet enfant?* (What will become of this child?), written in 1959, it would seem that Jean was moving into yet another area, what would later be called *cinéma verité* (a translation of Vertov's *Kino Pravda*). The development of lightweight sound and ciné equipment helped create the style, and we can only imagine how he would have used the new techniques if he had the chance. The phrase *cinéma verité* was coined to publicise Jean Rouch's *Chronicle Of A Summer* in 1961. In it, the anthropologist film-maker Rouch and sociologist Edgar Morin asked a cross-section of Parisians the question, 'Are you happy?' Jean's sketch for the film envisages something similar.

Que deviendra cet enfant? begins with the birth of a baby girl, then the question of the title is posed. A range of girls and women speak about their lives and ambitions to an unseen narrator. The last sequence returns to a close-up of the first baby, which dissolves to a very old woman sitting on a bench. She ends by saying, 'What is good in life is that one forgets the bad things and remembers only the good.'

In addition, Jean wrote a treatment of Knut Hamsun's famous first novel, *Hunger*, which he had wanted to make for some time. Entitled *Yladjali*, the exotic name the starving hero calls the woman with whom he becomes obsessed, the setting of Norway 1890 was changed to contemporary Paris, and the hero's name from Pontus to Vincent, certainly with Van Gogh in mind. One scene has the destitute Vincent meeting a tramp (Boudu?) on the banks of the Seine. 'Are you happy?' he asks the tramp. The man answers that he is when he finds the right places. 'Do you beg?' asks Vincent. 'Everybody begs in one way or another,' replies the tramp.

After Jean had seen Truffaut's *Jules et Jim* early in 1962, Jean thought of Oskar Werner for the lead. Other possibilities of work are mentioned, as well as his attitudes to film at the time, in a letter he wrote to Pierre Olaf in January 1961.

'It annoys me that you will not be playing in *Juniper* in New York. [John Patrick's play *Juniper And The Pagans* which did not reach Broadway.] But the world of entertainment is impulsive and perhaps *Juniper* will fall on its feet again with you. What frightens me in our *métier* is how little power even acknowledged talented people like John Patrick have . . . Perhaps one day we'll find ourselves working together on a 16mm film in an attic studio, the only way to make films . . . A few words on some television projects. A young producer called Jack Reeves asked me for five stories which he'll give to whoever wants them. I gave him some classics adapted to modern American life. It's not a new thing – *Carmen Jones*, *Damn Yankees*. *Ali Baba* is one of my propositions and an important man at CBS sees you in the role. But it's necessary for the project to be approved by the "Network", and if their response is favourable they will take an option for two months. All these woolly phrases are to tell you that even if they stick it won't be tomorrow. I've also got some even vaguer film projects. When they are more precise I'll tell you about them. Perhaps when I know we can talk about all that here over a lentil stew. Dido continues to get up at six in the morning and is happy in her garden.'[8]

Neither *Ali Baba*, which was to be set in Chicago in the 1920s with Olaf as an Italian caught up with gangsters, or any other of these TV projects came to fruition.

A new film, however, was in the offing in France.

39

The Good Soldier

'I have the impression that purely human values, like, let's say, simply the pleasure of being with a friend, stand out. When you come right down to it, this may be what so many directors are seeking today, an explanation, an order in this chaos.'

In the spring of 1961 Jean was asked if he would consider directing a film version of Jacques Perret's World War II POW novel, *Le Caporal épinglé*. It had already been adapted by the director Guy Lefranc, who had himself been imprisoned by the Germans during the war. However, the producers thought Renoir would do a better job. It seemed to be a perfect marriage of director and subject. So Jean and Dido packed their bags once more and went off to Europe.

The producers had in mind a kind of *La Grande Illusion* revisited and got Jean and Charles Spaak, his old co-screenwriter from that film, to work together. But it was difficult to find a smooth means of co-operating again after almost a quarter of a century, and Spaak left to contribute to Philippe De Broca's swashbuckling spoof, *Cartouche*. Jean therefore asked Guy Lefranc to help him with the specifics. 'He was able to take control of everything concerning exterior truth. Freed from this enormous concern, I was able to make stabs in a more poetic direction.'[1]

As the film was to be shot in Austria during the winter of 1961–1962, Dido and Jean left for Vienna in October. However,

when Dido heard that Bessie had been taken ill, she had to leave Jean and return to the USA.

Renoir had gathered a young troupe around him, many of them having emerged with the *nouvelle vague*. They included 29-year-old Jean-Pierre Cassel, who had made an impact in three of De Broca's effervescent sex comedies, and 25-year-old Claude Brasseur, son of Pierre Brasseur of *Les Enfants du paradis* fame. Jacques Jouanneau, from *French Cancan* and *Eléna*, the young cabaret comedian Guy Bedos, and the veteran German actor O. E. Hasse, providing a delightful cameo as a drunken passenger on a train, were also cast.

Although Jean did not use the same technique of lengthy rehearsals and long takes, he did employ several cameras in some sequences when he felt the actor should play out a scene from beginning to end without stopping.

Le Caporal épinglé begins in 1940, as the Germans march into France. Despite the armistice between the two countries, French soldiers are still kept in German POW camps. The majority of the prisoners adjust to the life in spite of their homesickness and grumbles, but one young corporal (Jean-Pierre Cassel), good-looking, educated and off-beat, dedicates himself to escape. With his two best buddies, the working-class Pater (Claude Brasseur) and the bespectacled Ballochet (Claude Rich), who works for the gas board, he endeavours to climb a wall and make a run for it. The Corporal's attempts all fail, and he is sent to detention camps for punishment. Finally, he and Pater, with the help of the daughter of a female German dentist, with whom he has had a romantic interlude, get back to Paris, where they vow to join the Resistance.

Renoir treats the serious subject from a perspective of gentle comedy and with great charm, yet he manages to suggest, by a series of subtle shifts of mood, the grimmer reality beneath the surface. There is nothing in this wry, poignant and entertaining film to indicate that it was made by a 67-year-old, but rather suggests, in its unadorned, lucid, free-wheeling style, the *nouvelle vague*. Curiously, Renoir considered it 'my saddest film despite my desire to make people laugh.'[2]

The importance of friendship has always been strong in Renoir's oeuvre, and the theme is at the centre of *Le Caporal épinglé*. In the army, 'a pal's a pal; it doesn't matter what he does in civilian life,' says Brasseur, the guy from Montmartre, to Cassel, who lives on the Left Bank. Brasseur considers that in Paris they would be

divided by more than just the Seine. Here, they all muck in – the farmer (Jean Carmet), the waiter (Jacques Jouanneau), the electrician (Philippe Costelli), and the ticket puncher in the Métro (Guy Bedos), each clinging to their vocation, which allows them a personal identity.

Yet, unlike many a Hollywood and British POW film, they do not represent a stereotyped cross-section of society, but are warmly and sympathetically drawn individuals. The character played by Claude Rich – who is selected as an interpreter though he cannot speak a word of German – admits his cowardice to Cassel, the walls of the latrine acting as a confessional. When he decides to make a bolt for freedom, and 'make his dreams a reality', the low camera angle and lighting create the image of a hero. The camera remains on the faces of his comrades inside the barracks as he exits, and the sound of gunfire is the only indication given that he has been shot. This sequence, and the final escape on the train, are only two examples of Renoir at work as the supreme story teller, not always a quality brought up in discussions of great film directors.

There are obvious and intentional echoes of La Grande Illusion in the comradeship of the POWs, the inevitably brief love affair between the French prisoner and a German girl, and two men of different classes escaping prison and the social conventions that keep them apart. But Le Caporal, finely photographed in misty winter landscapes, is a film of the 1960s, eschewing grand themes and gestures for a gentle reflection on a period where people behaved at their worst and best.

In May 1962, Le Caporal épinglé opened at four cinemas in Paris. It went to the Berlin and London Film Festivals, and was Renoir's most successful film for many years. Yet Jean was furious to learn that Pathé, the distributors, had cut part of the newsreel interpolations behind his back. He protested vehemently in an article in France-Soir that the cuts had reduced the political context, essential to the theme.

Truffaut also used newsreel footage to punctuate Jules et Jim which was shot a few months before Renoir's film. Jean saw Truffaut's third feature in February 1962 on his return to Paris from Austria, and thought it 'the most precise expression of contemporary French society that I've ever seen on the screen.'

In a letter to Truffaut soon afterwards, Jean gave his reaction to Jules et Jim. 'By setting your film in 1914 you have given to your

portrait an even more exact tone because the present style of thought
and behaviour was born with those high copper-plated cars. The
suggestion of immorality that apparently caused misgivings among
certain critics seems to me to be inexplicable. The recognition of a
fact cannot be immoral. Rain wets, fire burns. Wetness and burning
have nothing to do with morality. We have passed in a few years
from one civilisation to another. The jump is more impressive than
that executed by our forefathers between the Middle Ages and the
Renaissance. It is obvious that on the other side of the gulf the
contact between human beings is different. The stone cutter who
constructed Tournus didn't think of love in the same way as he who
set the cornices at Versailles. For the Knights of the Round Table,
their sentimental adventures were the subject of a great joke, for the
Romantics, they were cause for overflowing tears. For the characters
of *Jules et Jim* it is again another thing and your film contributes to
our understanding of what could be that "other thing". It is very
important for us other men to know where we are with women and
equally important for women to know where they are with men.
You have helped dissipate the fog which envelops the essence of that
question.'[3]

By the time *Le Caporal épinglé* was released in France, Jean was
back in California, preparing for his next film project. Alas, there
was to follow what he called, 'seven years of unwilling inactivity'[4]
between *Le Caporal* and his final film. Meanwhile, in 1962, the
book, *Renoir, My Father*, was published in French and English. Of
it, Orson Welles commented: 'There are two overwhelming reasons
for reading this book. The first, of course, is the wealth of
information and anecdote about Auguste. But the second is equally
important, for it demonstrates the inspiration behind the films of
Jean, who showed his heredity in masterpieces like *Une Partie du
campagne* and *La Règle du jeu* and who surely would not have been
one of the four greatest directors this century without that
influence.'[5]

On 15 December 1962, Charles Laughton died. Jean was one of
the pallbearers at the funeral, substituting for Billy Wilder at the last
moment. 'Jean and Dido sat next to me in what is called the family
room, where the close friends and relatives sit,' Elsa Lanchester
recalled. 'Dido looked like a Goya painting in her black lace
mantilla.'[6]

In August 1963, Jean wrote to Pierre Olaf: 'We have been very
upset by the death of Clifford Odets. His death leaves a great gap,

not least for us. His death also creates problems: two children at an awkward age [Nora and Walt were 15 and 12 respectively] . . . We have seen the Curtises [Tony Curtis and his new wife, German actress Christine Kaufmann] and they spoke a lot about you. They were coming here to dinner, but we had to put them off because of Clifford's death. The last few days we were with him. He was conscious when we left him late in the evening. He died an hour later. Luckily for the children they have very good friends, notably Lee and Paula Strasberg whom you should know and who are admirable. I continue to have gall stones which gives me an excuse to do nothing. I've been approached about a television programme in which I would only have to introduce sidelights on the history of various paintings. I told them, with firm determination, to do it before my projects for films in Paris. Dido is rather exhausted by the events, by the garden, by the heat and by the dirtiness of Nénette who is getting old and refuses to do her business outside the house.'[7]

Elia Kazan, describing his friend Odets' last days in hospital, found Renoir 'the most impressive figure of all his visitors. He was truly moved, deeply and simply. He stood at Cliff's bedside, slightly stooped, a bulky man like a big loaf of peasant bread. His concentration on Cliff and his experience was total. He bent over and kissed Cliff's hand.'[8]

Jean felt the loss of Odets very deeply. Although they had 'collaborated' on the French production of The Big Knife, they were eager to work on a film together, especially one of the life of Mozart, Odets' favourite composer. 'When Clifford Odets died,' Jean said, 'I thought I wanted to leave Hollywood. He was a prince. Every gesture, every way of thinking was noble. Although I love Hollywood, I have to say it is without nobility. But I stayed, of course.'[9]

Jean continued to write synopses, but the response to them was as if he had put them in a bottle and thrown it into the sea. He could have lived happily in Beverly Hills for the rest of his life cultivating his garden, but he detested, even at his ripe age, being idle, and suffered from the absence of offers to direct. The producer of Le Caporal had suggested the possibility of a film based on Vladimir Poznar's novel, Le Lever du rideau (The Curtain Rises), for which Jean sketched an outline with Leslie Caron and Vittorio Gassman in mind, but money was not forthcoming. (The book was adapted and directed for ORTF in 1973 by Jean-Pierre Marchand.)

In the European cinema of the 1960s, there was a spate of omnibus films, in which a number of directors each shot a short episode. In

1961, Philippe De Broca, Jacques Demy, Jean-Luc Godard, Roger Vadim, Claude Chabrol contributed to *Seven Deadly Sins*; the title *RoGoPaG* (1962) was made up of the names Rossellini, Godard, Pasolini and Gregoretti; and Truffaut continued the adventures of his alter ego Antoine Doinel in a sketch in *Love At Twenty* (1962).

In 1965, Jean envisaged an episodic film called *La Mort satisfaite* (Death Satisfied). It opens in a city devastated by war where an old woman, the wife of a general, holds a discussion with Death, dressed in military uniform. She asks what sex Death is. 'Alas, madame, I don't have any. The French address me in the feminine, the Germans in the masculine. It's of no importance. Sex is a terrestrial accessory. It's an attribute of my eternal rival: Life.'

Death then describes his domain. 'Youth, age, time, distance, before, during, after, far, near, it makes you forget all these notions.' When the woman asks Death why he is dressed as a general, she receives the answer: 'It attracts my clients. I take the form of their most ardent desire . . . Men search for me with such passion that they think me superior to life.'

Death then takes the woman by the arm and leads her through eight tales (or parables) to demonstrate how people court Death and the various forms it takes; for example, a large dish of *pâté de foie gras* that a fat man eats at his peril despite his doctor's advice; a racing car; a brilliantly waxed floor, the pride of a housewife who stabs her husband to death when he soils it. The final story was based on Hans Christian Andersen's *The Nightingale*, moved from ancient China to an unspecified modern country.

The film returns to a cemetery where the old woman regains her youth as she walks to her death, arm-in-arm with her husband, also young again. It is to be regretted that this meditation on Life and Death, told with humour and sadness, by a man who was only 14 years away from his own death, never reached the screen.

Another among the many Renoir's might-have-beens was his adaptation of Edgar Allan Poe's *The Lunatics* (filmed in 1912 by Maurice Tourneur, and by Chabrol for TV in 1979) intended for a French-Italian production in which a number of directors would interpret a Poe tale. When the film came to be made as *Histoires extraordinaires/Spirits Of The Dead* in 1967, Roger Vadim, Louis Malle and Federico Fellini were the directors. Renoir was excluded.

This project demonstrated, with *Le Testament du docteur Cordelier*, *Le Déjeuner sur l'herbe* and *La Mort satisfaite*, that he was more

interested in exploring the fantastical than ever before, almost
returning to the world of *La Fille de l'eau* and *La Petite Marchande
d'allumettes*.

The Poe tale was situated in the Midi in the present day, 'not the
laughing and sunny Midi of Renoir, but the sombre and tragic Midi
of Cézanne.' Jean wanted to keep the underlying comic tone of Poe's
macabre story of lunatics taking over an asylum. If it were made in
English, he thought Tony Curtis would be perfect as the young and
innocent writer who arrives at the château, though the star was
already 41 at the time. The girl he falls for had to be 'beautiful, pale,
diaphanous and moving', and have a good singing voice if possible.
In the role of the sinister false psychiatrist who runs the asylum, Jean
wanted someone in the Jules Berry mould. (Berry, the wonderfully
smooth and evil Batala in *Le Crime de Monsieur Lange* had died in
1951.) The other actors, mostly playing lunatics, could be recruited
from the circus and cabaret. He saw it in colour, which a good
cameraman could render 'very mysterious in half-shades and in
greys.'[10]

Apollon et Alexandra told of the life of a Russian *emigré* woman in
Paris from the 1920s, through the Occupation, and up to the present
day when she has ended up poverty-stricken and ill in Aubervilliers,
a workers' area of the city. In writing it, Jean had two main aims: he
wanted to demystify the French conception of Russian women as
being 'mysterious, fatal, foolish, and extravagant' and to treat Paris
as an important character, using many of its locations.[11]

In the spring of 1966, Jean was in Paris again for the opening of the
Jean Renoir cinema at 43 boulevard de Clichy, and to negotiate with
Pierre Braunberger for a sketch film to be called *C'est la révolution!*
While there he was interviewed by Jacques Rivette, as well as
reminiscing with Braunberger, Sylvie Bataille, Charles Blavette,
Michel Simon, Catherine Rouvel and Marcel Dalio for ORTF, not
all of it broadcast.

He would gladly have exchanged all these tributes and restrospec-
tives for the possibility of working again. Now he was spending
more of every year in Europe than in California. In 1967 he helped
in the re-editing of *La Marseillaise*, and was in Montreal in August
of that year for its showing at the World's Fair.

In between the visits for work or tributes, Jean would escape with
Dido to spend a few days with her younger sister Dirce on
Merseyside, where they would relax and unwind. He loved his toast

and marmalade in the mornings, and going off to the local pubs, where the locals just knew him as 'The Frenchman'.

Jean seldom carried money with him. On Sunday midday, before he and Dirce's Norwegian-born husband would go off to the Wheatsheaf at Neston, a gorgeous thatched-roof pub, Dido would say, 'Now, Jean, you do know you're in England now. You've got to pay for your round. Now this is a pound, this is five shillings. That's for your round. You must remember Jean.' Jean would put the money in his pocket, and come back with exactly the same amount. He would forget completely about paying his round. Not because of any lack of generosity, but it somehow never came to his turn as he was always being offered drinks.[12]

The Renoirs would also visit Rumer Godden and her husband James Haynes-Dixon at Lamb House in Rye, which had once belonged to Henry James. In turn, the English couple saw Jean and Dido on trips to Paris. Once, when the two couples were driving back from Le Havre, where Jean had gone to a gathering of Les Anciens Combatants, and a showing of *La Grande Illusion*, they stopped at a restaurant in Rouen that the Renoirs remembered as serving one of their favourite dishes, *tête de veau*, many years before. During the meal, the *patron-chef* stood against the wall staring at them and frowning. Jean thought they were making too much noise and apologised to the man. 'Not at all,' said the patron. 'I was just thinking how much you looked like the film director Jean Renoir.' 'But I am Jean Renoir!' The men embraced, and a bottle of cognac was produced.[13]

Godden also remembers a visit she and her husband paid with Jean and Dido to Jean-Pierre Cézanne, the painter's grandson, and his wife and children in their apartment on the Left Bank, where he ran an antiquarian bookshop. It was sparsely furnished, with packing cases making up for the lack of chairs. There were evident signs that the family was hard-up. Jean slipped a few bank notes to the eldest boy to go for some more wine. In the car afterwards, Dido said, 'They can barely survive.' Yet all round the room, there were Cézannes pinned to the wall, paintings, studies and sketches, few of them framed. 'There is a fortune of paintings in that house,' Jean confirmed. 'But they would never think of selling any.'[14]

In January 1968, Jean made a 20-minute film called *La Direction d'acteur par Jean Renoir*, in which he was seen in action directing drama students in an extract from Rumer Godden's novel *Breakfast With The Nikolides*, which he translated into French. The Nikolides

were Greek neighbours of Godden's family in India – there are many Greeks in the jute industry in Calcutta – who had been influenced by Hindu philosophy. This aspect particularly appealed to Jean.

In the following month, Jean found himself, for the first time since the days of the Popular Front, involved in politics. André Malraux, the former Communist and once-great political novelist, now De Gaulle's Minister of Culture, sacked Henri Langlois, the controversial head and co-founder of the Cinémathèque Française. This caused an uproar, and French and foreign film-makers (including Renoir, Truffaut, Godard, Resnais, Chabrol, Bresson, Franju, Rossellini, Antonioni, Fellini and Bergman) immediately announced that they would not permit the new administration to screen their films. The demonstrations outside the Cinémathèque at the Palais de Chaillot and in the streets, which brought out the riot police, was a prelude to the explosive events of May 1968.

Jean was appointed honorary president of the Committee for the Defence of the Cinémathèque Française. Its aims were 'to re-establish the full and proper administration of the Cinémathèque, and to do everything in its power to instil respect for the integrity of the Cinémathèque and its freedom. Thus its activities will not cease with the re-instatement of Henri Langlois in his position as artistic and technical director, a reinstatement demanded by the entire film industry.'[15]

At a press conference, Jean, a 73-year-old sitting among many cinéastes less than half his age, said: 'The Cinémathèque would not exist without Henri Langlois . . . if it weren't for the Cinémathèque there would be no focus for the struggle against the horrors of commercial filmmaking. The further things go, the more we have two kinds of cinema; we have the one that makes a lot of money, and that, shall we say, stupefies the public with the most ordinary pap. Then there are the people who try to do something that's a little better. For the people trying to do a little better, the Cinémathèque was a focal point, a rallying cry.'[16]

By April, the scandal was such that the government decided to reinstate Langlois, but withdrew its subsidy. When the events of May began to shake France to its foundations, the Cinémathèque was closed down, and so was most film activity. Any hopes of Jean making a film in France were swept away at the same time, and he was soon back in the Hollywood hills far from the students' shouts of 'De Gaulle Assassin! De Gaulle Assassin!' Although Jean had a certain sympathy for the youthful anti-establishment cries, it was

the surreal phrases chalked up on the walls of Paris that he enjoyed and endorsed: *Sous les pavés la plage* (under the paving stones, the beach), *L'Imagination au pouvoir* (put imagination in power), *Libérez l'expression* (liberate expression), *La Société est une fleur carnivore* (society is a carnivorous plant), *Prenez vos désires pour la réalité* (take your desires for reality), the very things he had been expressing most of his life in one way or another.

40

Curtain Call

'I have spent my life experimenting with different styles, but it all comes down to this: my different attempts to arrive at the inward truth, which for me is the only one that matters.'

As long ago as 1965, Jean had been planning a sketch-film called *C'est la révolution!* It was to be made up of five unconnected short stories, linked only be a general theme. 'From time to time, people get fed up, they've had enough of being martyred or bored or bullied or scorned, and so in one way or another, they try to put an end to it. They revolt. But my revolts are not necessarily grand revolts. They're small revolutions . . . Yet I also have one that's a great revolution.'[1]

The first episode was entitled *La Duchesse*, which Jean hoped would star Simone Signoret, whom he had got to know well in Hollywood in the summer of 1964 when she was filming *Ship Of Fools* there. The story, set in South America, tells of a duchess who falls in love with a sailor. But the sailor is arrested because 'he once fought for the cause of the oppressed.' The Duchess becomes a dancer in a nightclub and takes to drink. Eventually, the political prisoners break out of the jail, burn the dictator's palace, and proclaim a revolution. The Duchess and the sailor are reunited.

The second was to be *Crème de beauté*, featuring Paul Meurisse. Adrienne, a beautiful and wealthy woman, is being massaged in her

bathroom by her homely-looking maid. Her lover, Gaston, an elegant, middle-aged man, arrives to see her, but is kept waiting in the drawing room while Adrienne continues her *toilette*. She tells her maid, 'What men buy is not a woman, but a doll in a box. A doll they can exhibit and that other men wish to steal. Of course, it amuses them to make love from time to time, but the main thing is the possession of a rare object. Men are collectors . . . ' However, Gaston gets so impatient that he finally goes to bed with the unattractive maid. 'C'est la révolution!' he says when they are discovered by his mistress.

The third episode was *Le Roi d'Yvetot*, a provençale tale of a cuckold; the fourth, *La Cireuse électrique*, about 'man's revolt against an electric polisher', with Pierre Olaf and Colette Brosset; and the final tale would be *La Guerre*, 'a revolt against war', featuring Oskar Werner. In this last, a battle is raging for possession of a farm in a war between two imaginary countries. Two corporals from the opposing armies find themselves together in the same foxhole. Each wishes to be taken the prisoner of the other. Eventually, they decide to exchange uniforms so that they can be captured by their own troops. One corporal, however, becomes a hero despite himself.

Unfortunately, Pierre Braunberger, who was to produce it, was refused the advance of one million francs by the Committee of Advances on Receipts of the National Cinematography Centre, part of the three million required to film *C'est la révolution!* This prompted the newspaper *Combat*, on 1 August 1966, to headline an article by Henri Chapier, 'France scandalously sends Jean Renoir back to the United States.'

Jean, in fact, remained in France for the time being, and although he still had hopes of making the sketch-film, he turned his attention to *La Clocharde*, or *En avant, Rosalie!*, the story of a female Boudu, with Jeanne Moreau, 'probably the actress I admire most.'[2] What he wanted to show, as he did with the Michel Simon film, was the desire for 'freedom through renunciation, as opposed to the belief that happiness is in production and profit . . . That is why there are people – it's the case of many hoboes, as it is of hippies – who refuse to enter this system that consists of having to work, of having to obey, of having to adopt certain forms of behaviour . . . '[3]

He had wanted to work for some years with Jeanne Moreau, since he had seen her in *Jules et Jim*. In 1964, after she had starred in Luis Buñuel's version of *The Diary Of A Chambermaid*, there was talk of Jean's directing her in *Aspects Of Love*, based on the David Garnett

novel. When neither the latter nor the *clochard* story came off, he
wrote her another scenario entitled *Julienne et son amour*, a period
piece in 'the style of Bonnard and Debussy',[4] to be filmed in a
studio. But it was far too expensive a project for any producer to
risk, particularly since they were aware that the director, notwith-
standing he was Jean Renoir, was 74 years old.

Yet he finally did get to work with Jeanne Moreau, and two of
the sketches for *C'est la révolution! – Le Roi d'Yvetot* and *La Cireuse
électrique* – survived into *Le Petit Théâtre de Jean Renoir*, shot from
June to September 1969.

Jean introduces each of the four episodes while standing beside his
little model theatre. *Le Dernier Réveillon* that opens the film is a Hans
Christian Andersen tale which returns to the studio artifice and tone
of Renoir's silent *La Petite Marchande d'allumettes*. It is New Year's
Eve, and a group of rich people are celebrating in a posh restaurant.
A scrawny, hungry tramp (Nino Formicola) stands outside in the
snow. One of the guests, who finds him 'a wonderful specimen of
hunger' (an echo of Lestingois' remark about Boudu) gives him, by
way of a joke, a few francs to look through the window at the party
while they are eating. In order to get rid of the tramp, the *maître
d'hotel* gets waiters to supply the man with champagne, caviar and
other delicacies. The tramp takes these to his sweetheart (Milly-
Monti), who is trying to keep warm under a bridge. They imagine
themselves young lovers again, waltzing in the ballroom of a
château, before falling asleep in each others arms. In the morning
they are found dead.

It is a little disconcerting to find Renoir having to give in to a
process he always despised, namely dubbing. Only a few years
before he had said, 'Accepting dubbing means refusing to believe in
the kind of mysterious connection between the trembling of a voice,
the expression . . . in short, it means that we have ceased to believe
in the unity of the individual.'[5] But the exigencies of international
co-production forced him to cast Italians as the tramp couple. Their
detached voices create a distancing effect, the cadences too refined
for the poorest of the poor, even though Renoir is applying his
theory of the nobility of individuals regardless of social status.
Nevertheless, if the tramp had been as awful-looking as Boudu, the
effect on the bourgeois revellers would have made more impact.
Moreover, fairy tale or not, a little more realism might have diluted
the sentimental whimsy of the piece, in which the worst part of

Chaplin's influence still lingers. Still, it is touching in the context of Renoir's oeuvre, because his telling of the story with such simplicity and anti-sophistication is an attempt to regain the enthusiasm of his beginnings in the cinema.

La Cireuse électrique had been in Jean's mind for many years. It has its roots in his own family. He remembered the story of how his maternal grandfather, M. Charigot, ran off to America when his wife objected to his soiling her meticulously waxed floors, and his father's interdiction of the waxing of floors in case the children might fall. As a result the house where Auguste lived always smelled of Eau de Javel, as everything was washed down with it. The story also derived from a remark that Salvador Dali once made after Jean told him that he would like to make a film with Anna Magnani. 'Yes, and you should do a script about a woman in love with a wheelbarrow,' the surrealist painter suggested. Jean had forgotten about it, until he came to make *La Cireuse électrique*.[6]

Émilie (Marguerite Cassan) is obsessed with keeping her floors waxed and shiny. One day, a salesman (Jean-Louis Tristan) sells her an electric floorpolisher, the answer to her dreams. Unfortunately, her husband Gustave (Pierre Olaf) slips on the floor and is killed. On the wreath is marked 'Hero Of Household Progress.' Jules (Jacques Dynam), her second husband, is driven mad by the sound of the machine, and finally flings it out of the window. Distraught, the wife throws herself after it, plunging to her death. The ironic moral: 'To attack a human being is regrettable but to attack a machine is abominable.'

The satiric sketch was shot in and around an ugly new building, still under construction, called Résidence 'Grand Siècle', which allowed Jean a touch of Jacques Tati, with whom he shared the nostalgia for the old, *petit-bourgeois* Paris, with its picturesque *quartiers*, the corner bistro and accordion music; and Tati's hatred of the Paris of commerce, high-rise buildings, neon-lit drugstores and traffic jams. The interiors were shot in a small room with one camera and direct sound. Incidentally, during rehearsals, when Olaf is supposed to slip on the waxed floor and die, Marguerite Cassan fell and broke her arm.

La Cireuse électrique, in which a chorus sings directly to camera in a Brechtian mode, is a liberating lampoon made with simple means, taking domesticity to its lunatic extreme as the wife dances with the machine, almost making love to it.

'Quand L'Amour meurt' (the song Marlene Dietrich sang in

Morocco) provides a musical interlude before the final episode. Jeanne Moreau, dressed in a costume of *La Belle Époque*, a yellow dress trimmed with black lace and blue straps, black gloves, and wafting a yellow fan, sings the Octave Crémieux song in a high, small but affecting voice. According to Renoir, it 'takes us for a little while outside our century of sleazy progress.'[7]

The final story, *Le Roi d'Yvetot*, is Renoir out of Pagnol. Duvallier (Fernand Sardou) is blissfully in love with his young wife Isabelle (Françoise Arnoul). When she falls in love with a vet (Jean Carmet) who had come to attend to their dog, Duvallier is heart-broken. But he learns the virtue of tolerance, and decides that it is better to share his wife than lose her. The community becomes united in a game of *pétanque*, 'which I firmly believe to be an instrument of peace.' The extremely amiable anecdote, shot in natural settings in the Midi, ends with the cast coming forward to take a curtain call.

There was to have been a fifth sketch, but it was abandoned at a late stage. It was entitled *La Petite Pomme d'Api*, and involved an upper-class woman and three of her younger relatives on a chauffeur-driven trip through the countryside. Their large limousine gets stuck in a muddy section of the road, whereupon they make for a rundown farmhouse in order to hire oxen to draw the car out of the mud. A comic encounter with the unimpressed peasants ensues, and the *grande dame* finds the whole episode amusing, pretending that she is at one with nature.

Le Petit Théâtre de Jean Renoir was the director's valediction to the cinema, surely a fact of which he was conscious while making this *divertissement* which offers a summation of his career, from the silents, to the social concerns of the 1930s, to the visions of an ideal France, and an unregretful reminiscence of the days of his youth. His feelings are echoed in the song that Moreau sings so wistfully: '*Lorsque tout est fini/Quand se meurt votre beau rêve/Pourquoi pleurer les jours enfuis.*' (When everything is over/When your beautiful dream dies/Why cry for the days that have flown by.)

PART VII

THE ONENESS OF THE WORLD (1970–1979)

From too much of living,
From hope and fear set free,
We thank with brief thanksgiving
Whatever gods may be
That no man lives forever,
That dead men rise up never;
That even the weariest river
Winds somewhere safe to sea.

The Garden of Proserpine (Swinburne)

The Oneness of the World

'My French friends all ask me the same question: "Why have you chosen to live in America? You're French and you need a French environment." My answer to this is that the environment which has made me what I am is the cinema. I am a citizen of the world of films.'

Jean returned to California in October 1969, after paying his last visit to Essoyes for the funeral of his younger brother Coco, who had died aged 68. During the shooting of *Le Petit Théâtre*, the director had suffered greatly from pains in his leg, and needed a long rest, a fact confirmed when he went for a check-up at the Scripps Clinic in La Jolla.

His wounds oozed a lot, and he was in severe pain when he stood up for any length of time. However, his secretary, Ginette Doynel, considered him a hypochondriac and discouraged his taking too many pills, a habit to which he was prone. She told Leslie Caron, 'If he saw you taking pills for your menstruation he'd ask for one and take it.'[1]

Dido became Jean's protector from the moment he was diminished by illness. Not because his faculties were reduced but because his fatigue was such that he could not put up with long and tiring visits. She had always been in his shadow when he was well and working, now she ran everything. Dido estimated that as so many people wanted to visit Jean, she would only allow those whom she considered intimates, which included Leslie Caron, François

Truffaut, Alexander Sesonske, Nicholas Frangakis, who had re-entered secular life, Peter Bogdanovich, Norman Lloyd, Louis Malle and, of course, Jeannot Slade. Instinctively, his most intimate friends, when they saw Renoir was tired, would withdraw to let him rest.

Dido, who had been an extremely shy person when younger, had a somewhat haughty, insolent and blunt manner with people she disliked. She hated 'pests' taking time away from Jean's work. When Truffaut and Rivette were younger they were terrified of her, and when Michel Simon used to call Jean at two in the morning and say 'Oh, I feel lonely', Dido used to pick up the phone and say, 'For God's sake, leave Jean alone.' Pierre Renoir's grandson Jacques complained that Dido often prevented him from visiting his grand-uncle. Perhaps Dido judged that Jacques, though he fell into the category of family, was of another generation and had not seen a great deal of Jean over the years.

When Jean said that he did not feel like getting up or doing work, she would say, 'Yes, yes, of course you can.' It was her way of fighting his illness. Alain looked upon her as his mother, and she regarded him as her son. Sometimes, though a distinguished profes-sor of Old English at Berkeley, Alain would behave like a child to get her attention. Jean and Alain were very much alike, 'two, noisy brilliant people',[2] often sharing vulgar, barrack-room jokes, which met with Dido's pretended disapproval.

Dido often seemed to manifest jealousy of any woman who came too close to her husband. This had revealed itself when Jean was working closely with Rumer Godden, which sparked off rows. As she was a temperamental woman, she could not hide her feelings. 'I think in my case her jealousy was very slight and she controlled it,' commented Leslie Caron. 'I considered Jean my father. He was not a flirt but he had such a welcoming nature he couldn't refuse any relationship, whether it was a dog or a hobo. In fact, when he was working anyone could give him advice.'[3]

Although Madeleine Morgenstern had not seen Dido for 20 years, she was the first person she contacted after the death of François Truffaut in October 1984. They met about a year later in California, and went to Truffaut's favourite restaurant as a kind of pilgrimage, and drank the champagne he had liked. During the meal, a youngish man at another table came over to Dido, who was then in her late seventies. 'Excuse me, but I was listening to you, and you seem to me an exceptional person.' He didn't know who she was, but made

a platonic declaration of love. After he had left, Dido said, 'He's mad, he's mad that man.'⁴

Despite his comparative isolation, idleness and illness, Jean continued to take a passionate interest in everything around him, and kept up with developments in the cinema. News came from Paris that *La Vie est à nous* had been successfully shown to the public for the first time, and had featured on the cover of the November 1969 issue of *Cahiers du Cinéma*. Since 1968, the magazine had gone through a few editorial policy changes, reflected in their views of Renoir's films. When Bazin was editor, *Cahiers* praised his Hollywood and post-war European films above all. Gradually, under the influence of structuralism, it began to take a more Marxist position, its attitude crystallising after the events of May 1968. It rejected the humanism in Renoir, but embraced the films of the Popular Front such as *Le Crime de Monsieur Lange*, *Les Bas-Fonds*, and *La Marseillaise*.

At the end of 1969, *Cahiers* was in financial trouble because a major shareholder, French publisher Daniel Filipacchi, objected to the editorial policy and sold his shares. The magazine closed down for a while but survived. In a letter to François Truffaut in November, Jean wrote: 'It seems to me that *Cahiers* must emerge intact from these difficulties. It cannot be otherwise. We need it; it is the conscience of the cinema.'⁵

Jean continually showed an avid interest in the work of younger directors, and had seen Rivette's *L'Amour fou*, which plays with notions of theatre and film. 'When you see Rivette tell him that I'll never forget his film,' he continued in the letter. 'I hope you find in Toledo [Spain] the peace you need for the birth of your scenario. I don't know whether *Bed And Board* [the English title of *Domicile Conjugale*] is a good title. I don't speak English well enough to judge. It pleases me and if I saw it at the entrance of a cinema, I would go in without hesitation.'⁶

Jean was one of the first people to whom Truffaut sent a copy of *Les Aventures d'Antoine Doinel* (the published scripts of the four films with Jean-Pierre Léaud as the eponymous hero, whose name derived from Renoir's longtime secretary, Ginette Doynel), though Jean had not yet got round to reading it when he wrote to Truffaut in December 1970. 'Your letter was like the morning dew. It banished my nightmares. I won't go so far as to say that it restored my health, but it helped me out of a certain stagnation due to the impossibility

of my overcoming unpleasant dizzy spells. All the same, I think that I'm coming to the end of my troubles, and that I will be able to look at life and participate in it instead of being content to be on the sidelines, which is a depressing position to be in. Imagine that I haven't yet started to read *Les Aventures d'Antoine Doinel*. I will fall upon it today in order to absorb your work, not as a passive actor but as a companion on an adventure. I have not seen your latest film [*L'Enfant sauvage/Wild Child*]. All my friends around me in whom I have confidence dream of the film and consider it a masterpiece. I will rush to it at the first opportunity.'[7]

However, Jean found it more and more difficult to get around, and had little inclination to do so. He did possess copies of a number of his own French films, which he had screened quite often from a projector normally hidden behind a Cézanne at one end of the living room.

In another letter to Truffaut, in which he agreed to write the preface for a book on André Bazin's articles, Jean still seemed to have a faint hope of making *Julienne et son amour* with Jeanne Moreau. 'I haven't made progress on the film I want to make with her [Moreau]. It's perhaps because I now have all the material means to make it. But, alas, I lack the spiritual means. I feel an enthusiastic admiration for her and I would like to present her with a story worthy of her. I have to admit that up to now I haven't been able to do it. I am undergoing rigorous treatment in the hope that I will emerge from this unbearable fatigue. The results so far have not been brilliant.'

Leslie Caron tried to help him regain his vitality by giving him a pep drink recommended by Adele Davis, a well-known homeopathic nutritionist in whom she believed. She would come every day and give him a special concoction of vitamins. Jean took the potions for about a week, but when Caron called in to see him one day, she was informed that he had been taken to hospital with a serious intestinal blockage. 'I was horrified and I went to the hospital to see him,' Caron recalled. 'Dido was there. They explained that the cause was the potions I'd given him. I told them that they contained only natural ingredients – wheatgerm, vitamins and so on. The doctors insisted that the drinks had caused the blockage and I felt terribly guilty. Yet, I must admit that everyone knew that Jean, like Luther, was either constipated or had diarrhoea throughout his life. So it was nothing very new, but it seems he had been constipated for a week while he was taking my daily potion, and then became terrified that he was going to explode or had cancer, so

he went to the hospital for a check-up. He was given an enema, and left the hospital a few days later. Nobody actually blamed me directly, least of all Jean.'⁹

Not long after, in May 1971, Orson Welles, who was also having trouble getting his films made, wrote to Jean to ask him if he would make a short film with him about directing. Renoir had to decline because of ill health.

On 28 February 1973, Hollywood Television Theatre presented a production of *Carola*, written in 1957. It was produced and directed by Norman Lloyd, with decor by Eugène Lourié, and starred Leslie Caron and Mel Ferrer. 'The pay was very small, but we were working together to do something good,' recalled Caron. 'However, Mel Ferrer made some stink with the unions, because we were working long hours.'¹⁰

Renoir prefaced the play with a reference to Kipling's *Jungle Book*, where Mowgli, faced with a family of cobras, says to them, 'We're of the same blood, you and I.' Touched by the wild boy's good manners, the snakes put down their hoods. 'My great wish,' Jean writes, 'is that the snakes will realise that other creatures are of the same blood as them.'¹¹ Although this refers generally to the oneness of nature and humanity, the snakes are a particular reference, in the context of the piece, to the Nazis.

Carola takes place during and after a performance of Alfred de Musset's *Chandelier*, at a theatre in Paris under German occupation in World War II. The single set is the dressing-room of Carola Jansen (Caron), a celebrated actress, and an adjacent corridor. The Gestapo are looking for Henri Marceau (Michael Sacks), a young member of the Resistance. Between acts, he enters Carola's dressing-room, ostensibly for an autograph. When she finds out that he is on the run, she hides him in the cupboard before going back on stage. Von Clodius (Ferrer), a German general, who was Carola's lover some 12 years previously, comes to visit her. Marceau is discovered by Von Clodius, who does not give him away. On the return of Carola, who is carrying on an affair with Campan (Anthony Zerbe), the director of the theatre, she helps the young man escape, and faces Von Clodius. It gradually emerges that they still love each other. Von Clodius wants to flee the country with Carola (via Portugal to the USA as Jean and Dido had done), but she refuses. 'I won't abandon my comrades who haven't the chance of being the mistress of General Von Clodius.'

Although a conventionally structured three-act boulevard drama, with some rather contrived exits and entrances, *Carola* is full of wise and witty lines, reflecting many of Renoir's preoccupations that had resounded through his works over the years – the *ménage à quatre*, the idiocy of war, the way the love of art links civilised people of different nationalities, the blurred line between theatre and life, illusion and reality, a suspicion of 'progress', and the need to put duty to others before oneself. Carola is a sister of Camilla and Eléna, hedonistic women who know when to make a sacrifice; Von Clodius, 'the last gentleman in the German army', is a brother of Von Rauffenstein; Campan, the cowardly director of the theatre who turns hero, and Marceau, the Resistance fighter, resemble Charles Laughton's teacher and his antithesis (Kent Smith) in *This Land Is Mine*.

Truffaut's *Le Dernier Métro* (1980) bears some resemblance to the plot of *Carola* – it was set in Paris in 1942, in a theatre, in which a young member of the Resistance finds refuge, and the Gestapo are very much in evidence. When Pierre Olaf, who always thought that Truffaut traded on his relationship with Renoir, first saw the film, he exploded. '*Merde!* Truffaut has gone too far this time, I thought. What made me angry more than anything was that it was Jean's film. It's *Carola*, I said. It's exactly the same story.'[12] However, no matter how many of the incidentals might have been similar, the central romance between the German general and the French actress in Renoir's play, does not figure at all in the Truffaut film, the screenplay of which was written a few months after Jean's death.

It was around 1973 that Jean Renoir suddenly got it into his head that he would not walk any more. There was nothing clinically wrong; nobody could explain it. One day, after a dizzy spell, he sat down and claimed that he was unable to walk. Truffaut felt that Jean was convinced that at one point in his life he would become paralysed like his father. It was firmly embedded in his mind. In July 1973, Truffaut, on one of his tri-annual visits to Hollywood, wrote to his friend Helen Scott, 'Every Saturday afternoon I go and see Renoir, he's very old and very tired, he refuses to walk, it's not that there's any real physical cause, he simply refuses, but he comes to life every afternoon when dictating his memoirs to a French secretary.'[13] Eventually his fingers had become very pointed, and could no longer hold a pen.

Leslie Caron tried to make him walk by walking backwards in

front of him, and holding out her hands and saying, 'Come on, Jean, you can walk, you can walk. That's it, you're walking, you're walking. You can do it.' And like a child, he would look at her and smile and take a few pathetic steps. 'At one point he just took to the wheelchair as if he went to the convent,' said Caron. 'He had been more subdued ever since returning from making his last film in France. He gave up then. He decided to have another profession. To be ill. Something had clicked in him. It may have coincided with some date in his father's life not being able to walk anymore. I think he could have walked much longer had he wanted to. For a long time one wanted to know why he was in a wheelchair. The whole ceremony of getting up from the bed with the male nurse into the wheelchair, amused him. Like his father.'[14]

But his mind continued active, bubbling with ideas for screenplays and novels. As he could not physically write himself, he had a number of bilingual secretaries to take his dictation and handle his correspondence.

Eva Lothar, a Frenchwoman studying at the American Film Institute in Beverly Hills, was asked if she would consider working for Jean Renoir, taking notes for a novel a few days a week. Lothar jumped at the chance to sit at the feet of the master. In addition, she had made an Impressionistic documentary film on Cannery Row, which she hoped to show Jean.

During the first few days, Jean started dictating a novel about the memories of an old man dying in a hospital. However, in between narrating the story, he would reminisce about his own life. This led Lothar to suggest that Jean should rather write a book about his experiences in making films over the years. The novel was abandoned and he began dictating his memoirs, which were to become *My Life and My Films* (1974).

What started as one or two days' work a week was extended to a daily session from two till five in the afternoon. Jean would lie back on his reclining armchair, looking out on the garden through the french window, and speak about his life, while Lothar sat beside him, a notebook on her lap.

As the book took shape, Lothar said to Jean, 'I feel it's a great privilege being with you. A lot of people would like to be in my position. Why not let me make a film of you talking, so that audiences can share that privilege.'

At first, Jean resisted, saying he was far too old and ill, but gradually, as Lothar explained her ideas about it, he grew more

interested. She felt that it should be a series of conversations on different themes with different people: for example, a discussion of 'love' with Jeanne Moreau, and one on 'sex' with Henry Miller, with whom Jean had corresponded.

They were all ready to set up the film when Dido pulled the plug. She felt, rightly or wrongly, that it would be too tiring for him, and that she did not really want audiences to see Jean as this frail, thin, softly-spoken old person. She wanted people to remember him as the burly, boisterous and active man with the resonant voice, who had appeared in films and documentaries previously.

Dido also had the feeling that Jean and Lothar had been plotting behind her back, and she made conditions rather difficult for the young secretary. 'Dido became so insulting and unpleasant that I finally decided to leave,' said Eva Lothar.[15]

She was later replaced by Luli Barzman, and then by her 22-year-old brother Paulo. They were the children of Ben Barzman, a screenwriter who had been forced into self-exile in Europe as a victim of McCarthyism. Jean was also devotedly looked after by Greg Giacoma, a film student at UCLA, who acted as his nurse.

Jean described his physical condition in a letter to Truffaut in November 1974. 'I continue to have illusions about my state of health. It seems that illness is a well-defined kingdom with its frontiers, customs and even its own language. When one is ill one becomes rather childish. One gets used to having people around you constantly rendering you small services, above all, in my case, where I am prevented from using my legs. I adapt to dependence with difficulty. What's more, I'm a perfect coward. I have a horror of suffering and when I'm in pain I like to cry out. However, it seems to me that our civilisation doesn't approve of yelling, the only noise it approves of is mechanical.'[16]

In the middle of dinner one evening, Jean suddenly turned to his friend Pierre Olaf, and said, 'I feel very happy, Pierre, because I know I will die before you.' Olaf was dumbstruck, and could hardly restrain his tears.[17] It was another example of a sentiment expressed by Jean, that might have sounded self-regarding on the lips of anyone else. But Renoir was, of all the great artists of the twentieth century, one of the least pretentious.

In February 1975, he travelled for the last time to Europe to be present at the National Film Theatre in London for the largest retrospective season of his films ever assembled. Dido was unable to come with him, because Bessie, who by then was suffering from

cancer, had returned to settle in England, and she did not dare leave
the house with all the paintings. Ginette Doynel, who handled
Renoir's affairs in France, met him and took him to stay at Brown's
Hotel in Mayfair. Dirce Vogt, Dido's sister, came down from
Merseyside to see him and attend the opening reception at which
Jean, in his wheelchair, made a speech of thanks. The next day,
Ginette asked Dirce to help her out. 'Jean gets so exhausted and all
these reporters come and he's too kind to tell them to go. They
won't listen to me because I'm just a secretary, but could you, after
about five minutes go in and say, "Excuse me, gentlemen, but
Monsieur Renoir must have a little rest." '[18]

Back home in Beverly Hills, Jean and Dido watched the Oscar
Ceremony in April 1975, at which Ingrid Bergman accepted a
Special Honorary Award on his behalf. Bergman said that Renoir
had created films with intense individuality, and that his lyric eye,
poetic realism and, above all, his compassion marked all his work;
that he was a lover of mankind in all its nobility despite its folly. 'In
gratitude for all you have taught the tribes of young movie makers
and the audiences all over the world, I stand here to say with them,
Thank you, we love you, Jean.'

The official phrasing of the Academy was 'To Jean Renoir, a
genius who, with grace, responsibility and enviable devotion
through silent film, sound film, feature, documentary and television,
has won the world's admiration.'

By the end of the year, Jean was able to go out from time to time.
He went to see Woody Allen's *Love And Death*, and *Cabaret*. Of the
Allen film, he commented, 'His work is truly cinematic. He has
rediscovered some of the spirit of the early American directors.'
About the Bob Fosse musical, he felt, 'I am not in a good position
to judge the film having experienced that period in Berlin for
myself.'[19]

In the last years, still the compulsive story-teller, Jean dictated
three novellas, which drew from tales of his childhood, *Le Coeur à
l'aise* (1978), *Le Crime de l'Anglais* (1979), and finally *Geneviève*,
completed a few weeks before his death. The latter concerned a
wheelchair-bound girl who dies of love for a student.

It is likely that Jean wanted to end his days in France, content as
he was in his home in Beverly Hills, though he was not fond of
Hollywood. 'He had a real French soul,' explained Nicholas Fran-
gakis. A year after Jean's death, Truffaut wrote to a friend: '[Abel]
Gance imagines he would be happier in California, but it won't take

him long to realise that it's not the sort of country in which old people are treated with love and respect; I can't forget the loneliness of Renoir, who realised how happy he had been in Paris.'[20]

But it was far too late to make a change, and anyway Dido would never have gone back to France, to which she was not all that attached. She adored the sunshine, the house and her garden. She also felt more important to Jean in California than in France, where there were more people to lionise him.

Every time Leslie Caron's visits to Los Angeles ended, Jean would be the last person she would go and say goodbye to, generally on her way to the airport. In the final years, he would ask Greg to wheel him out in the courtyard to save Leslie time if she were in a hurry. When Ingrid Bergman, who was touring in *The Constant Wife*, went to see Jean he had Parkinson's Disease. The actress whom he had made laugh again, held his hand and talked to him of the past.

'Even when he could hardly talk any more, there was a burning light, like being in the presence of a saint,' Leslie Caron stated.[21]

When Jean became incapacitated, some of the Benedictine monks from the monastery in the Mojave Desert would visit him. The ailing artist and the men of God found mutual consolation in each other's company. On Christmas Day 1978, two of them arrived to celebrate mass with Jean, who took communion. Although he used to go to mass with Dido almost every Sunday, and accepted the Catholic faith, Jean never felt restricted by it. He was equally at home with Hindus, Jews, Protestants and atheists as he was with Catholics. He very rarely spoke of God or religion. His films are free from piety and barely touch on organised religion, unlike the atheist anti-clerical Luis Buñuel, whose work is steeped in Catholic imagery.

Like Auguste before him, Jean 'considered the world as a whole, comprised of parts which fit together, and that its equilibrium is dependent on every piece.'[22] The expression 'the oneness of the world' often passed Jean's lips. Despite the vast range of styles, subjects and genres that Renoir's films covered, one could also speak of the 'oneness of the work'.

On the morning of Monday, 12 February 1979, Jean spoke to Dido about an idea he had for a new novel. While waiting for Paulo Barzman to arrive so he could start dictating, Jean Renoir, aged 84,

died peacefully while dozing in his wheelchair by the window which looked out on the olive tree that his father had painted.

Four days later a funeral mass was held at the Church of the Good Shepherd on Santa Monica Boulevard, accompanied by Gregorian chants. A lunch for the family and friends was held afterwards at the Hotel Bel Air. (Greg Giacomo was not invited because Dido disapproved of his wife.) When the time came to pay the bill nobody had any money. Dido and Alain had forgotten their credit cards and their chequebooks. 'Jean would have laughed so hard at all of us standing there with no way to pay the bill,' recalled Dido.[23]

Early in March, Jean was buried in the same plot as his father, mother and brothers in the little graveyard at Essoyes.

Dido continued her life at Leona Drive, surrounded by the friends who seemed to keep Jean's presence alive for her. She also kept on Paulo as a secretary 'in memory of Jean'. 'I am trying to take up a normal life again,' she wrote to Truffaut in May. 'It's not easy. Norman Lloyd asked me to see *Boudu*. It is too early to show it without Jean in the house. Disastrous for me.'[24]

Thereafter Dido became the curator of Jean's memory, as well as trying to classify many of his piles of papers, looking after the house, and tending the garden. On 7 May 1990, Dido died aged 81 at the Beverly Hills home where she and Jean had lived since 1949. On 6th June, she was buried beside her husband at Essoyes. Dido Renoir was not credited on Jean's films but her imprint will remain on many of them forever.

Envoi

I am 80 years old

I am 80 years old. Of what does it consist? Physically, I am a little tired, but not more than yesterday or last month. Does there exist a uniform for living to an advanced age? Old age is hypocritical and jogs along without knowledge of its victims.

I examine myself carefully in the mirror. My face hasn't changed. The features are the same, but that doesn't say very much: have I not repeated a hundred times that human beings wear masks?

What I have before my eyes is nothing but an appearance. Behind this appearance, I sense another person, a secret and mysterious person who often acts in defiance of my will; another me who is only waiting for the opportunity to absorb

me. I feel panic-stricken. I find the idea of living with this invading ancestor unbearable.

But at the same time I am won over. I have decided that the person that I discover in the mirror pleases me: it is not the 'noble head of an old man', better still it has an expression of ironic wisdom *à la* Voltaire. My nose is obviously too small for its purposes. But wasn't this characteristic a sign of nobility in the Russia of the Tsars?

It reminds me of something I read in my childhood. A young Russian aristocrat, a perfect gentleman, brave officer, enjoying considerable support, dreamed of being admitted to the ranks of a celebrated regiment, Préobragenski. One of the conditions required for entry to the elite corps was to have a small nose. The enormous nose of our candidate prevented him from being accepted. During a charge against the Turks, the officer had his nose cut by a yataghan. Seeing himself thus transfigured, he presented himself again as a candidate. The Tsar, moved by such persistence, intervened and personally gave him the insignia of the illustrious regiment.

But I have wandered far from my mirror. Definitely, arriving at this phase of my life, I'm incapable of following a line. I have the impression of being a bird . . . a large bird that pecks at random a variety of the fruits of the orchard. I have often proclaimed my distrust of planning and even if I was at liberty to describe the things that interest me, I would have been drawn towards a sort of anarchic literature. Therefore my greatest joy in these last years was to orchestrate the disorder of my film, *The Little Theatre of Jean Renoir*. Luckily for me, I found people who liked this chaos. I hope that these same friends will be amused by the memories that I threw higgledly-piggledly into my last book *My Life and My Films*, and that they will find in it a more faithful image to myself than that which my mirror throws back to me.

For after all, I have been happy. I made the films that I wanted to make. I shot them with people who were more than collaborators, they were my accomplices. That is, I believe, a recipe for happiness; to work with those people that one really likes and who like you. The advantage of being 80 years old, is that one has a lot of people that one loves.

Jean Renoir, Beverly Hills, 27 August 1974.[25]

Acknowledgements

I could not have written this biography without Alain Renoir's opening doors for me onto the world of his father. I'll never forget how warmly he welcomed me at a time of great sorrow for him, a few days after the death of his 'mother'.

Through him, I was put in touch with a number of people who took a great deal of time and trouble to share their memories of Jean Renoir, many of them supplying me with letters, photos and delicious meals. Jean Griot in Louvenciennes; Maurice Renoir and Aline Cézanne in Fontainebleau; Jacques Renoir at Cagnes; Rumer Godden in Scotland; Hurd Hatfield in Ireland; Dirce Vogt in Merseyside; Leslie Caron, Pierre Olaf, Madeleine Morgenstern, Louis Malle and Eva Lothar in Paris; John Slade, Nicholas Frangakis, Arthur Friedman, Alexander Sesonske and Robert and Jeanne Weymers in California. I'm also extremely grateful to my friend and colleague Robyn Karney, who always manages to turn the job of copy editing into one of artistic collaboration, and to Clive Hirschhorn and Joel Finler for their invaluable help and advice.

If it hadn't been for Alain Renoir, I would not have met Alice Fighiera, an extraordinary 94-year-old woman, whose memory was as clear as the azure sky above Nice, where we sat talking in a spectacular restaurant overlooking the Bay of Angels. Alice recalled having seen Auguste Renoir painting in the gardens of Les Collettes, and the day on a boat on the River Loing in the forest of Fontainebleau, when Jean suggested for the first time that he should make a film.

'Oh, how much I loved Jean, *mon Dieu!*' Alice exclaimed. 'I saw Jean happy, I saw him unhappy, I saw him in his youth, I saw him in his old age. I knew him very young before marriage, during and after. In all circumstances he was the same man. Loyal. Good. Generous.' Then she sighed and lifted her glass of white wine. 'Chin chin. To our friendship. Ah, Jean would have enjoyed our conversation. If only he were here . . . ' Then, pausing for a moment, she said, 'He *is* here!' I felt something other than a shiver of pleasure at her company and the exquisite meal and the superb wine and the breathtaking view. I felt the personality of Jean Renoir in the room.

Wait for us, Jean.

Ronald Bergan, St Albans, March 1992

Footnotes

Abbreviations

MLMF	*My Life and My Films*, Jean Renoir (Collins, 1974)
RMF	*Renoir My Father*, Jean Renoir (Collins, 1962)
NOCG	*The Notebooks of Captain Georges* (*Les Cahiers du Capitaine Georges*), Jean Renoir (Gallimard, 1966)
OCI	*Oeuvres de cinéma inédites*, Jean Renoir (Gallimard, 1981)
S&S	'Discovering America: Jean Renoir 1941', Alexander Sesonske, *Sight and Sound* (Autumn 1981)
Bazin	*Jean Renoir*, André Bazin (Éditions Champ Libre, 1971)
Écrits	*Écrits 1926–1971*, Jean Renoir (Pierre Belfond, 1974)
Entretiens	*Entretiens et propos*, Jean Renoir (Cahiers du Cinéma, 1979)
Sesonske	*Jean Renoir: The French Films*, Alexander Sesonske (Harvard Film Studies, 1980)
Lettres	*Lettres d'Amérique*, Jean Renoir (Presse de la Renaissance, 1984)
HWFR	*A House With Four Rooms*, Rumer Godden (Macmillan, 1989)
Truffaut	Letters to François Truffaut in the archives of Les Films du Carrosse (supplied to author by Madeleine Morgenstern)

★ The quotes at the beginning of each chapter are all from Jean Renoir. Their sources are indicated below.

Chapter 1: A Chateau In Montmartre
★*RMF*　1 Ibid.　2 Ibid.　3 Ibid.　4 *Correspondance de Berthe Morisot* (Paris, 1950)　5 *RMF*　6 Ibid.　7 Ibid.　8 Jean Griot to author

Chapter 2: *La Belle Époque*
★*MLMF*　1 *RMF*　2 Ibid.　3 Leslie Caron to author　4 Rumer Godden to author　5 Ibid.　6 Jean Griot to author　7 *Renoir: Catalogue et l'exposition de mars 1913*, Octave Mirbeau and P. Forthuny　8 *Correspondance de Berthe Morisot* (Paris, 1950)

Chapter 3: The Little Theatre of Little Jean Renoir
★*MLMF*　1 *Renoir et ses amis*, Georges Rivière (Paris, 1921)　2 *RMF*　3 Ibid. 4 Ibid.　5 *MLMF*　6 Ibid.　7 *NOCG*　8 *MLMF*　9 *Les Archives de l'Impressionisme*, L. Venturi (Paris, 1939)　10 *Renoir peintre de la femme*, Gustave Geffroy (1920)　11 *RMF*　12 Leslie Caron to author　13 Bazin　14 *MLMF* 15 Ibid.　16 Ibid.　17 Ibid.　18 *RMF* 19 Ibid.　20 Ibid.　21 *MLMF* 22 Ibid.　23 *RMF*　24 Ibid.　25 *MLMF*　26 Ibid.　27 *RMF*　28 *MLMF* 29 Ibid.　30 *RMF*　131 *MLMF*

Chapter 4: A Champagne Childhood
★RMF 1 Ibid. 2 *MLMF* 3 Ibid. 4 *RMF* 5 Ibid. 6 *Entretiens* 7 *RMF*
8 Ibid. 9 Ibid. 10 Ibid. 11 *NOCG* 12 *RMF* 13 Ibid. 14 Alice Fighiera
to author 15 *RMF* 16 Ibid. 17 Pierre Olaf to author 18 *Renoir: The Man,
The Painter and His World*, Lawrence Hanson (Frewin, 1970)

Chapter 5: Painting Paradise
★RMF 1 *Les Archives de l'Impressionisme*, L. Venturi (Paris, 1939) 2 *MLMF*
3 Leslie Caron to author 4 Alice Fighiera to author 5 Maurice Renoir to
author 6 Pierre Olaf to author 7 Alice Fighiera to author

Chapter 6: The Rules of War
★MLMF 1 Ibid. 2 *RMF* 3 *NOCG* 4 Ibid. 5 *RMF* 6 Alain Renoir to
author 7 *NOCG* 8 *RMF* 9 Ibid. 10 Letters supplied by Aline Cézanne
to author 11 *Les Archives de L'Impressionisme*, L. Venturi (Paris, 1939)
12 *RMF* 13 Ibid 14 *MLMF* 15 Ibid. 16 *RMF* 17 *The Story of
Philosophy*, Will Durant (Garden City Publishing, 1938) 18 *RMF* 19 Ibid.

Chapter 7: A Fearsome Beam of Light
★MLMF 1 Ibid. 2 Ibid. 3 Ibid. 4 Ibid. 5 Ibid. 6 Ibid. 7 *King of
Comedy*, Max Sennett (Doubleday, 1954) 8 *MLMF* 9 Ibid.

Chapter 8: The Golden Muse
★RMF 1 *Renoir*, A. Vollard (Paris, 1920) 2 *RMF* 3 *Dictionnaire de l'art
contemporain* (Larousse, 1965) 4 Ibid. 5 *RMF* 6 Alice Fighiera to author
7 Ibid. 8 Ibid. 9 *MLMF* 10 *Renoir*, A. Vollard (Paris, 1920) 11 Ibid.
12 *Auguste Renoir*, Georges Besson (Paris, 1929) 13 *Télé 7 Jours* (1973)
14 Ibid. 15 *RMF* 16 *NOCG* 17 *MLMF* 18 Alice Fighiera to author
19 *Télé 7 Jours* (1973) 20 *RMF*

Chapter 9: Opening Sequence
★MLMF 1 Ibid. 2 Alice Fighiera to author 3 *Le Point* (December 1938)
4 *MLMF* 5 *Télé 7 Jours* (1973) 6 *MLMF* 7 Ibid. 8 *Cinéma* (June 1961)
9 *Cinéa-Ciné* (January 1926) 10 Alice Fighiera to author

Chapter 10: Forest Murmurs
★MLMF 1 Alice Fighiera to author 2 *RMF* 3 *MLMF* 4 *RMF* 5 *MLMF*
6 Sesonske 7 *MLMF* 8 Ibid. 9 Ibid. 10 Ibid.

Chapter 11: Femme Fatale
★MLMF 1 Ibid. 2 Ibid. 3 *RMF* 4 Ibid. 5 Ibid. 6 Ibid. 7 *Entretiens*
8 Alice Fighiera to author 9 *Le Point* (December 1938) 10 *MLMF* 11 Ibid.
12 *Cinema: A Critical Dictionary* (Secker and Warburg, 1980) 13 *MLMF*
14 Ibid. 15 *Télé 7 Jours* (1973) 16 *MLMF* 17 Ibid.

Chapter 12: Black and White Follies
★MLMF 1 Ibid. 2 Ibid. 3 Ibid. 4 Ibid. 5 Ibid. 6 Ibid. 7 Ibid.
8 Ibid. 9 Alice Fighiera to author

Chapter 13: Dédée in Toyland
★Entretiens 1 Ibid. 2 *RMF* 3 *Jean Renoir*, Pierre Leprohon (Seghers, 1967)

Chapter 14: Slapstick, Swords and Sand
MLMF 1 *Entretiens* 2 *MLMF* 3 Sesonske 4 *MLMF* 5 Ibid. 6 *RMF*

Chapter 15: The Bitch
Entretiens 1 Dirce Vogt to author 2 Alice Fighiera to author 3 Leslie
Caron to author 4 *OCI* 5 *Ibid.* 6 *Entretiens* 7 *MLMF* 8 Ibid. 9 *Télé 7
Jours* (1973) 10 *MLMF* 11 Ibid. 12 Ibid. 13 Ibid. 14 Ibid.
15 *Rediscovering French Film* (Museum of Modern Art, 1983) 16 *Cinema: A
Critical Dictionary* (Secker and Warburg, 1980) 17 Nicholas Frangakis to
author 18 *MLMF*

Chapter 16: Through a Lens Darkly
Entretiens 1 *MLMF* 2 Ibid. 3 Alice Fighiera to author 4 Ibid. 5 *Télé 7
Jours* (1973)

Chapter 17: *Nostalgie de la Boue*
Entretiens 1 *OCI* 2 Ibid. 3 Ibid.

Chapter 18: Filming Flaubert
Entretiens 1 *MLMF* 2 Sesonske 3 *MLMF* 4 Ibid. 5 *RMF* 6 *Entretiens*
7 Ibid. 8 Ibid. 9 Ibid. 10 Jean Griot to author 11 *MLMF* 12 *Entretiens*
13 *Bertolt Brecht*, Frederic Ewen (The Citadel Press, 1967) 14 *MLMF*

Chapter 19: Provençal Passions
MLMF 1 Ibid. 2 *Entretiens* 3 *Jean Renoir*, Armand-Jean Cauliez (Editions
Universitaires, 1962) 4 *MLMF* 5 *Entretiens* 6 Ibid. 7 Ibid. 8 *MLMF*
9 Ibid.

Chapter 20: '*Vivre Le Front Populaire!*'
Entretiens 1 Ibid. 2 Ibid. 3 Bazin 4 Ibid. 5 *Dictionnaire des Films* (Paris,
1965) 6 *Luchino Visconti: The Flames of Passion*, Laurence Schifano (Collins,
1990) 7 Ibid. 8 *MLMF*

Chapter 21: Two Months in the Country
Entretiens 1 *RMF* 2 *MLMF* 3 Ibid. 4 Ibid. 5 *Entretiens* 6 *Tribute to
Jean Renoir*, BBC television (1979) 7 Sesonske 8 *Entretiens* 9 Ibid.
10 Bazin 11 *Tribute to Jean Renoir*, BBC television (1979) 12 *Luchino Visconti:
The Flames of Passion*, Laurence Schifano (Collins, 1990) 13 Ibid. 14 *Ciné-
Liberté* (1936) 15 *MLMF*

Chapter 22: Moscow on the Seine
Entretiens 1 Ibid. 2 Ibid. 3 Ibid. 4 Ibid. 5 Ibid. 6 *MLMF*

Chapter 23: Brothers In Uniform
Entretiens 1 *MLMF* 2 Sesonske 3 *Hollywood Scapegoat*, Peter Noble
(Fortune Press, 1950) 4 Ibid. 5 *Cinéma 60* (July 1960) 6 *MLMF* 7 *Von
Stroheim*, Thomas Quinn Curtiss (Angus and Robertson, 1971) 8 *Entretiens*
9 Ibid. 10 *MLMF* 11 Ibid.

Chapter 24: '*C'est la Révolution!*'
Entretiens 1 *Écrits* 2 Ibid. 3 *Bertolt Brecht Letters* (Methuen, 1990)
4 *Entretiens* 5 *Pour Vous* (August 1937) 6 *Entretiens* 7 Ibid. 8 Ibid.
9 *MLMF*

Chapter 25: On and Off the Rails
Écrits 1 Ibid. 2 *OCI* 3 *Écrits* 4 *Entretiens* 5 Ibid. 6 Ibid. 7 Ibid. 8 *MLMF* 9 *Spectator* (1938) 10 *Fritz Lang In America*, Peter Bogdanovich (Studio Vista, 1968) 11 *Entretiens* 12 Bazin 13 Marcel Carné to author 14 Ibid

Chapter 26: Everyone Has His Reasons
Entretiens 1 Ibid. 2 *RMF* 3 *Entretiens* 4 *MLMF* 5 *Entretiens* 6 Ibid. 7 Ibid. 8 Ibid. 9 Ibid. 10 *Cinema: A Critical Dictionary* (Secker and Warburg, 1980) 11 Ibid. 12 *MLMF* 13 *Entretiens* 14 *MLMF* 15 *La Cinématographie française* (1939) 16 *Entretiens*

Chapter 27: A Shabby Little Shocker
Entretiens 1 *OCI* 2 Ibid. 3 Ibid. 4 *Ce Soir* (August 1939) 5 *Entretiens* 6 Ibid. 7 Ibid. 8 Ibid. 9 *MLMF* 10 Sesonske 11 *MLMF* 12 *Luchino Visconti: The Flames of Passion*, Laurence Schifano (Collins, 1990) 13 *MLMF*

Chapter 28: Fifteenth Century-Fox
Lettres 1 *MLMF* 2 Ibid. 3 Ibid. 4 Ibid. 5 Ibid. 6 *S&S* 7 Ibid. 8 *MLMF* 9 *Lettres* 10 Ibid. 11 *MLMF* 12 Ibid. 13 Ibid. 14 Ibid. 15 Ibid. 16 *Lettres* 17 *S&S* 18 Ibid. 19 Ibid. 20 Ibid. 21 Ibid. 22 Ibid. 23 Ibid. 24 Ibid.

Chapter 29: Occupation Therapy
MLMF 1 Ibid. 2 *Lettres* 3 Ibid. 4 Ibid. 5 *Jean Renoir*, Célia Bertin (Librarie Académique Perrin, 1986) 6 *Lettres* 7 Ibid. 8 *S&S* 9 *Lettres* 10 Ibid. 11 Ibid. 12 *OCI* 13 *Lettres* 14 *S&S* 15 *Lettres* 16 Ibid. 17 *MLMF* 18 *Bertolt Brecht Letters* (Methuen, 1990) 19 *Lettres*

Chapter 30: Americana
Lettres 1 *MLMF* 2 Ibid. 3 Ibid. 4 Ibid. 5 Ibid. 6 *My Life*, Marlene Dietrich (Weidenfeld and Nicolson, 1989) 7 *Entretiens* 8 *Jean Renoir in America*, William H. Gilcher (Des Moins, 1979) 9 *Lettres* 10 *Von Stroheim*, Thomas Quinn Curtiss (Angus and Robertson, 1971) 11 Pierre Olaf to author 12 *MLMF* 13 Ibid. 14 *MLMF* 15 *Entretiens* 16 *MLMF*

Chapter 31: What the Chambermaid Saw
MLMF 1 *Lettres* 2 Ibid. 3 Ibid. 4 *MLMF* 5 *Entretiens* 6 Ibid. 7 Ibid.

Chapter 32: The End of the Dream
MLMF 1 Ibid. 2 Ibid. 3 *Entretiens* 4 *MLMF* 5 *Histoire d'une revue* (Éditions Cahiers du Cinéma, 1991) 6 *Écrits* 7 *MLMF* 8 *Strangers In Paradise*, John Russell Taylor (Faber, 1985) 9 *MLMF* 10 *Lettres* 11 Ibid. 12 Alain Renoir to author 13 *Lettres* 14 Ibid. 15 *Jean Renoir*, Célia Bertin (Librarie Académique Perrin, 1986) 16 Alice Fighiera to author

Chapter 33: Way Out East
Entretiens 1 *Our Films, Their Films*, Satyajit Ray (Bombay, 1976) 2 *Satyajit Ray*, Andrew Robinson (André Deutsch, 1990) 3 *Our Films, Their Films*, op. cit. 4 *Entretiens* 5 *HWFR* 6 Ibid. 7 Rumer Godden to author 8 Ibid. 9 Ibid. 10 Ibid. 11 Ibid. 12 *HWFR* 13 Rumer Godden to author

14 *HWFR* 15 *MLMF* 16 Rumer Godden to author 17 *Satyajit Ray*, op. cit. 18 *MLMF* 19 Rumer Godden to author 20 Ibid. 21 *HWFR* 22 Ibid. 23 *MLMF* 24 *Entretiens* 25 Ibid. 26 *Satyajit Ray*, op. cit.

Chapter 34: *Commedia Delle Magnani*
Entretiens 1 HUAC transcript 2 *Écrits* 3 *Luchino Visconti: The Flames of Passion*, Laurence Schifano (Collins, 1990) 4 *Entretiens* 5 Ibid. 6 Ibid. 7 Ibid. 8 Ibid. 9 Ibid. 10 *Cahiers du Cinéma* (March 1953) 11 *OCI*

Chapter 35: The Ballad of the Butte
Entretiens 1 *Histoire d'une revue* (Éditions Cahiers du Cinéma, 1991) 2 *François Truffaut Letters* (Faber and Faber, 1989) 3 Louis Malle to author 4 *Nouvelle Observateur* (October 1984) 5 *MLMF* 6 Bazin 7 Jean Griot to author 8 *MLMF*

Chapter 36: Ingrid and Men
Entretiens 1 Leslie Caron to author 2 *MLMF* 3 Ibid. 4 Leslie Caron to author 5 Ibid. 6 Ibid. 7 *MLMF* 8 Pierre Olaf to author 9 Leslie Caron to author 10 Pierre Olaf to author 11 *Entretiens* 12 Leslie Caron to author 13 Pierre Olaf to author 14 *Ingrid Bergman: My Story*, Ingrid Bergman (Michael Joseph, 1980) 15 *Entretiens* 16 *As Time Goes By*, Laurence Leamer (Hamish Hamilton, 1986) 17 *Entretiens* 18 Jean Griot to author 19 *Entretiens*

Chapter 37: The Eternal Debutant
Entretiens 1 *Fritz Lang In America*, Peter Bogdanovich (Studio Vista, 1968) 2 *MLMF* 3 *Cahiers du Cinéma* (December 1957) 4 *OIC* 5 *Entretiens* 6 Madeleine Morgenstern to author 7 *France-Observateur* (October 1958) 8 *OCI* 9 *MLMF* 10 Sesonske 11 Truffaut 12 Louis Malle to author 13 *L'Avant-Scène du cinéma* (October 1965) 14 *Our Films, Their Films*, Satyajit Ray (Bombay, 1976) 15 *Entretiens* 16 *MLMF*

Chapter 38: Natural Insemination
RMF 1 *Entretiens* 2 *MLMF* 3 Ibid. 4 *RMF* 5 *MLMF* 6 *Entretiens* 7 Nicholas Frangakis to author 8 Letter supplied to author by Pierre Olaf

Chapter 39: The Good Soldier
Entretiens 1 Ibid. 2 Ibid. 3 Truffaut 4 *MLMF* 5 *RMF* (blurb) 6 *Elsa Lanchester Herself*, Elsa Lanchester (St Martins Press, 1983) 7 Letter supplied by Pierre Olaf 8 *Clifford Odets: American Playwright*, Margaret Brenman-Gibson (Atheneum, 1982) 9 *MLMF* 10 *OIC* 11 Ibid. 12 Dirce Vogt to author 13 Rumer Godden to author 14 Ibid. 15 *François Truffaut Letters* (Faber and Faber, 1989) 16 *Cahiers du Cinéma* (March 1968)

Chapter 40: Curtain Call
MLMF 1 *Entretiens* 2 Ibid. 3 Ibid. 4 *OIC* 5 *Entretiens* 6 Pierre Olaf to author 7 *MLMF*

Part VII: The Oneness of the World
MLMF 1 Leslie Caron to author 2 Dirce Vogt to author 3 Leslie Caron to author 4 Madeleine Morgenstern to author 5 Truffaut 6 Ibid. 7 Ibid. 8 Ibid. 9 Leslie Caron to author 10 Ibid. 11 *L'Avant-Scène Théâtre*

(November 1976) 12 Pierre Olaf to author 13 *François Truffaut Letters* (Faber and Faber, 1989) 14 Leslie Caron to author 15 Eva Lothar to author 16 Truffaut 17 Pierre Olaf to author 18 Dirce Vogt to author 19 Truffaut 20 *François Truffaut Letters*, op. cit. 21 Leslie Caron to author 22 *RMF* 23 *Jean Renoir*, Célia Bertin (Librarie Académique Perrin, 1986) 24 Truffaut 25 Ibid.

Filmography

(Dates of first showing given. All directed by Jean Renoir unless stated.)

Catherine (aka *Une vie sans joie*)
France 1924. Films Jean Renoir. **Director**: Albert Dieudonné. **Screenplay**: Jean Renoir. **Photography**: Jean Bachelet, Alphonse Gibory. **Cast**: Catherine Hessling (Catherine Ferrand), Albert Dieudonné (Maurice Laisné), Eugènie Naud (Madame Laisné), Louis Gauthier (Georges Mallet), Maud Richard (Madame Mallet), Pierre Philippe (Adolphe), Pierre Champagne (The Mallets' son). 75 mins.

La Fille de l'eau (*Whirlpool Of Fate*)
France 1924. Films Jean Renoir/Maurice Touzé/Studio Films. **Screenplay**: Pierre Lestringuez. **Photography**: Jean Bachelet, Alphonse Gibory. **Cast**: Catherine Hessling (Virginie), Pierre Philippe (Uncle Jeff), Pierre Champagne (Justin Crepoux), Harold Livingston (Georges Reynal), Maurice Touzé (Ferret). 70 mins.

Nana
France/Germany 1926. Films Jean Renoir. **Screenplay**: Pierre Lestringuez (from the novel by Émile Zola). **Photography**: Edmond Crown, Jean Bachelet. **Cast**: Catherine Hessling (Nana), Werner Krauss (Count Muffat), Jean Angelo (Count de Vandeuvres), Valeska Gert (Zoé), Pierre Philippe (Bordenavel), Pierre Champagne (La Faloise), Raymond Guérin (Georges Hugon), Claude Moore alias Claude Autant-Lara (Fauchery), André Cerf ('Le Tigre'). 98 mins.

Charleston (aka *Sur un air de Charleston*)
France 1927. Néo-Film. **Screenplay**: Pierre Lestringuez. **Photography**: Jean Bachelet. **Cast**: Catherine Hessling (The Dancer), Johnny Huggins (The Alien), André Cerf (The Monkey), Pierre Braunberger, Jean Renoir, Pierre Lestringuez, André Cerf (Four Angels). 21 mins.

Marquitta
France 1927. Artistes Réunis. **Screenplay**: Pierre Lestringuez. **Photography**: Jean Bachelet, Raymond Agnel. **Cast**: Marie-Louise Iribe (Marquitta), Jean Angelo (Prince Vlasco), Pierre Philippe (Casino Owner), Pierre Champagne (Taxi Driver). 2,400 metres.

La Petite marchande d'allumettes (*The Little Match Girl*)
France 1928. Jean Renoir/Jean Tedesco. **Screenplay**: Jean Renoir (from stories by Hans Christian Andersen). **Photography**: Jean Bachelet. **Cast**: Catherine Hessling (Karen), Jean Storm (Young Man/Wooden Soldier), Manuel Raaby (Policeman/Death), Amy Wells alias Aimée Tedesco (Mechanical Doll). 29 mins.

Tire au flanc
France 1928. Néo-Film. **Screenplay**: Jean Renoir, André Cerf, Claude Heymann (from the play by André Mouezy-Eon, A. Sylvane). **Photography**: Jean Bachelet. **Cast**: Georges Pomiès (Jean Dubois d'Ombelles), Michel Simon (Joseph), Fridette Faton (Georgette), Félix Oudart (Colonel Brochard), Jean Storm (Lieutenant Daumel), Kinny Dorlay (Lily), Maryanne (Madame Blandin), Zellas (Muflot), Jeanne Helbling (Solange), Catherine Hessling (Teacher). 2,200 metres.

Le Tournoi (aka *Le Tournoi dans la cité*)
France 1928. Société des Films Historiques. **Screenplay**: Henry Dupuy-Mazuel, André Jaeger-Schmidt. **Photography**: Marcel Lucien, Maurice Desfassiaux. **Cast**: Aldo Nadi (François de Baynes), Jackie Monnier (Isabelle Ginori), Enrique Rivero (Henri de Rogier), Blanche Bernis (Catherine de Medici), Suzanne Desprès (Countess de Baynes), Manuel Raaby (Count Ginori). 2,400 metres.

Le Bled
France 1929. Société des Films Historiques. **Screenplay**: Henry Dupuy-Mazuel, André Jaeger-Schmidt. **Photography**: Marcel Lucien, Léon Morizet. **Cast**: Jackie Monnier (Claude Duvernet), Enrique Rivero (Pierre Hoffer), Diana Hart (Diane Duvernet), Manuel Raaby (Manuel Duvernet), Alexandre Arquillière (Christian Hoffer). 87 mins.

On purge bébé
France 1931. Braunberger-Richebé. **Screenplay**: Jean Renoir (from the play by Georges Feydeau). **Photography**: Théodore Sparkuhl, Roger Hubert. **Music**: Paul Misraki. **Cast**: Jacques Louvigny (Bastien Follavoine), Marguerite Pierry (Madame Follavoine), Sacha Taride (Toto), Michel Simon (Chouilloux), Olga Valéry (Madame Chouilloux), Fernandel (Horace Truchet). 62 mins.

La Chienne
France 1931. Films Jean Renoir/Braunberger-Richebé. **Screenplay**: Jean Renoir, André Girard (from the novel by Georges de la Fouchardière). **Photography**: Théodore Sparkuhl. **Music**: Eugènie Buffet, Toselli. **Cast**: Michel Simon (Maurice Legrand), Janie Marèze (Lulu), Georges Flamant (Dédé), Magdeleine Bérubet (Madame Legrand), Pierre Gaillard (Alexis Godart), Jean Gehret (Dugodet). 100 mins.

La Nuit du carrefour (*Night At The Crossroads*)
France 1932. Europa Films. **Screenplay**: Jean Renoir (from the novel by Georges Simenon). **Photography**: Marcel Lucien, Georges Asselin. **Cast**: Pierre Renoir (Inspector Maigret), Georges Térol (Lucas), Winna Winfried (Else Andersen), Georges Koudria (Carl Andersen), Jean Gehret (Emile Michonnet), Jane Pierson (Madame Michonnet), Michel Duran (Jojo). 80 mins.

Boudu sauvé des eaux (*Boudu Saved From Drowning*)
France 1932. Société Sirius. **Screenplay**: Jean Renoir (from the play by René Fauchois). **Photography**: Marcel Lucien. **Cast**: Michel Simon (Boudu), Charles Granval (Edouard Lestingois), Marcelle Hainia (Madame Lestingois), Séverine Lerczinska (Anne-Marie), Max Dalbin (Godin), Jean Gehret (Vigour), Jean Dasté (Student). 87 mins.

Chotard et cie (*Chotard And Co.*)
France 1933. Films Roger Ferdinand. **Screenplay**: Jean Renoir (from the play by Roger Ferdinand). **Photography**: Joseph-Louis Mundwiller. **Cast**: Fernand Charpin (François Chotard), Jeanne Lory (Madame Chotard), Georges Pomiès (Julien Collinet), Jeanne Boitel (Reine Chotard), Max Dalban (Émile). 2,125 metres.

Madame Bovary
France 1934. Nouvelle Société de Film. **Screenplay**: Jean Renoir (from the novel by Gustave Flaubert). **Photography**: Jean Bachelet. **Music**: Darius Milhaud. **Cast**: Valentine Tessier (Emma Bovary), Pierre Renoir (Charles Bovary), Alice Tessier (Old Madame Bovary), Max Dearly (M. Homais), Daniel Lecourtois (Léon Dupuis), Fernand Fabre (Rodolphe Boulanger), Pierre Laquey (Hippolyte Tautin), Robert Le Vigan (Lheureux), Romain Bouquet (M. Guillaumin), André Fouché (Justin). 117 mins.

Toni
France 1935. Films Marcel Pagnol. **Screenplay**: Jean Renoir, Carl Einstein. **Photography**: Claude Renoir. **Music**: Paul Bozzi. **Cast**: Charles Blavette (Toni), Jenny Hélia (Marie), Célia Montalvan (Josefa), Max Dalban (Albert), Edouard Delmont (Fernand), Andrex (Gabi), André Kovachevitch (Sébastien). 95 mins.

Le Crime de Monsieur Lange (*The Crime Of Monsieur Lange*)
France 1935. Obéron. **Screenplay**: Jacques Prévert, Jean Renoir. **Photography**: Jean Bachelet. **Music**: Jean Wiener, Joseph Kosma. **Cast**: Jules Berry (Batala), René Lefèvre (Amédée Lange), Florelle (Valentine), Nadia Sibirskaïa (Estelle), Sylvie Bataille (Edith), Marcel Levesque (The Concierge), Maurice Baquet (Charles), Jacques Brunius (M. Baigneur), Henri Guisol (Meunier fils). 85 mins.

La vie est à nous
France 1936. Partie Communiste Français. **Directors**: Jean Renoir, Jacques Becker, André Swobada, Jean-Paul Dreyfus (later Jean-Paul Le Chanois). **Screenplay**: Jean Renoir, Paul Vaillant-Couturier, Jean-Paul Dreyfus, André Swobada. **Photography**: Louis Page, Jean-Serge Bourgoin, Jean Isnard, Alain Douarinou, Claude Renoir, Nicholas Hayer. **Cast**: Jean Dasté (Teacher), Jacques Brunius (President of Administrative Council), Pierre Unik (Marcel Cachin's Secretary), Julien Bertheau (René), Nadia Sibirskaïa (Ninette), Emile Drain (Gustave), Gaston Modot (Philippe), Charles Blavette (Tonin), Marcel Cachin, André Marty, Maurice Thorez, Jacques Duclos (as themselves). 66 mins.

Une Partie de campagne (*A Day In The Country*)
France 1946 (Shot in 1936). Films du Panthéon/Films de la Pléiade/Pierre Braunberger. **Screenplay**: Jean Renoir (based on the story by Guy de Maupassant). **Photography**: Claude Renoir. **Music**: Joseph Kosma. **Cast**: Sylvie Bataille (Henriette Dufour), Jane Marken (Madame Dufour), Gabriello (Cyprien Dufour), Georges Darnoux (Henri), Jacques Brunius (Rodolphe), Paul Temps (Anatole), Gabrielle Fontan (The Grandmother), Jean Renoir (Papa Poulain), Servant (Marguerite Renoir). 45 mins.

Les Bas-Fonds (*The Lower Depths*)
France 1936. Albatros. **Screenplay**: Eugene Zamiatine, Jacques Companeez (from the play by Maxim Gorky). **Photography**: Fedoze Bourgassof, Jean Bachelet. **Music**: Jean Wiener. **Cast**: Louis Jouvet (The Baron), Jean Gabin (Pepel), Suzy Prim (Vassilissa), Vladimir Sokoloff (Kostileff), Junie Astor (Natasha), Robert Le Vigan (The Actor), Gabriello (The Inspector), René Génin (Luka), Jany Holt (Nastya), Maurice Baquet (Aliocha). 92 mins.

La Grande Illusion
France 1937. RIC/Cinédis/Filmsonor-Gaumont. **Screenplay**: Jean Renoir, Charles Spaak. **Photography**: Christian Matras. **Music**: Joseph Kosma. **Cast**: Jean Gabin (Lieutenant Maréchal), Pierre Fresnay (Captain de Boeldieu), Erich von Stroheim (Captain von Rauffenstein), Marcel Dalio (Rosenthal), Julien Carette (Traquet), Dita Parlo (Elsa), Jean Dasté (Teacher), Gaston Modot (Engineer). 117 mins.

La Marseillaise
France 1938. CGT. **Screenplay**: Jean Renoir. **Photography**: Jean-Serge Bourgoin, Alain Douarinou, Jean-Marie Maillols, Jean-Paul Alphen, Jean Louis. **Music**: Lalande, Grétry, Mozart, J. S. Bach, Joseph Kosma, Roget de L'Isle, Sauveplane. **Cast**: Pierre Renoir (Louis XVI), Lise Delamare (Marie-Antoinette), Louis Jouvet (Roederer), Andrex (Honoré Arnaud), Ardisson (Fernand Flament), Nadia Sirbirskaïa (Louison), Jenny Hélia (The Interrogator), Léon Larive (Picard), Gaston Modot and Julien Carette (Volunteers). 135 mins.

La Bête humaine (*The Human Beast*)
France 1938. Paris Film Production. **Screenplay**: Jean Renoir (from the novel by Émile Zola). **Photography**: Curt Courant. **Music**: Joseph Kosma. **Cast**: Jean Gabin (Jacques Lantier), Simone Simon (Séverine), Fernand Ledoux (Roubard), Julien Carette (Pecqueux), Colette Régis (Victoire), Jacques Berlioz (Grandmorin), Jean Renoir (Cabuche). 99 mins.

Le Règle du jeu (*The Rules Of The Game*)
France 1939. Nouvelles Éditions Françaises. **Screenplay**: Jean Renoir. **Photography**: Jean Bachelet. **Music**: Joseph Kosma, Mozart, Monsigny, Saint-Saëns, Johann Strauss. **Cast**: Marcel Dalio (Robert de la Chesnaye), Nora Grégor (Christine), Roland Toutain (André Jurieux), Jean Renoir (Octave), Mila Parély (Geneviève), Gaston Modot (Edouard Schumacher), Julien Carette (Marceau), Paulette Dubost (Lisette). 113 mins.

Swamp Water
USA 1941. Twentieth Century-Fox. **Screenplay**: Dudley Nichols (from the story by Vereen Bell). **Photography**: Peverell Marley, Lucien Ballard. **Music**: David Rudolph. **Cast**: Dana Andrews (Ben Ragan), Walter Huston (Thursday Ragan), Walter Brennan (Tom Keefer), Anne Baxter (Julie), John Carradine (Jesse Wick), Mary Howard (Hannah), Ward Bond (Jim Dorson), Guinn Williams (Bud Dorson), Virginia Gilmore (Mabel). 90 mins.

This Land Is Mine
USA 1943. RKO. **Screenplay**: Dudley Nichols, Jean Renoir. **Photography**: Frank Redman. **Music**: Lothar Perl. **Cast**: Charles Laughton (Albert Lory),

Maureen O'Hara (Louise Martin), Kent Smith (Paul Martin), George Sanders (George Lambert), Walter Slezak (Major von Keller), Una O'Connor (Mrs Lory), Philip Merivale (Professor Sorel), Nancy Gates (Julie Grant). 103 mins.

Salute to France
USA 1944. Office of War Information. **Screenplay**: Philip Dunne, Jean Renoir, Burgess Meredith. **Photography**: George Webber. **Music**: Kurt Weill. **Cast**: Burgess Meredith (Tommy), Garson Kanin (Joe), Claude Dauphin (The Narrator and various Frenchmen).

The Southerner
USA 1945. United Artists. **Screenplay**: Jean Renoir (from the novel *Hold Autumn in Your Hand* by George Perry Sessions). **Photography**: Lucien Andriot. **Music**: Werner Janssen. **Cast**: Zachary Scott (Sam Tucker), Betty Field (Nora Tucker), Beulah Bondi (Grandma), J. Carrol Naish (Devers), Percy Kilbride (Harmie Jenkins), Norman Lloyd (Finlay), Charles Kemper (Tim). 91 mins.

The Diary Of A Chambermaid
USA 1946. United Artists. **Screenplay**: Jean Renoir, Burgess Meredith (from the play by André Heuzé, André de Lorde, Thielly Nores, after the novel by Octave Mirbeau). **Photography**: Lucien Andriot. **Music**: Michel Michelet. **Cast**: Paulette Goddard (Célestine), Burgess Meredith (Captain Mauger), Hurd Hatfield (Georges Lanlaire), Reginald Owen (M. Lanlaire), Judith Anderson (Madame Lanlaire), Francis Lederer (Joseph), Florence Bates (Rose). 91 mins.

The Woman On The Beach
USA 1947. RKO. **Screenplay**: Jean Renoir, Frank Davis, J. R. Michael Hogan (from the novel *None So Blind* by Mitchell Wilson). **Photography**: Harry Wild, Leo Tover. **Music**: Hanns Eisler. **Cast**: Joan Bennett (Peggy Butler), Robert Ryan (Scott Burnett), Charles Bickford (Tod Butler), Nan Leslie (Eve), Walter Sande (Vernecke). 71 mins.

The River
USA/GB 1951. United Artists. **Screenplay**: Rumer Godden, Jean Renoir (from the novel by Godden). **Photography**: Claude Renoir. **Music**: Traditional Indian. **Cast**: Nora Swinburne (The Mother), Esmond Knight (The Father), Arthur Shields (Mr John), Thomas E. Breen (Captain John), Radha Shri Ram (Melanie), Adrienne Corri (Valerie), Patricia Walters (Harriet), Suprova Mukerjee (Nan), Richard Foster (Bogey). 99 mins.

Le Carrosse d'or (*The Golden Coach*)
France/Italy 1953. Panaria Films/Hoche Productions. **Screenplay**: Jean Renoir, Renzo Avenzo, Guilio Macchi, Jack Kirkland, Ginette Doynel (from the play *Le Carrosse du Saint-Sacrément* by Prosper Mérimée). **Photography**: Claude Renoir, Ronald Hill. **Music**: Vivaldi, Corelli, Olivier Mettra. **Cast**: Anna Magnani (Camilla), Duncan Lamont (The Viceroy), Odoardo Spadaro (Don Antonio), Riccardo Rioli (Ramon), Paul Campbell (Felipe), Nada Fiorelli (Isabelle), Dante (Harlequin). 100 mins.

French Cancan (*Only The French Can*)
France 1955. Franco London Films/Jolly Films. **Screenplay**: Jean Renoir. **Photography**: Michel Kelber. **Music**: Georges van Parys. **Cast**: Jean Gabin

(Danglard), Maria Felix (Lola di Castro), Françoise Arnoul (Nini), Jean-Roger Caussimon (Baron Walter), Gianni Esposito (Prince Alexandre), Philippe Clay (Casimir), Franco Pastorino (Paulo), Pierre Olaf (Pierrot). 105 mins.

Eléna et les hommes (*Paris Does Strange Things*)
France 1956. Franco-London Films/Films Gibé/Electra Compagnia Cinematografica. **Screenplay**: Jean Renoir. **Photography**: Claude Renoir. **Music**: Joseph Kosma, George van Parys. **Cast**: Ingrid Bergman (Princess Eléna Sorokovska), Jean Marais (General François Rollan), Mel Ferrer (Henri de Chevincourt), Pierre Bertin (Martin-Michaud), Jean Richard (Hector), Magali Noël (Lolotte), Elina Labourette (Paulette Escoffier), Juliette Greco (Gypsy). 96 mins.

Le Testament du docteur Cordelier (*The Testament Of Doctor Cordelier*)
France 1961 (Shot in 1959). RTF Sorifrad/Compagnie Jean Renoir. **Screenplay**: Jean Renoir (from *The Strange Case of Dr Jekyll and Mr Hyde* by Robert Louis Stevenson). **Photography**: Georges Leclerc. **Music**: Joseph Kosma. **Cast**: Jean-Louis Barrault (Dr Cordelier/Opale), Teddy Billis (Maître Joly), Michel Vitold (Dr Lucien Séverin), Jean Topart (Désiré), Micheline Gary (Marguerite), André Ceres (Inspector Salbris). 100 mins.

Le Déjeuner sur l'herbe (*Lunch On The Grass/Picnic On The Grass*)
France 1959. Compagnie Jean Renoir. **Screenplay**: Jean Renoir. **Photography**: Georges Leclerc. **Music**: Joseph Kosma. **Cast**: Paul Meurisse (Professor Etienne Alexis), Catherine Rouvel (Nénette), Fernand Sardou (Nino), Ingrid Nordine (Marie-Charlotte), Charles Blavette (Gaspard), Jean Claudio (Rousseau). 92 mins.

Le Caporal épinglé (*The Elusive Corporal/The Vanishing Corporal*)
France 1962. Films du Cyclope. **Screenplay**: Jean Renoir, Guy Lefranc. **Photography**: Georges Leclerc. **Music**: Joseph Kosma. **Cast**: Jean-Pierre Cassel (The Corporal), Claude Brasseur (Pater), Claude Rich (Ballochet), Jean Carmet (Guillaume), Jacques Jouanneau (Pench-à-gauche), Cornelia Froboess (Erika), Mario David (Caruso), O. E. Hasse (Drunken Passenger), Guy Bedos (The Stutterer). 110 mins.

Le Petit Théâtre de Jean Renoir (*The Little Theatre Of Jean Renoir*)
France 1969. Son et Lumière. **Screenplay**: Jean Renoir. **Photography**: Georges Leclerc, Antoine Georgakis, Georges Liron. **Music**: Jean Wiener, Joseph Kosma, Octave Crémieux. **Cast**: 1) *Le Dernier réveillon* – Nino Formicola and Milly-Monti (Tramps), Roland Bertin (Gontran), Robert Lombard (Maître D'). 2) *La Cireuse électrique* – Marguerite Cassan (Émilie), Pierre Olaf (Gustave), Jacques Dynam (Jules), Jean-Louis Tristan (Salesman). 3) *Quand l'amour Meurt* – Jeanne Moreau (The Singer). 4) *Le Roi d'Yvetot* – Fernand Sardou (Duvallier), Françoise Arnoul (Isabelle), Jean Carmet (Féraud), Dominique Labourier (Paulette). 100 mins.

Jean Renoir: written works

Plays
Orvet (Gallimard, 1955)
Carola (L'Avant Scene, 1976)

Books
Renoir, My Father (Collins, 1962)
Les Cahiers du Capitaine Georges (Gallimard, 1966)
My Life and My Films (Collins, 1974)
Le Coeur à l'aise (Flammarion, 1978)
Le Crime de l'Anglais (Flammarion, 1979)
Geneviève (Flammarion, 1979)

Unrealised synopses and screenplays
Alice (1925)
Don Juan (1925)
L'Auberge des Quatre Vents (c. 1926)
La Rouquine (c. 1927)
Madame Bovary à rebours (c. 1930)
Pedro (1934)
La Séquestrée (1936)
Les Sauveteurs (1938)
Histoire d'enfants (1938)
Les Millions d'Arlequin (1938)
Roméo et Juliette (1939)
Amphitryon (1939)
Magnificat (1940)
A Trip to Tilsit (c. 1940)
Christine (c. 1951)
Une Nuit à Paris (c. 1951)
Premier amour (1952)
Les Horreurs de la guerre (1952)
Le Masque (1952)
Noblesse oblige (1953)
Vincent Van Gogh (1953)
Paris-Province (1954)
Villa de L'Extra (1957)
Que deviendra cet enfant? (1959)
Yladjali (1960–62)

La Mort satisfaite (1965)
Le Système du Docteur Goudron et du Professeur Plume (1966)
Apollon et Alexandra (c. 1966)
C'est la révolution! (1965–1969)
Julienne et son amour (1968)

Bibliography

Jean Renoir, Pierre Leprohon (Editions Seghers, 1967)
Jean Renoir, André Bazin (Editions Champ Libre, 1971)
Jean Renoir: The World Of His Films, Leo Braudy (Doubleday, 1972)
Jean Renoir, Raymond Durgnat (University of California Press, 1974)
Jean Renoir, Penelope Gilliatt (McGraw-Hill, 1975)
Écrits 1926–1971 (Pierre Belfond, 1974)
Jean Renoir, Claude Beylie (Cinema d'Aujourd'hui, 1975)
Entretiens Et Propos (Cahiers du Cinéma, 1979)
Jean Renoir – The French Films 1924–1939, Alexander Sesonske (Harvard University Press, 1980)
Jean Renoir – Oeuvres De Cinéma Inédites (Cahiers du Cinéma-Gallimard, 1981)
Lettres D'Amérique, ed. Alexander Sesonske (1984)
Jean Renoir, Célia Bertin (Librarie Académique Perrin, 1986)

Index

Entries in **bold** denote films, plays, screenplays, treatments and projects with which Jean Renoir had some involvement. Songs and melodies are in quotes.